Production Design for Screen

Visual Storytelling in Film and Television

Jane Barnwell

Bloomsbury Visual Arts
An imprint of Bloomsbury Publishing Plc

B L O O M S B U R Y
LONDON · OXFORD · NEW YORK · NEW DELHI · SYDNEY

Bloomsbury Visual Arts
An imprint of Bloomsbury Publishing Plc

Imprint previously known as AVA Publishing

50 Bedford Square	1385 Broadway
London	New York
WC1B 3DP	NY 10018
UK	USA

www.bloomsbury.com

**BLOOMSBURY and the Diana logo are trademarks
of Bloomsbury Publishing Plc**

British Library Cataloguing-in-Publication Data

A catalogue record for this book is available from the British Library.

ISBN: PB: 978-1-4725-8067-2

ePDF: 978-1-4725-8068-9

ePUB: 978-1-4742-5478-6

Library of Congress Cataloging-in-Publication Data

Names: Barnwell, Jane, 1967- author.

Title: Production design for screen: visual storytelling in film and television / Jane Barnwell.

Description: London; New York: Bloomsbury Visual Arts, 2017. | Series: Required reading range | Includes bibliographical references and index.

Identifiers: LCCN 2015044112| ISBN 9781472580672 (paperback) | ISBN 9781472580689 (epdf)

Subjects: LCSH: Motion pictures—Art direction. | Motion pictures—Setting and scenery. | Television—Art direction. | BISAC: ART / Film & Video. | PERFORMING ARTS / Film & Video / Direction & Production.

Classification: LCC PN1995.9.A74 B38 2016 | DDC 791.4302/5--dc23 LC record available at http://lccn.loc.gov/2015044112

Series: Required Reading Range

Cover design: Sutchinda Rangsi Thompson

Cover image: *Gold Diggers of 1935* directed by Busby Berkeley, 1935.

First National Pictures (controlled by Warner Bros. Pictures Inc.).

Photo by Vintage Images/Getty Images.

Typeset by Struktur Design

Printed and bound in China

To find out more about our authors and books visit www.bloomsbury.com. Here you will find extracts, author interviews, details of forthcoming events and the option to sign up for our newsletters.

Designs for *Scar Night* (Alec Fitzpatrick, University of South Wales, BA (Hons) TV and Film Set Design) which feature a world suspended by chains over a seemingly bottomless chasm.

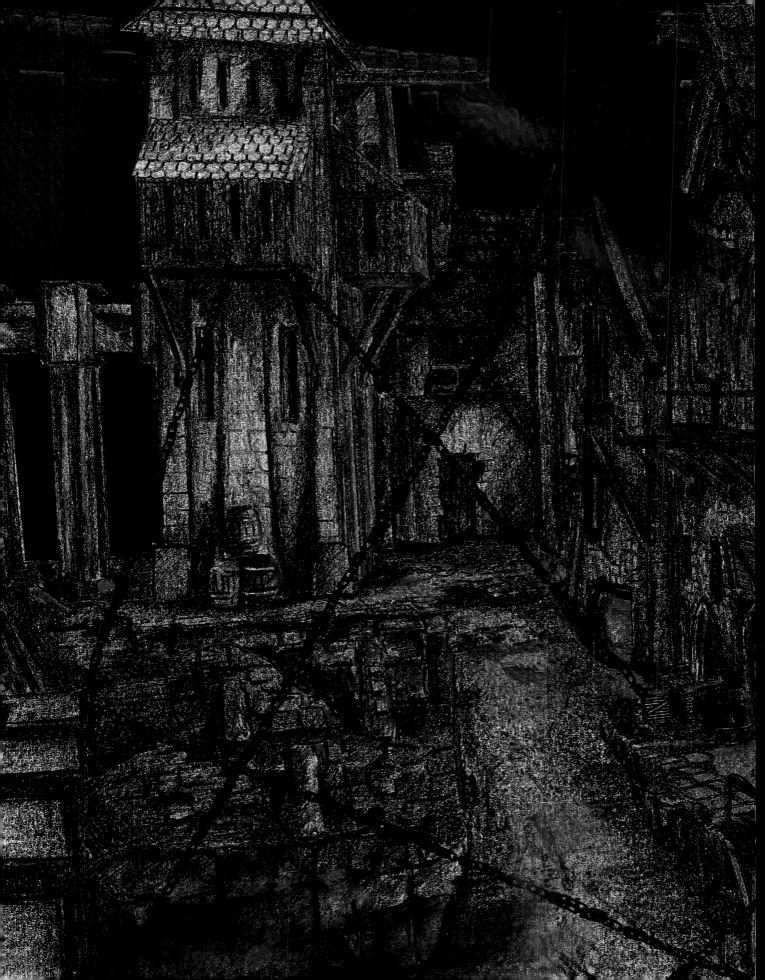

Introduction **6**
Authorship and the Visual Signature 7
Styles and Movements: A Timeline 9

Chapter 1 – Practicalities: The Design Process **22**
The Art Department 24
Breaking Down the Script 27
Developing Initial Ideas 29
Research Process 31
Sketches, Drafts, Models 35
The Budget 38
Studio Construction 40
Locations 42
Set Decorating and Dressing 44
Interview with Anna Pritchard 50

Chapter 2 – The Visual Concept **56**
Collaboration 58
Concept, Contrast and Transformation 58
Developing the Visual Concept 67
Inspiration 68
Interview with Stuart Craig 76

Chapter 3 – Space **82**
Space 84
Real and Imagined Worlds 85
Size and Scale 90
Geography of Space 92
Vertical Hierarchy 95
Interview with Alex McDowell 98

Chapter 4 – In and Out: Boundaries and Transitions **104**
In and Out 106
Doorways and Windows 108
Movement and Transition 114
Interiors and Exteriors 118
Case Study: Hugo Luczyc-Wyhowski 122

Chapter 5 – Light **128**

Sources and Position 130

Character and Story 134

Colour 140

Paintings 141

Interview with Ronald Gow 144

Chapter 6 – Colour **150**

Colour and Early Cinema 152

Painting and Perception 152

Colour Palette and Psychology 153

The Emotional Colour of a Scene 155

Character and Story 156

The Colour Red 159

Interview with Jim Bissell 162

Chapter 7 – Set Decoration **172**

The Set Decorator 174

Reflecting Character 175

Furniture and Dressing 183

Period and Style 185

Interview with Tatiana Macdonald 190

Appendix **198**

Clay – Student Script 200

Graduate Interviews 204

Designer Biographies 208

Selected Filmography 212

Further Resources 216

Acknowledgements 217

Glossary 218

Picture Credits 220

Index 222

INTRODUCTION

This book illustrates how the production designer (PD) is fundamental in the creation of place, character and narrative on screen through the use of distinct design elements.

Where are we? Whether in a shabby warehouse (*Reservoir Dogs*), a small town (*It's a Wonderful Life*), a futuristic city (*Metropolis*) or orbiting in space (*Gravity*) – it is the designer's job to answer that question, visualize the environment and transport us there. The paradox in this is that the setting will often remain unnoticed as it is traditionally harnessed to the aim of conveying story and character. Occasionally a space will draw attention to itself and possibly even the seams of its own construction and when that rupture occurs we are reminded that what we are watching has been conceived and created by a master of image making – the production designer. This book investigates what that role involves in relation to practice and concept, and considers the complex terrain that exists between design, the truth and realism.

The production designer interprets the script for the screen, weaving the visual elements together to create a coherent fictional universe. As Stuart Craig[2] says, 'I think design has very little realism. I think documentaries are about realism and feature films are about drama so it's a highly selective truth. You come at the truth by being stylized and it's a poetic truth.'[3]

Set design constitutes a paradox in that set elements are visible in the frame yet often invisible in our viewing of the film. As 'unconsciously registered backgrounds' there to support the story it can be argued that their invisibility is essential in the enjoyment of the narrative. Designers tend to agree that their role is in support of the illusion, which could be destroyed if the set features too prominently. But what about their contribution in the wider field of film appreciation? It seems that their background status carries through to the real world where all but a small handful of designers remain nameless to film audiences.

There is, however, increasing interest in this area with various studies into the role and practice of production designers that have sought to promote and make more visible their valuable contribution to the moving image. Some key titles are indicated at the end of this chapter and throughout the book.

This Introduction briefly signposts some of the pivotal events and key films in the evolution of production design.

> **"There is something about the medium of film that enables it to implant images in the mind that are more real than the real world; to stage manage our perception of the facts of everyday life. Southern Plantation houses look like Tara; airports look like the last scene in Casablanca; motels look like the Bates motel.[1] "**

AUTHORSHIP AND THE VISUAL SIGNATURE

In 1978 the exhibition 'Designed for Film: The Hollywood Art Director' held at the Museum of Modern Art, New York identified the 'signature' of the art director (AD) within the corporate vision of the studio system in a celebration of their contribution. The exhibition suggested that in spite of the branded identities of the Hollywood studio system, designers impacted on the look of a film in individual ways. This can be contextualised in relation to the discussions on authorship in 'auteur theory', which identifies the director as the single figure responsible for the look of a film.

As Laurie Ede points out in *British Film Design: A History*,[4] the designer's task is primarily shaped by the director's requirements, which means that in evaluating design the broader context of filmmaking must be referred to. The designer's role is in support of the narrative, characters and themes of the film; as such, an assessment of their output is necessarily bound to the whole film. So we can see in an overview of key moments in production design that on occasion the design department has influenced the film in terms of technology, aesthetic or sensibility and at other times they are responding to wider developments in film production and society.

Charles Affron and Mirella Jona Affron (1995) pick up on these issues of authorship and suggest that binomials like those used in music would be appropriate for the director/ production designer partnership, such as Gilbert and Sullivan or Rodgers and Hammerstein, who jointly created musical theatre and were co-credited as such. This notion of the designer's visual signature will be explored further in the chapters that follow.

Chapter 1 works through the practicalities of the design process from script to screen, outlining the importance of research in finding creative and practical solutions to the problems posed in the script. 'The designer's job is to illustrate the story in a dramatic way. You offer the producer a production solution and offer the director a dramatic solution.'[5]

Working in the studio and on location impacts on the look and feel of productions – we will consider how these have shaped the fictional space in practical, technical and aesthetic ways. Film and television throw up the issue of recurring settings – where the audience becomes familiar and therefore has expectations about a specific space – we will see ways in which designers have engaged with and built this into their approach – sharing methods and insights.

Leading on from this, Chapter 2 introduces a fresh perspective based on the visual concept. The model outlined here is based on the practice of professionals as elaborated upon in the interviews with selected designers at the end of each chapter. We explore how a designer creates a visual concept to give coherence to the film and draws this out by using a range of visual metaphors with the aim of enhancing and heightening aspects of the story, characters and atmosphere. The context of this conceptual development is always in relation to production constraints such as time and money.

Sets provide a film with its inimitable look, its geographical, historical, social and cultural contexts…sets aid in identifying characters, fleshing out and concretising their psychology…and thus evoke emotions and desires that complement or run counter to the narrative.[6]

In order to heighten the concept the designer usually creates a strong contrast to ensure the message is emphasised. Screen settings are rarely static and often reflect the journey of the major protagonist; frequently this is achieved through the transforming of the visual concept. Previous studies tend to concentrate on either practice or theory. The approach discussed here employs the methodology of practitioners to inform both practice and theory. From a theoretical perspective Chapter 2 lays the foundations for this approach – drawing on professional practice as a way of navigating the subsequent analysis of the screen image, and using the five tools expanded on in the chapters that follow.

Chapters 3 to 7 separate out the five strands employed to convey the visual concept. Namely, the space, the in and out, the light, the colour and the set decoration. As illustrated in the interviews, the designer's approach to these ingredients can be diverse. One aspect of this is the way in which a designer may collaborate to create the look and feel of screen space.

Each of these conceptual tools separated out for the purposes of this book are in practice integrated and overlapping – they are usually all present in the frame, crafting visual concept and driving narrative and emotion. I have separated them out into distinct chapters as a way of identifying how each one works, strands that are often so tightly woven it is difficult to speak of one without reference to the others.

INTRODUCTION

In terms of the key films discussed, some are revisited across chapters and viewed in relation both to the chapter subject and the relevant discussion gleaned from my conversations with production designers. As part of this process it has transpired that certain designers use particular elements more prominently than others sometimes due to the nature and requirements of the source material combined with the aesthetic approach and sensibility favoured by the individual designer. These are the creative tools and the language of practitioners which come from the professionals themselves and represent an original treatment and demonstration of the craft.

Within these conversations the same points reoccurred and began to form a narrative, a shared language voicing the mutual concerns of the designers which revolved around the five key strands previously mentioned. The results are illustrated in this book, in which a different perspective is provided with which to appreciate the conceptual nature of the designers' work and make visible their presence. My interpretative commentary builds on mise en scène theory (see Glossary) in that it allows contextual analysis of the image, but focuses on the perspective of the production designer and relates specifically to their concerns.

The book includes the generous contributions of production designers and art department personnel in the form of interviews and artwork. Featuring interviews and examples including Anna Pritchard, Stuart Craig, Alex McDowell, Hugo Luczyc-Wyhowski, Ronald Gow, Jim Bissell, Tatiana Macdonald, Moira Tait, Maria Djurkovic, Mimi Gramatky, Christopher Hobbs, Martin Childs, Jim Clay, Peter Lamont, Gemma Jackson, recent film graduates and current film students. These elaborations on the craft illuminate the practice with coherent simplicity.

"*From the time of the very first motion pictures at the end of the nineteenth century, the cinema has followed two paths: filming out of doors, as Louis Lumière did for* **The Arrival of a Train at La Ciotat Station,** *and filming in studio, like Méliès, whose work foreshadowed all future fairy-tale and dramatic films.*[7]"

STYLES AND MOVEMENTS: A TIMELINE

The production designer's evolution can be appreciated by looking at key styles and movements in the history of production design and the approaches that have helped shape it. This is in no way intended to be a comprehensive survey, but a selection of signposts of some pivotal points in relation to the designer's story.

In early cinema the technical and creative roles evolved according to the demands of the industry. Films were initially shot outdoors as sunlight was required to expose film. An artificial space – a glass studio – was later developed for shooting which became a covered studio with artificial light replacing daylight. (The Thomas Edison company built one of the first dedicated film studios in 1894.) During this time the camera was stationary and sets were built from this one perspective – reflecting theatrical traditions in design and build. A fixed master shot created a 'tableau' of each scene, which meant a painted backdrop was sufficient to provide a sense of place.

Set design progressed from the job of carpenters and painters who provided background scenery to an acknowledged expertise by the end of the 1930s.

Linked to the history of film and its technological advances adapting to each new development and using it to strengthen their repertoire (e.g. the addition of sound and colour), by the end of the 1930s the title 'production designer' described the supervisor of the art department. They influenced the production process. Studio design became the foundation of production in Hollywood and Europe. Outdoor and location shooting developed in the inter-war years in Europe (e.g. Italian neorealism) as the pendulum swung back to the apparent authenticity of the streets.

Further industrial and technical changes saw the designer evolve into the person responsible for the look of a film today, supplying a practical solution to the producer and an aesthetic one to the director.

> *"Sets are crucial in determining a film genre and are one of the central aspects of mise en scène whether using real locations or creating artificial or virtual spaces for the screen.[8]"*

INTRODUCTION

1895 • The Lumière brothers' public screening of their short films, focusing on everyday life as their subject matter. Recognized as the beginnings of the documentary film tradition.

1896 • In France, Georges Méliès pioneers special effects such as matte paintings where settings could be expanded on glass and integrated with live action. He also uses painted backdrops with *trompe l'œil* effects to create fantasy settings. Méliès' films mark a departure from the documentary-driven work of the Lumière brothers.

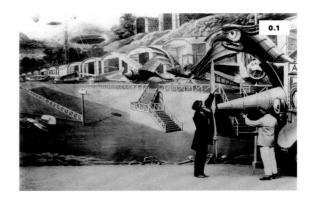

0.1
À la conquête du pole (The Conquest of the Pole), 1912, Georges Méliès.

1903 • American filmmaker, Edwin S. Porter combines real locations with painted backdrops in the silent Western, *The Great Train Robbery*. Studios start to construct larger sets to allow multiple settings and viewpoints.

• Technical developments free the camera from the static master shot and lead to three-dimensional sets to facilitate multiple viewpoints.

• France – Pathé sets – leading modern design in domestic interiors – including milestones of early cinema such as *The Passion Play* (1903, Lucien Nonguet, Ferdinand Zecca).

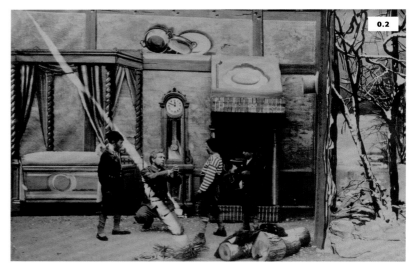

0.2
Le Mauvais Riche, 1902, Ferdinand Zecca. Pathé sets creating believable interior environments.

1908
- France – Film d'art sets use detailed domestic settings; for example, *The Assassination of the Duke of Guise* (1908), *Camille* (1912, André Calmettes, Louis Mercanton, Henri Pouctal, no design credit).

1914
- Italian film pioneer Giovanni Pastrone depicts ancient Carthage using different levels, depth and perspective, lavish surface effects of marble and brickwork and stone in *Cabiria* (1914, Giovanni Pastrone, no credit for design/art dept).

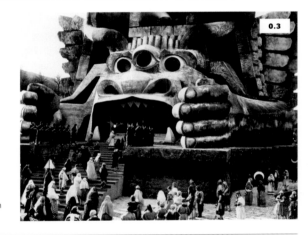

0.3
Cabiria, 1914, Giovanni Pastrone. The scope and detail employed in the film set a new standard in film design.

1915
- *Birth of a Nation* (1915, US, D. W. Griffith, set designer Frank Wortman, uncredited) striving to make interiors exact reproductions – indicative of realist aesthetic that predominates. The creation of more realistic interiors is considered a measure of their success.

1916
- *Intolerance* (1916, US, D. W. Griffith, AD Walter L. Hall, uncredited). The set design was on a grand scale and featured a 165-foot-high Tower of Babylon.

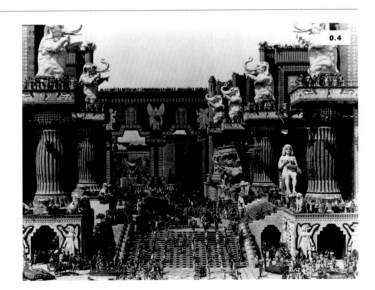

0.4
Intolerance, 1916, D. W. Griffith. In the United States, settings were being expanded and capitalized on as shrewd financiers recognized the potential for profit in the creation of spectacular settings such as these.

1919

- German Expressionism *The Cabinet of Dr Caligari* (1919, Germany, Robert Wiene, PD Walter Reimann, Walter Rohrig, Harmann Warm). Influentially uses expressive rather than realist codes to create an invigorating design environment that utilizes disorientating angles and perspectives to reflect the interior psychology of the characters. Other examples considered expressionist include *The Golem* (1920), *Nosferatu* (1922) and later *Metropolis* (1927).

- Design from this point forward can be situated on the spectrum between realism and expressionism, with many designers wishing to occupy the realm of poetic realism without drawing attention to the design which offered a stylized reality viewed through the prism of the characters of the story and genre.

- Artists and architects were drawn into cinema, influencing the form it was to take by moving it away from its theatrical origins. The creative potential of the medium was opening up and attracting new talent who were excited by the artistic possibilities offered by designing three-dimensional expansive worlds.

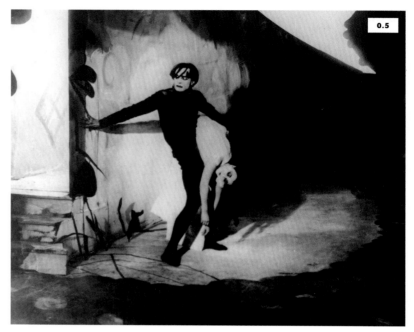

0.5

- These artists working with their art department team and in collaboration with film directors and directors of photography (DoPs) absorbed contemporary ideas and practices in the visual and decorative arts and in architecture and design, and reworked and disseminated these recurring visions, themes, styles and motifs to a wider public through design for the moving image.

0.5
The Cabinet of Dr Caligari, 1919, Robert Wiene. The ground-breaking designs of German Expressionism filter space through the psychology of character and use design to actively add meaning and comment on underpinning themes.

1920

- In early cinema the role of the designer was not fully acknowledged. The title technical director was replaced with interior decorator then art director. The first Griffiths film to give art direction credit was *Way Down East* (1920, D. W. Griffith, AD Clifford Pember, Charles O. Seesel).[9]

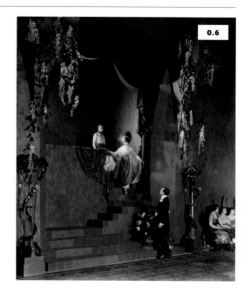

0.6

0.6
Way Down East, 1920, D. W. Griffith, AD Clifford Pember, Charles O. Seesel. The first US film to credit the art direction/design.

1922
- *Robin Hood* (1922, Allan Dwan, AD Wilfred Buckland, Edward M. Langley, Irvin J. Martin) and *The Thief of Baghdad* (1924, Raoul Walsh, AD William Cameron Menzies) are considered America's first masterpieces of art direction – exploring the spatial potential of the setting featuring curvilinear shapes influenced by Islamic design.

0.7
Robin Hood, 1922, Allan Dwan. Spending more time and money on how a film looked resulted in the construction of believable sets that worked in a practical and narrative sense.

1924
- Robert Mallet Stevens (1886–1945) was a French modernist architect who was interested in cinema (designed *L'Inhumaine*, 1924, Marcel L'Herbier) and studied camera angles which varied according to the lens focus: this was a development in the way the designer was to work. Jean Perrier follows on from this, developing a set of ratios that with camera position and lens produces the dimensions of the set that would be in the shot – helping determine how much of the set needs to be built.

- Cinemagundi Club formed. Sixty-three members met socially and this developed into a forum for what is now known as the Art Department.

- Three-dimensional models are used to add depth and atmosphere (e.g. *Ben Hur* (1925)). The Schufftan process combines models, live action and reflected miniatures and is used by Fritz Lang in *Die Nibelungen* (1924).

- Movements filter into design, creating a new aesthetic – for example, the 1925 'Exposition des Art Decoratifs et Industriel Modernes' in Paris showcases art deco – seen soon after in Hollywood films such as *Our Dancing Daughters* (1928). The 1932 exhibition 'Modern Architecture: International Exhibition', Museum of Modern Art, New York, coins the term 'International Style', and showcases and applauds modern architecture (see Studio signature styles for how design styles of the time were incorporated by the major film studios).

1927
- *Metropolis* (1927, Germany, Fritz Lang, designed by Otto Hunte, Karl Volbrecht and Erich Kettelhut). A landmark film that continues to impact on the science fiction genre today.

- *The Jazz Singer* brought in talkies influencing designers who now had to take into account the acoustics of a setting.

1928
- First Academy Award for Art Direction for *Tempest* (1928, US, Sam Taylor, Lewis Milestone, AD William Cameron Menzies).

- The rise of the Nazis in the 1930s results in a diaspora of talent – immigrants find work in Europe and Hollywood – impacting on the visual style of the sets internationally (e.g. Alfred Junge, Oscar Werndorff, André Andrejew).

1937 • The Cinemagundi Club became the Society of Motion Picture Art Directors (in 2000 this became the Art Directors Guild which supports and promotes members of the Art Department).

1939 • *Gone with the Wind* (1939, US, Victor Fleming, George Cukor, PD William Cameron Menzies). One of the most influential art directors of the period, Menzies is not tied to a studio, and working freelance gives him an independent edge. David O. Selznick invents the new title of production designer for Menzies based on his work in this film to indicate the collaboration with the director in the production planning. Menzies makes a thousand detailed sketches – shot by shot – visualizing the script to guide the camerawork, including size, angle and movement. Demonstrating the vital role the designer plays in the overall look of a moving image production and establishing practices still in use today.

• *The Wizard of Oz* (1939, US, Victor Fleming, George Cukor, AD Cedric Gibbons and several uncredited production designers – Malcolm Brown, William A. Horning, Jack Martin Smith). The fantasy musical begins in black and white shifting to colour when Dorothy is transported to the magical world of Oz. Vibrant colours help craft another world.

0.8
Gone with the Wind, 1939, US, Victor Fleming, George Cukor, PD William Cameron Menzies. The creation of the title of production designer was indicative of the partnership between the designer and director, and demonstrates the beginning of an appreciation of the overlap between the two roles. The role of the production designer now encompasses creative collaboration on the film rather than simply a technician supplying backgrounds.

0.9
The Wizard of Oz, 1939, Victor Fleming, George Cukor.

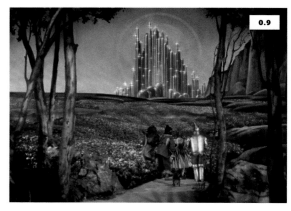

1920s – 1950s

• The Hollywood studio system creates a production line where responsibility is divided between the supervising art director (creates concept) and the unit art director (realizes the design). Although often managerial in nature the supervising art directors succeed in branding their studios with identifiable styles through their effective leadership skills.

STUDIO SIGNATURE STYLES

Studio settings provide a controlled environment where everything is intentional and ties in with the visual concept.

The eight major studios: Paramount, MGM, RKO, Warner Bros., Universal, 20th Century Fox, Columbia and United Artists incorporated distinct design styles to help define and differentiate themselves from the competition. Positive aspects of the studio system included teamwork and the opportunity to develop skills in a stable environment, with resources and facilities to draw on in-house which was beneficial in terms of time and money. However, the resulting lack of individuality has been a criticism of the system which identifies a homogenous industrial approach churning out sterile sets.

Recycling of stock settings produced a recognizable landscape made up of familiar streets, houses, saloons and so forth. The building of more complex sets led to the standing back lots – where stock street sets accumulated.

0.10

0.10
MGM *Our Dancing Daughters*, 1928, Harry Beaumont, AD Cedric Gibbons. The supervising art director was credited for all of the films produced by their studio, so would often be credited for films they had had very little involvement with.

Paramount – Supervising Art Director – Hans Drier (1923–1950)
The look – the modern big white set – art deco-inspired unadorned surfaces, elegant, using materials such as glass bricks and Bakelite.

MGM – Supervising Art Director – Cedric Gibbons (1924–1956)
The look – modernist, grand bourgeois – featuring opulent ornamentation and the use of constructed sets over painted backdrops – forging a three-dimensional approach and a strong authorship of imagery (*Grande Hotel*, 1932; *Our Dancing Daughters*, 1928; *A Woman of Affairs*, 1928).

RKO – Supervising Art Director – Van Nest Polglase (1933–1957)
The look – art deco combined with neoclassicism. Black-and-white sets showcased their famous musicals (featuring Fred Astaire and Ginger Rogers).

Warner Brothers – Supervising Art Director – Anton Grot (1927–1948)
The look – became known for their gangster films, e.g. *The Public Enemy* (1931), *Little Caesar* (1931).

Universal
The look – produced classic horror in gothic style: *Dracula* (1931), *Frankenstein* (1932) and the *Mummy* (1932).

1930s – 1940s

- During the mid-1930s colour is incorporated into the cinema, with films being conceived in colour becoming part of film language. Early technologies and the way they were lit results in distinctive colour palettes.

- US film noir filters expressionism into an identifiable style in support of the crime genre, using low-key lighting and shadow as a visual metaphor for the dark underbelly of society. For example, *The Maltese Falcon* (1941, John Huston) and *Cat People* (1942, Jacques Tourneur, art direction, Albert S D'Agostino, Walter E. Keller) created stylized environments imbued with an atmosphere of unease and anxiety.

- Musicals such as those by Busby Berkeley (*Footlight Parade*, 1933, *Gold Diggers*, 1933 and *The Gang's All Here*, 1943) accentuated the sets that were designed as theatrical spaces to showcase the performance rather than the seamless background to the story. Berkeley worked closely with designers including Anton Grot and Richard Day.

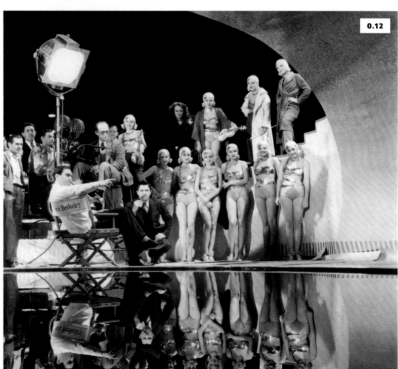

0.11
The Ghost of Frankenstein, 1942, Erie C. Kenton, AD Jack Otterson. Universal create gothic style in their horror genre.

0.12
Berkeley's films liberated dance in the cinema from the constraints of theatrical space to incorporate the movement of the camera and the dance in a seamless piece of choreography.

1940s – 1950s

- Edward Carrick publishes *Designing for Moving Pictures* (1941) and *Art and Design in the British Film: A Pictorial Directory of British Art Directors and their Work* (1948).

- Cahiers du Cinéma, French film magazine founded in 1951 – propose a manifesto that includes the notion of the auteur – director as author responsible for the *mise en scène* of a film. This notion potentially obscures the role of the production designer as fundamental to the creation of the visual concept and style of a film.

- The pendulum swings out of the studio and onto the streets with movements such as Italian neorealism (during the 1940s and 1950s, e.g. *Bicycle Thieves* (1948, Vittorio De Sica)) and French New Wave (during the 1950s and 1960s, e.g. *Quatre Cent Coup* (1959, François Truffaut)) where the studio was rejected as false in favour of real streets and locations.

- 1954 *On The Waterfront* (1954, US, Elia Kazan, AD Richard Day). Academy Award for art direction, shot entirely on location. Choice of locations, composition and dressing creates an authentic and evocative setting for the story. Instead of being made redundant, the designer becomes responsible for the choices and adaptation of real locations.

0.13

0.14

0.13
Ossessione, 1943, Luchino Visconti, Art Director Gino Franzi. Dark Italian melodrama.

0.14
On The Waterfront, 1954, Elia Kazan, AD Richard Day. Concerns over move to real locations were quelled when the film received Academy Award for Art Direction.

- British filmmakers Michael Powell and Emeric Pressburger create romantic and expressionistic visions such as *Black Narcissus* (1947, Powell and Pressburger, AD Alfred Junge), *A Matter of Life and Death* (1946, Powell and Pressburger, PD Alfred Junge, 1946) and *The Red Shoes* (1948, Powell and Pressburger, PD Hein Heckroth).

- Disneyland opens 1955 in California – a celebration of the worlds created on screen.

- The introduction of videotape during the late 1950s allowed pre-recording of shows that were previously live broadcast – expanding design possibilities.

0.15
Black Narcissus, 1947, Powell and Pressburger, PD Alfred Junge. The ornate environment of the Mopu Palace in the Himalayas pulses with energy, transforming the British nuns' outlook on life.

1960s • In the mid-1960s Hollywood studio styles diminish and become less coherent with more diverse looks evolving. The rise in television and the new wave filmmakers diversified moving image. Popular television formats offer a new aesthetic to the audience, with budgets, equipment and workflow that create a different sensibility.

0.16
You Only Live Twice, 1967, Lewis Gilbert, PD Ken Adam. Ken Adam forged a dramatic visual style for the Bond films during the 1960s and 1970s that helped create the world of Bond, with Peter Lamont carrying on the Bond tradition until 2006.

1970s

- During the 1970s computer-generated imagery is developed and continues to influence design.

- 1976 Leon Barsacq publishes *Caligari's Cabinet and other Grand Illusions* (originally published in French as the script 'Le décor de film').

- 1978 exhibition 'Designed for Film: The Hollywood Art Director', at the Museum of Modern Art, New York. Celebrating the pioneers of early Hollywood design.

- The studios responded to the competition posed by television by evolving to the changes with different marketing strategies, where, for example, genres, directors and stars are used to attract audiences rather the studio brand itself. The genres that we are familiar with today all rely heavily on their design to attract audiences in a similar fashion to the studio brands of the old studio system.

- Technical advances continue to drive the medium of moving image forward and influence the designer in relation to their design and build; lenses, shooting formats and computer-generated imagery, for example, all expand creative potential.

1980s – 1990s

- Postmodernism filters into the visual style of films during the 1980s and 1990s.

- Particular filmmakers and franchises forge coherent styles – Bond films utilize spectacular sets for dramatic effect.

- Films that acknowledge set design and reveal what goes on behind the scenes such as *The Player* (1992, Robert Altman,

PD Stephen Altman) and *Sunset Boulevard* (1950, Billy Wilder, AD Hans Dreier, John Meehan). The construction of movie worlds is celebrated in films that use the iconography of the back lot.

- 1995 Dogme 95 – Danish filmmakers create a manifesto for filming including location shooting and only props found in the location to be used.

2000 – Present

- Filmmakers such as director Baz Luhrmann and production designer Catherine Martin foreground the set design intentionally in visual spectacles such as *The Great Gatsby* (2013) and *Moulin Rouge* (2001).

- *Minority Report* (2002, Steven Spielberg, PD Alex McDowell) hires the first digital artist and sets up a fully digital art department.

- The theme park 'The Wizarding World of Harry Potter', based on the set designs of the *Harry Potter* series is built and opens in Orlando, 2010. *The Making of Harry Potter* opens at Warner Brothers studios in Leavesden in 2012.

- Today production designers inhabit and innovate the visual traditions of realism and expressionism. Production design continues to be influenced by political, technical and aesthetic developments.

Exercises

1. Watch films from the movements and historical periods mentioned and break down the elements that stand out as distinctive. For example – German Expressionism, Hollywood studios (Paramount, Universal, MGM), film noir, Italian neorealism, French New Wave.

2. Analyse some more recent films and consider whether they have a distinctive look and style. Break down the visual aspects and think about how these might have been achieved.

3. Research the designer of one of your favourite films. Find out where they trained, how they got into production design, look up their filmography. Can you identify a visual signature in the films they have worked on? Write notes about what you think that might be and any recurring elements in their designs.

Further Reading

In the literature, production design is being focused on from a number of angles: historical, aesthetic, technical. Here are some suggestions for further investigation into different aspects of the practice/craft.

Practical
LoBrutto, Vincent. *The Filmmaker's Guide to Production Design*. New York: Allworth Press, 2002.

Preston, Ward. *What an Art Director Does*. Los Angeles: Silman-James Press, 1994.

Rizzo, Michael. *The Art Direction Handbook for Film*. Amsterdam: Focal Press, 2005.

Shorter, Georgina. *Designing for Screen: Production Design and Art Direction Explained*. Ramsbury: Crowood, 2012.

Designer case studies
Christie, Ian. *The Art of Film. John Box and Production Design*. New York: Columbia University Press, 2008.

Ettedgui, Peter, ed. *Production Design & Art Direction*. Woburn: Focal Press, 1999.

Frayling, Christopher. *Ken Adam and the Art of Production Design*. London: Faber and Faber, 2005.

Halligan, Fionnuala. *Production Design*. Burlington: Focal Press, 2013.

Lucci, Gabriele. *Ferreti: The Art of Production Design*. Milan: Mondadori Electa, 2009.

Sylvester, David. *Moonraker, Strangelove and Other Celluloid Dreams: The Visionary Art of Ken Adam*. London: Serpentine Gallery, 2000.

Theoretical/historical
Affron, Charles and Affron, Mirella Jona. *Sets in Motion*. New Brunswick: Rutgers University Press, 1995.

Albrecht, Donald. *Designing Dreams: Modern Architecture in the Movies*. New York: Harper & Row, 1986.

Barnwell, Jane. *Production Design: Architects of the Screen*. London: Wallflower, 2004.

Barsacq, Leon. *Caligari's Cabinet and Other Grand Illusions: A History of Film Design*. Boston: New York Graphic Society, 1976.

Bergfelder, Tim, Sue Harris, and Sarah Street. *Film Architecture and the Transnational Imagination. Set Design in 1930s European Cinema*. Amsterdam: Amsterdam University Press, 2007.

Carrick, Edward. *Art and Design in the British Film*. London: Dennis Dobson, 1948.

Ede, Laurie. *British Film Design: A History*. London: I.B. Tauris, 2010.

Fischer, Lucy, ed. *Art Direction and Production Design: A Modern History of Filmmaking (Behind the Silver Screen)*. London: I.B. Tauris, 2015.

Mallet-Stevens, Robert. *L'Art cinematographique*. Paris: Felix Alcan, 1927.

Sennett, Robert S. *Setting The Scene: The Great Hollywood Art Directors*. New York: Harry N. Abrams, 1994.

Tashiro, Charles. *Pretty Pictures and the History Film*. Austin: University of Texas Press, 1998.

Whitlock, Cathy. *Designs on Film: A Century of Hollywood Art Direction*. New York: IT Books, 2010.

Notes

1 David Sylvester, 45.
2 See Appendix for further information on Stuart Craig and the interview with him in Chapter 2.
3 Stuart Craig, author interview, 2000.
4 Laurie Ede, 194.
5 Stuart Craig, author interview, 2014.
6 Tim Bergfelder, Sue Harris, and Sarah Street, 11.
7 Leon Barsacq, 121.
8 Bergfelder, Harris, and Street, 11.
9 *Photoplay* magazine (August 1916) pointed out that it was the property men who had previously been responsible for the sets. There is even debate around who the first art director was – whether D. W. Griffith's chief carpenter Frank Wortman (Sennett, 30) or the theatrical designer Wilfred Buckland who was signed by Famous Players-Lasky in 1914 (Barsacq, 56).

THE PRODUCTION TEAM

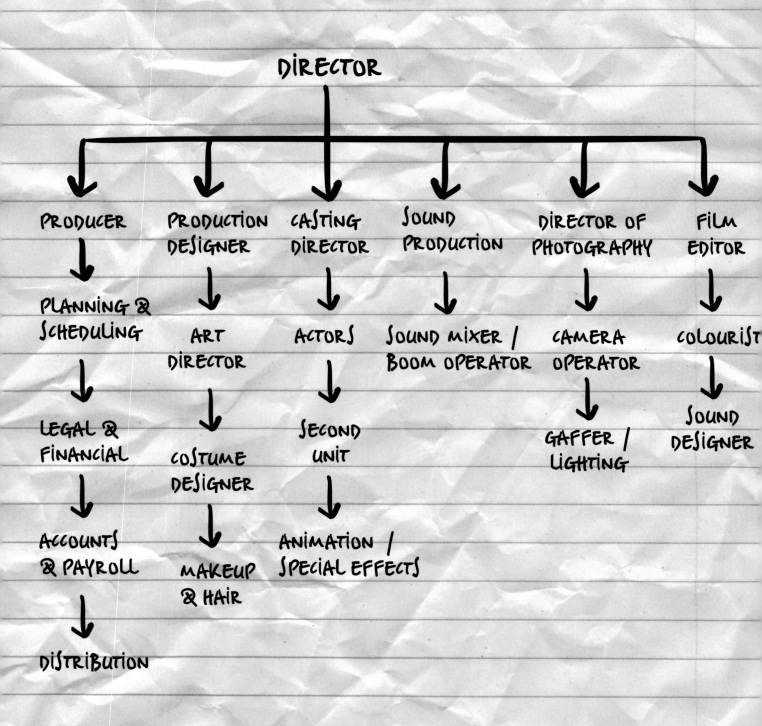

CHAPTER 1
PRACTICALITIES: THE DESIGN PROCESS

The production designer (PD) is head of the Art Department and it is their responsibility to define and manage the visual elements of a film or television production. Art directors (ADs) help realize the PD's vision. Assistant art directors develop initial sketches into working drawings for building and dressing by subsequent members of the Art Department.

Working with the producer and the director, the designer produces a budget and a schedule, and collaborates to create a visual concept from the initial stages of a production – sometimes before the project has been green lit – to researching and calculating costings for the potential feasibility of a production. Their design aims to support and strengthen the story and characters through the use of tools such as space, light, colour and dressing.

The design process is a highly organized operation that includes the skilled team of craftspeople who populate the Art Department. Working to tight budgets and schedules, the team turn around settings ready to shoot on throughout the production. The process is scaled up or down depending on the nature of the production and the budget.

This chapter looks at some of the roles within the Art Department and the practical process undertaken in order to help provide a sense of workflow and organization. In the next chapters the focus shifts to the more conceptual nature of the role and the tools of visual metaphor that convey the design intentions through every aspect of the frame.

"The Designer has to tame his imagination into the hard and fascinating task of making all things physically possible for filming.[1]"

1.1
The Production Team includes clear lines of communication within and between different departments essential to the smooth running of a production.

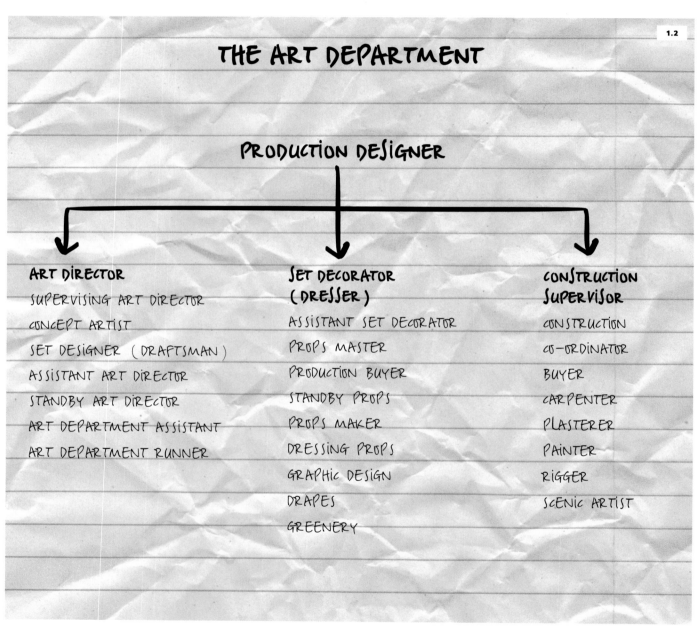

1.2

THE ART DEPARTMENT

PRODUCTION DESIGNER

ART DIRECTOR
SUPERVISING ART DIRECTOR
CONCEPT ARTIST
SET DESIGNER (DRAFTSMAN)
ASSISTANT ART DIRECTOR
STANDBY ART DIRECTOR
ART DEPARTMENT ASSISTANT
ART DEPARTMENT RUNNER

SET DECORATOR (DRESSER)
ASSISTANT SET DECORATOR
PROPS MASTER
PRODUCTION BUYER
STANDBY PROPS
PROPS MAKER
DRESSING PROPS
GRAPHIC DESIGN
DRAPES
GREENERY

CONSTRUCTION SUPERVISOR
CONSTRUCTION CO-ORDINATOR
BUYER
CARPENTER
PLASTERER
PAINTER
RIGGER
SCENIC ARTIST

1.2
The diagram shows the different roles within the Art Department and how they connect. The three main teams are Art, Set Decoration, and Props and Construction. Other roles can include drivers, archivists, accounts – roles can vary on each production.
There are some differences internationally (e.g. UK and US Set Decorating and Props departments have some variations on titles and job descriptions). Figure 1.2 can be treated as a guide.

THE ART DEPARTMENT

The digital department

The Art Department works to the production designer to help create, source and deliver the environment according to the designer's specifications. The number of people employed in the department varies depending on the scale of the production. Outlined here is an average size production including the three key teams of Art, Set Decoration, and Props and Construction.

The PD delivers their sketches (indicating mood, atmosphere, lighting, composition, colour and texture) to the art director who will oversee the creation of technical drawings and models. These are used by the Construction Department to build the sets and adapt locations. Props buyers and set decorators source props and organize the manufacture of specialist items. As the start of shooting approaches, the production designer manages lots of people, prioritizes the work schedule and monitors the budget. When shooting starts, they usually view each new set with the director, director of photography (DoP) and standby art director, reviewing any issues arising.

The PD monitors the construction and dressing of other sets, and signs off on sets/locations for the next day's shoot. During post-production some of the material will be cut, which may result in aspects created by the Art Department not making it to the screen. This is accepted as part of the job description because if a shot or scene isn't contributing to the overarching intentions of the production then it is superfluous.

The relationship between and integration of the crafts is an alchemical process, creating as it does an end-product greater than any of the individuals could create alone. Technology continues to influence the process: 'We can stand inside a space before it exists, we can share the outcome of our narrative intent in a 3D space. We can literally stand in the virtual space and make decisions about the way a specific piece of narrative is going to develop.'[2]

PD Alex McDowell says an indication of effective use of computer-generated imagery (CGI) is when we forget about the parts of a set that are virtual and the parts that are physical and the space feels seamless. 'I think for twenty years CGI caused a lot of trouble, there was this notion that they owned the digital space and when films started going digital everybody looked to the visual effects houses to help them navigate the digital environment. With *Minority Report* we took back the design process from post-production. We handled the design as a digital model for every single element of the film. We gave them fourteen 3 inch thick binders full of reference material for the post-production elements that weren't built in the set.'[3]

The CGI and art department budget have become vastly different. A chasm exists whereby the visual effects can be as much as ten times that of the design. We are constantly looking at the equation between how many shots there are in a set and how much the set costs and how many of those shots are pushing at the edges of the set so that they're going to have to be visual effects enhanced and how many of the shots can be 100 per cent contained on the set you've built.[4]

What McDowell describes has been integral to the role of the PD since Menzies (see the Introduction). The equations that McDowell talks about would result in more meaningful use of digital resources rather than relying on them to fix everything during post-production. This would make financial sense too as money will be saved from the budget by building physically; after all, part of the designer's job is making design decisions in relation to budget considerations.

The production designer–director–DoP relationship

The PD collaborates with the other heads of department during the production process when it is crucial that a good working relationship is established with the director and DoP. This is often described as the triangle of visual influence – the notion of a triangle is certainly more helpful than the perpetuation of the myth of a single author. The PD calculates the Art Department budget and decides how the money will be spent. The research period follows during which the designer and their researchers source ideas from books, photographs, paintings and so on.

After preparing a breakdown of the script, the PD will meet with the director to discuss ideas and decide which elements should be built (in a studio) and which should be shot on real locations. At this point they will also discuss possible visual *concepts* and the ways in which underpinning ideas in the script can be accentuated through aspects of the design. The designer–director relationship is fundamental to the process – clear communication is essential in achieving a coherent look to a production. When a working rapport is established between these two they will often choose to collaborate on future projects together – there are many examples of director/designer duos like this.

Michael Powell and Emeric Pressburger had a long and fruitful collaboration with production designer Hein Heckroth. Heckroth came to Britain from Germany in 1935 having been blacklisted by the Nazi state. His visual signature was a bold use of colour, saturated palette and layered textures such as cellophane and gauze. As Andrew Moor says, 'His art is representational but anti-realist. It is a theatrical visual rhetoric operating by its own logic of colour, line and texture and as such it marries with Powell's rejection of naturalism…'[5]

See: *A Matter of Life and Death* (1946, costume designer), *Black Narcissus* (1947, costume designer), *The Red Shoes* (1948), *Hour of Glory* (1949, original title, *The Small Back Room*), *Gone To Earth* (1950), *The Fighting Pimpernel* (1950), *The Tales of Hoffman* (1951), *The Wild Heart* (1952), *Oh… Rosalinda* (1955), *The Sorcerer's Apprentice* (1955), *Herzog Blaubats Burg* (1963, Powell).

Designer–director collaborations

There have been many notable designer–director partnerships. For example, director Spike Lee and production designer Wynn Thomas have worked on many films together spanning three decades: *She's Gotta Have It* (1986), *School Daze* (1988), *Do The Right Thing* (1989), *Mo Better Blues* (1990), *Jungle Fever* (1991), *Malcolm X* (1992), *Crooklyn* (1994), *He Got Game* (1998), *Inside Man* (2006).

Director Clint Eastwood and production designer Henry Bumstead established a working partnership that included thirteen films (earlier Bumstead work includes four Hitchcock films and eight films with George Roy Hill). Bumstead has said that Clint understood that the set functioned as another actor in film. Their films include *Unforgiven* (1992), *A Perfect World* (1993), *Absolute Power* (1997), *Midnight in the Garden of Good and Evil* (1997), *True Crime* (1999), *Space Cowboys* (2000), *Blood Work* (2002), *Mystic River* (2003), *Million Dollar Baby* (2004), *Letters From Iwo Jima* (2006), *Flags of Our Fathers* (2006).

Other significant partnerships include:

Baz Luhrmann and Catherine Martin: *Strictly Ballroom* (1992), *Romeo and Juliet* (1996), *Moulin Rouge* (2001), *Australia* (2008), *The Great Gatsby* (2013).

Bernardo Bertolucci and Ferdinando Scarfiotti: *The Conformist* (1970), *The Last Emperor* (1987), *The Sheltering Sky* (1990).

Mike Nicholls and Richard Sylbert: *Who's Afraid of Virginia Woolf?* (1966), *The Graduate* (1967), *Catch-22* (1970), *Carnal Knowledge* (1971), *The Day of the Dolphin* (1973), *The Fortune* (1975).

Jean Renoir and Eugene Lourie: *La Grande Illusion* (1937), *La Bête Humaine* (1938), *The Rules of The Game* (1939), *This Island Is Mine* (1943), *The Southerner* (1945), *The Diary of a Chambermaid* (1946), *The River* (1951).

Joseph Losey and Richard MacDonald: *The Gypsy and The Gentleman* (1958), *Concrete Jungle* (1960), *Eva* (1962), *The Servant* (1963), *King & Country* (1964), *Modesty Blaise* (1966), *Secret Ceremony* (1968), *Boom* (1968), *The Assassination of Trotsky* (1972), *The Romantic Englishwoman* (1975), *Galileo* (1975).

BREAKING DOWN THE SCRIPT

The script will spark ideas in the designer and they will begin to consider how to bring these to life visually.

The designer breaks down the script into scenes, locations, interiors and exteriors, day and night and time periods. From this they can see how many settings are needed for the project, which varies depending on the type of production and the size of the budget. For each setting a list is produced itemizing all of the requirements, including action props (that are named in the course of action), dressing props, graphics, animals, action vehicles, computers, photos, printing, copying consumables, visual effects and construction materials.

The designer will mark up the script: colour-coding it into sub-sections as illustrated in Figure 1.3.

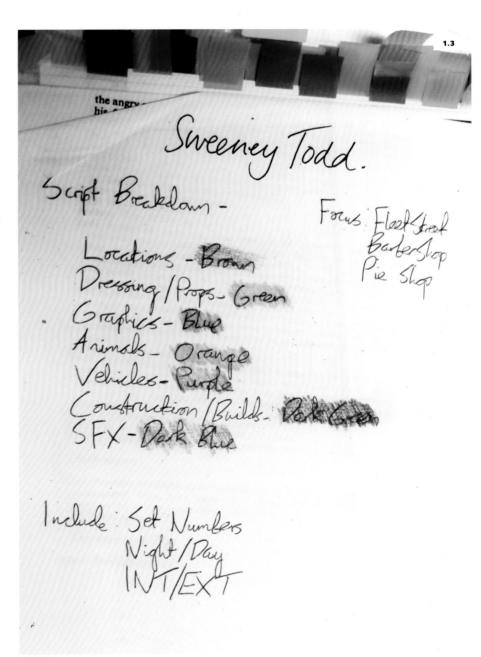

1.3
The categories that fall under the PDs responsibility that run through the script are colour coded in this way.

INT.BATHROOM.MORNING.

<div style="text-align: right">1.4</div>

SCENE NOS	D/N	PAGES	CHARACTERS	PROPS	NOTES
7	D	2–3	Joe	Mirror, shower curtain, funny animal bath accessories	Joe practises lines

EXT.MAIN STREET.DAY.

SCENE NOS	D/N	PAGES	CHARACTERS	PROPS	NOTES
8	D	3	Joe, old woman	Shopping bags	Joe helps an old lady

EXT.PEDESTRIAN CROSSING.DAY.

SCENE NOS	D/N	PAGES	CHARACTERS	PROPS	NOTES
9	D	3	Joe, mother, toddler	Buggy	Joe helps a mother and her toddler crossing the road

1.4
After colour-coding the script, a table breakdown can be produced like this one by student Elisa Scubla (2011), where information is divided into columns for scene numbers, day or night, page numbers, characters, props and notes.

DEVELOPING INITIAL IDEAS

The designer's emotional responses to the script are explored and the feelings that first arise on reading it help them to interpret the words into images.

Mood boards are composed to help illustrate the overall visual concept. A mood board is a collection of images, including for example, photos, sketches, paintings, textile samples, colour swatches and tear sheets from magazines. By sticking these images together, either on boards or digitally, the designer creates an overall sense of the visual elements. The pieces can be arranged, however preferred, to help illustrate the initial ideas such as location and environment, colour palette, costume, make-up, light and dressing details. The boards can also be annotated to make ideas clear and easy to navigate. A designer will collect these as part of their research process and may create several boards: one for the overall film and one for each scene or key section of a film. A simple and effective way to convey design intentions early in the process that helps the designer clarify ideas and share them with the production team. On larger productions this same process will result in a production bible, which includes details for every scene.

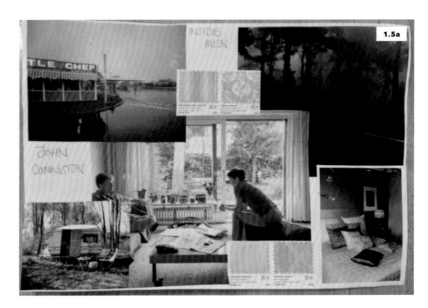

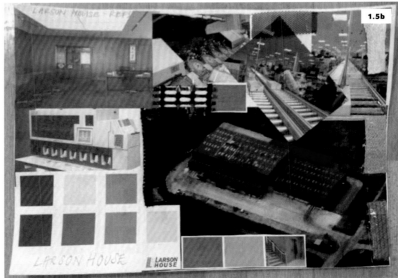

1.5a, 1.5b
Anna Pritchard's mood boards for the BBC production of a cash heist in the seventies *Inside Men* (2012, BBC, James Kent). Larson House is the counting house that gets robbed, which as Anna discusses later in this chapter was very difficult to source references for but colours, styles and details begin to provide shape for the eventual design.

Storyboards

A storyboard is the drawing of script scenes shot-by-shot in sequence, a paper version of what will eventually be shot. This is another time- and money-saving device which enables the whole team to see the way the film is being visualized. Ideas can be developed during storyboarding and tried out on paper before committing to shooting them. Often storyboards provide a template for production that is followed scrupulously, while at other times they are a guide only to help ensure the main action is covered effectively.

Sometimes it is the PD, the director or a specific storyboard artist who will draw the storyboards either freehand or using specialist software that is available to enable effective pre visualisation of shots and scenes.

1.6
Storyboards for student production by Elisa Scubla (2011, the Cass, London Metropolitan University). These detailed storyboards make clear the composition, light, movement and progression from shot to shot.

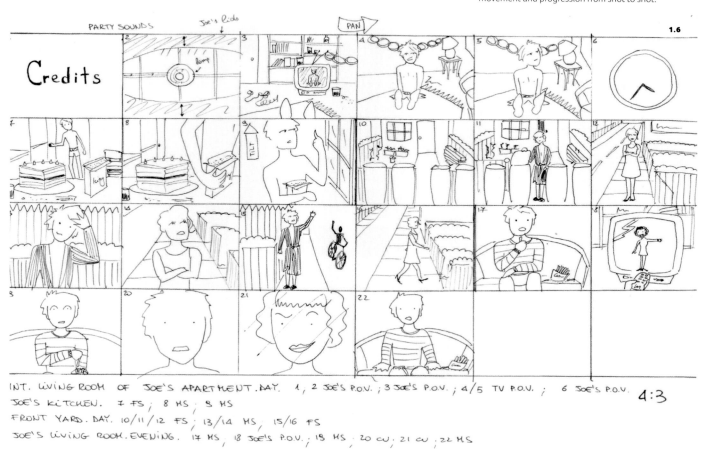

INT. LIVING ROOM OF JOE'S APARTMENT. DAY. 1, 2 JOE'S P.O.V. ; 3 JOE'S P.O.V. ; 4/5 TV P.O.V. ; 6 JOE'S P.O.V. 4:3

JOE'S KITCHEN. 7 FS ; 8 HS ; 9 HS

FRONT YARD. DAY. 10/11/12 FS ; 13/14 HS, 15/16 FS

JOE'S LIVING ROOM. EVENING. 17 HS, 18 JOE'S P.O.V. ; 19 HS , 20 CU, 21 CU ; 22 HS

RESEARCH PROCESS

Research is a fundamental part of the design process. During this time the designer looks at a range of sources to inform and enrich their work. Reference material can be varied, taking in locations, films, paintings, photographs, fashion, textiles, literature and even music. Decisions about how key settings should look are based on research and help underpin ideas in the script about the story, characters and atmosphere. The research can also help decide whether to shoot in a studio or a location. Often a production will combine studio-built sets with existing interior and exterior locations. There are advantages and disadvantages to both. When shooting in a location, painting and dressing are usually required to adapt the space to the specifications of the script.

PD Stuart Craig describes this aspect of pre-production:

> Immediately you have some images. You move on from there so dramatically because you start to research, you start to look at things, you start to visit real places so you do have to educate yourself very rapidly at the beginning and go at it with an open mind.[6]

During this stage in production the designer will immerse themselves in the project, searching for clues to help furnish the design with a coherent look and concept. If the film is an adaptation, the original novel will be scrutinized for details of character, place, story or theme. Field trips often provide a designer with unexpected inspiration – a texture on a wall, a piece of furniture, even a journey on the London Underground can spark an idea.

Research encompasses practical, technical and aesthetic considerations – all with the aim of enriching the design. Whether historical period, place or character the designer will respond to anything the script throws up and rigorously investigate – often taking projects in rewarding directions that weren't initially envisaged.

Period and place

Photographs and paintings can provide valuable reference material informing composition, colour, light, mood, landscape and architecture. Designers often draw on artists during pre-production; for example, when designing *Elizabeth: The Golden Age* (2007, Shekar Kapur), Guy Hendrix Dyas says:

> Turner's paintings were a great source of inspiration for us during pre-production and we tried to capture some of his skies and atmosphere in our London exterior scenes. Research is very important when making a period film. Paintings and etchings were all key in creating a visual guideline for the Art Department. Shekhar Kapur and I also visited many of the great manors of the period as well as their museums and private collections.[7]

The colours and mood of Turner's paintings of London and in particular the waterscapes of the Thames proved influential in the design of the film. Guy Hendrix Dyas evoked the Elizabethan period through historical research and inventive design to create an original look that conveys the spirit of the times. In other words, a creative interpretation of a period rather than necessarily repeating the conventions of other films set during that time.

Often work set in another historical period draws more attention as it is more visible than contemporary design. Due to the overt nature of period design this is often the work that is recognized when it comes to awards. Ironically, contemporary design requires just as much attention, if not more, to create effective design solutions. (See Chapter 7 for further discussion of approaches to set decorating for different periods.)

Inside Men (2012, BBC, James Kent) set during the 1970s required historical research into the recent past by Anna Pritchard, which included looking at the architecture of the time. The features of the buildings are spatially distinctive, utilizing shapes, materials and dimensions that connote the period effectively.

The details of a particular place require careful research: for example, an office, a church, a hospital, a convent, a pub or palace. A designer will investigate reference material in relation to the settings required in the script. Through this absorption process they will define their version of the place, prioritizing significant technical considerations such as where to position windows to create *motivated light sources* and how to enable the action occurring in the scenes to function effectively. For example, a practical lamp may be positioned in a room to give the DoP a place to position the film lighting from. In a similar way, a window may be the intended motivated light source: in which case the artificial light will be positioned to suggest that and intensity and light temperature will be adjusted accordingly. (Light is discussed further in Chapter 4.)

Having immersed themselves in the research of a setting, designers may find the real design impractical in relation to filming considerations. Hence, an adaptation of the research combined with personal ideas often emerges. The research process remains worthwhile as it is, imbuing the design with knowledge and authenticity that will underpin and enhance the production.

1.7a, 1.7b
Anna Pritchard's architectural references for *Inside Men* (2012, BBC, James Kent).

1.7a

1.7b

Studio versus location

Studio shooting provides a controlled environment in terms of sound, light, equipment and weather. However, there are budgetary implications such as studio fees for the number of days required for the production.

Locations can add depth and atmosphere. There are practical issues that can make it more difficult; for example, the weather, noise and light can pose problems which will need to be factored into the schedule. Budget considerations: it can be less expensive than studio hire but extra days' hire of crew and other resources due to weather issues can increase costs. When location shooting practical considerations such as power supply, catering and toilet facilities also have to be addressed.

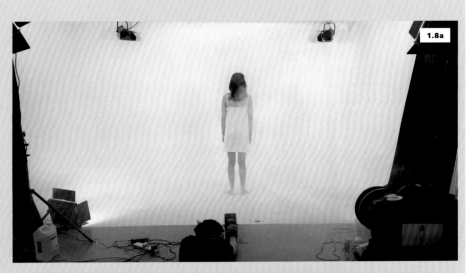

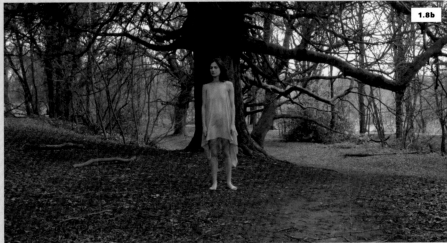

1.8a
Student production *Thrice* (2014, Siqi Zhang and Liya Ye, University of Westminster) uses a studio for this dream scene where a blank empty space is required.

1.8b
Student production *Thrice* (2014, Siqi Zhang and Liya Ye, University of Westminster) location shoot.

Characters

Considering the possessions a character would choose to have around themselves can add layers of meaning for the story, and some of the simplest items provide a key to character.

Production designer Hugo Luczyc-Wyhowski describes the requirements of research taking him away from obvious props and dressing and into the detail that exists in people's homes. Talking about *Nil by Mouth* (1977, Gary Oldman) he says:

It's the sort of film where a crumpled up betting slip has been sitting on the mantelpiece for three months and no one bothered to throw it away is more important than having the right sort of ornament. It's about having the textures of peoples' lives. Real life is quite strange. You often get quite weird things in people's homes.[8]

The characters can be enriched visually in these ways, providing depth and significant quantities of information in a set that would take pages of dialogue to narrate. The information may be factual – where a character lives, occupation, hobbies, eating habits. It may be emotionally driven, revealing their interior landscape, desires and dreams. The research informs and enables place and character to be established in potent ways.

University student Elisa Scubla working on a script about a young man who doesn't want to grow up came up with the concept of depicting him as still being a child. This sense of immaturity percolated through the living spaces.

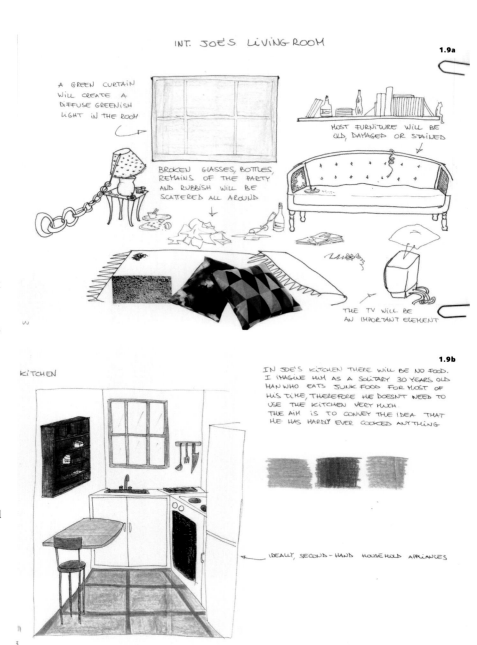

1.9a

1.9a
The dimensions of space aren't indicated in any detail. The focus here is on the props and dressing which build a sense of character through the textures of his life. Elisa has sketched the protagonist's living room, including dressing which gives a sense of his personality and underpinning concept. It is a messy uncared for space.

1.9b
Joe's kitchen is not as playful as some of the other rooms – this is designed to indicate that he doesn't spend very much time in there and is not domesticated in terms of cooking or nurturing himself or others. An intentionally cramped empty space is accentuated by the presence of a single solitary chair.

SKETCHES, DRAFTS, MODELS

The sketch enables the designer to develop their first impressions, with varying levels of detail, from simple line drawings to a full-colour image including light sources. It can begin to convey character and atmosphere. Stuart Craig outlines his process,

> I do hundreds of very rough doodles and then from that do a plan and a section. I prefer to quantify in terms of dimensions and then give them to the draftsman. We have the luxury of a very talented architectural illustrator Andy Williamson who translates that into these incredibly polished full-colour illustrations, which are much more sophisticated.[10]

One of Anna Pritchard's early sketches for *Inside Men* (2012, BBC, James Kent, shown in Figure 1.10a), followed by a more developed one (Figure 1.10b) helps illustrate the process. We can see that the structure is similar in the more developed sketch with a staircase leading down to the cash counting floor, but now the upper floor is elongated and a stronger sense of space and light is established. The second sketch encorporates further detail such as foreground props and dressing. We can also begin to see how the space might function in terms of blocking and staging of camera and action.

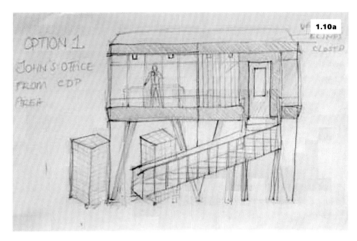

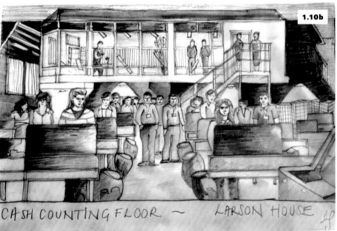

1.10a
Anna Pritchard, *Inside Men* (2012, BBC, James Kent), Larson House.

1.10b
Anna Pritchard sketch of cash counting floor, *Inside Men* (2012, BBC, James Kent), Larson House.

> **"I always start with a window. You know when you draw a face, you start with the oval of the head and then the next thing you put in are the eyes, and it's exactly the same with the set. My first doodle will be a rectangle of a window.[9]"**

Technical drawings

Technical drawings are made for all of the settings to be built in the studio. Floorplans and elevations are all drawn to scale and include doors, windows and architectural details. Depending on the size of the project either the designer, art director or draftsperson produces these and hands them over to the construction manager to commence the build.

Technical drawings can be produced by hand or using software designed specifically for this task – such as Computer Aided Design (AutoCAD) or Sketch Up.

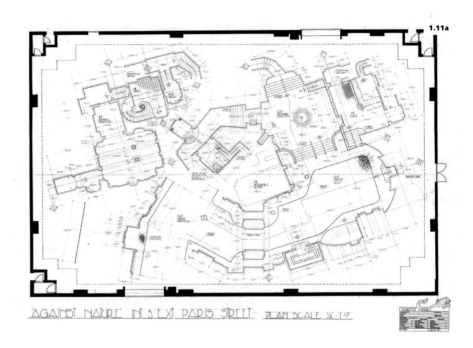

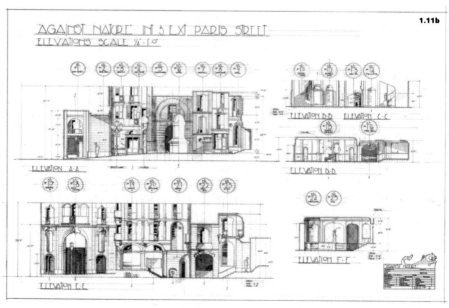

1.11a
Tom Turner floorplans of Exterior Paris Street, for paper project *Against Nature*.

1.11b
The floorplans and elevations provide the details and dimensions for the subsequent construction of setting.

Models

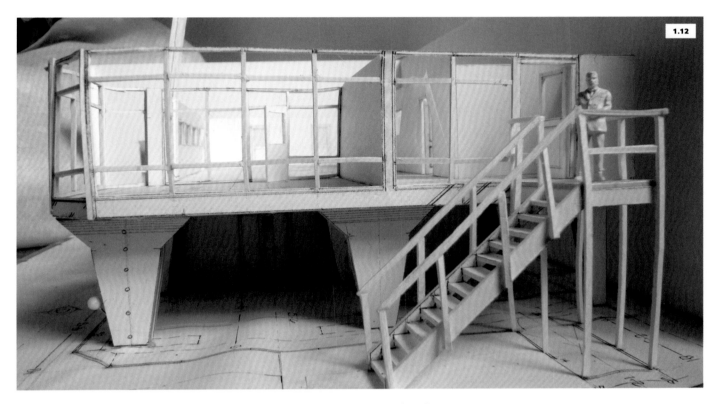

1.12

A scale model is usually made of the set before it is built. This miniature version helps the director and DoP visualize the set as a three-dimensional space, discuss potential pitfalls and ensure that they are happy before the set is built.

PD Gemma Jackson always makes models in white card during the early stages of her design process which she finds essential in visualizing a space for the screen:

> I mean there are one or two directors that it just doesn't make any sense to whatsoever. Of course Richard Ayres, who predominantly works in theatre, loves a model. I think if you're working in three dimensions you have to.[11]

This is a point in the process when the designer can show the director a three-dimensional physical representation of their designs which is really helpful as it allows key personnel to see something tangible and discuss it in relation to practical and technical issues – such as camera position and movement, actor movement and light.

1.12
Inside Men (2012, BBC, James Kent), Larson House, cash counting floor. Anna's white card model creates a three-dimensional space according to the technical drawings that helps the whole production team consider how effective the design is and the practicalities of shooting.

THE BUDGET

The Art Department receives around 10 per cent of the overall production budget. What eventually appears on the screen is influenced by budgetary constraints and the designer is always looking for ways to stretch and make the most of their resources. Designing relies on inventive use of the budget allocated. When working on a low budget it can be difficult to meet the requirements of the script but there are options such as borrowing from shops in return for a credit on the film, or buying from antique and vintage shops on the understanding that they will purchase items back when filming is finished. The designer must contain their ideas within the boundaries of the available time and money.

The designer collaborates closely with the producer on budget. The cost of realizing certain aspects of a script may be higher than the producer had originally allocated. This is where PD expertise is important in knowing how much certain settings and effects will cost and being able to use the available budget wisely so that it is reflected on the screen. When starting out, research is the best way to become familiar with this aspect of design; by looking at the budget breakdowns from other productions and talking to designers the required knowledge will be built up.

Big budget isn't necessarily an indicator of quality: often lower budget productions have to be more inventive which can result in particularly strong visual styles. The budget for University of Westminster student film *Clay* (2014) was £2,000, which the students raised through crowdfunding, creating an Indiegogo campaign. This needed to cover the costs of shooting on interior and exterior locations, vehicle hire and SPFX make up. A contingency is an essential element of any budget that allows for hidden costs or surprises not anticipated from the script.

"When you read the script you automatically put against it the costs – a living room set costs between four and seven thousand [pounds], a composite of a kitchen, hallway and stairs costs twelve thousand, then the props maybe £600 and you add them up... It's always going to be more though because there will be extras requested that aren't in the script.[12]"

"The job requires you to look at how much money you have to spend and be able to relate it to what you want to put on the screen.[13]"

1.13
Schedule for University of Westminster student film *Clay* (2014, Samuel Thornhill, James Wilkinson). A typical ten-minute student production might take one or two weeks to shoot. Scheduling takes into account the genre and medium of the production; television usually has a higher shooting ratio per day to achieve (for example, British TV show *Casualty* has a four-week block to shoot a 50-minute episode). Commercials and music videos are often turned around in a few days while a feature film may take a year or more.

The schedule

The filming schedule will be devised where scenes and locations are grouped together for practical, logistical reasons: to be as economical with time and money as possible. Depending on the budget, a shooting ratio will be worked out by the producer who will decide how many shooting days it will take to cover the action in the script. For example, the schedule may require one set to be built, while another is being dressed and another being shot on. The designer has to be highly organized and adept at making the Art Department schedule tie in with the demands of the overall production schedule. By communicating with members of their Art Department and other heads of department the designer creates realistic schedules that can be achieved on the time and budget available. As shooting rarely occurs in the chronological order of the script, the designer also has to pay careful attention to the continuity of settings.

Shooting script

The dialogue between the director and designer will become more concrete around this time – before any construction work takes place. The director will have ideas about camera and actor movement which may have been partially informed by discussions with the designer in the first place. This information is worked into a *shooting script* which will make clear what extent of a set will be shot on, and from what angles so that the designer will know how much of a set to build, decorate and dress. This helps save time and money – no one wants to build aspects of a set that won't be used.

DATE	SCENE	INT/EXT	LOCATION	SHOT DESCRIPTION	CAST	CREW	PAGES
Tuesday 18th	2	INT	Mortuary	Dialogue scene in the mortuary in which Francis discovers the stones within a deceased patient he is working on. Overcome with greed, Francis chooses not to report his discovery to Alan and instead opts to return to the body alone and retrieve the contraband.	Francis Alan Deceased Man	Samuel Thornhill James Wilkinson Harrison Geraghty Samuel Haskell Emily Stibbs Daniel Roversi Jannah Phillips	2–4
Tuesday 18th	3	EXT	Mortuary	Francis is late in returning to the mortuary the following day and arrives to be met by Alan, who has had to cover a burial that has been brought forward. Francis realizes that the body and its contents have been buried. Alan insists Francis joins him for a drink at a local bar.	Francis Alan	Samuel Thornhill James Wilkinson Harrison Geraghty Samuel Haskell Emily Stibbs Daniel Roversi Jannah Phillips Emily Patten	4–6
WEDNESDAY 19TH **UNIT MOVEMENT TO DERBYSHIRE. 10K GENERATOR TEST**							
Thursday 20th	5	INT/EXT	Moor	The mortuary contact is led through the moor, his hands and feet shackled by his captors who are looking to establish the whereabouts of their missing shipment, the valuable stones. After saying a short prayer, he is killed.	Mortuary Contact	Samuel Thornhill James Wilkinson Harrison Geraghty Samuel Haskell Emily Stibbs	1–2

1.13

STUDIO CONSTRUCTION

There are acknowledged advantages of shooting in a studio – studios offer a controlled environment where space, light and sound can be manipulated according to the demands of the production. From the designer's point of view the setting can be devised to their exact stipulations rather than the compromises necessary when using a location.

Exterior and interior locations may have contradictory information to that of the design and will need to be disguised or embellished. For example, architectural details such as position and style of windows and doors are unlikely to be exactly as originally planned; if budget allows locations may be repainted and redressed to tie in with the designer's intentions. On the other hand, when constructing a set in a studio the designer can create their vision as planned in terms of dimensions, architectural details, colours and materials down to the last detail.

Sets are built on sound stages in studios specially designed for production purposes. The varying stages of completion will be scheduled in accordance with the shooting script. In TV drama the set is sometimes built with the audience seating included in the space (e.g. sitcoms); the set design will have been conceived in relation to this technicality and will be more theatrical in nature due to the fixed position of the audience.

Air Force One was built for *10,000 Days* (2014, Eric Small, PD Mimi Gramatky) on a sound stage using several sections of plane stitched together. The film is based on the premise that 10,000 days ago a comet hit Earth sending it into a nuclear winter. Twenty-seven years later, the survivors are battling to stay alive. The visual world of the film is cold and dark as illustrated in Mimi Gramatky's pictures. Gramatky's photos of Air Force One illustrate the process from putting the pieces together to making the interior safe to shoot in and then distressing both the interior and the exterior to provide context, tell the story and illustrate the concept.

1.14
Painters and decorators work on one of Mimi Gramatky's set builds.

1.15a, 1.15b
Thrice (2014, Siqi Zhang and Liya Ye, University of Westminster student production). The studio was used to shoot a stage scene – which required the staging blocks and backcloth. The impression of a magic show was created through lighting and costume.

1.16a
10,000 Days (2014, Eric Small, PD Mimi Gramatky). Five plane slices from different 747s make up the 747 here.

1.16b
10,000 Days (2014, Eric Small, PD Mimi Gramatky). Interior as it was, inside fuselage bare except for a few chairs and the spiral stairs, which were still functional.

1.16c
10,000 Days (2014, Eric Small, PD Mimi Gramatky). Pieces assembled, painted and scorched.

1.16d
10,000 Days (2014, Eric Small, PD Mimi Gramatky). Then submerged and frozen.

1.16a

1.16b

1.16c

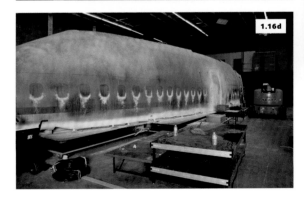
1.16d

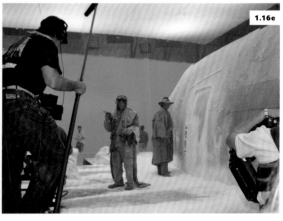
1.16e

1.16f

1.16g

1.16e
10,000 Days (2014, Eric Small, PD Mimi Gramatky). Exterior ready to shoot in front of green screen.

1.16f
10,000 Days (2014, Eric Small, PD Mimi Gramatky). The interior was made safe.

1.16g
10,000 Days (2014, Eric Small, PD Mimi Gramatky). Then destroyed and dressed.

LOCATIONS

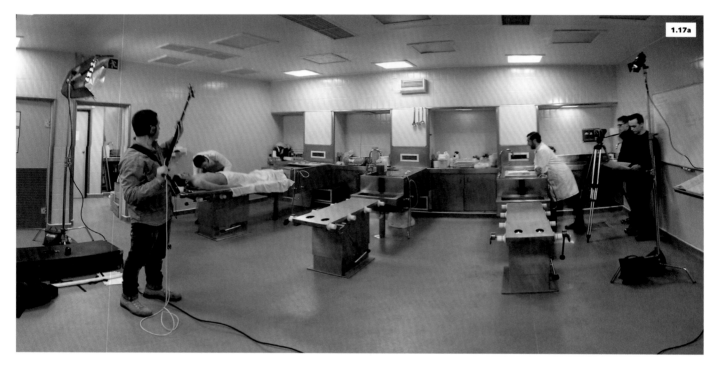

1.17a

Recces are set up by location scouts to view potential locations. These will assess practical, technical and aesthetic qualities and be alert to issues such as size, sound, position (e.g. away from busy roads, with sufficient parking space for cast and crew nearby) proximity to other location/studio being used and health and safety. Film location agencies and libraries have extensive databases of locations available for hire whether it is a mansion, a garden, a factory or a mortuary that is required. In the UK, regional film offices can be consulted when searching for locations in a particular area.

PD Gemma Jackson talks about how she was able to adapt the exterior of a real location in the country to appear as if in the city. *Iris* (2001, Richard Eyre) is the story of the relationship between Iris Murdoch and husband John Bayley, beginning in Oxford in their student days through to the novelist's mental deterioration from Alzheimer's disease in later life.

> What we did for the 1950s when Iris was having tea sitting in a window. Outside would have been green rolling lawns but I was able to build up a flat outside and make an alleyway like Oxford with bicycles and phone boxes, and you'd have thought you were in an urban area.[14]

(See Chapter 3 for further discussion of the ways windows can help frame and contextualize place from the inside out and outside in.)

1.17a, 1.17b
Clay (2014, Samuel Thornhill and James Wilkinson), interior/mortuary scene. The University of Westminster students hired a location for the mortuary – which came with most of the necessary dressing. They added action props like the knives, scissors, fake diamonds, sheets and costume – overalls, gloves. Dressing included writing names and job details on whiteboards and trolleys to add authenticity. Here a special effects make-up person designed and made a prosthetic wound which she attached to a living body (playing the corpse) and packed with 'diamonds'.

1.18
Clay (2014, Samuel Thornhill and James Wilkinson). An exterior location was found for the burial scene in the film – the ground was dug up to suggest a grave and a simple wooden cross was added. This is an example of how very small visual details can change the meaning of the narrative. There was discussion over the newness of the wood and a more weathered version was eventually used.

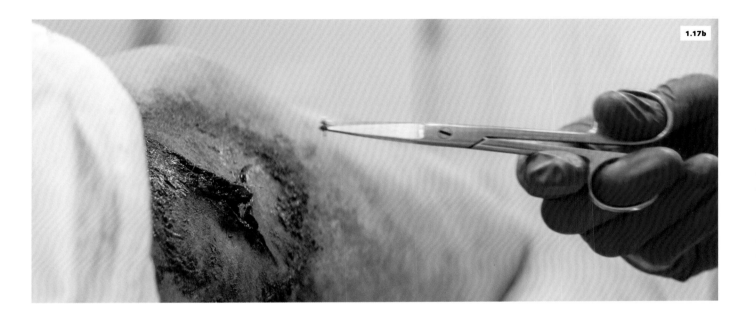

SET DECORATING AND DRESSING

Whether shooting in a studio or a location the set is decorated and dressed, which can include painting, furnishing, drapes and props. If in a location the space will be adapted to fit with the design scheme, removing anything that detracts or is in conflict with it. A dressing plan is worked out, plotting furniture and props in position in the setting.

An action prop is an object that is actively used in the scene, such as a telephone or a weapon. Props houses offer an excellent resource where diverse items can be hired: from small-hand held articles to furnishing, and even prosthetic body parts. Different prop houses offer specialist ranges such as certain periods, weaponry or medical hire. Their collections can usually be accessed online although a visit is recommended before making a final decision on items. Often the houses will negotiate a better deal for a student production. However, prop hire can be expensive so low-budget productions often rely on borrowing items from shops in return for a credit on the film or buying from second-hand shops.

University student Elisa Scubla, working on a script about a young man who doesn't want to grow up, found inspiration in a toy shop. She used unusual and vintage toys to dress the character's room, which illustrated the visual concept clearly. These ideas for props and dressing are in support of the immature nature of the character in the script. She explored the sense of him still being a child on some level, through his collection of toys.

Some props are specially designed and made to order where the budget allows – this gives a bespoke quality not present in the prop houses which can sometimes seem to only provide a homogenous selection. For example, the same props can reappear in similar productions, particularly items

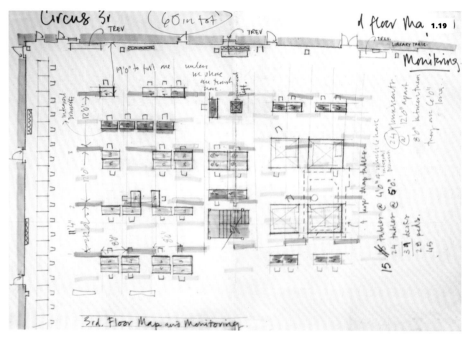

1.19
One of Tatiana Macdonald's dressing plan for *Tinker, Tailor, Soldier, Spy*. indicating where furniture and props will be positioned in the space.

that are used in historical/period dramas. Meanwhile genres such as fantasy and science fiction often require individual items to be crafted for the specific requirements of the production, allowing for a more distinct look.

Props and dressing are chosen to add authenticity to a location and communicate a sense of character and atmosphere – invigorating a space with layers of meaning and visual interest.

Martin Childs, when designing *Mrs. Brown* (1997, John Madden), filled the fruit bowl with dark fruit and dark green apples as a shorthand for Queen Victoria's mourning. Then at the end, when she finally comes out of mourning, he filled the fruit bowl with brighter fruit. 'Now that's a way of spending almost no money but getting across a visual kind of shorthand as to her state of mind. And sure enough on the day of the scene, Judi Dench walked on set and said: "Oh look, mourning fruit."'[15]

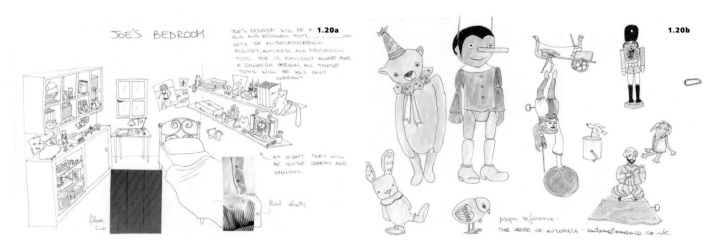

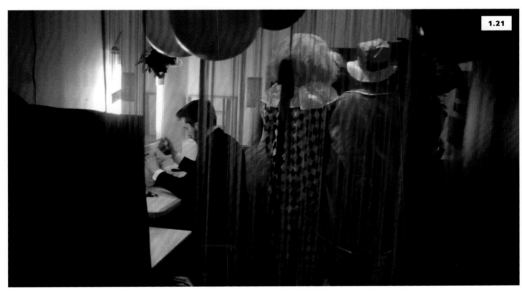

1.20a
Joe's bedroom, sketch with dressing and props. Paper-based project, 2011. Elisa visualized the bedroom as childlike with shelves full of toys.

1.20b
Sketches of mechanical toys as props.

1.21
Student production *Thrice* (2014, Siqi Zhang and Liya Ye, University of Westminster). Here, the dressing room is decorated with make-up, balloons and a fringed curtain. Extra characters are also important in signifying behind the scenes at a theatre as they form part of the composition in their different stage costumes.

Vehicles

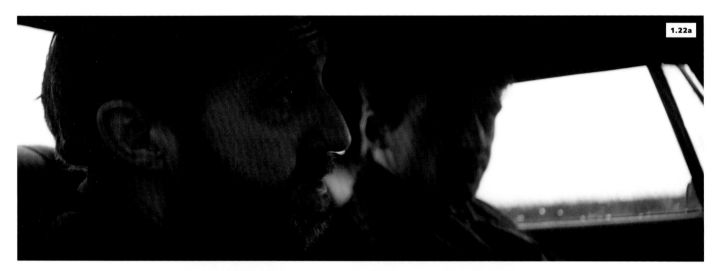

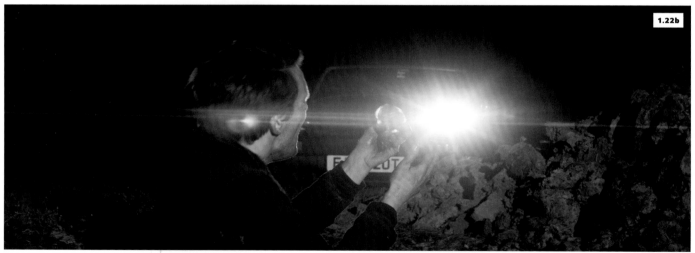

In this scene from *Clay* (2014), mortuary technicians who have stumbled on a jewel-filled corpse are corrupted by money. The interior of the car provides an intimate space for a pivotal conversation to take place in, while the exterior gives a practical light source – in the form of the car headlights for the digging up of the grave. The exterior also provides an interesting composition that ties in with the overarching design concept: the glare of the lights echoes the glinting and glistening of the diamonds that have led the characters to their downfall.

1.22a
Clay (2014, James Wilkinson and Samuel Thornhill, University of Westminster).

1.22b
Clay (2014, James Wilkinson and Samuel Thornhill, University of Westminster). The vehicle in this example functions in a number of ways.

Costume, hair and make-up

The PD liaises with costume and make-up as part of the overall look on a production. Costume designers are responsible for designing, making and hiring the actors' costumes on a production. The PD will coordinate ideas about looks, fabrics, colours and so forth with the costume designer. On some occasions the PD may also be responsible for the costumes. Make-up and hair designers will also need to coordinate with the production designer to ensure a coherent look that complements the overall design concept and intentions.

Animals and special effects

Sometimes animals feature in a script and these will be identified in the initial breakdowns. Specialist animal agencies and wranglers will usually be called upon to supply the relevant type of animal that can respond to the requirements of the script. In the example illustrated in figure 1.24 the students wanted a white rabbit to fulfil the magician's rabbit role and to symbolize purity.

Special effects have been used since early cinema with traditional techniques such as matte shots, scale models, glass shots, and back and front projection. They can encompass e.g. fire, explosives, weather conditions – using mechanical engineering, hydraulics or robotics. Today, digital manipulation can create lots of time and money-saving effects such as partial models that form a composite image – combining a setting that exists with one that is digitally rendered. This is often used to add drama, scale or context to a production. CGI has impacted on the landscape of filmmaking in spectacular and subtle ways. Action can be shot in a studio with blue or green screens to enable chroma key – which is where the background can be digitally added in post-production. In the examples shown in Figures 1.25a, b, c and d, students shot their actor in the green screen and later used after-effects software to add an other-worldly environment suggestive of the Biblical themes in their script.

1.24
Thrice (2014, Siqi Zhang and Liya Ye, University of Westminster). The rabbit is adored by the protagonist and antagonist in the story, making it an essential element to be sourced in this short film.

1.23
Thrice (2014, Siqi Zhang and Liya Ye, University of Westminster). In this instance the colour and style of the car have been chosen to help convey ideas about the character and foreshadow future events in the narrative. The character is in red and drives a cream/white car. The rabbit she plans on stealing is white which symbolizes purity, and her red dress has been selected to symbolize her desire.

1.25a

1.25b

1.25a
The Descendent of Mary Magdalene (2014, Kit Dafoe, University of Westminster).

1.25b
The Descendent of Mary Magdalene (2014, Kit Dafoe, University of Westminster).

1.25c
The Descendent of Mary Magdalene (2014,
Kit Dafoe, University of Westminster).

1.25d
The Descendent of Mary Magdalene (2014,
Kit Dafoe, University of Westminster).
Student Kit Dafoe used green screen
shooting combined with after-effects
software to create an atmospheric
landscape for this short film.

INTERVIEW WITH ANNA PRITCHARD

Production designer Anna Pritchard has worked in film and television for over a decade honing her craft. More recently in her work in television drama, Anna has collaborated with some of the best directors and writers in the business, including Dominic Savage on his projects *Dive* (ITV), *Freefall* (BBC) and *The Secrets*, currently in production for the BBC with Working Title TV, with credits including Series 2 of Channel 4's acclaimed *Top Boy*, Sky Living's *The Psychopath Next Door*, the BBC's *Inside Men* and the RTS-nominated drama *My Murder*.

Can you tell us about the project *Inside Men*?
Inside Men, produced by the BBC in Bristol, is a heist thriller and morality play; a heist committed by a sensible and quiet man, John Coniston (Steven Macintosh). It's loosely based on a book called 'Heist' about a real-life inside job in a cash counting house in Tunbridge Wells.

The first word that was mentioned to me by the director James Kent was current 'Dystopia'; he wanted me to make an outmoded, unfashionable and decaying world of security depots.

Cash sterling is collected from banks and supermarkets but no one wants to hold on to it. Cash is becoming outdated and archaic, and a high proportion of fraud is now committed over the Internet.

How did you respond to that in terms of your design?
Sixties Brutalist architecture was employed for both interiors and exteriors with a strong reference to seventies colours: burgundy, mustard and for the main character, stable dark green.

What images did you refer to?
The initial references came from the book, which had stills taken from video security footage. These were really dull images, not at all cinematic, although they did have some details like reinforced doors for the security airlock, that were useful.

The cash counting world is a very closed one, and there was absolutely no way we could get in to see how these depots worked, let alone film in them. The only real reference we got was from a detailed chat we had with a company that supplied cash counting machines, who could tell us how the procedure worked, and from then I could sketch out basic ideas. They told us the place was always messy and dirty, with exposed pipes on the walls, cables hanging down and boxes strewn around. The houses were always located in remote faceless industrial estates with no signage. The basic procedure of the money counting was integral to the layout of the space and the movement of their staff.

What about exteriors, did you use any real locations?
The Exterior of Larson House was a food recycling factory near Bristol Docks that had closed down for two weeks in the summer. What we particularly loved about the location was that it was quite remote, amongst the mud flats near Bristol Docks and great for an aerial shot. There was no security there, so we needed to enhance the factory by installing all the fences, adding moving security gates, rotating entry gates, barbed wire and security lights.

Can you give an example of how you used space to convey story/character?
After reading the script, the most important image to me was that John Coniston could see the rest of the workers from his office. The Boss is in charge and overseeing his workers.

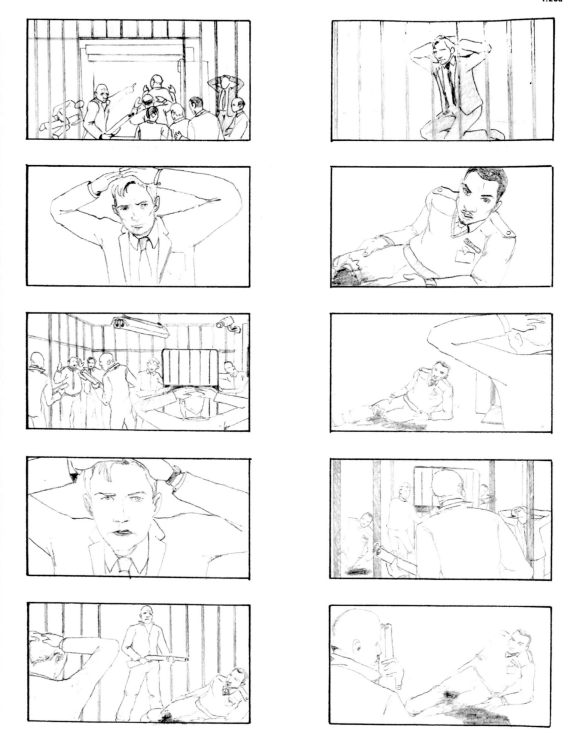

1.26a
Storyboards for *Inside Men* (2012, BBC, James Kent). Anna's storyboards indicate action and environment, props and dressing.

So this was one of the central ideas for your design?
Yes, I initially started sketching the sets, which I talked through with James Kent the director. We tweaked the plan to accommodate the movements of the actors of the pivotal heist scenes, which is the major set piece of the first series.

We decided on this car park as it had a strong 1960s Brutalist style: dark greys and murky colours, creating an atmosphere of suspense. We thought it was visually strong with concrete crosses for the opening shot. We gave the main character John Coniston a reliable Volvo, in a safe stable green colour, an ordinary car for an ordinary guy.

Can you talk about the characters' movement, particularly in and out of the setting? How did you go about designing something that requires such careful choreography?
The whole of Larson House was conceived by placing three locations/sets together.

These were the exterior location, loading bay with control room and security holding area, cash vaults, and the interior sets of the cash counting warehouse and offices. These were all linked together with a strong corridor set.

The on-screen corridors were built as one long corridor set, in a studio space with interchangeable doors at either end. We changed wooden fire doors, factory plastic flaps, lift doors, signage and the position of fire extinguishers to suggest different corridors; we did this because of budgetary constraints and the need to shoot with a quick turnaround.

We placed some of the grilles in the cash vaults to shoot through, and although the vault door was authentic to the location it no longer worked so we needed to adapt the locks and adapt the keys for visual effect. The control room and security holding area (or airlock) were part of an old bank in Bristol, but we needed to get all the knobs and switches and doors to work and update all the CCTV screens.

The access doors of the exterior location had to be similar to the loading bay. The loading bay needed to lead onto corridors, corridors led to the lift to the vaults and also onto the cash counting warehouse.

How closely did you collaborate with the director on this?
The director needed detailed sequences of events for certain scenes, they needed to be very specific, and so we employed a storyboard artist to draw out these events.

What issues arose in terms of dressing?
The cash floor procedure needed to be authentic and correct, using trolleys with grey storage boxes, all tagged up. The money on the cash floor needed to be ordered, counted and logged into computers, sent down the conveyor belt and double checked into the large cash counting machine.

1.26b

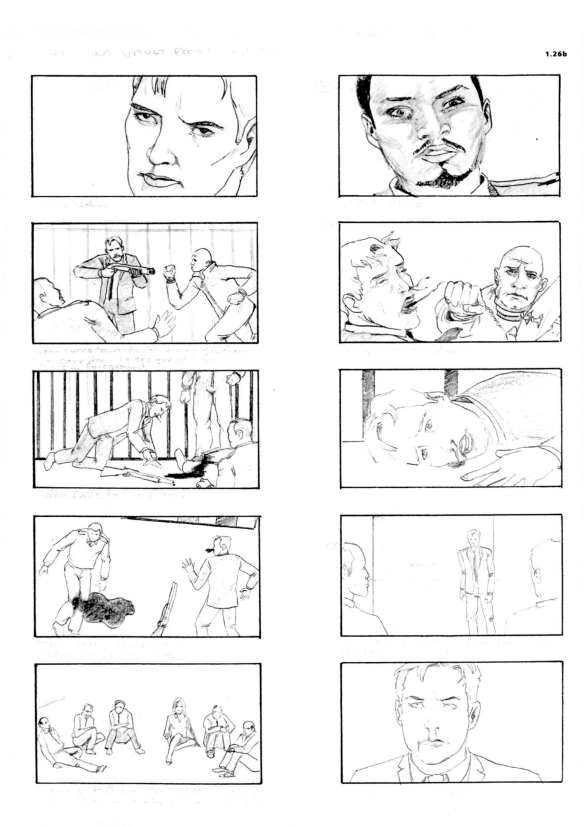

1.26b
Storyboards for *Inside Men* (2012, BBC, James Kent). Anna's storyboards indicate action and environment, props and dressing.

Exercises

The following two exercises require you to turn to the short student script, *Clay*, included in the Appendix of this book.

1. Break down the script using the ideas discussed in this chapter about the different stages of the pre-production process, and the practicalities involved in getting from script to screen.

Mark the script up with colour-coded sections, and then put into columns – locations/props/computers/ graphics/vehicles/construction/dressing/special effects/animals/other.

Think about the practicalities necessary to bring this script to life. What sort of locations will be needed? How many? What design ideas immediately come to mind when you read the script? Think about other films and television productions that you could look at that conjure a similar atmosphere to the one you'd like to create for this? Watch those films and make note of aspects of them you deem effective.

Consider scheduling and budgeting implications. How many days might this take to shoot? What costs are implied?

2. Read the script pages and collect images to create your own mood board (using photos, tear sheets from magazines, colour swatches, fabric swatches, references from films, paintings, photographs, exteriors and interiors of locations). You will find that lots of ideas spring from this process: images you find appealing during research like this can become the fundamental building blocks of your design. It may be a simple sketch, the texture of a fabric swatch or a postcard you've picked up that inspires a whole concept.

Further Reading

Dyas, Guy Hendrix. 'Elizabeth: The Golden Age'. *The Scenographer* 8 (2007): 48–57.

Horton, Andrew. *Henry Bumstead and the World of Hollywood Art Direction*. Austin: University of Texas Press, 2003.

Landiss, Deborah Nadoolman. *Filmcraft: Costume Design*. Lewes: ILEX, 2012.

Marner, Terrance St. John. *Film Design*. London: Tantivy Press, 1974.

Moor, Andrew. 'Hein Heckroth at the Archers: Art, Commerce, Sickliness'. *Journal of British Cinema and Television* 2, no. 1 (2005): 67–81.

Olson, Robert. *Art Direction for Film and Video*. Boston: Focal Press, 1998.

Rizzo, Michael. *The Art Direction Handbook for Film & Television*. Burlington: Focal Press, 2014.

Shorter, Georgina. *Designing for Screen: Production Design and Art Direction Explained*. Ramsbury: Crowood, 2012.

Notes

1 Terence St. John Marner, 9.
2 Alex McDowell, author interview, 2015.
3 Alex McDowell, author interview, 2015.
4 Alex McDowell, author interview, 2015.
5 Andrew Moor, 70.
6 Stuart Craig, author interview, 2008.
7 Guy Hendrix Dyas, 52.
8 Hugo Luczyc-Wyhowski, author interview, 2010.
9 Stuart Craig, author interview, 2008.
10 Stuart Craig, author interview, 2008.
11 Gemma Jackson, author interview, 2005.
12 Laurence Williams (*The Bill*, *EastEnders*), author interview, 2001.
13 Christopher Hobbs, author interview, 2001.
14 Gemma Jackson, author interview, 2005.
15 Martin Childs, author interview, 2004.

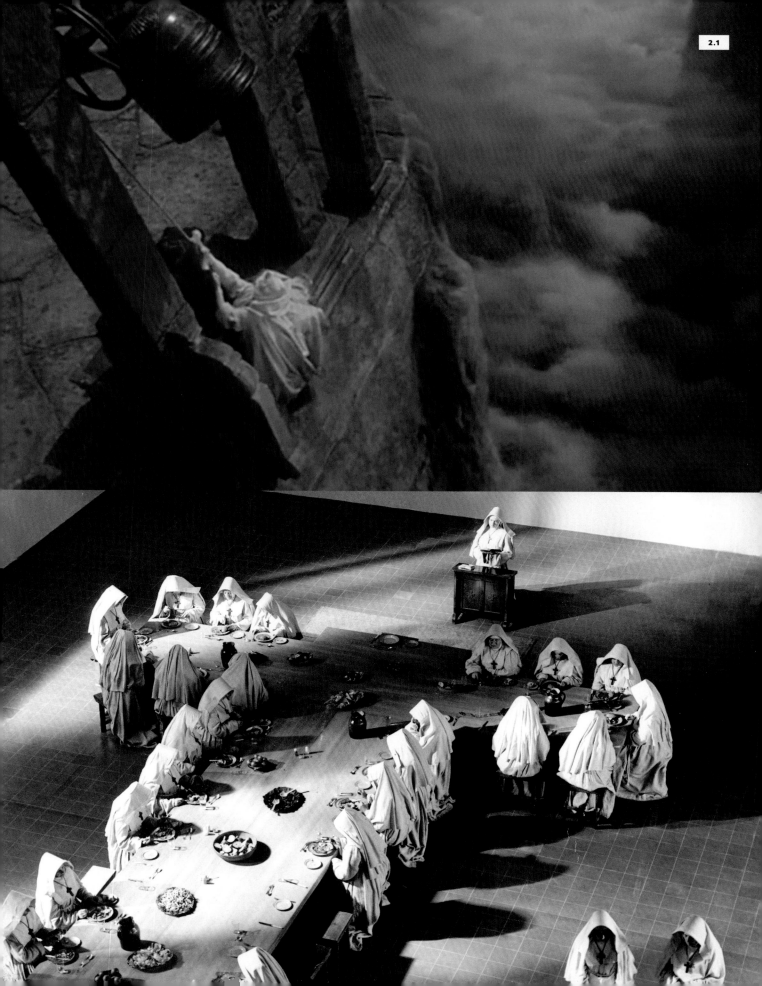

CHAPTER 2
THE VISUAL CONCEPT

The designer interprets the script, identifying a concept and drawing this out using a range of visual metaphors. The aim is to enhance and heighten aspects of the story, characters and atmosphere. This process relies on a set of conceptual tools, which allow the designer to communicate ideas visually. The way they are articulated defines the look of a film.

Where the concept comes from and how it is visualized depends on the individual designer; it is an emotional response to the script and each designer will interpret this differently depending on their background and influences. Through the designer interviews featured in this book the process is illustrated in a variety of case studies – providing inspiration and resource for designers and those searching for a method of analysis. A contrast is often used to enhance the concept where, for example, the magic of Hogwarts seems more marvellous next to the suburban home that Harry Potter comes from. The other technique considered in this chapter is transformation: whereby a design concept is established and then changes either subtly or dramatically over the course of time.

The tension that exists between realism and expressionism has produced different design solutions. What do we take from real life and what do we discard in the design process? It is the selection and combination of these choices that creates distinctive looks that are situated on a spectrum in relation to notions of representation. Designers all share concerns around realism and how to interpret aspects of the script visually while maintaining its integrity. Responses range from strict adherence to realism to poetic realism (for example, in France in the 1930s) which created a stylized sense of authenticity. 'Poetic realist designs have been interpreted as significant in their consistency in playing a narrative role and as key elements in the establishment of place, particularly as evocative creations of a cinematic conception of Paris.'[2] Today Stuart Craig (interviewed at the end of this chapter) calls his approach the 'poetic truth' – meaning he researches very thoroughly then distils his findings to create a dramatic solution that is a highly selective version of the truth. The process of finding a concept, a contrast and subsequent transformation is explored in this chapter.

2.1
Black Narcissus, 1947, Powell and Pressburger, PD Alfred Junge. The Visual Concept of the film is contained in the contrasting settings that drive narrative and emotion.

"Since film uses the real world as its material and therefore uses objects with which one is often familiar, certain things have to be overstated, otherwise they would not be recognised as part of the drama...the settings should be directed with as much conviction as the actors.[1]"

COLLABORATION

CONCEPT, CONTRAST AND TRANSFORMATION

Clint Eastwood is alleged to have said to the PD Henry Bumstead 'Where do you want me to put the camera today Henry?' As we have seen in earlier chapters, the designer is part of a team that has evolved to produce moving image on time and on budget. The creative collaboration between the designer and other key members of the team is fundamental to the process, creating inventive images and creative solutions to design and staging problems. This process is different on every production depending on the people and the nature of the project. Some collaborations are so fruitful they span many films and years. Directors have different strengths: some can visualize the script while others concentrate on the characters and the emotion, tension and drama that emanate from them.

The designer and the director is a pivotal relationship:

Intuition is the only way for a production designer to discover what the director wants. If you ask him outright, very often he'll describe the opposite of what he really wants…eventually you narrow it down and you decide on a look.[3]

PD Jim Clay describes working with Woody Allen on *Match Point* (2005): 'Woody communicated a lot. We spent seven weeks with him driving around picking locations. He was always astute and embraced something if he was enthusiastic and other times he would immediately dismiss it.'[4]

Collaborating with writer/director Richard Curtis on *Love Actually* (2003), Clay says:

Richard admitted that he didn't begin to understand design or how design worked or even what designers do. So I said as a writer you write a story by putting words together in sentences, then sentences into paragraphs and eventually they become stories. I take space and light and put a few walls in certain places and gradually build it up into either a Venetian palace or an unemployment office.[5]

This sort of collaboration around setting reveals the extent to which the designer contributes to notions of place that become anchored, impossible to imagine occurring anywhere other than what has been visualized on the screen. Mimi Gramatky says 'Sometimes we are even hired before the director and almost always before the DP [Director of Photography]. Some directors can visualize and some can't. As Dick Sylbert said "Warren Beatty couldn't visualize what he was having for breakfast." It is our job as PDs to help the director visualize the story.'[6]

Classic concepts that feature in drama include intimacy, isolation, pride, honesty, revenge, love, and human flaws such as greed, decadence, hate, betrayal and injustice. These are universal themes that an audience can appreciate and engage with. The design will work on amplifying these visually to enable the imagery, action and dialogue to combine effectively.

Each designer responds in a unique way to a brief – visualizing the script through a range of visual metaphors each of which are broken down and explored in further chapters. Without a design concept a story may appear disjointed, with visual elements that do not tie in, and which potentially contradict the key ideas in the script.

The designer begins to find resonance with themes within the script. Further discussions and research help develop these initial responses into workable ideas that can create a coherent look for the project. As Leon Barsacq elaborates:

As a general rule, airy sets with many windows or other openings give an impression of gaiety and thick walls, narrow windows, low ceilings create a heavy atmosphere…The designer can play with height and depth, large or small scale, matte surfaces or gleaming floors, gold and mirrors with a range of dull colours or violently contrasting tones. Each combination arouses different feelings that are difficult for the spectator to analyse but of which he is nevertheless aware.[7]

The PD devises a visual concept (usually including contrast and transformation) conveyed through the design of:

1. Space
2. In and Out
3. Light
4. Colour
5. Set decoration.

Through the strategic use of these tools the visual story is told. Every decision about these five elements is linked and returns to the logic of the central concept driving the design. In the *From Hell* example here, each of the tools is briefly outlined to illustrate how these five interact in practice. For the purposes of this book, each tool is separated and expanded on through the five chapters that follow.

In *From Hell* (2001, Hughes brothers, PD Martin Childs), Victorian London sees Inspector Abberline investigate the notorious case of serial killer Jack the Ripper. Set in the deprived Whitechapel district where poverty and crime are rife, a group of prostitutes are targeted by the killer. The contrast between the hellish streets of the East End and the air of affluence and normality in the West End are visualized through the design of PD Martin Childs:

I had this idea of building the whole of London in a field outside Prague. And I honestly think to this day, that the studios accepted the idea because the sketch was presented on a small scrap of paper. I did this drawing of the Whitechapel district and devised a way that it could also work as Mayfair. The design allowed you to point the camera in one direction to get Mayfair and point it in another direction to get Whitechapel. I connected the two settings with a network of little alleyways, all of which were the bits in Whitechapel where the prostitutes were murdered.[8]

Hence, everything was shot in a built set in the Czech Republic apart from a few pick-up shots that were done in London to stitch the film together. Childs' design visualizes key elements of the story through his initial sketch – a response to considerations around location shooting and budget. The visual concept of Whitechapel as hell is conveyed through the labyrinthine passages and spatial connection and contrast with Mayfair. Although much of the film takes place on the street, these settings were built to heighten the architecture of the original period (1888), densely packed with buildings and people.

The space envelops the characters in a deliberately forced perspective that prevents a horizon from appearing, enforcing and heightening the sense of claustrophobic entrapment. This concept is further supported by the technique of restricting natural light or sunshine in favour of gas street lamps and other forms of artificial light. The way in and out is often ambiguous with the women and the streets of the East End entwining as one. The colours of the environment are dark neutrals, a restricted palette that allows the vividly coloured dresses of the prostitutes to stand out.

The dressing of Inspector Abberline's home is a deliberate reflection of the absence of a woman (his wife is deceased) contrasting with the prolific presence of women in the exterior streets. Martin Childs designed the inspector's home in this way in order to heighten the contrast. Rather than this environment transforming to reflect the narrative or emotional journey, the surviving prostitute Mary Kelly is transported out of the city to a cottage situated in a vast open landscape with acres of sky and sea.

Visual concepts

Caravaggio (1986, Derek Jarman, PD Christopher Hobbs). A dramatization of the life of the seventeenth-century painter, revealing his painting style and approach to life in irreverent and gritty form.

Visual concept – art transcends time and place.

Do the Right Thing (1989, Spike Lee, PD Wynn Thomas). On the hottest day in Brooklyn, racial tension rises to violence. Sal's Italian American pizzeria becomes the focal point for anger and conflict.

Visual concept – a desert in the city.

The English Patient (1996, Anthony Minghella, PD Stuart Craig). At the end of the Second World War, a nurse looks after a burn victim of a plane crash. His past reveals a tragic love affair.

Visual concept – contrast between pre-war opulence and post-war austerity.

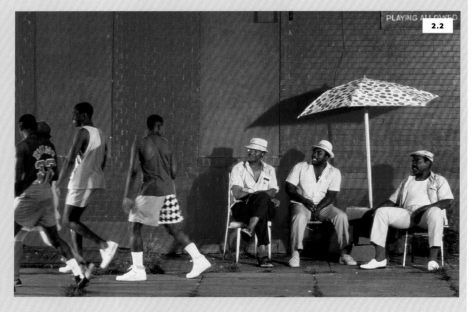

2.2

The Godfather trilogy (1901–1980, Francis Ford Coppola, PD Dean Tavoularis). The criminal activities of the Mafia are contrasted with the importance placed on family values.

Visual concept – dark versus light visualises the contradiction between the work and home environment.

2.2
Do the Right Thing (1989, Spike Lee, PD Wynn Thomas). The colour palette supports the concept, suggesting the intensity of heat.

Student Alec Fitzpatrick created designs based on the novel *Scar Night* by Alan Campbell, an epic urban fantasy. Alec chose to design the area Black Lung Lane which features a world suspended by chains over a seemingly bottomless chasm. His images convey the instability of the area, creating an inhospitable and volatile environment held together by the chains forged by the blacksmiths. The visual concept communicate the precarious nature of existence. Alec says:

> The area of Deepgate that I chose to design was named Black Lung Lane, because of the profession of the residents of the area. They are all blacksmiths, making this part of the city almost unliveable. The smoke and dust from the endless kiln blacken the lungs of every soul. My first objective was to create the feel of a street that had once been inhabited by the average citizen, and which has been invaded and adapted by blacksmiths because of the endless need for steel and chains to keep the ever-balancing city stable. I wanted to show the feeling of the ever-shifting city with my design. I chose to show this with the stepping up of the streets' foundations ending in a huge cliff, kept stable by the endless crossing of supporting chains barely keeping the street and city functioning.[9]

2.3a, 2.3b
Designs for *Scar Night* (Alec Fitzpatrick, University of South Wales, BA TV and Film Set Design) which feature a world suspended by chains over a seemingly bottomless chasm.

Contrast

In order to heighten the concept the designer usually creates a strong contrast to ensure the message is emphasized. Consider the superficial conformity of the ballroom competitions contrasting with the authentic roots of flamenco in *Strictly Ballroom* (1992, Baz Luhrmann, PD Catherine Martin) or the contrast in *Notting Hill* (1999, Roger Michell, PD Stuart Craig) between the impersonal world of the celebrity and the community of Notting Hill. Or the magical versus the mundane in *Harry Potter* (2001–2011, PD Stuart Craig), (Hogwarts versus the suburban Dursley home), or the gothic mansion on the hill with the sea of uniform houses in the town below in *Edward Scissorhands* (1990, Tim Burton, PD Bo Welch). Put simply to show what something is it helps to show what it is not. An opposition can be small or completely pivotal to the look and feel of a film. Film narrative works in binary oppositions – good/bad, heaven/hell, black/white, hero/villain. It follows that the visuals reflect this simple technique to heighten the sense of polarity that drama is rooted in.

Based on George R. R. Martin's fantasy novel series, *A Song of Ice and Fire*, *Game of Thrones* (HBO) is set in the fictional continents of Westeros and Essos. Much of the series is filmed in Northern Ireland, as well as Croatia and Malta, and features distinctive sets and costume designs. Former series designer Gemma Jackson established a strong contrast between the different worlds to visually distinguish the North and the South. She was inspired by Tibetan buildings set in mountain regions for Castle Black and the Mediterranean for King's Landing. The design has to function in a practical sense on *Game of Thrones* because of the nature of the show and the way in which it cuts from one location and storyline to another – the settings need to be instantly recognizable.

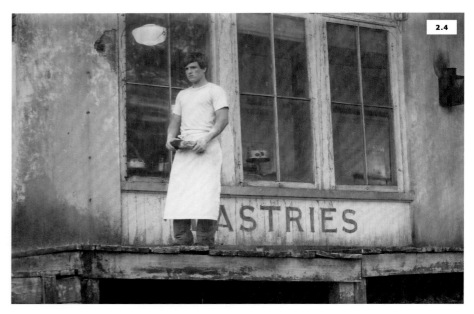

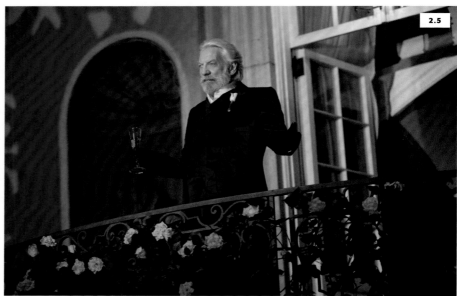

2.4
The Hunger Games (2012, Gary Ross, PD Philip Messina). In the villages the light, space, colour and dressing support the notion of poverty and deprivation.

2.5
The Hunger Games (2012, Gary Ross, PD Philip Messina). In the city the same design elements are used to indicate affluence and prosperity, creating a clear and effective visual contrast between the two places which supports the story.

Jim Clay says:

> Yes, it's definitely all about contrast and
> keeping the audience's interest. So you
> are entertaining the audience visually
> and you are defining where the character
> is and following the basic rules of: who
> are we? Where are we? And why are
> we here? That's something that Dennis
> Potter told me in the very early days of *The
> Singing Detective*. He said the fundamental
> building blocks of storytelling are those
> three things.[10]

Stuart Craig tries to base his designs on
just one or two ideas, which stem from
fundamental differences in the story.
By conveying visually the key contrast
in the drama, he is able to promote the
underpinning ideas in the script. In *The
Hunger Games* (2012, Gary Ross, PD Philip
Messina), the distinction between the poor
villages and the excessive affluence of the
city accentuates the injustice that is at the
heart of the story. The two are designed to
visually convey the story and stand for the
whole film distilled.

Black Narcissus (1947, Powell and
Pressburger, PD Alfred Junge) begins by
establishing the nuns tucked away in a safe
British convent, in a controlled, simple,
minimalist environment. They journey to
the Himalayas to the Mopu Palace where
they are embraced by nature; the wind blows
through the ostentatious palace acting as a
catalyst for their transformation. The exterior
is perched precariously on top of a mountain
situating them in a spectacular landscape
metaphor for the dramatic challenges their
new home has stimulated. The opposition
between the two environments drives the
narrative and transforms character.

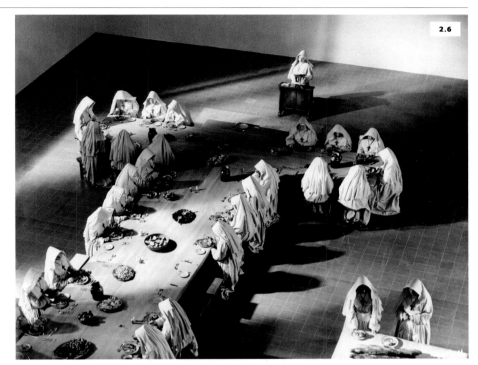

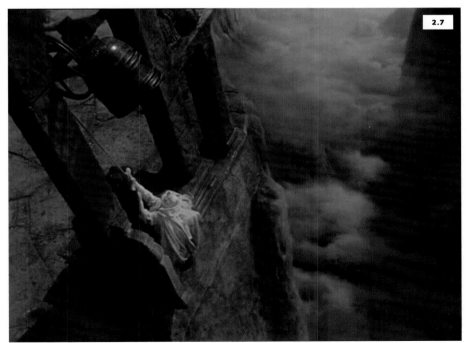

2.6
Black Narcissus (1947, Powell and Pressburger, PD Alfred
Junge). The ordered British convent.

2.7
Black Narcissus (1947, Powell and Pressburger, PD Alfred
Junge). The untamed Himalayan landscape where the
nuns travel to take residence in the Mopu Palace.

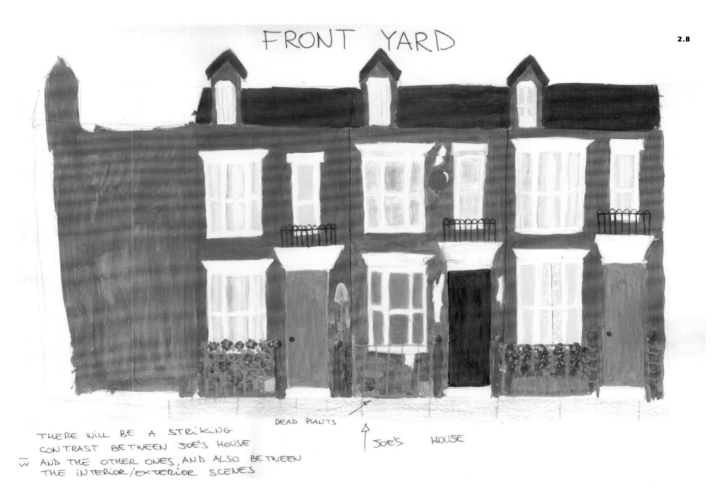

FRONT YARD

2.8

THERE WILL BE A STRIKING
CONTRAST BETWEEN JOE'S HOUSE
w AND THE OTHER ONES, AND ALSO BETWEEN
THE INTERIOR/EXTERIOR SCENES

DEAD PLANTS

JOE'S HOUSE

These conceptual tools can be applied to limited resources and budget in the same way. For example, student Elisa Scubla designed the exterior of a protagonist's house to contrast with the other houses in the street. Elisa decided to make the house stand out as neglected next to his neighbours' well-kept house exteriors. The visual concept was developed from the character arc in the script – which sees a young man celebrating his thirtieth birthday and struggling with what it is to be a grown-up, having thus far led a carefree existence. As seen in some of Elisa's sketches in Chapter 1, the protagonist is portrayed as immature at the beginning of the script. This exterior sketch of his home furnishes us with a sense of who he is in relation to others, creating a nice visual contrast.

2.8
Elisa Scubla's student project. Exterior sketch of houses. Although the houses are connected, they are decorated and tended to in a different way that Elisa intended to reflect the contrast between the main character Joe and his peers. This contrast helps visually convey the character and his story as he attempts to lead a more meaningful life.

Transformation

Once the concept and contrast are established, this is often transformed through the course of the film to illustrate change in the character and/or story. Film settings are rarely static and often reflect the journey of the major protagonist: for example, in *About A Boy* (2002, Chris Weitz and Paul Weitz, PD Jim Clay), the home of Will (Hugh Grant) is impersonal, cold and reflects his isolation. At the end of the film his apartment is transformed into an inviting homely space. As Jim Clay elaborates:

> For the part of the movie when he's alone the design is very clinical with cold colours like metallic blues, aluminium, metal and chrome. Once he starts to have a relationship with Rachel (Rachel Weiss) then it starts to warm up a bit. There were coloured Christmas decorations and everything just softened it wasn't quite as pristine and as orderly and we were reflecting the development of his character where those things aren't so important. [11]

Gemma Jackson says she aims to reflect the changes in a character's world through the design of their environment. A particular example of this in the home can be seen in the film *Iris* (2001, Richard Eyre, PD Gemma Jackson). Following author Iris Murdoch's journey from Oxford undergraduate to celebrated novelist and her subsequent battle with Alzheimer's disease. The gradual deterioration of Murdoch's interior mental state is externalized in her home physically in the design,[12] which becomes more and more cluttered and disordered:

How did I try to tell the story of the people visually? As the couple deteriorated, the home got worse, and it got quite hard to show just how bad it was. There's a scene where a policeman enters the room and he runs out gagging. You couldn't really put much more on the set. When she had a pee you see that they don't clear it up. You have to be observant to register that it had deteriorated to that extent.[13]

Another home that reflects the transformation of character and story is *The Servant* (1963, Joseph Losey, PD Richard Macdonald). Aristocrat Tony hires a new servant Hugo Barrett to take care of his home. Barrett manipulates the power balance and gains control of Tony and the home for his own selfish wishes. The set can function as another character as exemplified in a film like this, where Tony is obstructed and intimidated by changes in the environment. In *The Servant*, the owner becomes a prisoner at the mercy of his servant who reverses roles through his physical control of the home and psychological control of the owner. The house disintegrates into a den of iniquity where Tony is ensnared by his alcohol addiction and dependence on Barrett.

The set itself is sometimes conceived as a character in this way. According to the Affrons, 'Decor becomes the narrative's organizing image, a figure that stands for the narrative itself. Whether the set is a repeated figure, a persistent figure or a ubiquitous figure it is inseparable from the narrative.'[14]

The house Manderley in *Rebecca* (1940, Hitchcock, AD Lyle R. Wheeler) exerts influence over character and impacts on the emotional wellbeing of the new Mrs de Winter until it is destroyed in a fire. Manderley seems to be a physical embodiment of Max de Winter's late wife Rebecca, taunting the new Mrs de Winter and making her question her husband's devotion. The decoration and dressing of the house echo Rebecca in terms of style and personality; gazing out from portraits, she appears to look down on the current Mrs de Winter. The housekeeper Mrs Danvers idealized Rebecca and fetishizes her former possessions: clothing, bed sheets, even her hairbrush are caressed and admired. It is through the distorted lens of Danvers that Manderley is portrayed in an idealistic fashion, unattainable, unknowable in its intricacy and beauty. The new Mrs de Winter is intimidated, seemingly beaten by someone who is no longer alive. Transformation takes place in the form of destruction: the house is burnt down taking Danvers with it in the flames. The old order is destroyed along with the building, no longer able to exert its unhealthy influence and eradicating the power and grip that Rebecca seemed to have over the living.

2.9a
Rebecca (1940, Hitchcock, AD Lyle R. Wheeler). The exterior of the house 'Manderley' at the beginning of the film appears imposing and impressive. Framed through the glass of the car windscreen gives it a painterly quality, which adds to its grandeur.

2.9b
Rebecca (1940, Hitchcock, AD Lyle R. Wheeler). The house in flames – a transformation that embodies the end of Rebecca's power and a new beginning for Maxim and his current wife.

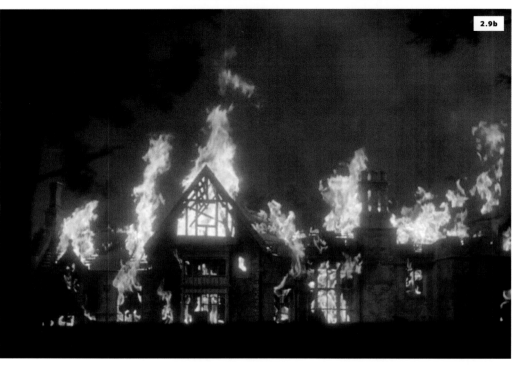

DEVELOPING THE VISUAL CONCEPT

Research

Research is fundamental to the visual concept. It can encompass a sensibility of place or time or it may be a small detail on a ceramic tile or the pattern of wallpaper used in a particular period that 'clicks' with the designer and enables them to form a coherent sense of the project.

Designers collate their research often in what is termed a bible – which contains every design detail such as textiles, colours, photos, paintings, architectural references, etc. This practice was part of the early Hollywood studio period where each production had a bible indicating the visual world of the film – a creative and practical tool providing a visual shorthand for the Art Department, often in the form of paintings

that contribute to our visual heritage and culture. The resonance of imagery taken from painting through moving image is explored in Anne Hollander's book *Moving Pictures* (1991, Harvard University Press) which considers art history in relation to film design and the perpetuation of iconic imagery. As outlined in the Introduction, the use of a bible would also enable art departments to stay visually connected to the corporate imagery of a particular studio brand, where stock images relevant to the genre could be flicked through before going into production.

Mimi Gramatky says she usually creates a bible for every project she works on, especially for a project that may have sequels, so that she can always refer back to it.

For *10,000 Days* (2014, Eric Small, PD Mimi Gramatky) the bible was a four-inch binder and a box of materials including types of synthetic snow and ice used.[15]

The bible for *Minority Report* (2002, Steven Spielberg, PD Alex McDowell) included projecting into a possible future the philosophy of a world where pre-crime exists and how that might translate in design terms.

INSPIRATION

The narrative

Jim Bissell: The metaphors are what make it resonate and make it feel like it's appropriate and to me that's really good dramatic design – after you've seen a good story, you can't imagine it being any other way than how it was presented and usually that's because it's so filled with those metaphors. Every time you think about the way it looked, sounded the way the characters did, what they did, it keeps pointing back to the narrative, it keeps redirecting you. If you start thinking maybe they should've done this and maybe they should've done that, then it starts to unravel a bit.[16]

The PD takes inspiration from the themes, characters and story. Designers will almost always describe their job as in support of the narrative. Their work is not intended to stand alone but is in the service of narrative to create visuals rich with information to this end. 'Sets are prized precisely where they are not noticed and where they blend in to the requirements of the film narrative.'[17]

The designer is involved in the way the narrative is triggered by the relationship between the character and the environment, which is the holistic nature of narrative design. Where the camera is positioned in space and the spatial influence on both of those moving elements (the character and the environment) is the tension that Alex McDowell says he is interested in:

They are all entwined so to make a decision about light has to consider the movement of the camera and has to consider the scale of the space and the amount of people populating the space and what the function of that space is. A film designer's job is unique in that you are thinking about all of these elements and you are creating the possibility for the story to exist at the centre.[18]

As Jim Clay says 'If the concept is strong and is rooted in the story then it works. If it's just from the purely visual side of things it doesn't. For example, in *Onegin* (1999, Martha Fiennes) the duel was originally in a barn and then I had this idea to set it on a jetty in the water. Now you couldn't imagine the duel taking place anywhere else.'[19] By finding a physical solution that philosophically made sense in terms of the story itself, Clay helped create a visual with such resonance that it becomes fused with the action.

Richard Sylbert writes a recipe based on the essence of each script he designs; for example, one of the story strands in *Chinatown* (1974, Roman Polanski) is the apparent drought/lack of water and his recipe included the colours to suggest this absence – burnt grass, amber, straw yellow through to a brown shade of peanut butter.[20] In the same film, the narrative is also visually suggested through repeated reference to water in the form of pictures. Images of water rather than water itself are used to dress the set, thus providing a constant contrast and reminder of the element that is actually missing. As the private detective Jake Gittes (Jack Nicholson) probes further into the case, he discovers corruption linked to the city water supply.

Water or the lack of it visually connects the two examples outlined – an essential to life with powerful associations creates another layer of meaning stemming from the narrative and strengthening the resulting designs.

The characters

On one project Jim Clay helped invent the characters, as they hadn't been fully formed by the writer:

He writes fantastic stories but he doesn't write visually. With characters I would ask, 'What does the Daniel character do?' So the characters were invented through our discussions. (talking about *Love Actually* (2003, Richard Curtis)).[21]

The characters in the script are scrutinized by designers who often discover inspiration from who they are and the journey the script takes them on. This is not always a straightforward process. When we are introduced to a character, their environment can communicate useful detail and depth. Personality is suggested through tools including space, light, colour and dressing. Where a character lives or works has an impact on our understanding. A tower block, a cute cottage, a mansion, a derelict railway arch, each of these immediately signify ideas about the character's psychology and situation. Given the opportunity to design a character's home interior, designers will consider carefully which items add depth and tie in to the concept, whether it's a cluttered cosy home full of organic materials or a minimal cold, streamlined apartment (design shorthand for empathy and distrust). The absence of personal detail may also be used to suggest that the person is mysterious, has a secret, split personality and so forth. The spy James Bond in the Bond films, for example, is rarely seen at home, so remains enigmatic; this lack of intimate detail reflects his character as a secret agent effectively.

Clues may be given as to the story trajectory. *Withnail and I* (1987, Bruce Robinson, PD Michael Pickwoad) as the title suggests revolves around the two characters and their relationship. Two out-of-work actors Withnail and Marwood, sick of the city, decide to take a break in the countryside. The house they share is a liminal space: both are hoping for their big acting break and survive on limited means. As a shared space their house contains visually conflicting information; the lack of comfort it provides helps propel them on somewhere else. The two characters are stuck there waiting for their lives to begin, which is reflected in the neglected and inhospitable space that drives them to escape to Uncle Monty's country cottage for a holiday in the Lake District, where they are jolted out of their rut.

In *Bridget Jones's Diary* (2001, Sharon Maguire, PD Gemma Jackson), the concept stems from the idea that the character is a like a princess at the top of the tower waiting to be rescued. In reality, a single young woman living in London would often live in shared accommodation. Rather than adhere to the realism of where she could afford to live, Bridget Jones' home was based on the concept that she was waiting to be rescued by a prince. This resulted in her home being designed to echo a fairy-tale castle. As Gemma Jackson articulates:

In the first Bridget we were trying to create an environment for a young woman who was struggling, a bit lost, poor, living in London. I think everyone had to agree that it was slightly unusual that a woman of her income was likely to have her own place. I loved the fact we gave her a flat at the top of that pub so she was a little bit like a princess at the top of a castle.[22]

Charles Tashiro elaborates similarly:

When sets reflect a particular character's emotional, material, physical state, we can call it 'expressive decor' – this room is expensively furnished because the man who owns it is wealthy, for example. This definition relies largely on story dynamics for motivation, which is to say that the resulting set may express character, but do little to catch our attention as viewers.[23] The PD is motivated by story dynamics in the first instance and tends to move beyond these in the creation of the visual concept that includes more poetic layers of expressive decor.

The notion that character and narrative are inseparable is supported by designers, who strive to enhance both as twin pillars of their concept.

Dreams and memories

Dreams and memories can help convey the interior life of a character. Dreams are rich with unusual and often vivid imagery. The fact that dreams are encoded with symbolism makes them all the more potent for use in creative practices such as painting, photography and film. Psychoanalytic film theory considers the strong links between film worlds and dream worlds through the distillation of human experience in a dimension other than the everyday, exploring connections between film and the unconscious. Dream images reverberate with feeling and emotion that reflect inner psychology rather than how things actually might look in an objective sense. The ideas of Sigmund Freud and Jacques Lacan have been applied to film theory in particular. In *The Interpretation of Dreams* (first published 1900)[24] Freud argued that unconscious thought could dictate people's behaviour. Freud characterizes the spectator as a compulsive with murderous and incestuous tendencies – recognized in drama.

The Nightmare by Henry Fuseli (1782) created an influential image that has been drawn on repeatedly in art, literature and moving image. The painting has had many interpretations but it is not through words but through further images created for the screen that it speaks of the unconscious, and layers of narrative and cultural context continue to resonate with a contemporary audience.

Particular filmmakers and films have used dreams to invest a strong design aesthetic in their work; for example, David Lynch, Terry Gilliam, Tim Burton, Powell and Pressburger have all imbued their work with dreamlike qualities. Films such as *The Red Shoes* (1948, Powell and Pressburger), and others such as *Eternal Sunshine of The Spotless Mind* (2004, Michael Gondry) and *Pans Labyrinth* (2006, Guillermo del Toro) include scenes that represent a dream or another reality where the unconscious mind constructs varied versions of 'real' events.

The way we remember is also highly subjective: events are usually tinted with our feelings at the time, resulting in an emotional rather than a realistic photographic representation. As such, a memory can take an experience and create a distinct and unique impression that helps convey the emotions and atmosphere – moving beyond how a place looks to what a place feels like. In *The Long Day Closes* (1992, Terrence Davies), PD Christopher Hobbs designed the director's memory of his childhood home and adjusted the scale to that from a child's perspective rather than from an adult's point of view. A simple change in scale like this altered the sense of space and transported the audience in to the director's memory of place. This physical distortion had an emotional effect, typical of Hobbs' imaginative design approach of invention over conventional representation.[25]

As Christopher Hobbs says:

I always do my research very carefully first, before branching out in rather wild directions. The images all look the same in books because that's the only reference point and so the trick is to do the research and then try to think yourself into the period as far as you can go and then invent the past. There is so much that we don't know, that is forgotten or has disappeared. So there's a lot of leeway as long as you keep within the spirit of the period. A lively notion that privileges the imagination.[26]

Surrealism extends these ideas, departing as it does from attempts to represent objects as they physically appear to emotional responses. In *8 ½* (1963, Fellini), for example, Dante Ferretti designed a sink without plumbing to communicate the uneasy sense present in much surrealist work. An alternative universe was created in the apartment in *Last Tango in Paris* (1972, Bernardo Bertolucci, PD Fernando Scarfiotti): the story of a French woman and American man's affair conducted in an apartment where no names are exchanged. Fernando Scarfiotti's visual concept was based on the notion of fantasy; the paintings of Francis Bacon were also used as reference in terms of light and colour. The resulting design of the apartment where the couple meet connote another place that exists in fantasy rather than reality, disconnected from the outside world.

2.10
Last Tango in Paris (1972, Bernardo Bertolucci, PD Fernando Scarfiotti). The apartment functions as a fantasy space separate from the outside world – it looks and feels different.

2.10

Paintings and photographs

As discussed previously in the section on dreams and memories, paintings as visual reference or for emotional resonance provide a way of enriching film design and stylistic inspiration. Either for atmosphere or for details like composition, colour, light, mood or landscape, particular painters have been drawn on heavily in moving image – for example, Edward Hopper, Rembrandt, Turner and Caravaggio paintings have been hugely influential. The colour palette for *Shallow Grave* (1994, Danny Boyle, PD Kave Quinn) was inspired by Edward Hopper, apart from one room which was deliberately given a different colour reference based on the paintings of Francis Bacon to indicate contrast, making it stand out from the other interiors. This contrast hinted at aspects of the story and highlighted this room as uncanny – in the film flatmates sharing a house are looking to fill one of the rooms. The new flatmate arrives – only to be found dead in his bed the next day. Thus the room he dies in is deliberately designed using a distinctly different colour palette.

2.11

Shallow Grave (1994, Danny Boyle, PD Kave Quinn). The sitting room with a colour palette, including warm golden yellows, reds and browns, based on the paintings of Edward Hopper.

Jim Clay

Jim Clay sometimes uses music as inspiration. He used the music of composer Ludovico Einaudi for *Panic Room* (2002, David Fincher) to help him in terms of the emotional tone of the film. This may seem a more surprising reference point as it is not visual; however, the atmosphere and emotion of music can be used by designers in identifying the essence of their concept. When we consider the poetic nature of design this idea becomes easier to grasp. Music can transport us through time and space; for example, to the period it was produced, the instruments used or the lyrics. Jim Clay says:

I play music when I'm designing. When I was designing *Captain Corelli's Mandolin* (2001, John Madden) there was a particular scene when I was designing the town square and at that time in the script Doctor Iannis was going to be hung by the Nazis in the town square. I was designing it late at night and I was listening to Radio 3 and Arvo Pärt (*Spiegel im Spiegel*) suddenly came on the radio and that then became my piece of music for the whole movie and I played that over and over again. There's such a sad resonance in that music which seemed absolutely relevant to that particular scene.[28]

Another example Jim Clay gave was when he worked on *Copycat* (1995, Jon Amiel) in San Francisco with Sigourney Weaver.

The director briefed me on what Sigourney's character's apartment interior would look like and he gave me a piece of music (*Requiem for the Dead*). He said, 'I can't tell you what it looks like but that's the piece of music.' Sigourney's character was a criminologist who'd spent her life studying death and murder and suddenly that has a great relevance.[29]

2.12

Further chapters elaborate on and consider examples of the way painting styles and approaches have helped define film concepts.

In a similar way to paintings photographs are a frozen frame that include elements such as composition, lighting, colour and atmosphere that can prove a rich source of reference material. Photographs form part of the research process where a selection help create the intended mood or a single image becomes the organizing principle for a whole film. As Jim Clay says:

It's one of the ingredients. It might be seemingly totally irrelevant but there's some emotional element in that photograph.[27]

The photographs of Helmut Newton and Robert Mapplethorpe were used by Hugo Luczyc-Wyhowski for *My Beautiful Laundrette* (1985, Stephen Frears, PD Hugo Luczyc-Wyhowski) to help visualize themes of sexuality and race.

2.12
Shallow Grave (1994, Danny Boyle, PD Kave Quinn). The Francis Bacon inspired-room that new flatmate Hugo (Keith Allen) dies in. The contrast in colour palettes delineates the interior space within the house. The use of purple and red suggest conflict and death in visual language.

Films

Filmmakers sometimes look to other films for research and inspiration. International film heritage results in a rich library to draw on where designers can reference other films to strengthen and support their design concept. When this is carried out intentionally the audience recognition can be a source of great pleasure. An overt example of this is when Quentin Tarantino films pastiche and pay homage to earlier films such as *Django* (1966, Sergio Corbucci), *Foxy Brown* (1974, Jack Hill) and *City on Fire* (1987, Ringo Lam). Specific details are directly appropriated on occasion – such as Dr Shultz' dentist's wagon featured in *Django Unchained* (2013, Quentin Tarantino) – which is similar to McTeague's wagon in *Greed* (1924, Erich Von Stroheim) with a giant wobbling tooth on top. Martin Childs refers to films as a form of communicating ideas and aesthetics with the director. He says there are bits of *The Third Man* (1949, Carol Reed) in everything he's designed.

As discussed in the Introduction, the Hollywood studio system created distinct identifiable styles:

There is a Paramount Paris and MGM Paris and RKO Paris and Universal Paris and of course the real Paris – but Paramount Paris was the most Parisian of them all.[30]

and these styles are still drawn on for inspiration today.

Film distils the essence of a place, intentionally designed to discard anything contradictory that might dilute the concept. Real places embody diverse elements that do not all conveniently tie in with design intentions. The nature of cinema means we have a shared visual archive brimming with a wealth of iconic designs for the contemporary designer to employ.

Mimi Gramatky says that she always looks at other films when designing: 'One of my new projects, *Crypto*, I describe as a mixture of *The Conformist*, *Brazil* and *Barton Fink*.'[31] Gramatky has chosen these films because she says that the twists and absurdities in Terry Gilliam and Coen brothers' movies are perfect for what she is trying to create for this Second World War thriller. It is this sort of cross-referencing of aesthetic style that can create an exciting visual language informed by contemporary imagery and designers from the past.

In terms of genre there is a shared visual iconography in for example Westerns, musicals, horror and science fiction that is repeatedly referenced; although genres evolve, early works continue to resonate. For example, film noir's striking visual aesthetic style originally appeared in 1940s Hollywood attached to crime thrillers such as *Double Indemnity* (1944, Billy Wilder) and *The Postman Always Rings Twice* (1946, Tay Garnett) and it is persistently drawn on today for films as diverse as *Chinatown* (1974, Roman Polanski), *Blade Runner* (1982, Ridley Scott), *Heat* (1995, Michael Mann), *Seven* (1995, David Fincher), *The Usual Suspects* (1995, Brian Singer), *LA Confidential* (1997, Curtis Hanson), *Dark City* (1998, Alex Proyas), *The Machinist* (2004, Brad Anderson), *Sin City* (2005, Frank Miller, Robert Rodriguez), *Children of Men* (2006, Alfonso Cuaron) and *Shutter Island* (2010, Martin Scorsese).

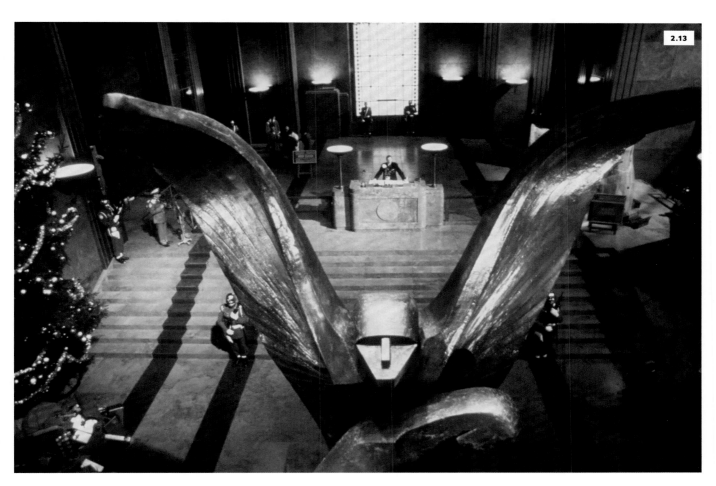

2.13

2.13
Brazil (1985, Terry Gilliam, PD Norman Garwood) depicts a dystopian future that references the past in idiosyncratic fashion. One of Mimi Gramatky's references for the project *Crypto*.

INTERVIEW WITH STUART CRAIG

Stuart Craig's first job was as a junior in the Art Department for *Casino Royale* (1967, Martin Campbell), a James Bond spoof. His work with Richard Attenborough on *A Bridge Too Far* (1976) led to designing *Gandhi* (1982, Richard Attenborough) and his first Academy Award in 1983. Craig went on to work with Attenborough on *Cry Freedom* (1987), *Chaplin* (1992), *Shadowlands* (1993) and *In Love and War* (1996). He received further nominations for *The Elephant Man* (1980), *The Mission* (1986), *Chaplin* (1992), *Harry Potter and The Sorcerer's Stone* (2001) and *Harry Potter and the Goblet of Fire* (2005). He won Academy Awards for *Dangerous Liaisons* (1989) and *The English Patient* (1996).

Stuart was in pre-production on *The Legend of Tarzan* (2016, David Yates) at Leavesden when we met in July 2014.

What was the brief for *The Legend of Tarzan* and how are you going to conceptualize that in design terms?
I was asked by David [Yates] whether I would be interested in finding a way of making it on the budget available. The brief, because it didn't work budget-wise before, was to explore if there was a different way to make the film.

So what was your solution?
Rather nervously and with great trepidation, I volunteered the idea that we might be able to find West African locations in the UK and so I went off to Wales and was shown a black slate quarry, which could have been anywhere in the world and it was very dramatic, so that was encouraging. That began to fulfil the brief and since then things have been refined and looked at repeatedly, sometimes it's more expedient to make it a visual effects shot and at other times do as much in camera as possible.

Are you going anywhere else apart from Wales on location?
We do have to go to Africa, and our visual effects camera man will shoot background plates, we'll shoot background elements to foregrounds which are shot here in the UK, sometimes just against a blue screen as they often are these days, sometimes with a bit of physical set.

In what other ways is the budget impacting on your design ambitions and process?
Harry Potter films tended to be 20 to 26 weeks of shooting, so already there's a big difference there. Tarzan is a 14-week shoot so there are real constraints. It's a very ambitious film, there are lots of animals, West African animals in it and they're digitally created, the costs of which are pretty phenomenal. So we're maintaining the ambition within the available budget.

How many different settings are being shot on the back lot here in Leavesden?
We've got the top of a mountain, the colonial town, the capital of the Belgian Congo in 1819 when this was set, so we built the colonial centre of Boma. The Governor's house, the minister's buildings, the quayside, the waterfront, there's a train in there. All of this is being built right now. There are two stages full of jungle which are difficult; architecture's comparatively easy if you get the detail right, the texture and the finish is easy to accomplish really. But trees and foliage are much more organic, much more difficult to fake in a sense.

How do you manage to stay in budget on such an ambitious production?
We have one scene which involves hundreds of carriages and we don't financially have the means to support supplying hundreds of carriages, so you start with 10–15 carriages and then replicate them, change the signs on the buses and use the same 15 carriages, ten times and you piece together this composite image and that's happening all over the place, with views of the jungle, so many situations have composite images.

Is there anything in particular that you're referencing to create the look?
I think a comic book image is something we all have in our heads and therefore it's a heightened reality, an exaggeration of the real world. In our version of the forest there's big rainforest trees with the big buttress roots, which in reality grow hundreds of yards apart because they're massive and the forest floor couldn't sustain trees of that size so close together, but because we wanted to create this mysterious world, we put them much closer together. The real jungle's a mess, you can't see very far, so we've made something that's very ordered, almost architectural in its design.

2.14a
The Legend of Tarzan (2016, David Yates, PD Stuart Craig) The West African exteriors furnish the film with the context of huge vistas.

2.14b
Jungle foregrounds created at Leavesden Studios provide intimate settings. Craig enjoys playing with the scale to heighten the comic book quality of the design.

You've talked about trying to choose colour in relation to the psychology of the scene. Can you give examples in *Tarzan* of this?
There's a lot of green (!), it's a very green film, but it's about textures, it's about wide African rivers reflecting the sky, reflection is a big part of it, black slate is a big part.

Kedleston Hall was chosen because it has great austerity and simplicity about it and it's also a uniform colour throughout. The interior is this amazing grey-brown marble. The whole place is intimidating. This is where Lord Greystone (Tarzan) and his wife Jane live, their English country home, but she loves Africa and he was born there and so they're trapped in this very beautiful but intimidating prison and that has a lot to do with architectural forms, purity in design, but it's also got a lot to do with the colour, that really similar dour colour inside and out.

How much has dressing played a part?
We're not dressing it very much, it's very pure and unadulterated so it's very limited, the emptiness of it, furniture-wise, is part of its character and we'll actually do more taking out than putting in. I often find myself taking colour and making things a greyer version of the same colour and invariably we'd end up with this very muted palette really, and a lot of that was experiments in the subtlety of colour.

You've talked about the importance of finding a design contrast before, is that contrast going to be between the jungle and the city?
That's absolutely right, it isn't scripted, that big shot in London, the crowded metropolis, the chaos and confusion, that isn't scripted, but you can begin to look into it, photographs of the period and look at Parliament itself. It grabs your attention and it's the best possible contrast with West Africa. Certain scenes have massive vistas, their context is huge such as the overview of the jungle, whereas other scenes are incredibly intimate, those big forest trees can provide very intimate settings, so that's interesting playing with scale.

How did you approach the light in these scenes?
In the forest – strong backlight in almost every one. Henry Braham (DoP) saw a plan from us and said he'd like to experiment and just blast light on the face of the backing, which could well be interpreted as light burning through the forest, through foliage and fronds and so this idea of a very hot backlight really came from him, and these illustrations (Stuart refers to the detailed artwork covering the walls of his office) really convey our talks with him. Design and lighting are inseparable.

What about the lighting for the city?
Actually you want London the way it was in the Industrial Revolution, with heavy, grey, wet streets and overcast skies. It would be very expensive, but it would be great to put that black soot all over the buildings as there used to be. The reality is that we'll have to turn up at 3am on a Sunday morning and get what we can, as soon as the sun comes up.

Can you elaborate on your collaboration with the director and DoP on this project?
Well on this project, just this morning I did what I usually do, which is talk to them about something before showing them. For example, there was a certain amount of nervousness regarding this black slate, this black rock set because we've got scenes with black tribesmen, and so the idea of having black skin against black rock is a concern. It's extremely dramatic because it's such shocking black, but it will be broken up by mist and other coloured, textural layers. We can take advantage of the similarity and exploit the differences too.

For someone that hasn't built their reputation yet, how would you advise them to go about those kind of conversations?
I'd advise them to act according to their strengths. It only takes a couple of key decisions to be respected and that then gives you clout in the future. Don't make it up as you go along because you'll be found out. The thing about the designer, he has to collaborate with the director and serve the script and has to involve the cameraman. And so the designer's role becomes very integrated into the DoP's role and the director's role. When it works well it becomes a seamless mix of three disciplines.

2.14c
Keddleston Hall exterior location used for Greystoke mansion. The British home of Lord and Lady Greystoke.

2.14d
The architectural lines contain the characters suggesting order and structure imposed by social convention. Colour and light further this sense with the muted palettes of grey brown marble.

Exercises

The following exercises require you to turn to the short student script, *Clay*, included in the Appendix of this book.

1. Using the *Clay* script, identify some possible concepts through considering the characters and events. What ideas or themes can you see? Think about other films that have similar themes or storylines. What is the visual style of these films?

2. Find two films that you would like to use as reference for this – see if you can identify their concept.

3. Look at other sources – paintings, photographs find two that you would like to use as visual reference.

4. Research and gather visual references for the people and places. Visit real locations or picture/location libraries online. In this script the mortuary and the pub are strong settings that provide a vast range of options in terms of style.

5. The characters: what ideas from the script do you glean about these characters? We do not see either of their homes so information will have to be conveyed through their workplace/how they look/ what sort of personal possessions they might carry about.

Further Reading

Affron, Charles and Affron, Mirella Jona. *Sets in Motion*. New Brunswick: Rutgers University Press, 1995.

Barsacq, Leon. *Caligari's Cabinet and Other Grand Illusions: A History of Film Design*. Boston: New York Graphic Society, 1976.

Berger, John. *Ways of Seeing*. London: Penguin Modern Classics, 2008.

Bergfelder, Tim, Sue Harris, and Sarah Street. *Film Architecture and the Transnational Imagination. Set Design in 1930s European Cinema*. Amsterdam: Amsterdam University Press, 2007.

Dowding, Jon. 'The Production Designer'. *Cinema Papers* 36 (1982): 27–30.

Ettedgui, Peter, ed. *Production Design & Art Direction*. Woburn: Focal Press, 1999.

Freud, Sigmund. *The Interpretation of Dreams*. London: Allen and Unwin, 1954.

Harper, Leslie. *Dreams on Film: The Cinematic Struggle between Art and Science*. Jefferson: McFarland & Co, 2003.

Harper, Sue and Vincent Porter. *British Cinema of the 1950s: The Decline of Deference*. Oxford: Oxford University Press, 2003.

Hollander, Anne. *Moving Pictures*. Cambridge: Harvard University Press, 1991.

Landis, Deborah Nadoolman. *50 Costumes/50 Designers: Concept to Character*. Berkeley: University of California Press, 2004.

Landis, Deborah Nadoolman. *Dressed: A Century of Hollywood Costume Design*. New York: Collins Design, 2007.

McAnn, Benn. 'A Discreet Character? Action Spaces and Architectural Specificity in French Poetic Realist Cinema'. *Screen* 45, no. 4 (2004): 376.

Mills, Bart. 'The Brave New Worlds of Production Design'. *American Film* 7, no. 4 (1982): 40–6.

Richardson, Michael. *Surrealism and Cinema*. Oxford: Berg, 2006.

Street, Sarah. 'Sets of the Imagination: Lazare Meerson. Set Design and Performance in *Knight without Armour* (1937)'. *Journal of British Cinema and Television* 2, no. 1 (2005): 18–35.

Sylvester, David. *Moonraker, Strangelove and Other Celluloid Dreams: The Visionary Art of Ken Adam*. London: Serpentine Gallery, 2000.

Tashiro, Charles. *Pretty Pictures and the History Film*. Austin: University of Texas Press, 1998.

Notes

1 Jon Dowding, 27.
2 Sarah Street, 18–35.
3 Bart Mills, 40–6.
4 Jim Clay, author interview, 2005.
5 Jim Clay, author interview, 2005.
6 Mimi Gramatky, author interview, 2014.
7 Leon Barsacq, 126.
8 Martin Childs, author interview, 2005.
9 Alec Fitzpatrick, author interview, 2015.
10 Jim Clay, author interview, 2005.
11 Jim Clay, author interview, 2005.
12 Another example of this approach can be seen in Anna Asp who is a production designer that creates characters for each of the houses she designs, with each having a face.
13 Gemma Jackson, author interview, 2005.
14 Charles Affron and Mirella Jona Affron, 158.
15 Mimi Gramatky, author interview, 2014.
16 Jim Bissell, author interview, 2015.
17 Tim Bergfelder, Sue Harris, and Sarah Street, 12.
18 Alex McDowell, author interview, 2015.
19 Jim Clay, author interview, 2005.
20 In Peter Ettedgui, 40.
21 Jim Clay, author interview, 2005.
22 Gemma Jackson, author interview, 2005.
23 Charles Tashiro, 22.
24 Sigmund Freud, 1954.
25 Christopher Hobbs' approach includes thinking himself into a period in order to liberate himself from stylistic clichés. He and the director Derek Jarman had a productive collaboration on the films *Jubilee* (1978, costume), *Caravaggio* (1986), *The Last of England* (1988), *Edward II* (1991), *Projections* (1993). Other examples of his designs include *Gormenghast* (2000), *Velvet Goldmine* (Todd Haynes, 1998), *Mansfield Park* (1999), *The Tribe* (Stephen Poliakoff, 1998), *Cold Lazarus* (1996), *Neon Bible* (Terence Davies, 1995).
26 Christopher Hobbs, author interview, 2001.
27 Jim Clay, author interview, 2005.
28 Jim Clay, author interview, 2005.
29 Jim Clay, author interview, 2005.
30 David Sylvester, 45.
31 Mimi Gramatky, author interview, 2014.
32 Stuart Craig, author interview, 2014.

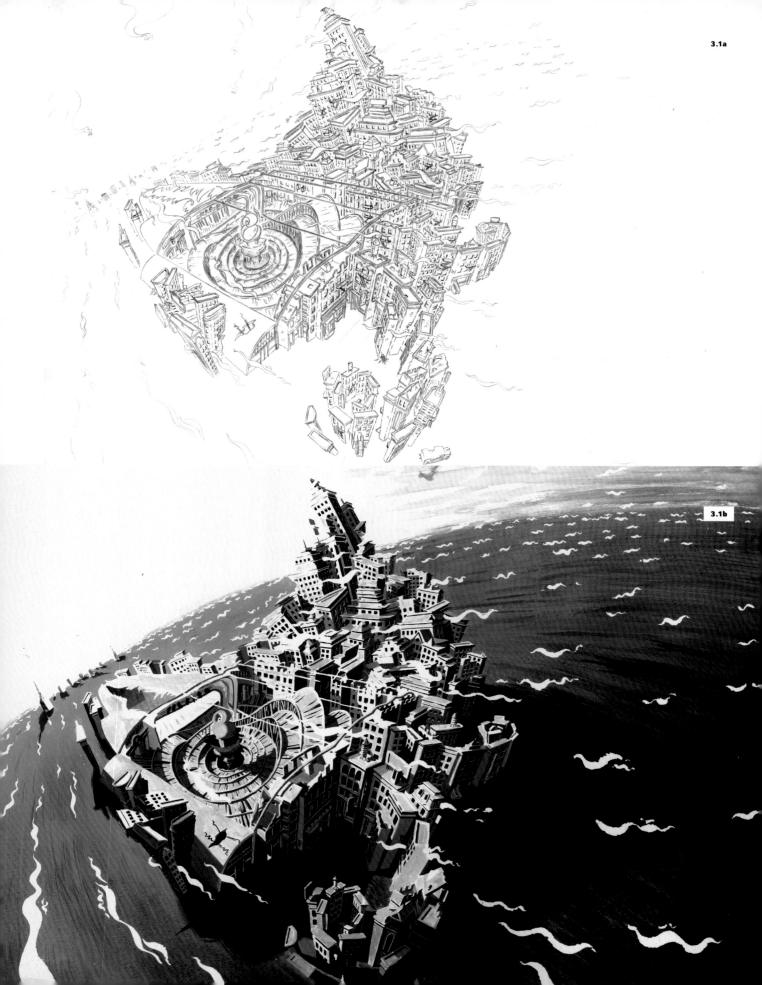

CHAPTER 3
SPACE

The overlapping perspectives of architecture envelop us in everyday life – the way space is designed impacts on our emotions and actions. So the choice to use an existing building or design from scratch will be partly based on how a building makes us feel and the possibilities of conveying that on screen, either through the way it is photographed or the manner in which the characters relate to it. It shapes our experience visually and psychologically, influencing how characters respond to their world and how we in turn relate to them.

Screen space can be closed in like a box, or opened up through architectural details such as ceiling height, shapes, angles, levels or layers. The designer organizes space and structures it according to key aspects of the visual concept. How characters move around within the space is equally designed, as PD Hugo Luczyc-Wyhowski says:

> It is crucially important when designing a room to interpret where the actors are going to be on the set. The designer has a way of manipulating that. You put a big table in the middle of the room or you make them go to the end of the room where the telephone is. Or you make them stand by a door where there's backlight.[1]

Filmmakers such as Terry Gilliam acknowledge that the architecture is as much a set of characters as those that speak and wear clothes. The sets represent ideas designed to visually support the profile and journey of the human characters. This chapter considers some of the ways in which spatial metaphors support concept on screen.

3.1
Castle sketch and gouache painting for *Jack and the Beanstalk* by Tom Turner, The National Film and Television School, UK. A project based on the fairy tale, but set in 1930s New York above the skyscrapers.

SPACE

In architecture, space is the void within a building to be moulded and defined. Spatial principles such as circulation, hierarchy, symmetry, geometry, balance, scale, proportion and contrast are considered and composed in relation to each other. How these architectural elements are arranged makes space memorable in connection to our imagination. The history of architecture indicates shifting fashions and priorities in the structure of space. Whether classical, art deco, Bauhaus or modernist architectures, proportions differ to create identifiable spatial relationships. Architecture is configured with key ideas and concerns of the period resulting in certain lines, shapes and materials predominating as a reflection of the times.

Shapes have symbolic meanings that conjure up concept. Lines, shapes, texture and pattern can be used in composing space to signify ideas. For example, one of the simplest elements of a composition is the line, and the direction it takes can change the intention of a space: vertical lines can indicate dignity, formality, strength or rigidity, while horizontal lines can suggest nature, balance and tranquillity. Shapes such as squares and rectangles emanate from the joining of these lines and have been used to connote the manufactured, as opposed to the natural world. Diagonal lines can signify movement and change, and can form triangular shapes that suggest power balance. Curved lines symbolize notions of nature, beauty and elegance. Taking the curved line further into the shape of a circle, it can be harnessed in relation to the concept of the life cycle and the universe. The illusion of three dimensions created through shadow suggests form, width and depth on the screen.

Notions of architectural space translate to the screen in many ways, with the exception that there is no actual depth on the screen only the illusion of form. The audience do not experience a space the way they would a real building (physically walking around it themselves), but through the way the characters interact which is expressed through the combination of design, photography and editing.

How compositional elements are organized within a frame can create a range of responses, from balance and harmony to discord and chaos. Sometimes a grid is used to divide space and position key lines and shapes to suggest depth, height, symmetry and so on. Wes Anderson and Peter Greenaway films use grids to create screen symmetry very deliberately and strategically, crafting a pictorial effect that embraces staging and the construction of the fiction itself.

Ideas of space become distilled in production design, as was illustrated during the Hollywood studio system in the concentrated shorthand used to suggest a place in relation to story and genre. It was here that a film rendering of a city or space becomes the archetype that the real places are subsequently measured against. This has been partly attributed to the condensing of key components of space and place by production designers, and the eradication of elements that do not tie in or contradict the key concept. Real places contain anomalies and details that cinematic spaces may not.

As illustrated by the statement in Chapter 2 regarding the authenticity of Paramount Paris over the real city. The studio construction condensed the visual iconography of Paris and created a version of the city that encapsulates a poetic cliche.[2]

The design process impacts on how we come to understand what spaces should look like; during the research stage the designer will refine and distil their findings accepting what works for the project and discarding contradictory styles or details. For example, Martin Childs says:

> For *Shakespeare In Love* (1998, John Madden, PD Martin Childs), I did tons of research into the Rose Theatre and found that a lot of the research conflicted. So again, I took the parts that I liked and the bit that applied to what I wanted to do and what the film needed. So you cherrypick the research until you build up the image that you want to convey. And that's the same for doing the homes of Queen Victoria, which I have done on two films.[3]

Character's homes provide a particularly good opportunity to reflect ideas, with home exteriors and interiors that communicate character through the geography of space. Revamping a space or recycling elements from a set build also begins to create a sense of familiarity with settings. This can be for budgetary reasons or aesthetics; for example, Martin Childs talks about a project where he used the same space for creative reasons:

> On this film [untitled project] we're going to be repeating the same space and sometimes repeating the same space in a slightly unfamiliar way. I will be designing these rooms in people's homes, which will be repeated but with slightly different details. Like differently proportioned doors or the mirror image of a set that you've become familiar with in one strand of the story.[4]

Childs' concept sprung from the fractured personality of the character in the story and his therefore unreliable recollection of place. Film space has a profound connection to the architecture of the mind and can be used in this way to provide insight both into an individual's interior world or into a wider collective consciousness.

REAL AND IMAGINED WORLDS

Stuart Craig points out the conflict that exists between the real world and the story world:

> In the real world there is too much conflicting information – every time you pick a real location you better make sure it's saying what you want it to say and you better try to eliminate anything extraneous, because the real world is confusing, it sends out conflicting signals all the time. The designer's job is to simplify down to the essentials and make its meaning absolutely clear.[5]

If using a real location, recces to possible places will consider the size and suitability of space and to what extent it reflects the concept in relation to dimensions, shapes, layers and other details. Often with the talented assistance of a location scout, existing places can be identified for filming purposes that tie in and enhance design intentions. At other times constructing a set in a studio is preferred (see Chapter 1 for practicalities around these choices) and increasingly, using software to digitally create a virtual space is another option. On some occasions all three of these will be combined – a real place with a partial set build further enhanced by computer-generated imagery. Screen space therefore doesn't just refer to a single space in time but can be a composite of several places that exist in real and digital spaces. These choices are part of the design process which encompasses different dimensions of real and imagined worlds that can be woven together to build innovative environments. When settings are designed from scratch they can be built with details that exactly correspond to the concept, from size and shape, to door and window position, scale and perspective.

PD Alex McDowell talks about 'world building' rather than 'set building', which he says relates more closely to the work of the production designer who visualizes a world for the story to take place in. In terms of style and genre, some spaces are necessarily tied to reality while others are fictional and therefore freer from the ties of verisimilitude.

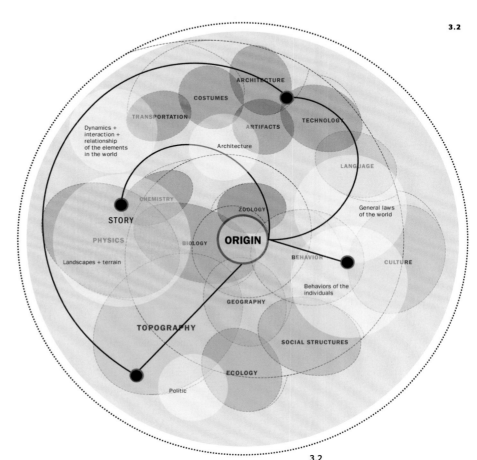

3.2

3.2
World building mandala. Alex McDowell captures the fluid and overlapping nature of a possible story space where the elements impact on each other and offer up multiple worlds in terms of values and underpinning ideology. This process allows the team to philosophize around how those worlds might be visualized.

CHAPTER THREE – SPACE

3.3

For *Man of Steel* (2013, Zak Snyder, PD Alex McDowell) the key to creating the other world on Krypton came from thinking about a society that was highly evolved in some respects, yet feudal in others. The distinctive design of Krypton became the absence of straight lines in favour of the curvilinear motifs of art nouveau inspired the shapes of every aspect of this world. Plant-like forms informed the shapes of rooms and props, spaceships, and even the Superman symbol S itself sculpted by a machine. This is a perfect expression of the notion of world building. Another world has been fashioned in space and time that takes elements from our world and adapts them to visually illustrate another society and the concepts that underpin it.

A designer can employ forced perspective which is an optical illusion that makes an object seem closer or further away or bigger or smaller than it is. As noted in the Introduction, German Expressionism used geometry to distort the perspective and reflect the inner turmoil of the characters and themes, filtering space in direct accordance with the emotional state of the subject and creating an innovative aesthetic. *The Cabinet of Dr Caligari* (1920, Robert Wiene) is one of the most striking examples of this: using painted views to distort the perspective as a reflection of the thematic distortion, and to create a disturbing claustrophobic world. The noir genre continued this technique, using angles and perspectives in expressionistic ways. Individual films such as *Edward Scissorhands* (1990, Tim Burton) and *Sweeney Todd* (2007, Tim Burton) have employed these more recently.

3.3
Krypton in *Man of Steel* (2013, Zak Snyder, PD Alex McDowell). McDowell fought to build most of Krypton, rather than have it created digitally. The majority of the sets up to 15 feet high are in camera; the actors thanked the Art Department for surrounding them with a physical environment instead of a green screen.

The intriguing perspectives of the paintings of M. C. Escher have informed screen environments as diverse as *Labyrinth* (1986, Jim Henson, Elliott Scott) and *Inception* (2010, Christopher Nolan, Guy Hendrix Dyas). Both films create other worlds that rely on a different set of physical principles, making Escher paintings a useful inspiration. Their colliding staircases contradict and physically disorientate, causing confusion and stimulating debate.

Architecture can be seen as a metaphor for the mind whereby mental characteristics are reflected in structures and mental contents are projected onto the physical world.[7]

The scale of the hotel in *The Shining* (1980, Stanley Kubrick, PD Roy Walker) accentuates the loneliness of the inhabitants, increasing their apparent vulnerability. The physical structure is fused with the father's dissolving mental state. For Jack Torrance, the empty isolated hotel represents a psychological projection of his psychosis, mirroring his emotional and creative sterility. The scale of space dwarfs the inhabitants and the physical distance imitates the emotional distance between the family members. The contrast in the enormity of the hotel and the small family unit creates a visually schizophrenic screen image.

In the three examples that follow, there are two spaces that co-exist – one is supposed to be real until a discovery is made that reveals another space, reality and truth. Character space is limited and the extent of the real world is concealed through the physical restriction of boundaries. The characters are confined by ideological structures that are reflected in their spatial containment.

3.4

3.4
Labyrinth (1986, Jim Henson, Elliott Scott). The Goblin King (David Bowie) occupies and appears to control his physical universe at the heart of the Escher inspired labyrinth.

"The entire spatial configuration of the hotel is a maze that cannot be visualized or conceived. In the incomprehensibility of its shape the labyrinth of Overlook resembles the library labyrinths in Umberto Eco's The Name of the Rose *and Jorge Luis Borges'* The Library of Babel. *And to complete the metaphor the film is the tragic story of a father who is gradually lost in the maze of his own disturbed mind.[6]"*

In *The Truman Show* (1998, Peter Weir, PD Dennis Gassner) the set maps out the story spatially. An insurance salesman discovers that his whole life is a television show. The space where Truman (Jim Carrey) lives – Seahaven – is a set, the physical boundary of which cannot be crossed by him otherwise the illusion would be shattered. Where the set ends, real life begins – the two distinct spaces represent different realities clearly in a simple metaphor. Truman attempts to cross the border on occasion and the television production crew mobilizes actors to prevent him from doing so. Finally, when Truman discovers the truth, he physically exits the studio construction through a door in the sky.

Similarly in *The Village* (2004, M. Night Shyamalan, PD Tom Foden), a distinct space is defined by the parameter of the wildlife area the group inhabit. What first appears to be an isolated nineteenth century Pennsylvanian village turns out to be a wildlife preserve where a small group of people have retreated after suffering trauma as a result of living in the contemporary urban world. The founding group keep the younger generation unaware of the outside world – a fear of mysterious creatures that live beyond their village helps maintain the demarcation and prevents the villagers from venturing too far from apparent safety. When the young blind girl Ivy goes on a mission to get medical supplies for an injured villager, we discover that the home established in the enclosure is an illusion invented for protection from the difficulties of the outside world.

Science fiction often uses space in a similar fashion using a boundary between two places as a metaphor to indicate the presence of other worlds and ideologies. *The Island* (2005, Michael Bay, PD Nigel Phelps) employs this idea in that the characters are actively trying to get to another place: the island is their reward if they win the competition. However, the island is imaginary – a construction to keep them in the facility as unwitting organ donors to 'real' people. In fact, Lincoln Six Echo (Ewan McGregor) and Jordan Two Delta (Scarlett Johansson) leave the confines of their space and enter the real world, discovering the truth that their lives are a facade. They enter a space between the two realities in the form of James McCord's work area (Steve Buscemi) which functions as a transitional place linking them to the real world and enabling their escape from their fabricated home.

These three films use contained space to physically limit and control the knowledge and perception of the characters (note Plato's allegory of the cave). *Total Recall* (1990, Paul Verhoeven, PD William Sandell) and *The Matrix* (1999, Wachowski brothers, PD Owen Paterson) are among other films that utilize similar false consciousness models.

Stock settings

Archetypal interiors that are a recurring feature in film and television include homes, bars, restaurants, nightclubs, offices, hotels, museums, prisons, shops and subways. Each of these has become a stock setting in itself, providing a shorthand for the genre and story type. Characters' home and office space can be designed to visually convey emotional and psychological details about the individual, whereas shared hotels can provide the wider environment of the film and a sense of the story world the characters inhabit. Museums, hotels and subway settings, for example, often act as a conduit for people with problems – thieves, tourists, the lonely, the confused, those in hiding, those searching or being searched for, fugitives, adulterers, spies, ghosts and aliens. These are all transitory settings where an unlikely combination of people occupy the same space, which provides rich potential for action and story. As such, these stock settings often feature on screen and accumulate to form a sense of expectation based on the moving image rather than the locations themselves.[8]

Further viewing for museums, subways and hotels on screen

Museums and art galleries

The Wakefield Case (1921, George Irving), *Blackmail* (1929, Alfred Hitchcock), *Bulldog Jack* (1935, Walter Forde), *Night of a Demon* (1957, Jacques Tourneur), *The Ipcress File* (1965, Sidney J. Furie), *The Day of The Jackal* (1973, Fred Zinnemann), *Maurice* (1987, Ivory), *The Mummy Returns* (2001, Stephen Sommers), *On The Town* (1949, Gene Kelly, Stanley Donen), *How to Steal A Million* (1966, William Wyler, PD Alexander Trauner), *The Thomas Crown Affair* (1968, Norman Jewison, AD Robert Boyle), *One of Our Dinosaurs is Missing* (1975, Robert Stevenson), *Manhattan* (1979, Woody Allen, PD Mel Bourne), *The Relic* (1997, Peter Hyams, PD James Murakami, Eric Orborn), *Russian Ark* (2002, Aleksandr Sokurov, AD Natalya Kochergina and Elena Zhukova), *Matchpoint* (2005, Woody Allen, PD Jim Clay), *Night at the Museum* (2006, Shawn Levy, PD Claude Pare).

Undergrounds/subways

Underground (1928, Anthony Asquith, AD Ian Campbell Gray), *Bulldog Jack* (1935, Walter Forde, AD Alfred Junge), *Passport to Pimlico* (1949, Henry Cornelius, AD Roy Oxley), *Saturday Night Fever* (1977, John Badham, PD Charles Bailey), *Subway* (1985, Luc Besson, PD Alexandre Trauner), *Sliding Doors* (1998, Peter Howitt, PD Maria Djurkovic).

Hotels

Grand Hotel (1932, Edmund Goudling, PD Cedric Gibbons), *Hollywood Hotel* (1937, Busby Berkeley, Robert Haas), *Vertigo* (1958, Alfred Hitchcock, PD Henry Bumstead, Hal Pereira), *Psycho* (1960, Alfred Hitchcock, PD Robert Clatworthy, Joseph Hurley), *Death in Venice* (1971, Luchino Visconti, Ferdinando Scarfiotti), *The Shining* (1980, Stanley Kubrick, PD Roy Walker), *A Room with a View* (1985, James Ivory, PD Brian Ackland Snow, Gianni Quaranta), *Mystery Train* (1989, Jim Jarmusch, PD Dan Bishop), *Pretty Woman* (1990, Garry Marshall, PD Albert Brenner), *Barton Fink*, (1991, Coen brothers, PD Dennis Gassner), *Dirty Pretty Things* (2002, Stephen Frears, PD Hugo Luczyc-Wyhowski), *Lost In Translation* (2003, Sofia Coppola, PD K. K. Barrett, Anne Ross), *The Grand Budapest Hotel* (2014, Wes Anderson, PD Adam Stockhausen).

SIZE AND SCALE

Models made to scale assist in providing a sense of three-dimensional space prior to building, saving time and money. 'I always make models – I worked in the theatre originally and they are very particular about their models. So I do them to scale in white card and they are a tremendous help.'[9]

Depending on what lens is going to be used to shoot the setting, the designer is able to calculate how much of the set will be in shot and therefore needs to be built. This will vary depending on the focal length of the lens but generally, the shorter the focal length, the wider the angle of view and the longer, the narrower. The angle used to subsequently shoot further affects audience perception.

PD Martin Childs says that decisions about the space are determined by long conversations with the director and the director of photography:

To reach a compromise, whereby you can fit the crew into the room but still have the room look the size as you meant it to be. You don't want to spend all the time taking down walls and putting them back, because it injures the set and it wastes time. The ideal is to create a set that can contain the cast and crew but still looks the size you want it to be. I don't know how, in *Vera Drake*, Mike Leigh and Eve Stewart between them managed to make the sets look absolutely the right size. Maybe it's because they are such tiny rooms they completely filled them with people.[10]

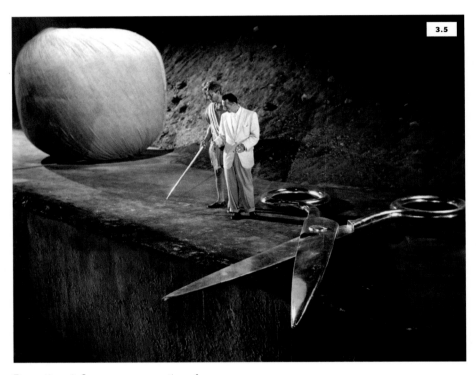

3.5

Proportions influence our perception of space deeply for example if elements are scaled up and enlarged, or scaled down and diminished, it impacts on our fundamental sense of where we are and why. PD Dante Ferretti has said that when researching a setting he looks at the real space and then makes it bigger. The simple act of enlarging the dimensions of a space will be influential in how it appears and communicates concept. For practical shooting space, making it bigger is often helpful and in dramatic terms it can amplify the connotations of that space. Large spaces can be associated with intimidating or formal settings such as churches, courtrooms, and arenas so by enlarging a particular space these notions can be attached. Conversely, condensed space can be suggestive of intimacy and reflect interior landscape and personality.

3.5
The Incredible Shrinking Man (1957, Jack Arnold). Size refers to the physical dimensions of an object. Scale is the relative size of objects to others.

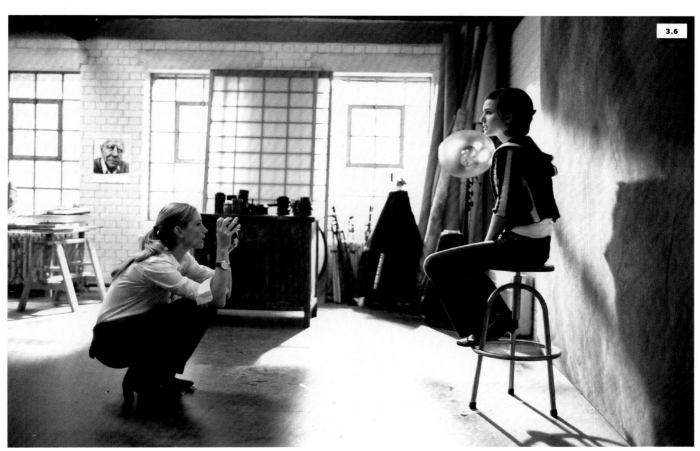

3.6

In *Closer* (2004, Mike Nichols, PD Tim Hatley), the relationships of two couples become complicated by an affair and deceit. The intimacy between the couples is reflected in the spaces they inhabit, which visually convey their story with simplicity. The two home environments use contrasting space to illustrate the distance between the characters inside and outside of their relationships. The scale of physical distance and the emotional distance between the characters becomes tangible. Gemma Jackson says:

With something like *Closer*, the monochromatic qualities of it and the spaces they have, like that big apartment where Clive Owen and Julia Roberts have their break-up scene, it's a big space, there was a lot of room and it was quite lonely and cold and the other two were in this tiny place. I thought it was beautiful, I really liked the structure of the space and how people used that space.[11]

3.6
Closer (2004, Mike Nichols, PD Tim Hatley). Anna (Julia Roberts) photographs Alice (Natalie Portman) in her studio. Photographer Anna lives and works in an expansive apartment, allowing physical distance between characters to reflect the emotional void between them.

GEOGRAPHY OF SPACE

The action in relation to space and movement around and between settings is considered carefully. PD Jim Bissell looks for what the action is going to be and how tension is created in the physical and psychological space:

> In each scene there's a bit of denouement where the scene pays off in terms of that part of the story that forwards the overall narrative. There are a number of different images, and my job is to make a geography in which all of those images can take place. I'll make sure the key imagery of a set is agreed on with the director, DP, producer and writer. If it's the entrance of a character or a final confrontation I'll do that. I will do that same scene from a wider perspective and show how the set can support the narrative in terms of creating a space where this actually takes place.[12]

The audience becomes familiar with the set when it is used consistently, gaining an awareness of the geography of the space, understanding how the different rooms link together. A pattern or rhythm can be built up through recognition, which can be effective in itself or used to highlight a point when it is broken.[13]

In *Fight Club* (1999, David Fincher, PD Alex McDowell), the house the key characters move into during the fight club phase provides a fascinating and multi-faceted example of space as character. The house was built in a real place, as opposed to a studio back lot and had to work as a device to enable the narrative to operate. The backstory for the house was devised through the design process to the extent that the team knew when it was built, what sort of people had lived there, and how many different occupants there had been prior to Tyler Durden (Brad Pitt) and the narrator (Edward Norton) moving in. This meant that for the interior, different structural developments such as multiple staircases followed a logic that reflected the history of the house. The house is in a dilapidated state when Tyler (Brad and alter-ego Edward) moves in – a metaphor for his interior landscape. The facade of normality and convention represented in his home at the beginning of the film – a generic, sterile apartment filled with Ikea furniture – is destroyed as he breaks out of his conventional lifestyle and false consciousness to embark on an exploration of his subconscious. The concept for his original home contrasts strongly with the subsequent home and follows the transformation of character from a uniform wage slave living within the boundaries of conventional society to a complex fractured personality. The house for fight club uses space as character and enables the split personality premise to work. Revealed as the film goes on, Tyler (Brad Pitt) is not another person as initially seems to be the case but is actually the narrator's (Edward Norton) alter-ego – he appears to enable Tyler's rebellion and embodies everything he is not. The illusion that this is two distinct characters is created through the design of the house, and in particular the movement around it via an eccentric combination of staircases and doorways that supports and allows the continued sense that two separate people live there.

Gemma Jackson designed Bridget Jones' home with the connection between the different rooms as an integral part of the space – devised for functional and conceptual effect. 'You were supposed to be able to look from the living room through to the bedroom and to see her whole world more or less. You can be theoretical, but it doesn't really work, it has to be a physical thing, it has to work.'[14] This connectedness can help support design in visualizing the character movement. However the concept didn't make it into the film. As this example indicates though, important elements of the design can often be neglected or rejected for practical or technical reasons.

Dr Strangelove: Or How I Learned to Stop Worrying and Love the Bomb (1964, Stanley Kubrick, PD Ken Adam) uses a limited number of settings with the war room acting as a metaphor for power, fear and corruption. The angles of the set enclose the characters in an environment that is supposed to be safe but feels hostile and prison-like. The imbalance between the compositional lines and shapes reflects the conflict. Bold shapes make up the space in the form of the circles of the table and the pool of light. The key image is concentrated in the triangular shape of the space, a shape suggestive of authority, religion and hierarchical structures. The angles of the room are diagonal, creating a dynamic energy and atmosphere. The floor is dark and lit with hard light to reflect a cold intensity. The ring of light is suspended above the table, creating a halo effect floating above the scene, later echoed in the circle of the atomic bomb as it explodes and destroys the world. These simple shapes form a concentrated image and a potent metaphor as the world leaders who sit beneath, lit by its glow, are ideologically responsible for the subsequent destruction. Adam's process has been documented and described by several writers – some of whom are detailed at the end of this chapter.

The war room takes up the metaphor of the cave, but inverts its positive connotations. The protective cave becomes a place of horror, of de-individualization: the incubator of a megalomaniac craze that destroys mankind.[15]

For *Good Night and Good Luck* (2005,

George Clooney, PD Jim Bissell), the visual concept was to show journalism evolving in an environment that was freely mixed with entertainment and a corporate structure. The nature of journalism and entertainment in one space creates conflict around clashing agendas and sensibilities. Jim Bissell explains the way tension was created in the set to support the story and visual concept:

> George [Clooney] didn't want to do the movie in a series of cuts, he wanted to be able to get energy into the performance by chasing the actors around with the camera, and he wanted a lot of freedom so that meant the set had to be relatively modular but always offer up the big idea. It was one principal set – and we used lots of wonderful tricks like little L-shaped sets shot at a rake angle and you just have a backing wall in or put a mirror in the set and simply have a wall in the mirror that makes you feel like you're in a bigger space.

Bissell used one small key set and lots of clever spatial tricks to suggest a large intimidating space where employees are part of the corporate machine rather than significant individuals.

> The beginning when the two characters come from the lobby and into the elevator – that's a very big shot and it really says everything – you're in a big corporation – you are going to a very small portion of the corporation and it's all laid out in a big way that opens up the movie. It's a teeny little set, one of those scenes where the end corridor that they walk towards to have a confrontation with the president of CBS was redressed as the lobby.

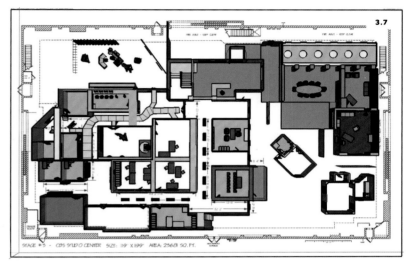

3.7

> When they got into the elevator it was on a rotating platform on a turntable and then you went to another opening door and you thought you'd got out of another door and I actually used an existing part of the soundstage that was built in 1942. It felt huge with a minimal amount of construction.[16]

In *The Terminal* (2004, Steven Spielberg, PD Alex McDowell) space is also used to delineate the story world effectively. In this example, the character's problematic identity/nationality is visualized through being stuck physically in the airport terminal. Due to changes in his national status that occurred during his flight, he is unable to go back to his country or forward into another. Viktor Navorski (Tom Hanks) is stuck inside the terminal which acts as a liminal space – a border he cannot cross – between two places. His limited spatial possibilities physically illustrate his problematic national status and ambiguous identity.

3.7
Good Night and Good Luck (2005, George Clooney, PD Jim Bissell). Floor plan for CBS studio centre. Low-budget film, £7.5 million all in. Bissell designed the space to illustrate the ideological collision between corporate power and journalistic enterprise.

Divisions and layers

Space can be divided in the foreground vertically or horizontally to enhance ideas in the script. For example, in the foreground of *Notting Hill* (1999, Roger Michell, PD Stuart Craig), the entrance appears to be cut in half down the middle to represent William Thacker's (Hugh Grant) half-life as a divorcee. The kitchen on the left and the stairs on the right create two vertical slices within the space. Spatial divisions like this also operate from the front to the back of the screen. As PD Hugo Luczyc-Wyhowski indicates, the depth in his designs is crucial; for example, the importance of the glass partition in *Nil by Mouth* (1997, Gary Oldman): 'It became the focus of the whole thing and it was obviously a symbol for the partition between the characters and a metaphor for the whole film.'[17]

Space is sliced horizontally to support the concept of a moral hierarchy in *Shallow Grave* (1994, Danny Boyle, PD Kave Quinn). When three friends find their new flatmate dead, the fact he has lots of cash on him divides opinion as to what to do with the corpse. The attic space above the living room becomes a refuge – inhabited by the flatmate David (Christopher Ecclestone) – who doesn't agree with the plans of the other occupants, Juliet and Alex (Kerry Fox and Ewan McGregor), to steal the money and dispose of the body. The occupation of the space above the main living room physically raises him above the characters who are behaving in a morally questionable manner.

Settings are sometimes shown as slices through a whole house; for example, in *Delicatessen* (1991, Jean-Pierre Jeunet and Marc Caro), we see above and below, and to the right and the left of different separate rooms. We are given a privileged view in this way, seeing through walls and the arbitrary nature of what separates people. The Brown family home in *Paddington* (2014, Paul King, PD Gary Williamson) is presented like a dolls' house: featuring camera moves between floors cutting through walls and ceilings, suggesting that the structure need not confine the characters to convention. As an alienation technique that shows the audience the constructed nature of the setting, we are reminded that these are characters in a story. The mobile camera passes easily through boundaries, which suggests both containment and freedom. Characters are boxed in by convention while this effect reveals it to be merely another social construction – an illusion and a boundary that can be transgressed.

Height

The height of ceilings is something often unseen in film and TV, as studio construction may not include a ceiling in order to enable flexible shooting angles. However, the spatial distance between floor and ceiling is indicated even when unseen, through the head height and other proportions. Low ceilings will often create a closed-in environment that can be used to signify a cosy, homely dwelling or a deprived and depressing hovel. Where the interior is in relation to the exterior building – for example, a penthouse apartment or a basement flat – is also used to suggest and support the concept.

Martin Childs says it can be useful to actually build the space at a height rather than fake it in post-production. For example, on *Shakespeare in Love* (1998, John Madden), the intention was to have Shakespeare's bedroom up high to tie in with romantic notions of the creative writer in an attic:

> It was a garret with a high up bed and was designed to go with the romantic idea of the artist's garret, and the child in the audience that would say: 'I'd love to have a bedroom like that', even though at home they've got a much nicer bedroom with a bigger bed in it. It's the sort of romantic idea of the creative bedroom, and you have to, in a sense, embrace the cliché and then turn it into something that isn't a cliché. Not just for practical reasons, but to get the idea of it being at the top of a building in somebody's head, is to put it up on a rostrum and keep the camera down low. That way you feel more as if you are in a 'garrety' space. And I think in giving the actors a sense of it, it's still important for that room to be as high as you can possibly make it, in order to remind people of what it is.[18]

VERTICAL HIERARCHY

The spaces in the examples that follow are layered according to a system of stratification where physical situation is a reflection of notions such as status, power and ideological position.

The space in *Minority Report* (2002, Steven Spielberg, PD Alex McDowell), was created before the script was complete. The geography of the environment was designed according to the premise of the film, which was built on the idea of an apparently utopian future but with sinister undertones. In the year 2054 crime is prevented by 'pre-cogs' who send officers to arrest murderers before their crime is committed. The flaws in the system are uncovered when officer John Anderton

(Tom Cruise) is arrested for a future murder. The PD built a world based on research around how urban planning might respond to such a scenario, which included a spatial concept that echoes *Blade Runner* (1982, Ridley Scott) in its vertical hierarchy (also based on the Philip K. Dick story *Do Androids Dream of Electric Sheep?*). In this world, the privileged live at the heights, while the underclass inhabit the ground level.

'London Below' and 'London Above' symbolise similar notions of social status attached to those positioned at a physical height. Dan Fishburn chose to design the setting of the labyrinth from the book *Neverwhere* by Neil Gaiman:

In 'London Below' the familiar names of London all take on new significance, a parallel world in and beneath the sewers. Its inhabitants include the homeless and people from other times, such as Roman legionnaires and medieval monks as well as fantastical characters.

3.8
Dan Fishburn, student on the BA in TV and Film Set Design (Cardiff School of Creative and Cultural Industries, University of South Wales) created the design for the TV series *Neverwhere* (1996, Dewi Humphreys), written by Neil Gaiman. The story follows the character Richard into 'London Below' whose inhabitants are largely invisible to the people of 'London Above'.

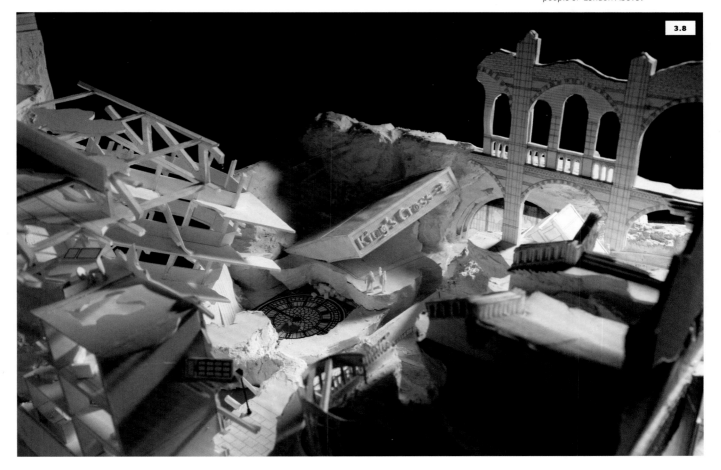

3.8

Other locations in the book are connected through name to 'London Above', the labyrinth is where physical pieces of London as we know it have fallen through to form a confusing environment that the main group of characters must journey through.[19]

The iconic London landmarks have been appropriated to create an imaginary space beneath the real streets of London.

> I wanted to create a set that had all these different pieces of recognizable London in one space that are interconnected to provide the characters with an adventurous and challenging setting.[20]

Familiar locations from New York city were transported to a place above the city in the next example. Tom Turner, on a paper-based project for *Jack and the Beanstalk* at the National Film and Television School (UK), worked on the spatial composition through scale drawings, illustrations, paintings and model-making. The idea is that the giant is an imaginary creature created by Jack, living in the clouds above New York, stealing people's homes. Set in the Great Depression of the 1930s (when a lot of people lost their homes), Jack's family has to move to Hooverville (a shanty town for homeless people.)

The photos of the model and the technical drawing are of the giant's castle in the sky (floating above the Statue of Liberty, with the torch poking out in the middle). The walls around the castle have been made from buildings the giant has stolen. The floor looks like a crazy roller-coaster like something based on the layout of Coney Island. Tom says: 'I tried to design everything to look like they came from existing things in New York, but distorted in a way which may look like it belongs in someone's imagination. Also the roof of the castle is based on a train station roof the giant has stolen.' Both of these concepts rely on audience recognition of landmarks in London and New York to add potency to place.[21]

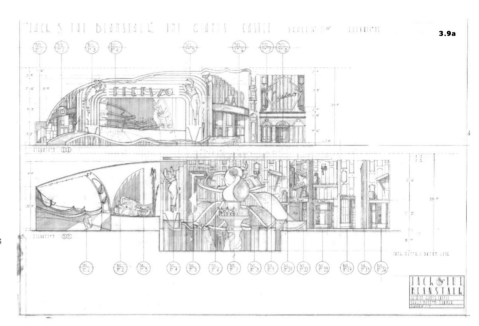

3.9a

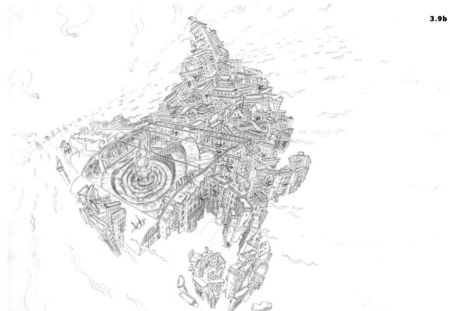

3.9b

3.9a
Elevations for *Jack and the Beanstalk*, paper-based project, by Tom Turner.

3.9b
Castle sketch, *Jack and the Beanstalk*, paper-based project by Tom Turner.

3.9c
Gouache painting, *Jack and the Beanstalk* by Tom Turner. A project based on the fairy tale, but set in 1930s New York above the skyscrapers.

3.9d
Tom's artwork follows the design process through with his sketches of place being plotted into technical drawings that translate initial ideas into real dimensions, followed by the building of a scale model of the setting. The creation of a three-dimensional model helps visualize the space in terms of size, scale and action.

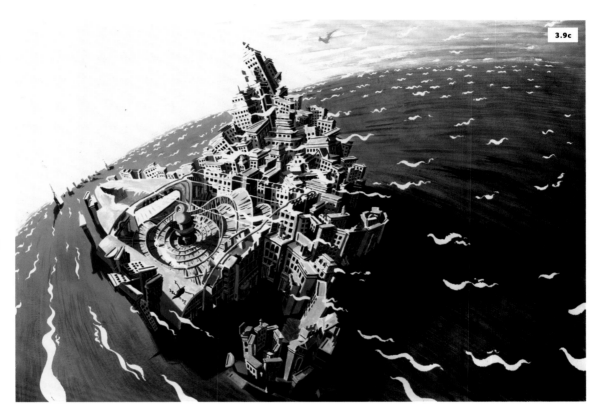

3.9c

3.9d

INTERVIEW WITH ALEX MCDOWELL

Alex McDowell has worked as a production designer with David Fincher, Steven Spielberg, Terry Gilliam and Anthony Minghella. He is now working as Professor of Practice at the USC School of Cinematic Arts and says what he teaches now is a holistic approach – trying to rethink design and narrative style.

How would you describe the overarching concept for *Minority Report*?

The first meeting with the director is the thing that triggers and shapes everything, as they are fresh and they have a sense of what they want. When I first met with Stephen Spielberg – before there was any script he launched me with the broad concept. We knew the setting was Washington DC in 2050 and that he did not want it to be a science fiction film – we called the approach to the vision for the film 'future reality'.

So for me it was how you envision a world in 2050 realistically: how do you frame it within the idea of extrapolating forward from the present rather than a blue sky science fiction kind of approach. And if within this realistic future there is a central disrupter, which is the pre-cogs and the idea of precognition, how do you launch a world that way?

We imagined that the pre cogs had a limited range of influence, say 50 miles and that because DC is the only place in the world that they are working there would be a vast inflow of people into the Washington DC area.

The first discussion was around what Steven wanted to establish philosophically. He wanted to lull the audience into a false sense of security – that the world was benign and not dystopic – a world that's working with pre-cogs functioning, so he could pull the rug out from under us when we realize that this is actually a loss of civil liberty. He wanted it to be grounded in a world we could understand because he wanted it to be a possible conceivable future.

There wasn't a script (based on the Philip K. Dick novel) – So we didn't have that traditional framework where you spend the next few weeks breaking it down and turning it into categories for research. The writer and I started on the same day and we knew it would be six months before there was a script and that we would be collaborating on the way the narrative would evolve.

We started a very different research process, very rigorous, we started developing what our sense of the world might look like in the future, social planning, vehicles, transportation, etc. Steven convened this think tank with a group of ten domain experts, people coming from the real world. Gathering these futurists and the serious idea that the world had to reflect a future reality our process was research first. Then we were sketching a lot broader view of the world – what it might look like architecturally and the position of the new city in relation to traditional DC. DC is zoned so you can't ever build higher than the capital building.

How did you begin to visualize the notion of space in the film?

One of the early ideas was that it was a mall city, a kind of connected city of malls: habitation and retail and schooling and sports and a whole infrastructure. So we were doing a lot of work in illustration and in compositing research. At the start of the film, I hired the first digital artist on this film and there were none – so we did have pre-vis illustration. We were 100 per cent digital using CAD, Maya [computer animation software] – we also hired from architecture and worked with Frank Gehry's office to bring architects in who we had to get into the union.

Did you look at other films with a futuristic vision as part of the process?

I'd say we didn't – I don't think I reference movies very much in my work unless it's important to the director because my background is as a painter. I think I'm more interested in the plasticity of space if you like. I moved my thinking from 2D with painting and graphics into space fairly quickly when I started doing music videos in the early 1980s. Then I got really interested in the relationship between a viewpoint or a camera in space and what that plasticity of space was capable of doing in terms of narrative.

3.10a

3.10a
Minority Report (2002, Steven Spielberg, PD Alex McDowell). A shot taken from the film's vertical car chase.

Can you give examples of how you used space to convey story and character?

The areas we spent the most time thinking about were: space as a framework for narrative – the city itself – at a large scale; the vertical city and the horizontal structure above to think about a graphic sense of a stratified society; the idea that the upper city would cut out light from the lower city and it would technologically track its population – wherever you go the city knows where you are – so there's a security system in place.

We spent a lot of time thinking about the future of advertising and targeted advertising. Instead of a government surveillance system the police would tap into a consumer tracking system in order to conduct surveillance, which became a big narrative piece.

Anderton (Tom Cruise) only gets to escape because he goes from the upper city, where he is completely surveilled all the time and every billboard knows who he is, to the lower city where those tracking systems are not in place because it's not a sophisticated retail consumer space. So that masking of the light of the lower city from the upper city gave us the opportunity to look at the vertical space as a narrative space. The vertical car chase, the way he escapes, pushed the development of a new kind of vehicle, a car that would move vertically and horizontally. A combination of an elevator and a driverless car led to a vertical car chase becoming a big scripted moment.

I've referenced this a lot because it made me realize that the world could propagate narrative. The vertical car chase would never have existed if it hadn't been part of a design iteration of the narrative space. The car itself evolved out of the needs of the world and gave Steven and Scott Frank [screenwriter]

an opportunity for a specific piece of narrative that they could attach to that. The sort of sculptural evolution of the city allowed for the vertical narrative and then became the driver of where he used to be and where he has to go and how he escapes.

Did you actively look for the contrast that's there between the upper and the lower city or did that evolve from the narrative more organically?

It's probably a little bit of both. What we imagined was that they'd built the new city on top of the old city, and so the conditions of the architecture, the style and the function of the architecture would be driven by what was old and what was new to an extent.

There's this layer of technology that's been imposed on the old architecture but the old architecture remains in place. That was a simple idea but a sort of revelation. When you're thinking about future-facing films you rarely see old architecture but we live among architecture that's three and four hundred years old (not so much in LA). There's a scale of evolution – large buildings aren't going to go away just because we are twenty years in the future, and there's a sliding scale of the smallest thing like a mobile phone changing the most rapidly.

So you could imagine this kind of imposed modernity or future technology but it's woven through a traditional landscape. That was the push and pull of the world space and some of that drove narrative and some of it was context.

The other end of the scale of [three-dimensional] sculptural space – narrative space – was the pre-cog chamber so we did a similar thing inside out; we said pre-crime is set in a traditional part of DC but it's a carved out piece of modern architecture. The structure of pre-crime represents the entire narrative – the plan view of pre-crime has the pre-cog chamber, this kind of black egg shape that's hanging in space. Metaphorically it says it's all in plain view but it's also a completely closed space that nobody has access to, so it's a secret in the centre of this open space.

It has the appearance of nothing to hide. The floors are a spiral and each of the floors is at a different level, so there's very little familiar stratification. It looks like an integrated system. We did elaborate architectural solutions to having no vertical walls in the space at all.

If you look at the plan of it it's like a pebble dropped in water, and that's the idea, that the pre-cogs trigger narrative and that narrative ripples through the secret hidden in the centre of pre-crime. The water is a really powerful component because the pre-cogs' mother is actually drowned in water (and the truth is later revealed through water).

That led to the idea of the surface of the inside of the pre-cog chamber also being an elaborate series of ripples coming from three points, so we mapped a flat plan of the three pre-cogs as trigger points for waveforms and then we turned that into a 3D model and those three waves became sculpted ripples and they each intersected, but they were wrapped around an asymmetric egg shape in the interior. So you get this elaborate pattern that comes from the intersection of three points of origin of a waveform that is happening on a 3D interior surface that is non symmetrical. So it was very much a scientific mapping of a philosophical approach to narrative, and how you would visualize narrative in plastic space and capture it as a sculptural element.

That must be very satisfying to have crafted such an effective visual metaphor for concept and story.

Yes, it's layers and layers. The shot I'm really happy with is when they first enter the pre-cog chamber and you understand that it's a continuous space from the viewing chamber down the spiral ramp and into the pre-cog chamber itself. That was a very complex set, 360 degrees, one set wrapped around another set. Very hard to light, very hard to film!

We built big sections that could be pulled out, but it was designed to be a continuous spiral space – a mirror reflection of the very bright light spirals on the other side of the pre-crime architecture.

So we spent months and months working on the narrative, the philosophical effects of the narrative on the architecture, and then how you would design it, what tools were needed to take mathematical waveforms and turn them into sculpture,

3.10b
Minority Report (2002, Steven Spielberg, PD Alex McDowell). Pre-crime plan view, the transparent centre of the Pre crime design suggests there is nothing to hide before the flaws in the system become apparent.

and how we would physically print it. So we spent a lot of time researching rapid prototyping, CNC fabrication (which was just beginning to be used in architecture), and we cut foam directly. The waffle pattern on the walls comes from the maximum size that the machines could cut, which was what defined the lines of the grid. And layered on top of that was a lot of science. So Neil Gershenfeld [MIT Professor] hypothesised that pre-cognition could be solved by quantum physics – there's a theory that two events can happen simultaneously in different places and that they're interconnected – so the idea was that an event could be triggered at a distance in time.

There is some version of science in there that came from quantum physics and the way you would try and get images out of the brain. Although they think we're fifty years away from being able to do that, but here was the real science behind it – the optical system. So the set-up being in liquid and the headgear that they had and the surface inside of the egg were all being driven by the narrative, about how you extract imagery from someone's brain and how you reduce noise, so it was like a sound chamber for the brain, which was the visual idea.

3.10c
Minority Report (2002, Steven Spielberg, PD Alex McDowell). Pre-cog chamber interior. For this setting the visual idea was a sound chamber for the brain.

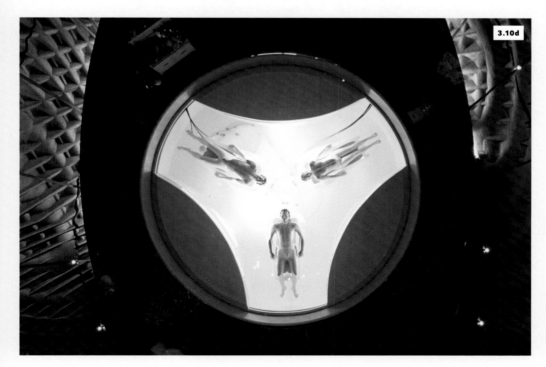

3.10d
Minority Report (2002, Steven Spielberg, PD Alex McDowell). Pre-cog chamber interior from above. The mapping of a philosophical approach to narrative, visualized in space.

Exercises

1. Sketch the room you are in – including windows, doors and other details. Describe the room – what ideas does it suggest?

2. Take measurements and draft scale drawings either by hand or using software (e.g. Sketch Up or CAD) of the room.

3. Watch the films mentioned in this chapter – make notes on the use of space in relation to geography of space, height, divisions and layers, shapes, angles, size and scale.

4. Consider the *Clay* script in the Appendix and choose one of the key interior settings to design.

5. Create a floor plan for one of the key spaces in the script, by hand or using a software programme such as Sketch Up, CAD or similar.

6. You could also try building a scale model of the space to see how it will look, feel and function as a three-dimensional space.

Further Reading

Affron, Charles and Affron, Mirella Jona. *Sets in Motion*. New Brunswick: Rutgers University Press, 1995.

Bachelard, Gaston. *The Poetics of Space*. Boston: Beacon Press, 1964.

Ching, Francis D. K. *Architecture: Form, Space & Order*. 3rd edn. Hoboken: John Wiley & Sons, 2007.

Eisner, Lotte. *The Haunted Screen. Expressionism in the German Cinema and the Influence of Max Reinhardt*. London: Secker & Warburg, 1973.

Frayling, Christopher. *Ken Adam Designs the Movies: James Bond and Beyond*. London: Thames & Hudson, 2008.

Hars-Tschachotin, Boris. 'Superpower Paranoia Expressed in Space'. *Kinematograph: Stanley Kubrick* 20 (2004): 84.

Jacobs, Steven. *The Wrong House: The Architecture of Alfred Hitchcock*. Rotterdam: NAI010 Publishers, 2013.

Ludi, Heidi. *Movie Worlds: Production Design in Film*. Stuttgart: Menges, 2000.

Neumann, Dietrich. *Film Architecture from Metropolis to Blade Runner*. Munich: Prestel, 1997.

Pallasmaa, Juhani. 'Monster in the Maze: The Architecture of The Shining'. *Kinematograph: Stanley Kubrick* 20 (2004) 199–207.

Schaal, Hans Dieter. *Learning from Hollywood: Architecture and Film*. 2nd edn. Stuttgart: Axel Menges, 2009.

Shiel, Mark. *Art Direction and Production Design*. New Brunswick: Rutgers University Press, 2015.

Sylvester, David. *Moonraker, Strangelove and Other Celluloid Dreams: The Visionary Art of Ken Adam*. London: Serpentine Gallery, 2000.

Notes

1 Hugo Luczyc-Wyhowski, author interview, 2004.
2 David Sylvester, 45.
3 Martin Childs, author interview, 2005.
4 Martin Childs, author interview, 2005.
5 Stuart Craig, author interview, 2000.
6 Juhani Pallasmaa, 199.
7 Juhani Pallasmaa, 202.
8 'Gibbons advocated the use of standing sets for trains, hotel suites and dining rooms, lobbies and offices, which could be modified slightly from film to film.' (Mark Shiel, 60).
9 Gemma Jackson, author interview, 2005.
10 Martin Childs, author interview, 2005.
11 Gemma Jackson, author interview, 2005.
12 Jim Bissell, author interview, 2015.
13 Charles Affron and Mirella Jona Affron.
14 Gemma Jackson, author interview, 2005.
15 Boris Hars-Tschachotin, 84.
16 Jim Bissell, author interview, 2015.
17 Hugo Luczyc-Wyhowski, author interview, 2004.
18 Martin Childs, author interview, 2005.
19 Dan Fishburn, author interview, 2015.
20 Dan Fishburn, author interview, 2015.
21 Tom Turner, author interview, 2015.

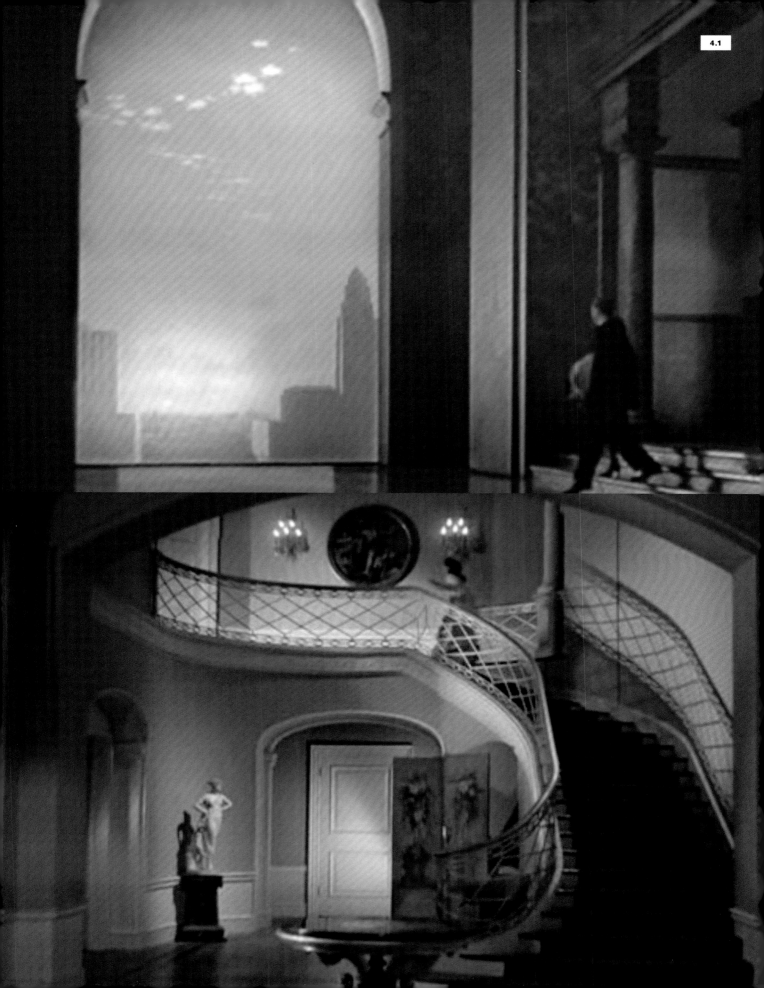

CHAPTER 4
IN AND OUT: BOUNDARIES AND TRANSITIONS

How characters enter and exit settings is designed with great care and attention. Whether it is through a columned doorway in *Notting Hill* (1999, Roger Michell, PD Stuart Craig), a decrepit stairwell in *Nil by Mouth* (1997, Gary Oldman, PD Hugo Luczyc-Wyhowski) or an urban fairy-tale turret in *Bridget Jones's Diary* (2001, Sharon Maguire, PD Gemma Jackson), these all impact on our sense of character and story. This is one of the techniques a PD has for building the visual concept. The way a character interacts with their environment will help set up and situate the drama that follows. This can become even more potent if it is how we are initially introduced to a character or a recurring entrance or exit point. In domestic settings it is doorways that are often the portal between different ideas in a film. The size, shape, material and design of the door will change our perception of place and character very quickly. Theorists agree that decor 'speaks', paraphrasing the narrative's concerns and architecturally reflecting the emotions and mental states of the individuals inhabiting it.[1]

The connection between the interior and exterior is deliberately designed to suggest and enhance narrative and character detail. Often an exterior will be shot somewhere completely different to the interior so how this is stitched together creates different effects. US sitcoms have a long tradition of using a cursory exterior establishing shot to set the scene, without any attempt to disguise the fact it is somewhere entirely different to the studio-built interior – for example, *Frasier* (1993–2004), *Cheers* (1982–1993) and *Friends* (1994–2004). Whereas in *About a Boy* (2002, Chris Weitz and Paul Weitz) and *Bridget Jones's Diary* (2001, Sharon Maguire), the interiors are studio-built and the exteriors use two distinctive areas of London, Clerkenwell and Borough Market, to situate the characters emotionally.

4.1
Mildred Pierce (1945, Michael Curtiz, PD Anton Grot and Bertram Tuttle). Mildred's journey is visualised through the transitions and boundaries of the setting.

IN AND OUT

For *Notting Hill* (1999, Roger Michell, PD Stuart Craig) the home interior of the character William (Hugh Grant) was a set build, but the exterior blue columned doorway was a real location – it was the real exterior that caused audiences to question the verisimilitude of place. Criticised as being too grand for the character who was supposed to reside there, this exemplifies the way in which the real world can disrupt the construction of place – as it includes contradictory information that is not all deliberately designed in the service of the story. It illustrates the importance of thresholds – doorways in particular – as transition points that cohere with the visual concept.

In *Bridget Jones's Diary* (2001, Sharon Maguire, PD Gemma Jackson), in the exterior establishing shot of Bridget's home above the Globe pub in London's Borough Market, a railway bridge cuts across at the top, and roads on either side create a moat effect. PD Gemma Jackson found the location and chose it for its fairy-tale-like qualities. The studio-built interior was designed with two flights of stairs wedged between the railway bridge and the pub for Bridget to get up to her front door. Once inside, the attic angles continue the turret theme. According to Jackson, where the character is in space and how they are designed to move around that, is fundamental to her concept. The notion of the in and out is equally applicable within a setting – the way movement and staging is designed from one room to another is a transition point.

As PD Gemma Jackson says:

> I think about light but I think very much about how to get people from A to B. How to get people to arrive at a good place. That's from my theatre training, getting actors to arrive in the middle of the stage. I think an awful lot about the movement. On the built set of the house in *Iris*, I put a door in-between the kitchen and the living room, which was absolutely tantamount because it provided a lovely transition. Movement first, light second.[2]

Student Amy Smith created designs for *Sabriel*, a fantasy novel by Garth Nix (the Abhorsen trilogy) that amplify notions of movement. Amy says:

> The story follows Sabriel, a young girl attending Wyverly College in the fictional country of Ancelstierre. She undertakes a dangerous journey reaching the safety of Abhorsen's house. The house is perched on an island on the edge of a mighty waterfall, a series of deadly stepping stones cross the river to the house which is protected by old magic, and characterized in the novel by its terracotta roof and pencil-like tower.[3]

The book is set in a fantasy world, which Amy was able to reflect in her concept for the Abhorsen house. One of the key features of the design is the interior–exterior connection – how the building is linked to the landscape suggests harmony and balance with nature.

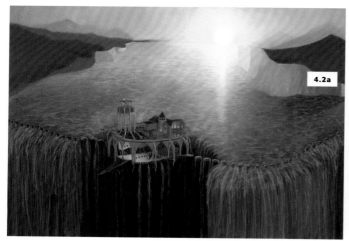

4.2a
Abhorsen's house (Amy Smith), TV and Film Set Design, University of South Wales. Perched on the precipice of a waterfall the structures open fluid design is in harmony with nature.

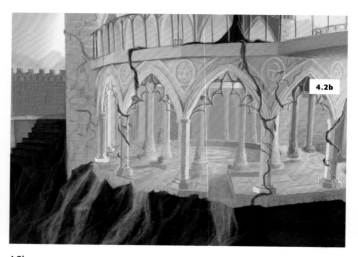

4.2b
The bathhouse and tower are two important elements in my design and both used for significant scenes. The bathhouse was an element I wanted to elaborate on more in my design. It is where Sabriel is bathed by a servant which has a ritualistic feel about it. I have designed it to flow seamlessly into the natural environment, without restriction from walls; the water from the bath is able to flow outside into the water garden. The bathhouse (Amy Smith), TV and Film Set Design, University of South Wales.

I began researching styles of architecture. My main influences originated from Roman Villas, Japanese architecture, and inspiration from artist Edward James whose work I have always admired. His sculptures in Las Pozas [Mexico] and West Dean [West Sussex, UK] in particular embrace the idea of inside/outside spaces, which is what I wanted to reflect in my design. Abhorsen's house is portrayed as a place of safety and wellbeing, the gardens have an almost idyllic feel, and so I intended to create a structure that harmonizes with the natural environment around it.

Because the water plays a significant role in this set, I chose to bring it inside the walls of the island. The book describes Abhorsen's house as having an orchard and large garden, but I wanted to evolve that idea and create a space that relates to the river and its surroundings, so I brought the element of water and stepping stones into the garden. This would be a tanked set filmed in a studio. The river and rock below the studio floor would also be CGI.

I began with the structure of the island, described as having castle-like walls protecting it; however, I didn't want to enclose the design behind towering walls, and instead created the pillared perimeter surrounding it, giving the feel of a protective structure that still embraces the use of space and flow. Amy's concept heightens the magical nature of the material with an open structure that enables flow and circualtion between the interior and exterior. The gravity defying design enhances the notion of a powerful and enduring force.

The tower is used for a number of scenes. Below it lies an icy dungeon where Sabriel casts a spell to summon a tidal wave. In my design I have added green screen at the base of the tower so the spiral stairs can be continued deep into the ground in post editing. The top of the tower houses the observatory where Sabriel climbs to watch the tidal wave destroy the creatures invading the house. I continued the theme of inside/outside space in the tower, much like the bathhouse. I have used decorative pillars to serve as walls, creating a whimsical and flowing space.

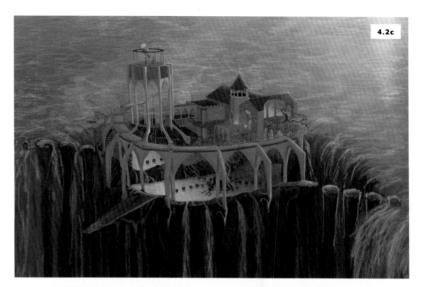

4.2c

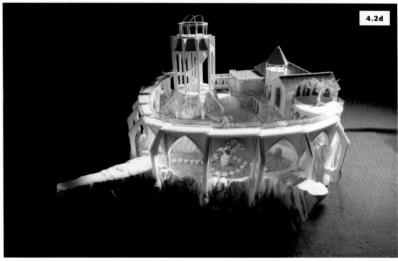

4.2d

4.2c
Abhorsen's house (Amy Smith), TV and Film Set Design, University of South Wales.

4.2d
Abhorsen house model (Amy Smith), TV and Film Set Design, University of South Wales.

DOORWAYS AND WINDOWS

Doorways and windows suggest transition and change as thresholds between the interior and exterior that can symbolize contrast between the two worlds. *The Godfather: Part 2* (1974, Francis Ford Coppola, PD Dean Tavoularis) uses doors to define separation of gender roles and identify feminine spaces of family and domesticity and masculine spaces of business. Like much of design, they are a practical necessity that is also an opportunity to design meaning into the choices such as position, size, style and so forth. Where doorways and other thresholds are positioned by the designer can influence our reading of place, character and story. For example, in the film *Betty Blue* (1986, Jean-Jacques Beineix, PD Carlos Conti), Zorg lives in a simple fashion as a handyman until he becomes involved with Betty whose wild personality spirals out of control across the course of the narrative. We see Betty arrive at Zorg's beach-shack home: she stands in the open doorway before stepping inside. The shack is close to nature and Betty's entrance suggests how simple it is to enter his uncomplicated world. Betty's physical presence rapidly transforms his environment, culminating in its destruction (when she burns it down) and reflecting her complex mental state.

In *About a Boy* (2002, Chris Weitz and Paul Weitz, PD Jim Clay) the carefully constructed boundaries of the protagonist Will's home are infiltrated by the young boy Marcus, whose visit is an unwelcome intrusion of his solitary space. This gives us the chance to see the exterior, which is a plain wooden door, leading out into a characterless street. A concealed stairway continues the notion that he is somehow tucked away and hidden from view. Similarly in *The Matrix* (1999, Wachowski brothers, PD Owen Paterson), Neo (Keanu Reeves) is not seen physically

coming in or out until he is unplugged from the Matrix. Once he is released and sees the world as it really is, his movement also becomes more grounded in reality.

The Hobbit's doorways in *The Lord of The Rings* (2001, Peter Jackson, PD Grant Major) are all organically arched, following the line of the rounded hills. They sit in a rural village setting – their homes are their normality and a visually significant starting point. This reflects the idea of the Hobbits as of nature, simple honest folk who embody truth and integrity. Their doorways represent the start of a journey that contrasts effectively with the new environments they venture to. The places visited subsequently are strange and exotic dreamscapes, or are dark, threatening, brutal and hostile.

Designers arrive at these decisions through a range of methods and approaches. For example, Eve Stewart's designs for Mike Leigh films are informed by the character interviews that take place, where each actor spends an hour talking to the designer about the history of their character, which then feeds into the design choices. Whatever the methods, the visual concept will help define these choices in terms of style and material, while the position of the doors will usually be driven by staging concerns. For example, how characters arrive in a scene or move around within a scene, as mentioned by Gemma Jackson earlier in relation to her choice to position a door between the kitchen and living room in *Iris* (2001, Richard Eyre, PD Gemma Jackson).

In fifteenth century Flemish and Italian painting we see landscapes through open windows which literally frame and help contextualize what is then portrayed. In film, it is again the framing, whether looking

from outside to inside or the reverse, which combines to make meaning spatially and psychologically; frames within frames are often employed in cinematic language as metaphor.

Deep space can be created through the position of doors and windows. From exterior to interior or vice versa a window draws the viewer into the frame within the frame. Interior doors can also connect further inside spaces – separating and connecting two or more interior rooms. Open doors became a feature of seventeenth century painting – the Dutch concept of *doorkijke* or 'see-through' can be seen in the work of Nicolaes Maes, Pieter de Hooch, Diego Velázquez and Johannes Vermeer who all used doors and windows to create compositional depth in their paintings. Filmmakers use similar devices:

> Sometimes people in the foreground almost function as a kind of exhortation towards the central figures in the back; they show us how to respond emotionally to a certain situation, just like in classical paintings by Jacopo Tintoretto.[4]

Open and closed doors are employed to suggest notions of trust and truth or the lack of it. For example, in *Spellbound* (1945, Alfred Hitchcock, PD James Basevi), there is a scene where several doors open in sequence – a cathartic moment of realization. Psychiatrist Dr Constance Petersen (Ingrid Bergman) is falling in love with amnesiac John Ballantyne (Gregory Peck) who is suspected of murder. She attempts to uncover his memory to discover his true identity and prove his innocence. The scene also represents the unlocking of doors in the mind to uncover events previously hidden or obscured as too traumatic or painful to acknowledge.

4.3a
Spellbound (1945, Alfred Hitchcock,
PD James Basevi). The first door opens
creating a space beyond the foreground.

4.3b
Spellbound (1945, Alfred Hitchcock,
PD James Basevi). A second door opens,
revealing further depth spatially as well
as symbolically in the mind of Constance
Petersen.

4.3c
Spellbound (1945, Alfred Hitchcock,
PD James Basevi).

4.3d
Spellbound (1945, Alfred Hitchcock,
PD James Basevi). The sequence
continues to expand space deeper into
the background.

4.3e
Spellbound (1945, Alfred Hitchcock,
PD James Basevi). The final door opens,
creating a tunnel effect which echoes
the narrative as we travel deeper into the
mind of Dr Petersen. The light at the end
of the tunnel further strengthens the
notion that boundaries are being crossed
and she is reaching a place that was
previously closed and unavailable
in her mind.

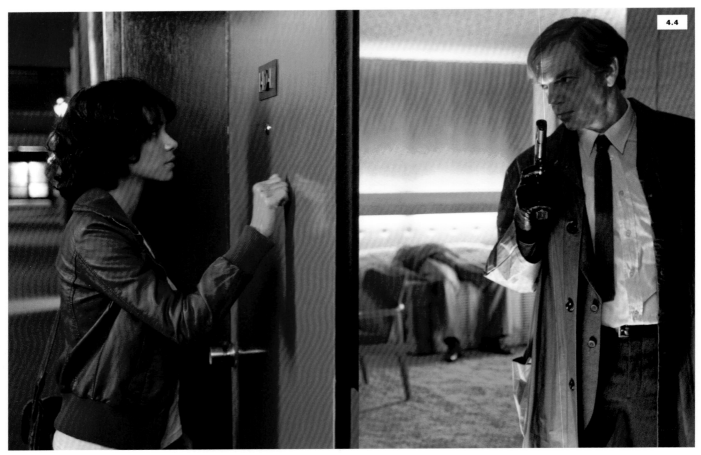

4.4

Door after door opens, journeying further away from the foreground and metaphorically deeper into the subconscious. This is a moment of revelation in the film, as prior to this Dr Petersen has been established as a highly pragmatic character who brushes aside emotion. The change in her interior landscape is visualized through a series of doors that open up in sequence, progressively deeper and deeper, and further into the background. This creates a repeating pattern that amplifies the action, its meaning and the moment.[5]

In *Cloud Atlas* (2012, Tom Tykwer, Andy Wachowski and Lana Wachowski), journalist

Luisa Rey knocks on a closed door. She is positioned on the outside by the physical boundary reflecting the access to knowledge that is being withheld. There are two separate frames created by the division of the door down the centre of the screen in the foreground. Thus although the door is closed to the characters who occupy the space either side and are detached from each other, the audience is given insight which reveals that both spaces are simultaneously connected. The characters are contrasted through their spaces, which helps to build a sense of conflict. The equality of space on either side of the door adds further tension as neither side dominates.

4.4
Cloud Atlas (2012, Tom Tykwer, Andy Wachowski and Lana Wachowski, PD Hugh Bateup and Uli Hanisch). The door between the characters conceals that a murder has taken place inside the hotel room. On the outside, Luisa Rey (Halle Berry) is also protected from the danger inside.

Windows

In the following examples, windows are designed to add depth from interior to exterior, sometimes working to connect the two. The window can also position the character effectively on the inside or outside, framing and contextualizing performing a similar function to doorways.

Tom Turner created designs for *Against Nature* [À Rebours] by Joris-Karl Huysmans. The novel is set in Paris during the 1930s and is based on a decadent self-indulgent character who isolates himself. Turner says: 'In the café interior I wanted to use contrasting warm and cool colours. In the book the main character wants to stay indoors all the time, and never go outside, so I tried to up the contrast between indoor and outdoor.'[6]

We are positioned on the inside of the café in Tom Turner's *Against Nature* sketches, with large windows looking out onto the street. This supports the notion of the character as dwelling inside as he is reluctant to venture outside. Seeing the division created by the windows indicates an exterior world beyond that of the character located within. Turner's contrast works effectively to separate and divide, heightening the distinction between inside and outside and creating an empty lonely interior atmosphere, which is reinforced by light and colour.

4.5a

4.5a
Against Nature, café sketches (Tom Turner, National Film and Television School, UK). Tom Turner indicates in these early sketches, division between inside and outside in the frame.

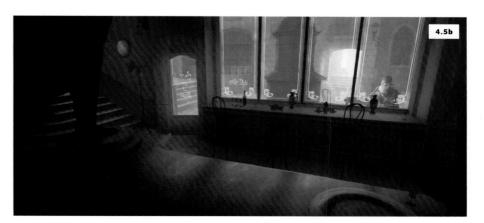

4.5b

4.5b
Against Nature (Tom Turner, National Film and Television School, UK). Although the interior and exterior are linked through the window they appear separate and secluded.

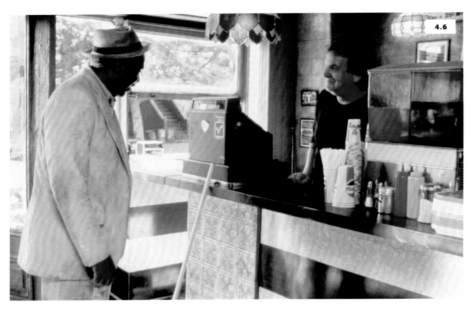

4.6
Do The Right Thing (1989, Spike Lee, PD Wynn Thomas). Inside the pizzeria, including views of the street outside. Glass-panelled doors and windows add depth as we see through from the interior to the exterior. The interior and exterior are further connected through matching lighting design, creating a sense of visual harmony.

4.7
Do The Right Thing (1989, Spike Lee, PD Wynn Thomas). Outside the pizzeria, including views of the interior. Mookie (Spike Lee), Sal (Danny Aiello), Vito (Richard Edson) and Pino (Jon Turorro), now positioned in the exterior of the street. The lighting on the in and the out are in contrast, which is suggestive of the conflict unfolding in the drama.

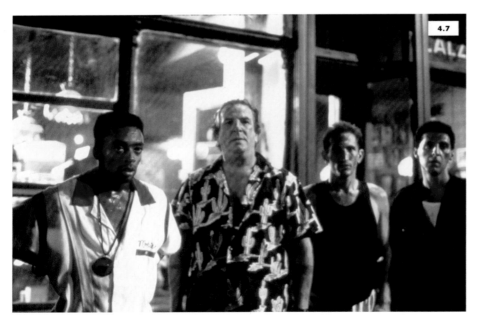

Do The Right Thing (1989, Spike Lee, PD Wynn Thomas) is set in the New York neighbourhood of Brooklyn, where Italian American Salvatore (Danny Aiello) runs a pizzeria. Local Buggin' Out takes exception to the fact that the wall of fame in the restaurant features only Italian actors, wishing it to include black actors. The disagreement becomes the focal point of racial tension that culminates in violence. The pizzeria and the street outside are fundamental to the story – the location is essential in terms of establishing the sense of community context. Visual coherence is set up at the beginning where the characters and the restaurant appear integrated into the community, yet become fractured and dislocated as conflict arises.

The visual concept displays divisions in society based on race, where the inside was comfortable and cushioned from outside forces in the beginning of the film. The outside and inside are strongly linked and eventually the smashing of the window punctures the relative safety and security of the interior space. The status quo is challenged and access to power and representation confronted in the visual breaking of the boundary between interior and exterior.

A Single Man (2009, Tom Ford, PD Dan Bishop), set in LA in the 1960s, sees English professor George (Colin Firth) struggling to cope with the death of his boyfriend. His home acts as both a sanctuary and a prison, featuring glass that he sees out of but which further disconnects and isolates him from the exterior world. The windows in George's

home connect the interior and exterior, allowing compositions that include both that keep him strongly associated with the inside. The Shaffer House is a real location in Los Angeles, built in 1949 by John Lautner (Frank Lloyd Wright's apprentice). It was chosen for its distinctive style featuring open-plan rooms with glass walls supported by redwood beams, which enhances the visual concept of isolation.

Rear Window (1954, Alfred Hitchcock, AD J. McMillan Johnson & Hal Pereira) playfully interprets interiors and exteriors in its design which intensifies the story. L. B. Jefferies (James Stewart) is injured and temporarily using a wheelchair, stuck on the inside of his apartment looking out. The exterior then is seen from his point of view through a great deal of the film. It is L. B. Jefferies' window at the back of his apartment that he fills his time looking out of and into the windows of the block opposite. The window he looks out of is several storeys high, giving him a vantage point into those dwellings he overlooks. The frames of the windows reveal glimpses of the different inhabitants' lives, condensing character into what is seen from the relatively fixed position of the protagonist's window. The design hinges on the windows and the connection between the interior of L. B. Jefferies' apartment where we are positioned for the majority of time (looking out of) and the neighbours' windows that he and the audience look into. Each window reveals a different set of characters and narrative, each frame acting like a moving painting (note the doorkijke motif mentioned earlier in this chapter).

4.8
A Single Man (2009, Tom Ford, PD Dan Bishop). George (Colin Firth) trapped in his beautiful home.

4.9
Rear Window (1954, Alfred Hitchcock). L. B. Jefferies (James Stewart) and Lisa Carol Fremont (Grace Kelly) are looking out of their window as we look in on them. We, the audience mimic their voyeurism – gazing in through their window unseen. The reverse shot, the subject of their surveillance, is an apartment block opposite. Looking into their neighbours' homes they piece narrative together from images and snapshots. The position of the windows and the composition of each suggest several scenes within one frame.

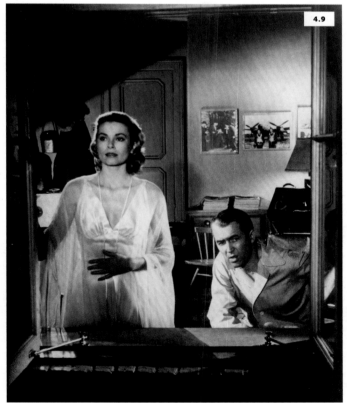

MOVEMENT AND TRANSITION

Corridors

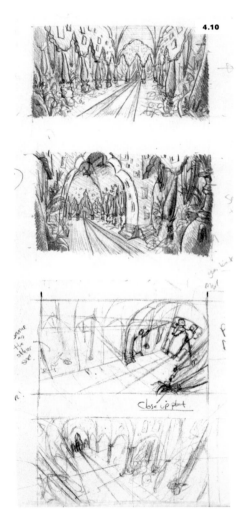

Corridors are used by designers to extend physically and prolong visually the transition from one place to another. They are a space of journey, termed as liminal; as they are in-between more meaningful spaces they often act as punctuation. The details of distance, width, material and so forth alter our perception of where the character is travelling to and what they might find when they arrive. Corridors can effectively build suspense and play with notions of time and space. In *The Shining* (1980, Stanley Kubrick, PD Roy Walker), the little boy plays on his go-cart, pedalling down the long hotel corridors which are made visually striking by the patterned carpet punctuated by gaps. A visual rhythm is created that builds tension up to the point where the pattern of the carpet breaks.

In the sketches in Figure 4.10, Tom Turner uses height and perspective to extend the visual trajectory through the hall to the entrance. As the doorway was a significant entrance point in the narrative Turner wanted to sketch the space to deliberately draw the eye there. The king is hoarding treasure here and it is not sketched as a place to linger, but rather as a transitional space to be moved through to the point of entrance and exit. Turner intended the space itself to feel cavernous and lonely.

The scene in *The Wizard of Oz* (1939, Victor Fleming, George Cokor), where Dorothy, the Scarecrow, the Lion and the Tin Man reach and gain entry to the Emerald City, the extended corridor is designed to show the culmination of the characters' journey. The forced perspective suggests the infinite nature of their quest as the corridor seems to go on endlessly. Dorothy is trying to get home physically but learns through the course of her journey that she can go home as soon as she comprehends what that means conceptually, accepting 'there's no place like home'. Dorothy's adventures in Oz represent a psychological passage – deliberately dreamlike with the corridor in particular resonating with tunnels linking life and death, dream and reality states.

4.10
Tom Turner's (National Film and Television School, UK) hall background sketches for the animation *Banaroo* (2015, Grace Cooke), sketched as a transition space to be moved through.

4.11
The Wizard of Oz (1939, Victor Fleming, George Cukor). The corridor extends in a surreal way creating an impression of infinity.

The design of the setting in *Alien* (1979, Ridley Scott, PD Michael Seymour) used tubular passageways that have been compared to female reproductive organs. These passages created a visual metaphor for the alien creature's gestation period and birthing of children. The organic shape and texture of the opening is threatening and monstrous in its scale in relation to the humans.

Cloud Atlas (2012, Tom Tykwer, Andy Wachowski and Lana Wachowski, PD Hugh Bateup and Uli Hanisch), explores the impact of the actions of individuals on themselves and others across time, reflecting on the connections between past, present and future worlds. The character Sonmi-451 travels from a dark closed door towards an open door which illustrates the concept of freedom and consciousness-raising. In spite of the visual contradiction of her bound hands, she has won freedom from the ideology that has controlled her.

The corridor connects the two ideas and places – the one Sonmi-451 has come from as a second-class citizen (server) without human rights, and the place of her successful challenge to the status quo of the authorities where she is empowered and liberated before subsequent execution. As such, the corridor is both a visual metaphor for transition and an actual journey – from the restricted boundaries of the mall café and her psychological journey to enlightenment.

4.12
Alien (1979, Ridley Scott, PD Michael Seymour). H. R. Giger's designs formed the basis of much of the Alien series visual concept. The alien species is concerned with its own propagation and the destruction of others.

4.13
Cloud Atlas (2012, Tom Tykwer, Andy Wachowski and Lana Wachowski, PD Hugh Bateup and Uli Hanisch). The prisoner Sonmi–451 (Doona Bae) is led through shafts of light and shade to her trial for transgressing the boundaries of her status.

Staircases and lifts

Staircases and lifts can function in a similar sense to corridors and passageways, with the addition of height. Travelling up or down can suggest different notions and brings together two distinct physical locations and connect different viewpoints psychologically. Staircases and lifts are also useful as metaphor for the rise or fall in character arc; they symbolize themes effectively depending on details such as material, style, size, shape and so forth. Lifts can also create meeting points where characters unlikely to meet under other circumstances briefly share a confined, condensed space, creating narrative space for subsequent story. Spiral staircases are often used to signal loss of control, disorientation and danger. Ben McCann includes staircases in what he terms 'action spaces', which he says act as the symbolic spine of the house. They are what might be termed 'plastically symbolic' insofar as they are constructed linking devices that enable the transferral of character movement through the decor.

It was the production designer Alexander Trauner who persuaded the producers of *Le Jour se Lève* (1939, Max Carné) that the character François (Jean Gabin) should be isolated on the fifth floor of the apartment block. After committing a murder, François barricades himself into his apartment and looks back over the events that have positioned him here. Trauner built an apartment block and situated François at the top of it in the tallest building on the street at a junction. The character's physical position in space visualizes his psychological situation. The original plan was to have located François on the first floor, which would have weakened the elements of suspense and isolation. According to McCann, the choice of fifth rather than first

floor creates a strong architectural signifier for François' mental state that reinforces the narrative and character of the film.[8]

The staircases in Mildred Pierce visualise themes of social mobility. In spite of Mildred's rise in status and wealth she remains an embarrassment to her aspirational daughter.

Mildred Pierce (1945, Michael Curtiz, PD Anton Grot, Bertram Tuttle) tracks the upwardly mobile hard-working mother Mildred, who suffers hardships in an attempt to give her spoilt daughter everything she wants. The daughter is ungrateful and insatiable in her desire for more, rendering Mildred's journey from working class to middle class a hollow success.

4.14
Mildred Pierce (1945, Michael Curtiz, PD Anton Grot, Bertram Tuttle). The elegant sweeping staircase is the spine of the empty home. The sparse superficial grandeur described in Mildred's home here contrasts with the home we first meet her in at the beginning of the film.

Staircases and lifts

Gone with the Wind (1939, Victor Fleming, PD William Cameron Menzies), features a grand sweeping staircase used to suggest, wealth, beauty and pride.

The lifts in *Being John Malkovich* (1999, Spike Jonze, PD K. K. Barrett), transport Craig Schwartz (John Cusack) and Maxine Lund (Catherine Keener) between the different levels that takes them to the mysterious floors that are measured in halves. When Schwartz discovers a portal into John Malkovich's head, the design distorts the scale in relation to the bizarre notion that a person's head is being entered physically and conceptually. The set influences the physical actions and behaviour of the characters who go inside his head and out again as if on a circus ride.

In *Cloud Atlas* (2012, Tom Tykwer, Andy Wachowski and Lana Wachowski, PD Hugh Bateup and Uli Hanisch), lifts afford the opportunity for chance meetings and the collision of diverse characters who wouldn't usually share narrative or physical space. Luisa Rey (Halle Berry) and Isaac Sachs (Tom Hanks) find themselves alone together in a lift, condensing the space physically and creating the narrative space for subsequent story.

The Grand Budapest Hotel (2014, Wes Anderson, PD Adam Stockhausen) uses glossy red lifts to convey Monsieur Gustave H. (Ralph Fiennes) when he is in control at his peak as the hotel concierge. Later this is contrasted with his demise in status when he has to crawl up stairs and over walls to escape prison.

In *Vertigo* (1958, Alfred Hitchcock, PD Henry Bumstead), the chapel scene use of stairs underpins the whole premise of the film whereby a wooden staircase that looks

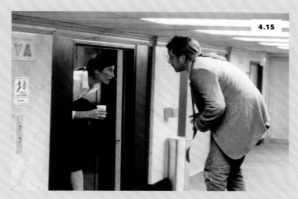

4.15

fragile reflects the precarious situation Scotty Ferguson is in. Suffering from vertigo, he already has a lot to lose by travelling so high in pursuit of Madeleine.

When the stairs collapse in *The Money Pit* (1986, Richard Benjamin, PD Patricia Von Brandenstein), it is a metaphor for the whole narrative – the characters attempting to develop a property find that they have been tricked into buying a completely dilapidated house.

The famous Odessa Steps scene in *Battleship Potemkin* (1925, Sergei Eisenstein) is a visual metaphor for the political revolution and overturning of the existing hierarchy in Russia during that period. They are referenced subsequently in *The Untouchables* (1987, Brian de Palma).

The *Harry Potter* series commences with Harry living under the stairs in a tiny cupboard for a bedroom in the Durselys' suburban home. Later in the Hogwarts School for Wizards, the mobile grand carved staircases are used to transport the students across sections within the school.

A Matter of Life and Death (1946, Powell & Pressburger, PD Alfred Junge) uses sculptural stairs in the sky to connect heaven and earth (note the 106 20-foot-wide steps) which are driven by an engine to create a fluid escalator movement.

4.15
Being John Malkovich (1999, Spike Jonze, PD K. K. Barrett).

4.16
Vertigo (1958, Alfred Hitchock, PD Henry Bumstead).

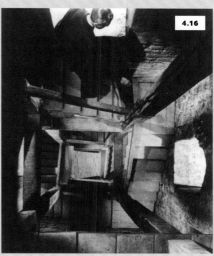

4.16

In *Rocky* (1976, John G. Avildsen, PD Bill Cassidy), the steps outside the Philadelphia Museum of Art offer a clear visual metaphor – his training has taken him to the top physically and psychologically where he can be champion.

INTERIORS AND EXTERIORS

In

Choices around exteriors and interiors are often established by the scriptwriter in the first instance. However, others may be introduced by the designer as in the Stuart Craig example from Chapter 2. Some films deliberately dwell in the interior for the majority of the scenes, which creates a range of feelings and meanings. For example, the film *Carnage* (2011, Roman Polanski, PD Dean Tavoularis) takes place almost entirely in the living room of a family apartment on the upper floors of an attractive block. The opening exterior situates the story in New York after which we see a couple entering another couple's apartment, via an elevator where they remain for the duration of the film. This use of the interior is theatrical in its origins, in the sense that a play will remain bound to the stage no matter how many scene changes there may be. Why use this technique in film when the medium liberates the audience from one setting, allowing us to travel widely around homes, cities and the world with ease? This choice to remain inside forces the audience to

stay with the characters and intensifies our understanding of them. Feelings of claustrophobia physically and a sense of being emotionally trapped in a situation can result from this technique. This visually tells the story of characters who are part of a social structure, operating within conventions that they are unable to step outside of. Utilizing interiors also forces us to look at the internal story of the characters, which is often exposed as a result of being constrained in a limited physical environment where people snap after being cooped up together for an extended period of time.

12 Angry Men (1957, Sidney Lumet, PD Bob Markell) is another limited interior setting; this time, the characters are members of a jury and actually locked in while they deliberate over the case of the accused. The tension rises when one of the jurors questions the guilt of the murder suspect and slowly manages to turn the verdict around from guilty to not guilty. There are windows from which we gain a sense of the city occasionally, but

ultimately the drama takes place in a closed box. The jurors sit around a rectangular table and there is very little depth in the frame at any time – the focus is close up on each of the character's faces – increasing the intensity. When their verdict is reached and they finally leave the room, we see them exit but don't go with them. The audience are left behind in the room until the final exterior shot on the courtroom steps – which again doesn't show the city or any wide shots. There is a spatial release but it is minimal.

Similarly in *Mildred Pierce* (1945, Michael Curtiz, PD Anton Grot, Bertram Tuttle), Mildred and her ex-husband are released from the police station to a hopeful arch framing the city skyline. Having spent the night in police custody as murder suspects, the exterior suggests their freedom and a new beginning.[9]

Another example of extended use of interiors is *Moon* (2009, Duncan Jones, PD Tony Noble), which ties in with the story and supports visually the concepts in the film. Set on the moon, the base is home to Sam (Sam Rockwell) who is supposedly on a contract for three years, after which time he will return to earth and his family. As the time gets closer for him to leave, he discovers he is never going to get off the moon. The extreme isolation is told through keeping the audience inside too, with only brief occasional glimpses outside. Sam slowly comes to realize that he is never returning to earth and will end his life on the moon. The space station envelopes the character in on himself; corridors like this suggest movement but spatially this is limited to the confines of the station, which remains on an infinitely repeating loop.

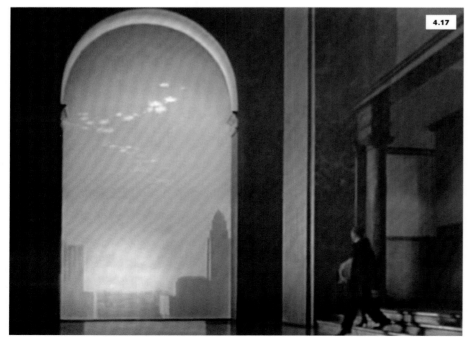

4.17
Mildred Pierce (1945, Michael Curtiz, PD Anton Grot, Bertram Tuttle).

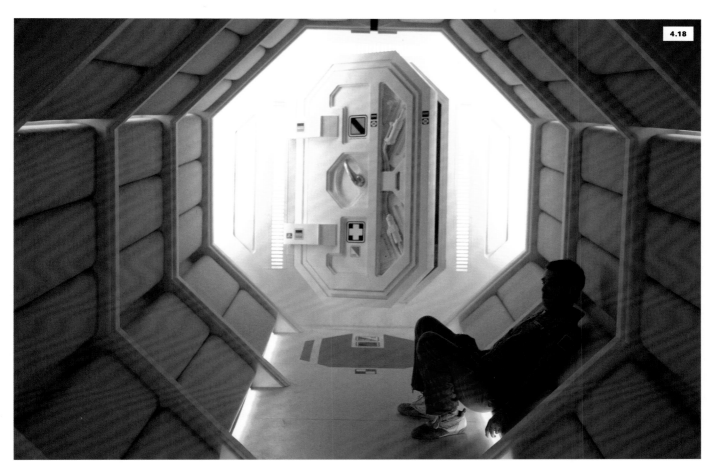

4.18

4.18
Moon (2009, Duncan Jones, PD Tony Noble). A limited space such as the one used for this film helps create a claustrophobic environment physically and emotionally for Sam Bell (Sam Rockwell).

When choosing interiors the decision to use an existing location or build a set on a sound stage will create different effects, impacting on the physicality of the setting and the atmosphere. As already discussed in earlier chapters, there are practical reasons for choosing to use a location or studio which often revolve around time and money concerns. These choices will influence visual metaphor in every respect (space, in and out, light, colour and set decoration). When using a real location the doors and windows will already be installed and there will be limited options to alter them. Hence, an interior location will be chosen with this in mind, and the position of doors and windows will need to tie in with the overarching visual concept. Real locations may convey an energy and authenticity admired by filmmakers with a realist agenda.

Out

To choose an exterior over an interior can help suggest ideas of freedom, adventure and possibility. Conversely they can also be hostile, dangerous and unwelcoming environments in many instances. As mentioned earlier, exteriors have been harnessed by filmmakers in search of unadorned realism, with authentic and raw qualities. The city can sometimes be portrayed as a main character in itself. For example, *The Great Beauty* (2013, Paolo Sorrentino) has many scenes set outside in the city of Rome. When cinematic cities such as Rome are used for exteriors they recall earlier films, and all of their associations can be harnessed to strengthen story. These films are in dialogue with each other by using recognizable exteriors: in this way ideas are built on and elaborated.

Rome has been portrayed as an exciting and picturesque tourist attraction, as a symbol of poverty and urban decay, as a debauched and sinister place of degenerate partygoers and criminals. Each incarnation of the city brings new perspectives and frames places and spaces, buildings and monuments in support of the filmmaker's themes and visual concept. Cities can be used in cinema as a shorthand for ideas that an audience will understand and respond to.

Rome on screen

Rome is a city with a rich film heritage. For example:

Rome Open City (1945, Roberto Rossellini), *Bicycle Thieves* (1948, Vittorio De Sica), *Roman Holiday* (1953, William Wyler), *Three Coins In the Fountain* (1954, Jean Negulesco). The Trevi Fountain is used again in 1960 for *La Dolce Vita* (1960, Frederico Fellini), *L'Eclisse* (1962, Michelangelo Antonioni), *Mamma Roma* (1962, Paolo Pasolini), *Il Boom* (1963, Vittorio De Sicca), *Roma* (1972, Frederico Fellini), *The Belly of An Architect* (1987, Peter Greenaway), *The Talented Mr. Ripley* (1999, Anthony Minghella), *Il Divo* (2008, Paulo Sorrentino).

The Rome locations that habitually feature include:

The Trevi Fountain, Villa Borghese, St Peter's Square, St Sebastian's Basilica, the Trastevere, the Vittoriano, the Spanish Steps and Piazza Lovatelli, Via Del Corso, Palazzo della Sapienza and Villa di Fiorano and the Ara Pacis Fountain. Also, the EUR, a district planned by Mussolini to celebrate Fascist rule in 1942, in which modern, wide open spaces contrast with the crowded busy streets of the city centre.

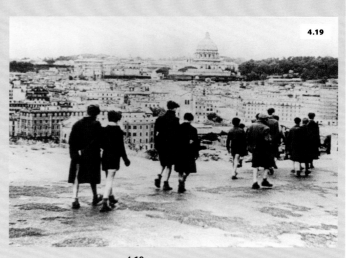

4.19

4.19
Rome, Open City (1945, Roberto Rossellini), part of Rome's rich screen heritage. Familiar images such as this are often revisited.

New York is another such city that features iconic locations with a familiar identity and many screen persona. Locations that have been revisited are immediately recognizable such as the New York Public Library, Fifth Avenue; Central Park, Tribeca, Times Square, Greenwich Village, Grand Central Station and the Empire State Building. The choice to use these identifiable locations brings narrative and atmosphere to a production.

Television series set in New York City include sitcoms such as *Seinfeld* (1989–1998) and *Friends* (1994–2004) that have used the familiarity of general views of the city cut with their signature meeting places, Central Perk and Monk's Diner. The backdrop of the city provides context in these examples. Films also use the city to stand as a metaphor and shorthand for certain types of characters and stories. The distinct elements that are special to that environment are also utilized as visual metaphor in new ways with every film produced.

Films that use the city as metaphor include:

King Kong (1933, Merian C. Cooper, Ernest B. Schoedsack), *The Naked City* (1948, Jules Dassin), *Breakfast At Tiffany's* (1961, Blake Edwards), *Sweet Charity* (1969, Bob Fosse), *Midnight Cowboy* (1969, John Schlesinger), *Mean Streets* (1973, Martin Scorsese), *Dog Day Afternoon* (1975, Sidney Lumet), *Taxi Driver* (1976, Martin Scorsese), *Saturday Night Fever* (1977, John Badham), *Manhattan* (1979, Woody Allen), *Fame* (1980, Alan Parker), *Once Upon A Time In America* (1984, Sergio Leonie), *Ghostbusters* (1984, Ivan Reitman), *Desperately Seeking Susan* (1985, Susan Seidelman), *Wall Street* (1987, Oliver Stone), *When Harry Met Sally* (1989, Rob Reiner), *Do The Right Thing* (1989, Spike Lee), *Leon* (1994, Luc Besson), *Vanilla Sky*

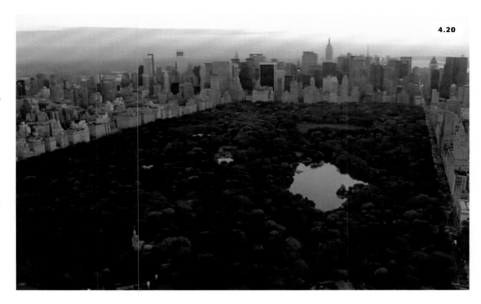

4.20

(2001, Cameron Crowe), *The Adjustment Bureau* (2011, George Nolfi).

Landscapes such as forests and beaches can be beautiful and highly emotive, operating inside or outside of the narrative as visual spectacle evoking spiritual and religious themes such as seen in *The Lord of The Rings* trilogy (2001–2003, Peter Jackson). The wider landscape operates as context and metaphor in screen geography because it provides a means to explore the intersection between narration and geography.[10]

Nature in the form of rural exteriors also provides bold imagery; landscapes can be used to suggest the power of nature and the insignificance of humans. Deserts such as those seen in *The Paris, Texas* (1984, Wim Wenders), *The Sheltering Sky* (1990, Bernardo Bertolucci) and *The English Patient* (1996, Anthony Minghella), isolate characters in the enormity of the landscape, visually communicating physical and emotional loss. The Western genre often uses the scale of deserts and prairies in opposition to key

themes of civilization, where characters are pitted against nature. Conversely, nature can be used to connote harmony and balance; for example, In *The Cave of The Yellow Dog* (2005, Byambasuren Davaa), the lush Mongolian landscape is peaceful and serene and the characters are strongly connected to it, living at one with nature.

4.20
Sex and the City (1998–2004) captures the cinematic skyline of Manhattan.

CASE STUDY – HUGO LUCZYC-WYHOWSKI

The work of production designer Hugo Luczyc-Wyhowski spans the cult 1980s film *My Beautiful Laundrette* (1985, Stephen Frears), which offers a stylized slice of Thatcher's Britain to period drama *Mrs Henderson Presents* (2005, Stephen Frears), where the Windmill Theatre, Soho is resuscitated to its risqué wartime glory. The focus we consider here: *My Beautiful Laundrette*, *Nil by Mouth* (1997, Gary Oldman) and *Dirty Pretty Things* (2002, Stephen Frears). The principal question is how Luczyc-Wyhowski's work has contributed to these films in relation to the design of the in and out. All three films demonstrate psychologically perceptive design as highlighted here. In addition, they are all set in London but do not appear to adhere to the 'landmark London' popularized in 'mid-Atlantic' films such as *Notting Hill* (1999, Roger Michell) or *Love Actually* (2003, Richard Curtis).

The home as discussed in Chapter 3 is a classic interior traditionally used to imply a safe place, often signifying stability, privacy and comfort. However, it can also be used to explore fear, where danger resides in the home itself. In the Luczyc-Wyhowski examples, the home is more ambiguous, with the issue of homelessness being key and the lack of clear division between safe interior and dangerous exterior combining to create a provocative composition. For the purposes of this chapter, we will focus on his use of in and out in these three films which support themes in the narrative and convey ideas about the character that promote depth.

In these three films we can see partitions being used as metaphor to clearly convey the visual concept. The design is layered, often through glass and mirrors, building up a depth in the frame which indicates a complexity where there is always something to see beyond the central focus of the frame. Often the space is organic and we see beyond and out of a window, a door or another room. In this way the design uses the dead space to further enhance the image.

My Beautiful Laundrette (1985, Stephen Frears) is set in south London, during the 1980s. Omar (Gordon Warnecke) teams up with his uncle to run a lacklustre laundrette. He has big plans for the place and transforms it with the help of old school friend Johnny (Daniel Day Lewis). As the laundrette comes together so do they – their relationship creates complications, where family and racial loyalties are tested.

Johnny and Omar are introduced framed by open windows in daylight. Johnny sits next to an open window, curtains flapping, natural light flooding in. The same window is soon to be employed as Johnny's exit point. Both Johnny and Omar's domestic space is framed by the exterior. In Omar's it is the balcony, where he is seen hanging out washing, and which associates him strongly with the outside as the trains speed past. Although potentially hostile, the exterior is also full of possibility and change as expressed by the dynamic of the train.

The film opens with an entrance piled up with furniture barricading the door to prevent imminent eviction – it is the south London squat where Johnny (Daniel Day Lewis) lives, and from which he is forced to leave via the window. He puts a couple of possessions into a bin bag and departs.

Omar moves through his father's home from window to balcony – we don't see him actually come in or out of an exterior doorway onto the street. Thus no exterior is created to match his interior. This communicates concept in that he is disconnected from the wider context – reflecting his ambivalent racial/national identity as a second generation Asian.

Luczyc-Wyhowski designs in a measured way, which he calls a waveform. This often involves a composition that has partitions separating the interior space that give depth and indicate a space beyond a space.

4.21a
My Beautiful Laundrette (1985, Stephen Frears, PD Hugo Luczyc-Wyhowski). The doorway boundary is reinforced with furniture.

4.21b
My Beautiful Laundrette (1985, Stephen Frears, PD Hugo Luczyc-Wyhowski). From the inside out, depth is created through the glass panel in the door. The boundary is smashed open through force.

4.21c
My Beautiful Laundrette (1985, Stephen Frears, PD Hugo Luczyc-Wyhowski). Johnny (Daniel Day Lewis) exits the squat via a window.

4.21d
My Beautiful Laundrette (1985, Stephen Frears, PD Hugo Luczyc-Wyhowski). Omar looking out of the window.

Set in the 1990s in south London, *Nil by Mouth* (1997, Gary Oldman) focuses on a working class family struggling with issues of alcohol and drug abuse, crime and domestic violence. The central characters Ray (Ray Winstone) and Valerie (Kathy Burke) live in a council flat on an estate. Long graffitied corridors of concrete, safety glass and fluorescent light lead in and out of the flat. The journey through this harsh environment is deliberately alienating. Inside, the curtains and nets are always closed; no natural light enters the home of Ray and Valerie.

The key space is divided by a glass partition between the kitchen and lounge areas, which operates to add depth and build layers as with the earlier example. Artificial light (from the television, a lava lamp and practical lamps) is reflected from the glass partition that divides the sitting room and kitchen area adding further layers. The partition also isolates the characters, closes them off and symbolizes both theirs and the wider alienation reflected in the film.

The visual transformation of the home in *Nil by Mouth* (1997, Gary Oldman, PD Hugo Luczyc-Wyhowski) is more subtle than in the Rebecca example in Chapter 2, and is in proportion to the changes it reflects in the narrative. Raymond is violent and abusive to his wife Val, who leaves him when he finally goes too far. The design visually conveys their confinement through the five strands of visual metaphor. Their home is designed to mirror the limited possibilities open to them and the tensions and isolation between characters. The transformation of the flat visually shows the story arc starting in a state of limbo mid-way through its repainting. It is subsequently trashed by the

protagonist in an alcoholic rage and finally redecorated at the end of the film when the family seem to be reunited – a glimmer of hope flickers in character and story world.

Luczyc-Wyhowski designed *Nil by Mouth* using the concept of a fish tank to reflect the family's struggle to survive in an unnatural hostile environment. Hugo visualized this idea through the use of glass partitions which metaphorically divide the key characters and physically confine them in their home.

It was kind of like a fish tank. The idea was that they were trapped in it. It allowed you to be in the room but to be separate from them as well.[12]

The concept of a fish tank effectively creates a claustrophobic sense intensified by close-ups. The windows increase the sense of enclosure as we don't get to see out of the nets (not like in *My Beautiful Laundrette* when outside and inside are engaged in the same frame). The layers reflect inwards and condense rather than expand outwards as in the earlier example.

In the third film, *Dirty Pretty Things* (2002, Stephen Frears), illegal immigrant and former Nigerian doctor, Okwe (Chiwetel Ejiofor) works two jobs: as a taxi driver and a hotel porter. He rents a sofa space from Senay (Audrey Tatou), a Turkish refugee, who is a maid at the same west London hotel. The hotel is the location for drug dealing and prostitution. Okwe finds a human heart in one of the toilets and uncovers an illegal operation of organ transplants being exchanged for passports.

Their flat is situated above and behind a grocery shop in a bustling multicultural area. A key is shared between the immigrant flatmates Senay and Okwe, who must go through the shop and up a metal staircase at the back of the building to gain entry. This reflects their status as illegal immigrants and the concept that is based around their invisibility. They are employed in service industries by which they try to make a living while being denied

> **"Nil by Mouth: *that's probably as close as it gets to knitting the character into the room. It's interesting because at first it looks like you've gone into a council flat but we actually entirely constructed that.*[11] "**

"It's a much more sophisticated film from a design point of view. It was very carefully constructed. The hotel in the film is made up of seven different elements. It's a mixture of three theatre sets and four locations. All made to fit together. You don't notice that. I mean you could never shoot that material in any hotel because they wouldn't let you. I mean no hotel would want to be associated with the film's theme – a human heart is found in the toilet. The small flat where they lived was a built set.[13]"

legal status.

The concept is further supported by the use of windows that provide natural light but no views from them, so the interior remains hidden and separate from the exterior world – the division is clear.

Inside, a piece of fabric hangs from the ceiling providing a flimsy boundary dividing 'her' space and 'his'. Space is used expressively in this way to condense the characters' lives, with a piece of material being all that separates them. Soft diffused light through fabric is used inside the flat. Again, Luczyc-Wyhowski employs layers to create depth in the frame – not through glass or seeing beyond and out of windows but through the material that creates a partition between the characters which is soft and more fluid, signifying the intimacy between them.

Senay is permitted to live there but Okwe is illegal and as such, a sense of invisibility is key, he has no possessions, the house functions as a temporary shelter, not a home. Immigration officials invade the domestic space, turning it upside down for clues that another person lives there. As with the first example, *My Beautiful Laundrette*, a window is used instead of a door to make a quick exit by Okwe. Ultimately the domestic space is abandoned – Okwe picks up Senay's possessions and they leave the country.

In these examples, the in and out are used expressively to communicate fragmentation and disruption of family life, community and domestic relations. The domestic space is intruded on through eviction, violence, crime and the authorities – there is a complete lack of safety or security.

A distinctive sense of place is created through the design which, as Luczyc-Wyhowski says himself, may at first appear almost documentary in its realism but on closer scrutiny has been carefully composed so as to reflect the characters' emotional lives:

I mean, a room is just a box and ultimately fairly uninteresting. You can have a room and dress it like a box and make something incredibly claustrophobic and block out the outside, or you can really open it up and make it airy, atmospheric and modulate the way the light works.[14]

These films all feature working class/underclass characters – the complexity of whose lives is reflected through the in and out. The boundaries created with different materials mean different things in each film and can be read as metaphors for the narrative of each. In *My Beautiful Laundrette* fluid boundaries blur the distinction between in and out that conveys possibilities for the future. Rigid boundaries in *Nil by Mouth* signify the concept that the characters are trapped in a cycle of abuse. In *Dirty Pretty Things*, temporary boundaries are used to imitate shifting nationality and status. In each example, the way the interior space has been divided underlines key narrative strands within the films and the choice of transitions between interiors and exteriors. The brief examples given here aim to indicate the way in which the interior life of the character may be reflected in the deliberate use of the visual metaphors used in relation to the in and out.

Exercises

1. In relation to the *Clay* script in the Appendix, consider the concepts from Chapter 2 and think about how these might be conveyed visually through the metaphors of the in and out. The characters' homes are not seen in the script, so think about their workplace, the pub and the exteriors.

2. Try sketching the key settings – think carefully about the position of windows and doors in terms of the action taking place and the inclusion of exteriors and interiors in the same frame.

3. Produce a floorplan for one of the settings either by hand or using a software programme such as CAD or Sketch Up.

4. Photograph and sketch a range of entrances and exits. Visit a range of real locations and look at location libraries online. Research architectural details/styles.

5. Watch the films discussed in this chapter – make note of the in and out – what do they say about character, story and atmosphere?

Further Reading

Block, Bruce. *The Visual Story: Creating the Visual Structure of Film, TV and Digital Media*. Oxford: Focal Press, 2013.

Bloom, Ivo. 'Frame, Space, Narrative. Doors, Windows and Mobile Framing in the Films of Luchino Visconti'. *Acta Univ. Sapientiae, Film and Media Studies* 2 (2010): 91–106.

Bordwell, David. *Poetics of Cinema*. New York: Routledge, 2008.

Ealsesser, Thomas and Hagener, Malte. *Film Theory: An Introduction through the Senses*, London: Routledge, 2015.

Freud, Sigmund. *The Interpretation of Dreams*. London: Allen and Unwin, 1954 [first published 1899].

Hockenhull, Stella. *Aesthetics and Neo-Romanticism in Film: Landscapes in Contemporary British Cinema*. London: I. B. Tauris, 2013.

Lukinbeal, Chris. 'Cinematic Landscapes'. *Journal of Cultural Geography* 23, no. 1 (2005): 3–22.

McCann, Ben. 'A Discreet Character? Action Spaces and Architectural Specificity in French Poetic Realist Cinema'. *Screen* 45, no. 4 (2004): 375–82.

Shiel, Mark. *Italian Neorealism: Rebuilding the Cinematic City*. London: Wallflower Press, 2006.

Notes

1 McCann, 375.
2 Gemma Jackson, author interview, 2005.
3 Student synopsis of her design intentions. 2015
4 Bloom, 96.
5 See also *Senso* (1954, Luchino Visconti, PD Ottavio Scotti) for another example of doors opening in a similar fashion, as metaphor for psychological issues in terms of crossing thresholds, opening up covert mental spaces and building trust.
6 Author interview, 2015
7 McCann, 375. (Ben McAnn: 378-382. Screen 45:4 Winter 2004, A discreet character? Action spaces and architectural specificity)
8 McCann, 375–82.
9 See also *The Hustler* (1961, Robert Rossen, PD Harry Horner), which utilizes interiors to amplify the claustrophobic sense of lifestyle – Paul Newman's character is trapped in a subterranean world of pool halls. He is a pool hustler whose environment visually conveys his life – low ceilings in smoke-filled rooms contain him. On the very rare occasion we see outside, it provides striking contrast, reminding us how hemmed in we have been.
10 Lukinbeal, 4.
11 Hugo Luczyc-Wyhowski, author interview, 2004.
12 Hugo Luczyc-Wyhowski, author interview, 2004.
13 Hugo Luczyc-Wyhowski, author interview.
14 Hugo Luczyc-Wyhowski, author interview, 2004.

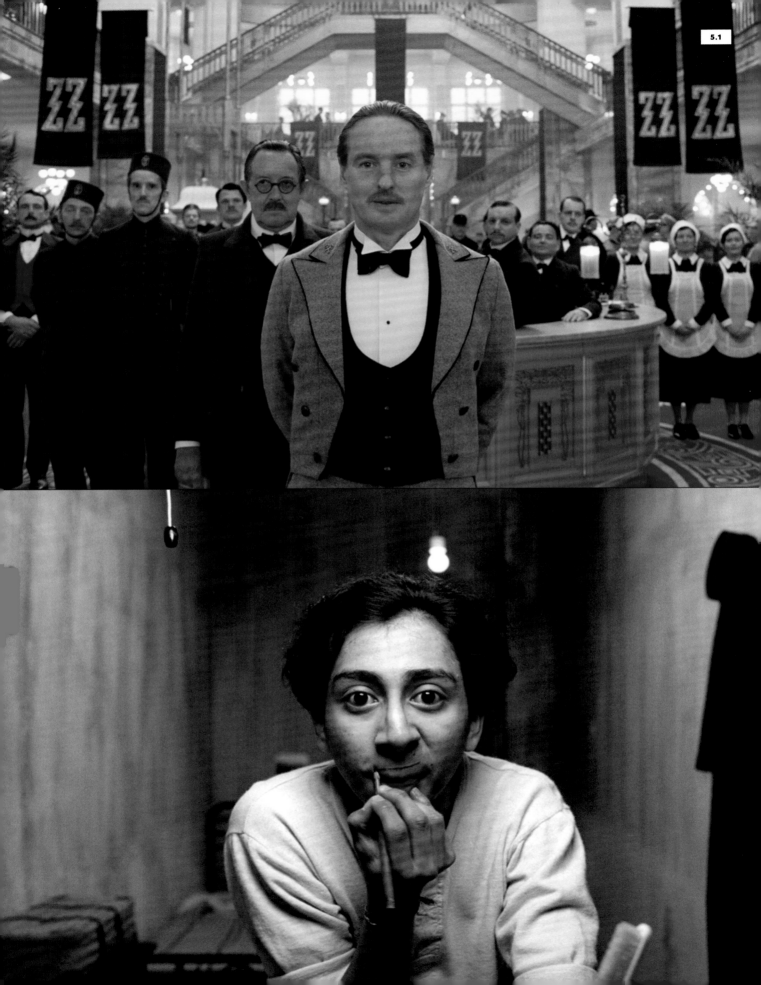

CHAPTER 5
LIGHT

The PD's decisions on where to position windows, practical lamps and other light sources is crucial to the composition in practical and emotional ways. The choice of light sources – natural or artificial and their intensity and direction all create different meanings in the frame. With windows, for example, curtains can be drawn and artificial light used to create a sense of isolation; curtains open with lots of daylight flooding in immediately alters the mood. Designers often consider light to be one of the most fundamental decisions in the overall visual concept, influencing character action and movement.

Thus, when a PD first imagines a scene the light will be one of their first considerations. The motivation of the light (where the light sources imitate existing sources) is integral to the concept, in that the PD's first impression of a script involves responding to and visualizing the light in relation to the story, characters and themes in the script.

As light is essential to human existence it can be harnessed to suggest powerful ideas around life, death and the afterlife. As a force of nature and as something more metaphysical, light is designed to convey and support themes such as love, beauty, truth, spirituality and religion. The absence of light is equally potent in image and connotation, and often provides visual shorthand for negative aspects of story and character. Where the light and shade accentuate each other, a beam of light in the darkness can illuminate a scene and create positive associations. Binary oppositions of good/bad and life/death are conventionally attached to light and shade to help tell story. The lighting enhances the other design elements – how space is carved and configured, colours, and textures of dressing are all dependent on the lighting to define much of the designer's work.

5.1
The Grand Budapest Hotel (2014, Wes Anderson, PD Adam Stockhausen). The light source and position indicate personality and emotional context.

SOURCES AND POSITION

Natural light may be produced by daylight, fire, candle light and so forth. Artificial sources could be interior or exterior lamps, television or computer screens. Light can be used to highlight a character, an issue, a key point in the narrative – if we look at where the light is positioned and the quality, it can elaborate on essential elements of story. A lack of highlights can give a dull flat effect to a scene, when there are no contrasting light and shade it can be suggestive of notions of safety, conformity, boredom or inertia.

Moonlight, sunrise and sunset all have distinctive qualities of light that create different atmospheres. These physically relate to the position of the sun or moon in the sky and the emotional connection of these times of day and night. Lighting position and direction can be used to create shape and volume with shadow sculpting space in evocative ways. North light refers to natural light coming from the sky rather than directly from the sun. In the Northern hemisphere it comes from the North and is often preferred by artists, architects and designers.[6]

The intensity of light will also impact on the design; for example, bright light can bleach out the detail and textures of an environment while soft, more diffuse light allows the textures and tones to have greater visibility. High key lighting will create a brightly lit scene, without much shadow, built on the notion of one main light source. Low-key lighting is used to create more complex tones and a range of shadows. Hard light strongly illuminates a specific area creating contrast and shadow, while soft light covers a wider area with a more diffuse light.

The (DoP) usually needs motivated light sources in a location to enable the lighting

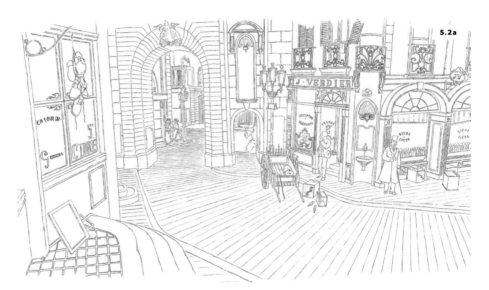

5.2a

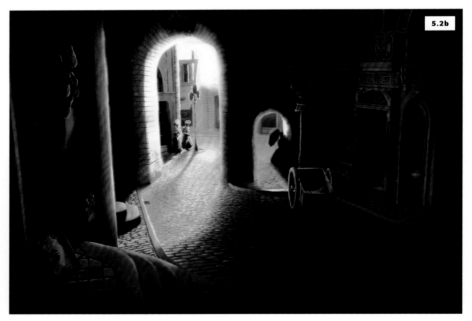

5.2b

5.2a, 5.2b
Tom Turner, *Against Nature*. This was a film school project (National Film and TV School) to create a set based on the book *Against Nature*, by Joris-Karl Huysmans. Here we can see an initial sketch and a more developed visual. In the sketch the form and composition is established but with the addition of colour and light in the later visual, depth and atmosphere is created.

design to make sense from a practical point of view. So the PD must position practical lights, windows and doors in dialogue with the DoP in order to satisfy the demands of the story, characters and atmosphere in the context of the space.

PDs' sketches include the lighting position and source, indicating its place as an essential ingredient in the production design process. This is a practice dating back to the 1930s when designers frequently had knowledge of painting not possessed by cinematographers that proved useful in advising lighting strategies. For example, Alfred Junge's drawings always indicated key sources of light.[1]

PD Stuart Craig says that where you put the window or practical lamp is the most important decision because without light there is no form, which is crucial. 'We discuss it, make sketches and models and talk to the cameraman as early as possible. You block the scene in your head with that in mind.'[2] Craig has compared windows in a set to eyes on a face. He considers the windows and the placement of them to be fundamental in establishing the design environment. His first sketches will always feature windows.

Reflected light can be an intentional design element where materials such as glass are used to bounce and create a soft diffuse effect, layering luminance to evoke atmosphere. Stuart Craig has talked of his fondness for building in real locations to capture the effect of light on the landscape: 'We went to Scotland and built on the mountainside of Glen Coe, great fun to do and the result was very satisfying – real cloud shadows moving over our set across this vast landscape was just terrific.'[3]

PD Hugo Luczyc-Wyhowski likes to create depth through the use of windows, doors and corridors and modulate the light to highlight and pick out details and textures. 'In *Dirty Pretty Things* we did a lot of trying to use things reflected in the glass – fruit machines, lights – it's a way of creating something more complex. If there's a design shorthand it's using space and light – absolutely the most powerful tools in a designer's armoury.'[4]

Tom Turner created designs for the novel *Against Nature* by Joris-Karl Huysmans. The protagonist Des Esseintes, not wishing to venture outside his villa, becomes a recluse. Turner's sketches utilize light as a key element of his visual concept.

Turner says: 'I went for a focal point in the picture where there is a bright spot. In the exterior set of Paris behind the arch is very bright, where the sun has bleached everything, and the foreground is much darker. Although it is an exterior set, because of the light it looks like inside and outside.'[5]

In a primal sense we expect daylight to come from above. When light sources are positioned at different angles it evokes a range of atmospheres. One of the most deliberately effective lighting positions is from below, and is used in the film noir and horror genres to signify that all is not as it should be. Light from below casts unnatural-looking shadows, creating unease and anxiety in the viewer. A look that visually supports the classic themes of crime and justice in a nocturnal, artificially lit environment.

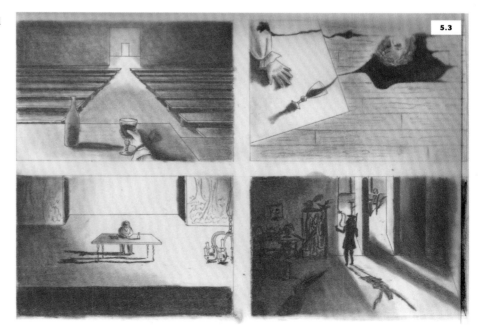

5.3
For this paper based student project set in a theatre, Elisa Scubla defined each of the four key spaces through sketches including light position and direction creating atmosphere and effective contrast.

Shadows typically created by venetian blinds or other combinations of horizontal and vertical lines visualize how characters are often ensnared by their own weaknesses. When faces are half in light and half cast in shadow it is used to suggest conflict, indicating internal issues that need to be resolved or suggesting a psychologically fractured personality disorder. In its simplest form, it can represent the binary opposition of good and evil, or a turning point where two equally strong forces are at work.

These expressionistic lighting approaches have been influential in filmmaking, with designers referencing distinct styles in inventive ways. Crime dramas, thrillers and action genres often use direct shafts of light to suggest police lights or helicopter beams, for example, where hard cold light is literally searching out someone on the run. Sharp beams of light like this are used to signify danger and violence or a quest for truth or justice. The *Batman* films (1989, 1995, 1997, 2005, 2008, 2012) nod to the original graphic novels, the style is deliberately exaggerated, allowing for sharp, contrasting lighting distilled in the bat signal itself. A stencil of a bat projected in the sky by a powerful searchlight is used by the city police when they need Batman's help to solve a crime. In *Breaking Bad* (2008–2013), bright sunlight indicates harsh facts of life and danger. Each character is visualized and described through their relation to light, and are lit specifically according to their role in the story and relationship to each other.

Lens flares can signify ruptures in reality or a character's consciousness. Early examples of this in *Easy Rider* (1969, Dennis Hopper, PD, Jeremy Kay) were created through breaking the rules of camera work at the time. This effect had been previously considered undesirable and avoided as it can look like a mistake – it has subsequently been appropriated as a mark of authenticity, with contemporary filmmakers creating a lens flare effect using after-effects in post-production. For example, in *Star Trek* (2009, J. J Abrams), the director has been accused of overusing the technique in an attempt to visualize the future. These flares create a luminous quality that can show key character development and pivotal points in story.

The lack of natural light, whether motivated by night-time scenes or genres such as science fiction allows light to be used expressively where visual styles can be crafted motivated by aesthetic concerns and the emotions of characters. In *Bringing Out the Dead* (1999, Martin Scorsese, PD Dante Ferretti), Frank Pierce (Nicholas Cage) is a paramedic struggling with depression. Taking place during three intense night-shifts, almost all the scenes are set at night using artificial light – this allows him to be expressively lit and to shine out in the darkness. *Blade Runner* (1982, Ridley Scott, PD Lawrence G. Paull) takes noir lighting schemes and adds colour. Harrison Ford is the blade runner who is in pursuit of four replicants in search of their creator. The lighting design is one of the influences that contributes to it stylistically combining science fiction and film noir. The rain in the city scenes adds another layer of light – as drops catch the light they glint, adding texture to the frame. The neon signs echo those of noir films, but this time with colour and movement. *Dark City* (1998, Dir Alex Proyas, PD George Liddle, Patrick Tatopoulos) is set in a world without sun, which supports the story in a practical and atmospheric sense. The protagonist tries to remember his past, eventually realizing that there is no sun because he is not on earth. The unsettling lighting contributes to the essence of the story. As the mystery is investigated, we discover that this is not earth and the dark city is actually being controlled by alien beings seeking to control the human soul.

5.4

5.4

Betty Blue (1986, Jean Jacques Beineix, PD Carlos Conti). An open doorway with light flooding in. We can see the inside and the outside connected in the same frame which is significant when Betty first visits Zorg's beach home. Betty (Beatrice Dalle) brings with her passion, turbulence and change.

Windows and doorways

Open doorways and windows create lighting opportunities – using natural or artificial light to define a space. Whether looking from the outside in or from the inside out provides shifting perspectives as discussed in Chapter 4. Choices the designer makes about windows will influence the look and mood enormously. In a day scene the natural light suggested from a window creates a completely different effect to alternative artificial sources.

The Western genre employs doorways to deliberately signify boundaries between civilization and the desert. This is often accentuated by the lighting to create silhouette to further enhance the binary oppositions of bright light and dark shadow. Much has been written[7] on the frames within frames created in this genre to suggest cultural division and potential hostility.

Set in a post-apocalyptic France, a delicatessen advertises for handymen who are then butchered to feed the community. In *Delicatessen* (1991, Jean Pierre Jeunet, PD Marc Caro), natural light is abundant through the large open windows during the day, which is contrasted with the artificial light in the underground scenes. During the day the house is bright and well-lit, and at night the darkness underpins the duality of the space that nocturnally transforms into an abattoir.

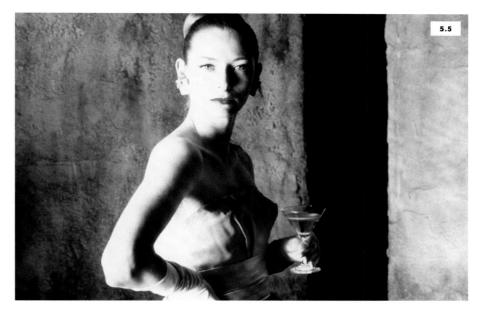

5.5

The designer Christopher Hobbs rejected the principles of motivated light sources for *Edward II* (1991, Derek Jarman), in which the entire film was designed without windows, doors or practical lamps. Without any points for the light to realistically come from, there is no attempt to insinuate light source or direction in this way. The solution was for the lighting to be motivated by the emotion of the scene – a bold and effective departure from the conventions of lighting. Hobbs repeated this lighting approach in the television adaptation of *Gormenghast* (2000, Andy Wilson, PD Christopher Hobbs), but on a grander scale.

5.5
Edward II (1991, Derek Jarman, PD Christopher Hobbs). Unmotivated by practical lamps, windows or doors, the lighting is motivated by the emotion of the scene which creates a more expressive visual style disconnected from codes of realism often used in the language of film lighting.

CHARACTER AND STORY

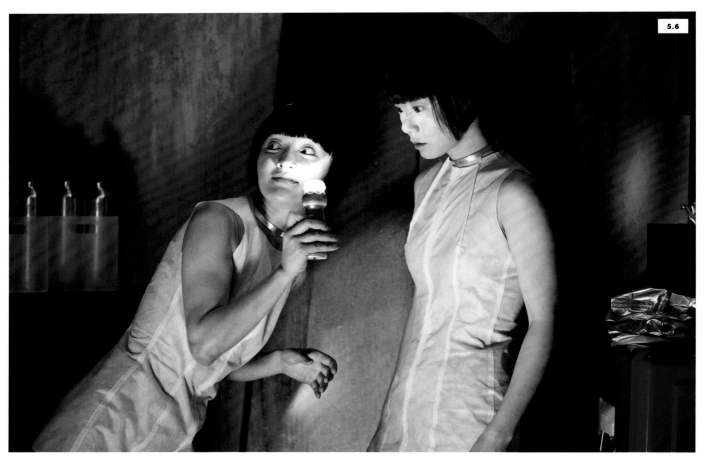

5.6

The source of light will often be indicated to some extent in the script, depending on whether a scene is set during the day or night, interior or exterior, all of which will be influential factors in a practical sense. However, the lighting is also motivated by the emotion of a scene so the designer will consider ways of drawing this out visually.

Lighting decisions are usually worked on collaboratively with the DoP and director. As PD Jim Clay says, the designer creates possibilities for the DoP to light from:

You always work with the DoP very closely. It's usually about tone and texture in the individual spaces and the overall piece. Providing them with opportunities to light, for example, the positions of windows in a place. Does a place have a full ceiling on it? Is sun streaming in from one direction?[8]

5.6
Cloud Atlas (2012, Tom Tykwer, Lana Wachowski and Lilly Wachowski, PD Hugh Bateup and Uli Hanisch). This night scene uses a handheld prop/torch as lighting source. Yoona-939 and Sonmi-451 are lit by the torchlight coming from Yoona-939. The key motivated light source is atmospheric in this transgressive scene in which the non-pure bloods (who have been mass-produced in order to work as servers to the pure bloods) get out of their sleeping pods to explore and question the extremely limited boundaries of their existence.

Depriving characters of natural light is a technique utilized in moving image to reflect a range of concepts, as illustrated in the examples that follow.

The limited lighting in the scene in Figure 5.6 from *Cloud Atlas* (2012, Tom Tykwer, Lana Wachowski and Lilly Wachowski, PD Hugh Bateup and Uli Hanisch) supports the concept that these characters are trapped in a relentless cycle, without pleasure or natural light. They are denied any illusion of freedom, dwelling as they do in an underground shopping mall, serving fast food all day and sleeping in a coffin-like pod at night. Yoona-939 breaks the rules by getting out of her pod and having some fun, which is potentially punishable by death, and therefore making this seemingly frivolous scene representative of something much more sinister.

PD Mimi Gramatky agrees that lighting helped to define the interiors and the exteriors in a recent project, *10,000 Days* (2014, Eric Small, PD Mimi Gramatky). In the story, a comet has struck Earth and sent it into a deep freeze. Twenty-seven years later the survivors are still fighting to stay alive:

As with everything else, all light appeared to be natural or from man-made sources that were recycled – nothing new. Exteriors were cold, dark and threatening, directional, while interiors were soft, warm and shadowy because of limited light. The interior of Air Force One was a combination of the two. The only light in the plane came from the actors' helmet lights or LED flashlights, as if light brought life back into the felled plane for all of its frozen captives...flashlight beams come through the plane windows and with them literally the breath of life.[9]

Based in the Paris metro stations, *Subway* (1985, Luc Besson, PD Alexander Trauner) uses limited light – the absence of daylight can create a sinister subterranean atmosphere, but in this instance a wonderful world of colourful subversive characters is drawn on as an alternative to the conventional world above ground. A character welding becomes a magical scene watched by the ensemble like a firework display, with sparks of light spraying in the darkness deprived of any natural light source, which creates a dreamlike atmosphere. All lighting is artificial in the subway, but this particular form is elemental and marks a transition point for Helena (Isabelle Adjani) who sees hope in the light and refuses to continue in her unhappy marriage any longer – light is used as a metaphor for truth and hope.

5.7
Mimi Gramatky, *10,000 Days* (2014, Eric Small). The only light sources in the plane come from the characters' helmet lights or handheld LED torches. Torchlight creates atmosphere and a feasible light source for the situation.

Mimi describes the use of light as supporting the story in relation to the practical situation of the characters in a post-apocalyptic scenario. The restricted artificial light is due to limited resources and works as a metaphor for life and hope for survival after the disaster.

The Shining (1980, Stanley Kubrick, PD Roy Walker) follows a family to the isolated Overlook Hotel where the father plans to write while acting as caretaker during the out-of-season hotel closure. A malevolent spirit pervades the hotel, infiltrating the father's mind and putting his wife and son in danger. The hotel is lit by electric lighting, and lack of natural light helps disorientate and separate the characters from the outside world. Regardless of the time of day or night the light remains the same which affects the sense of being trapped further. There are an absence of views from windows. In the ballroom scene, which is suddenly filled with figures – the products of his deranged mind, Jack sits at the bar lit by a powerful fluorescent strip stretching along the length of the bar – and by other reflected strips of light. Immersed in strong fluorescent light, at this point he is completely out of control. With the resolution of the film, daylight returns and Jack is found dead sitting outside frozen in the snow. The light design in terms of source follows the character arc in this way.

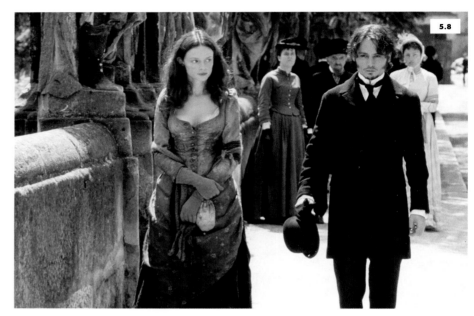

From Hell (2001, Hughes brothers, PD Martin Childs) sees a group of women working as prostitutes preyed on by Jack the Ripper. Inspector Abberline attempts to unravel the mystery and motivation of the killer. The lighting design reinforces the contrast between the east and west of the city of London. The majority of the film takes place in Whitechapel in the east where there is a lack of sunlight, and mostly nocturnal, the light sources being gas street lamps or candles. These sources visually support the

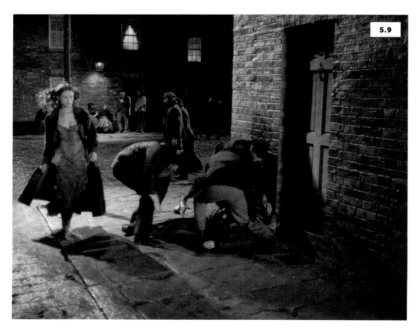

5.8
From Hell (2001, Hughes brothers, PD Martin Childs). Mary Kelly (Heather Graham) and Inspector Abberline (Johnny Depp), in one of the rare glimpses of natural daylight, which features on a visit to a gallery located in the west end of the city. The colour of Mary's dress makes her stand out and exaggerates the difference between the respectable subdued colours of the passers-by.

5.9
From Hell (2001, Hughes brothers, PD Martin Childs). Mary in her natural habitat of the Whitechapel District in the East End of London. Largely in shadow, lighting from windows and street lights is low key and motivated.

concept of the East End as subterranean hell. When Inspector Abberline and Mary Kelly leave the East End to visit the National Portrait Gallery in central London, the lighting design transforms to bright sunlight. The simple contrast in light source dramatically changes the atmosphere and sense of place. The daylight-lit streets of respectable London seem ordered and safe, clearly differentiated by the light source from the unruly world of Whitechapel.

In *St Vincent* (2014, Theodore Melfi, PD Inbal Weinberg), an unlikely friendship develops between 12-year-old Oliver and his misanthropic next-door neighbour Vincent. Oliver is begrudgingly nurtured by war veteran Vincent (Bill Murray) whose house exterior is dilapidated, with peeling paint, woodwork in disrepair and a garden of dusty earth where grass once grew. This exterior is mirrored in Vincent's dishevelled appearance and interior world – he is self-destructive which culminates in him smashing into his own fence while drink-driving. The light in Vincent's home is dark, often featuring artificial light sources, from lamps and the television screen. The light reinforces the concept in relation to his personal space, and follows his journey as an unlikely saint in the eyes of the young boy in search of reliable male role models after his parents' recent divorce. The character Ocinski and his mother's home provides the opportunity to create visual contrast to enhance the problems (lack of light and order) identified in Vincent's life and home.

The lighting in *The Rewrite* (2014, Mark Lawrence, PD Ola Maslik) follows a similar trajectory. The protagonist is Keith Michaels, a screenwriter who has taken a job teaching. This is a last resort after his home in LA is literally plunged into darkness when the power supply is cut off due to his lack of income/work. This absence of light leads him to take the teaching job he has obvious

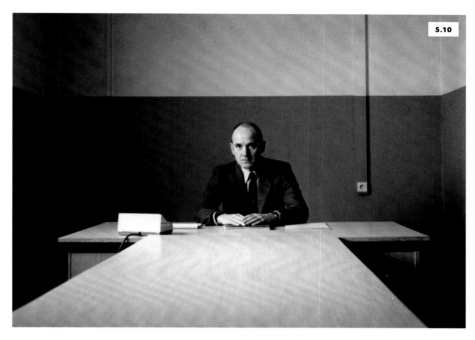

5.10

disdain for. When he gets to the small town of his new post his office is dimly lit; in spite of windows and apparent natural light, this space is lacking light. His journey involves mistakes, flaws and desperation but through teaching he finds new inspiration and the light (both physically and metaphorically) gradually returns to his life.

In *The Lives of Others* (2006, Florian Henckel von Donnersmark, PD Silke Buhr), the contrast in light design illustrates the different sensibilities and values of two of the main characters. Set in East Berlin during the 1980s, the Stasi spy on individuals thought to be involved in subversive activity. The playwright Dreyman is put under surveillance, watched by Stasi officer Weisler – the design for the homes of the two characters encapsulates the story. Weisler's sterile bland apartment is lit with artificial light, while Dreyman's home is bursting with character and natural light. Weisler's cold grey apartment, office, clothes and existence signify the uniformity of the political system he is working for. The warmth and

humanity of those he is watching seeps into his life, infiltrating his subsequent actions. Surveillance equipment is set up in a loft above Dreyman's apartment. The loft space is a transition space where Weisler slowly becomes enchanted by the lives he is observing. As such it is empty, concealed from view and includes bursts of daylight and shadow – possibility exists here and Weisler slowly opens to it. This lighting design underpins the characters and highlights the contrast between the ideological positions they embody, thus promoting the visual concept of opposing values and ways of living.

5.10
The Lives of Others (2006, Florian Henckel von Donnersmark, PD Silke Buhr). Weisler's cold, flat, grey environment before he is affected by Dreyman's light and life.

Set in Washington DC in 2054, in *Minority Report* (2002, Steven Spielberg, Alex McDowell), a pre-crime unit is set up to arrest criminals before the crime is committed. The visual concept reflects the hierarchy of power that stems from the inequity of the system. The upper city is populated by the privileged middle class adhering to and controlled by the pre-crime corporation, while the lower city is off the grid, neglected by the corporation and left to fester. The underbelly of society is deprived of light, sharing a similar visual concept to that discussed in the *From Hell* example.

Fluorescent lighting was used in the lower city (in contrast to the upper city), effectively highlighting the absence of natural light there that is being blocked by the upper city. PD Alex McDowell worked with the DoP to create motivated light within the set, so that the quality of light is integral to the design and can be used as practical lighting:

> The DP Janusz Kaminski's love of fluorescent light as a source and our desire not to have to pull the set apart to do external lighting led to our including it in the set as a source. That's my preference, to build lighting into the environment in collusion with the DP so the kind of lighting equipment that we put in looks like fluorescent light and it's being bumped up sufficiently for the DP.[10]

This is an example of how the collaborative process between departments enhances and creates a stronger end-product than any of the individuals working on a production. McDowell says:

It's such a creative tension when it works – I love the pressure that a DP puts on the designer about how the camera should move, what's the access to the space, how do we get the lights in there, how do we resolve the tension between wanting a physically intact set that will put enough light in for the DP's requirements – it's a constant dialogue.[11]

When Anderton in *Minority Report* goes in search of the truth, he finds further clues from one of the original pre-cog team about the possibility of an alternative prediction where he might not have committed murder – a minority report. Bathed in the natural light of a greenhouse, the nurturing environment has positive connotations of hope in relation to growth and life, while also reminding us of the strength of the survival instinct. This pivotal moment in the narrative reveals a fact previously unknown that may save Anderton and prove his innocence. Whole walls and structures of glass illuminate the

scene bringing clarity at the same time as vulnerability by making him visible to his enemies. The light in terms of story has gradients, from the limited fluorescent light in the lower city to the ampler light of the upper city, and the bleaching out of natural light in the greenhouse. These are simple metaphors for the narrative in relation to concealing and revealing truth.

In *Psycho* (1960, Alfred Hitchcock, Robert Clatworthy and Joseph Hurley), Marion Crane is on the run with stolen money. Instead of banking the cash for her boss, she decides to take it and drive to her boyfriend Sam in California to help finance a fresh start together. However, as Marion travels further away from home, it becomes darker and darker as night falls and she gets into more and more trouble and danger as she propels herself into the darkness. She eventually pulls off the road when she sees a neon sign for the Bates Motel. Looking up to the windows of the house behind the motel, she

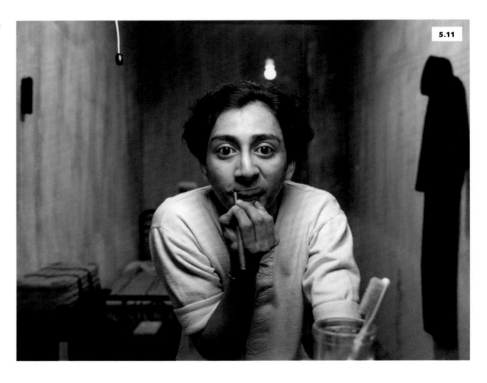

5.11
The Grand Budapest Hotel (2014, Wes Anderson, PD Adam Stockhausen). Zero (Tony Revolori) in his tiny cramped room with a single light bulb as visual illustration of character and story.

5.12
The Grand Budapest Hotel
(2014, Wes Anderson,
Adam Stockhausen). The
front of house in the hotel
tells a different story.
The assembled staff of
the hotel gather in the
spacious and opulent
reception area illuminated
by abundant light sources,
including chandeliers and
windows.

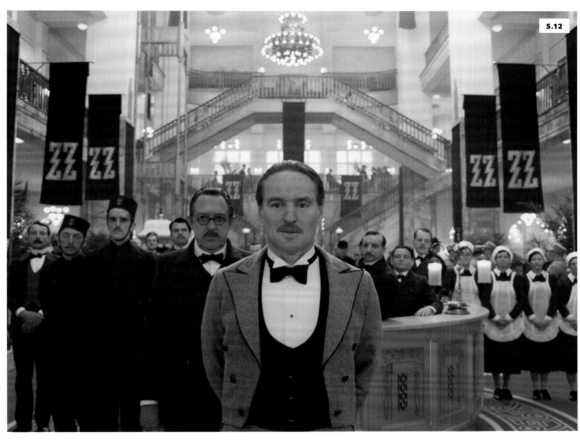

glimpses what will become apparent as the mother figure, in silhouette at a brightly lit window. The lighting is significant in many ways – at this distance it helps to convey the impression of a woman's shadow. The strength of the lighting also signifies the harshness of what the mother subsequently says and the potentially threatening nature of her character to both Marion Crane and Norman Bates.

In the case of *The Grand Budapest Hotel* (2014, Wes Anderson, PD Adam Stockhausen), the lighting contrast between the hotel guest space and the staff quarters is used to define differences between the two worlds. Colour, space and dressing all enhance the distinction between the attractive front-of-house creation and

the behind-the-scenes life of Zero (Tony Revolori), the new bellboy. Set in the 1930s in a popular European ski resort, the hotel concierge Monsieur Gustave H. (Ralph Fiennes) keeps things running smoothly until a hotel guest dies mysteriously and he becomes a suspect in her murder.

The use of these different light sources within the hotel function to indicate spatial difference and communicate character detail and narrative information. For example, the geography of the hotel is delineated by the difference in lighting, with guest areas being attractively lit with warm soft light in contrast to the sparse lighting provided in the staff areas. Zero's bedroom lighting indicates his lowly status as a bellboy who is starting at the bottom of the hotel hierarchy. Later in the

office scene, Zero is helping the concierge M. Gustave who since becoming a suspect in a murder enquiry is no longer bathed in the front-of-house lighting glow. He is now subject to the harsh fluorescent light in the office, indicating a dramatic shift in fortune and status. On the other hand, for Zero this lighting design has positive implications – in place of the solitary light bulb in his bedroom there are now two strips of fluorescent light. He is no longer alone.

COLOUR

Lighting colour is manipulated with coloured gels and filters and subsequent colour grading. Cold blues and warm straw-coloured gels are popular in naturalistic productions to create everyday lighting and to balance with either daylight or tungsten light sources. A stronger use of coloured light will create a sense of another environment and a more dramatic atmosphere. Cold, hard blues have become shorthand for futuristic sci-fi projects as seen in *Children of Men* (2006, Alfonso Cuarón, PD Jim Clay) and *Minority Report* (2002, Steven Spielberg, PD Alex McDowell), for example. More recently, *Her* (2013, Spike Jonze, PD K. K. Barrett) used hazy, warm light departing from this convention.

Light in *V for Vendetta* (2005, James McTeigue, PD Owen Patterson) included a lot of red to convey conflict, drama and tension, while the use of purple light in *Chicago* (2002, Rob Marshall) signalled death. Yellow and green lighting is often used to convey unnatural, other worldly or sinister concepts. The green light that features in *Far From Heaven* (2002, Tod Haines, PD Mark Friedberg) indicates that something is being perceived as not acceptable in the social environment.[12]

The *Harry Potter* films, although shot in colour appear almost monochrome because of a combination of the film stock, lighting and colour palette of the film. Stuart Craig has suggested that one of the safest approaches to colour is to get rid of it which then allows the lighting to work. Craig says grey is part of a British colour sensibility with grey skies reflecting and influencing the architecture that surrounds us.

> Grey is part of our sensibility and we recognize it as part of our lives [in Europe].[13]

Lighting colour choices can be selected to differentiate period and place, for example in *The Hours* (2002, Stephen Daldry, PD Maria Djurkovic) which uses three separate colour palettes to define the three main character's distinct storylines and eras. The three colours emotionally reflect the journey of the characters: for 1923–1941, a soft filter is used that subdues the colours; for the 1950s pastel shades are used; and for the present-day, cold blue. Seamus McGarvey, the DoP chose these filters to work with the emotional trajectory of the characters.

Traffic (2000, Steven Soderbergh, PD Philip Messina) contains complementary colours of blue in the foreground and orange in the background. These two lighting colours are employed to highlight two locations: Mexico is orange and Ohio is blue. Colour-coding the film underpins the concepts of capitalism and social injustice while also clearly orienting the audience between the two geographies. *Pan's Labyrinth* (2006, Guillermo del Toro, PD Eugenio Caballero) also colour-codes two worlds. In this example, one is the real world, the other is a fantasy. The real world is identified by cold colours, grey, blue and green and the fantasy world uses warm golden reds and yellows. When the two worlds begin to affect each other the colour palettes collide, indicating the boundaries between fact and fiction are blurring. Subsequently 'reality' becomes more difficult to discern as ambiguity replaces the certainty of the earlier contrasting environments.

PAINTINGS

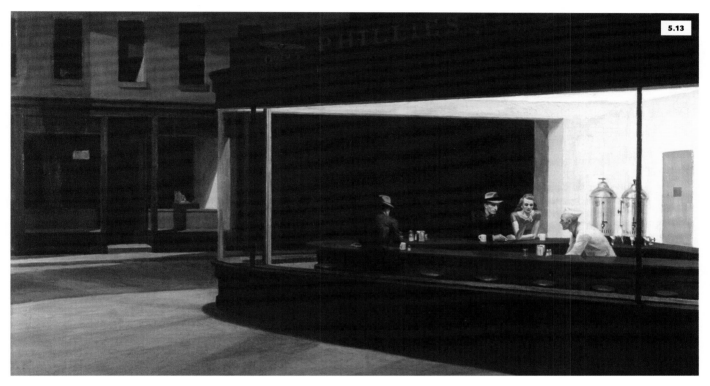

5.13

Paintings are often referred to for the way light is used in composition. Stuart Craig looks at a range of painters for inspiration:

> John Martin, a Victorian artist, painted these huge apocalyptic landscapes, catastrophic storms and terrible seizures between planetary systems. If you were designing *Lord of the Rings* it would be perfect. Other painters I refer to are Caravaggio and Hopper, both very cinematic in their composition and use of light. So there are favourites and you often find they're shared.[14]

Other shared favourites include Rembrandt, Turner and Vermeer. By studying paintings that have a particular atmosphere or emotional effect, designers can create similar moods and lighting opportunities for the DoP. The size and position of windows, doorways and practical lights can help produce the desired effect.

Such is the importance of painting in relation to light that several film courses and design schools use exercises that consist of 'building a painting'. Moira Tait at the National Film and Television School (UK) gives her students a different painting each year to recreate in every respect. This requires the students to examine the light sources and try and construct these as closely as possible.

The painter Edward Hopper (1882–1967) is often referred to in film and television for light, composition and colour. His painting *Nighthawks* (1942) is referenced explicitly in Wim Wenders' *The End Of Violence* (1997, PD Patricia Norris) (the film has a scene featuring a live recreation of *Nighthawks*) – and as a visual reference for *Blade Runner* (1982, Ridley Scott) with the painting's colour and light palette influencing the portrayal of Deckard's isolated city life. Ken Adam reproduced Hopper's *Nighthawks* and *New York Movie* (1939) for *Pennies from Heaven* (1981, Herbert Ross).

5.13
Edward Hopper, *Nighthawks*. 1942. Oil on canvas, 84.1 cm x 152.4 cm. Art Institute of Chicago, Chicago, Illinois.

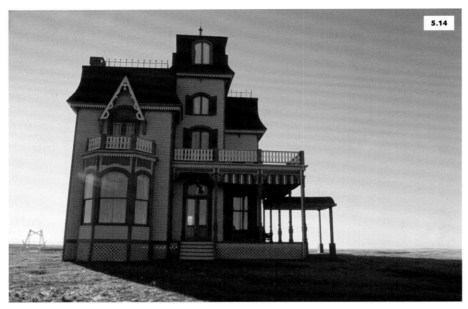

5.14

5.14
Days of Heaven (1978, Terrence Malick,
PD Jack Fisk). Edward Hopper's isolated
mansion of his painting *House
by the Railroad* (1925) has also been
referenced in *Giant* (1956, George
Stevens), and *The Addams Family* (1991,
Barry Sonnenfeld) home.

Hopper and in particular *New York Movie* was also influential in *Road to Perdition* (2002, Sam Mendes, PD Dennis Gassner) to capture the dark urban Depression-era interiors. Hopper's paintings of lakeside and seaside houses were also drawn on for the still and peaceful light of protagonist Sullivan's final destination.

For *Psycho* (1960, Alfred Hitchcock, AD Robert Clatworthy), Hopper's *House by the Railroad* (1925) is referenced, featuring a Gothic farmhouse with a mansard roof in an isolated landscape that resonates with a lonely quality, and which informed the look of the Bates house. Hopper's recurring themes of people being trapped by their own design, through framing of subjects in windows or the buildings in his paintings, echoes the confined, isolated existence of Norman Bates. This painting is also an influence on Terrence Malick's *Days of Heaven* (1978, Terrence Malick, AD Jack Fisk) and the homestead in it. The film is set in the vast prairies of Texas (but shot in Canada), and the bright afternoon sunlight creates a warm golden glow. Another

painting that influenced *Days of Heaven* is *Christina's World* (1948) by Andrew Wyeth which features a woman helplessly crawling through an expanse of field under a blue sky, and which directly informs the light and colour choices.

The paintings of the original master of chiaroscuro (that is, the treatment of light and shade), Michelangelo Merisi da Caravaggio's work (1571–1610) has influenced many filmmakers. Martin Scorsese has commented on the staging and lighting in *The Calling of St Mathew* (1599–1600), for example, as being highly cinematic in its modernity and a huge influence on *Mean Streets* (1973, Martin Scorsese) in particular. The way Caravaggio composed his subject matter broke with painting tradition in that he staged the scene at the centre of the action, engaging the audience in the drama. This direct approach stripped away the romanticism of earlier painting and attempted to get to the heart of the story and character. Caravaggio is identified as a realist in his approach to his subject matter and style.

After in-depth research for a biopic of Napoleon fell through, director Stanley Kubrick used the material on the period to adapt the 1844 novel *The Luck of Barry Lyndon* by William Makepeace Thackeray. It is a satire about a character's entry into the English aristocracy. To convey the elegant candlelit interiors of the period, he avoided repeating the usual artificial light seen in costume dramas, and took inspiration from the period paintings of the time such as William Hogarth's 1745 painting *The Country Dance* for the look and lighting of his scenes. Thus the *Barry Lyndon* (1975, Stanley Kubrick, Ken Adam) interior scenes have candles in them that are actually providing the light for shooting. This required special lenses with large apertures to allow sufficient light to create the radiance of a pre-electrical age on screen. The flickering glow of candlelight found in painting is achieved in the film, imbuing a sense of authenticity and verisimilitude.

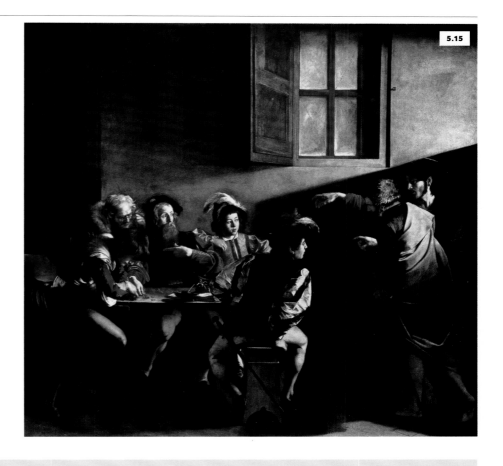

5.15
Michelangelo Merisi da Caravaggio, *The Calling of St Matthew.* 1599–1600. Oil on canvas, 322 cm x 340 cm. Church of St Louis of France, Contarelli Chapel, Rome. The window is a key motivated light source in this painting, crafting depth, character and vibrant life into the scene.

Suggested viewing

Here are some films that directly refer to painters and attempt to capture the light quality of their work:

Johannes Vermeer (1632–1675)

Girl With a Pearl Earring (2003, Peter Webber, PD Ben van Os) focuses on the Dutch painter Johannes Vermeer and his maid who becomes his assistant and model. The lighting in the film strives to capture the lighting in Vermeer's paintings in direction, source and intensity.

J. M. W. Turner (1775–1851)

Mr. Turner (2014, Mike Leigh, PD Suzie Davies) explores the personal life of British painter J. M. W. Turner in which he secretly becomes involved with a seaside landlady. He is seen executing various paintings and recreating familiar scenes.

Michelangelo Merisi da Caravaggio (1571–1610)

Caravaggio (1986, Derek Jarman, PD Christopher Hobbs) This is a fictional biopic which considers the seventeenth-century Italian painter and ponders ways in which his personal life may have been reflected in his work.

Vincent Van Gogh (1853–1890)

Lust for Life (1956, Vincente Minnelli, PD Preston Ames, Cedric Gibbons, Hans Peters). This film portrays the Dutch artist struggling with mental illness and failure but continuing to paint in the face of much adversity.

Rembrandt Harmenszoon van Rijn (1606–1669)

Nightwatching (2007, Peter Greenaway, PD Maarten Piersma) is based on Rembrandt's painting *The Night Watch* (1642) and the controversy around his identification of a murderer in the painting.

INTERVIEW WITH RONALD GOW

Ronald Gow's professional experience as a designer has been both in film and television, including feature films, short dramas, sitcoms, talk shows, game shows and variety shows, as well as in developing and producing non-fiction programmes and film documentaries. He has also designed and collaborated in staging a number of exhibitions, conferences and festivals, as well as producing corporate-related graphic design material and designing shops and furniture.

Can you give a brief overview of the project *Killing Time* (1996, Bharat Nalluri, PD Ronald Gow) please?

Killing Time (1996, Bharat Nalluri, PD Ronald Gow) – the project actually started with another proposed film, *Downtime* (1998, Bharat Nalluri) (a much better script) with Channel 4 attached. *Killing Time* was done quickly so as to prove Pilgrim Pictures could do a feature – that is how I understood things. Much of *Downtime* was set in a working lift in a tower block. I started researching and making models of lift shafts and how we could get a full-scale lift moving as well as models. This proved useful a few years later on a student production where the shaft was horizontally not vertically laid out in the studio on a rostrum, and run about 10–12 metres, with the camera on a dolly and arm, and turned 90 degrees to the shaft – which gave the sense of moving up and down the shaft. Smoke was a problem – our gravity wasn't right. But it worked well.

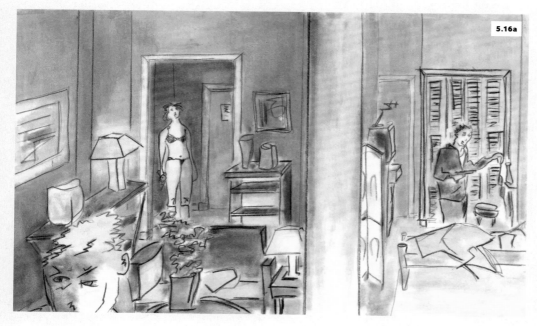

5.16a

5.16a
Killing Time (1996, Bharat Nalluri, PD Ronald Gow). Interior hotel suite – view of lobby, reception and bedroom spaces, looking towards the doorway with the female assassin about to kill the intruder.

5.16b
Interior hotel showing
bedroom and bathroom
spaces. The intruder finds
a body and the female
assassin is disturbed in
her bath.

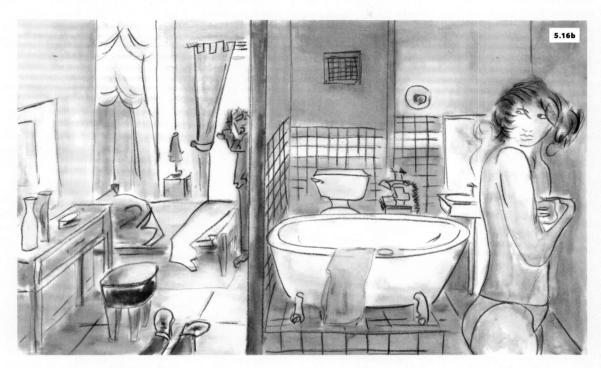

5.16b

How would you describe the overarching design?

The majority of the story of *Killing Time* is that a woman arrives
in Newcastle in the morning, goes to her hotel and waits for an
appointment scheduled for the evening: she doesn't leave the
hotel room till then. She is a hit woman on an assignment; local
gangsters and the police 'visit' her throughout the day – some
seeking to kill her or arrest her. She kills time by killing some of
them. So how do you make a hotel room dramatic, and dramatic
over the course of the day? That was the challenge.

What were your references? Did you have any key images that you used?

I had been looking at mazes and labyrinths. A person is controlled
by a precise 'path of circulation' that is constructed by the
pattern of the maze or labyrinth (in garden design). Then I looked
to see whether this had been used in architecture and then
focused slightly more on film design.

There were two film references. The first was Renoir's *Rules of
the Game* (1939, Jean Renoir, PD Max Douy and Eugene Lourie)
and the antics in the house at the costume party where various
chases take place across and through a number of composite
spaces. The other is much more specific, the Palm Beach hotel
room suite that Robert Stack takes Lauren Bacall (and Rock
Hudson) to in Sirk's *Written on the Wind* (1956, Douglas Sirk, AD
Robert Clatworthy and Alexander Golitzen). I borrowed a lot of
the actual layout and dressing of my hotel suite from this scene.

What is your starting point in creating a coherent visual concept?

It varies but usually it is about mapping where the characters
move to and from and what they do. Entrances/exits and the
mechanics of action, but at the same time how that character
would do that and whether this could produce a specific logic.

Can you talk about the characters' movement in the setting – especially the in and out? How early do you decide on the relationship between the interior and exterior, and how do you make that relevant and possibly enhance the story?

To me, it was all about the character moving in and around the space – knowing it and making it her territory and domain. A space she controlled and one in which others who came into it were in jeopardy.

Design has to be absolute, there on screen. Don't buy the idea that bashing light through some bars says the character is imprisoned or looking in a mirror…the context is the key. In the *Killing Time* hotel suite, the chain of spaces as designed had the logic of a maze pattern. But [it was] a logic I could subvert by allowing our heroine to escape her visitors – by climbing up through ventilation shafts or circumnavigating them by using doors, in a way that goes against the logic of how you move through this suite.

Could you describe how you used light in your design?

Taking the cue from *Written on the Wind* (1956, Douglas Sirk, AD Robert Clatworthy, Alexander Golitzen) there are two double patio windows – at 90 degrees to each other. The exterior day and daylight would illuminate and precisely mark the passing of the day over the course of the film – it starts in light and moves to darkness.

How closely did you collaborate with the director, DoP and other members of the team?

The original DoP dropped out as we started – his operator took over. The big person was the gaffer [Vic McCullagh] – who I'd worked with before – and Vic did a lot of the lighting. Collaboration wasn't really the name of the game – it was more getting it done.

In what ways has budget influenced your process?

Money can get things done but design and the design process should solve many of these problems cheaply if given time. Yes, money has to be spent but it has to be carefully thought about – we are making illusions, and doing a trick is surely part of the fun.

Stuart Craig talks about the importance of sketching settings from the idea of where the master shot is. He says 'If you allow an alternative to present itself all can be lost'. Would you agree?

He is almost quoting Alfred Junge – and I agree – 'we' have to put X on the floor [this was part of Alfred Junge's practice which was termed total design] very early on and say this is the master shot, but don't think contemporary digital filmmaking – at present like that, 'they' want the world '360'.

Do you look at other designers? Whose work do you admire and why?

Historically – William Cameron Menzies as an illustrator, Junge as a pragmatist and painter, Hein Heckroth as a painter and fantasist. Chris Hobbs' work with Jarman and Davies. Tony Abbot at the BBC from the 1950s onwards – stylization and abstraction. Mark Leese who has just done *High Rise* (2015, Ben Wheatley). He previously did *This is England* (2006, Shane Meadows) and loads of other stuff – he gets it right in terms of socio-historical context.

The recent version of *Far from the Madding Crowd* (2015, Thomas Vinterberg, PD Kave Quinn) is a great film with incredible detail and moving onto the costumes – period but not…and the general design, not chocolate box but Gustave Courbet (besides being a painter he wrote a treatise on realism in 1855 which is crucial to the idea).

5.16c
Killing Time (1996, Bharat Nalluri, Ronald
Gow). In the hotel suite the intruder sees
a body lying next to the sofa. The woman
assassin is sitting on the bed waiting
in the adjoining room – she is lit by the
natural daylight flooding in the patio
doors. Her victim is also lit by another set
of patio doors in the next room.

Exercises

1. Study the **paintings of the artists** mentioned in this chapter and note what direction the motivated light is coming from.

 - Is there more than one light source?

 - Are they of the same intensity?

 - How does the light affect the scene in terms of understanding of character and story?

 - What sort of atmosphere is created through the lighting?

2. Sketch a scene for one of the settings in the *Clay* script provided in the Appendix. Include position, direction, colour and intensity of light sources.

 - Sketch the same scene using variations on the light sources based on a painting of your choice.

 - Consider the ways in which this might alter the look and feel of the scene.

Further Reading

Alton, John. *Painting with Light*. Berkeley: University of California Press, 2013.

Bellantoni, Patti. *If It's Purple Someone's Gonna Die: The Power of Color in Visual Storytelling*. Burlington: Focal Press, 2005.

Bergfelder, Tim, Sue Harris, and Sarah Street. *Film Architecture and the Transnational Imagination. Set Design in 1930s European Cinema*. Amsterdam: Amsterdam University Press, 2007.

Brown, Blain. *Cinematography: Theory and Practice: Image Making for Cinematographers and Directors*. Burlington: Focal Press, 2011.

Cardiff, Jack. *Magic Hour: A Life in Movies*. London: Faber & Faber, 1997.

Frayling, Christopher. *Spaghetti Westerns: Cowboys and Europeans from Karl May to Sergio Leone*. London: Routledge and Kegan Paul, 1981.

Graham-Dixon, Andrew. *Caravaggio: A Life Sacred and Profane*. London: Allen Lane, 2010.

Hollander, Anne. *Moving Pictures*. Cambridge: Harvard University Press, 1991.

McIver, Gillian. *Art History for Filmmakers. The Art of Visual Storytelling*. London: Bloomsbury, 2016.

Saunders, John. *The Western Genre: From Lordsburg to Big Whiskey*. London: Wallflower Press, 2001.

Storaro, Vittorio. *Storaro: Writing with Light*. Milan: Mondadori Electa, 2011.

Notes

1 Tim Bergfelder, Sue Harris, and Sarah Street, 89.
2 Stuart Craig, author interview, 2008.
3 Stuart Craig, author interview, 2008.
4 Hugo Luczyc-Wyhowski, author interview, 2015.
5 Tom Turner, author interview, 2015.
6 North light has luminous efficacy (lm/w48, colour temperature 6,500 degrees Kelvin and colour rendering index R = 94).
7 See John Saunders, 2001; Christopher Frayling, 1981.
8 Jim Clay, author interview, 2005.
9 Mimi Gramatky, author interview, 2014.
10 Alex McDowell, author interview, 2015.
11 Alex McDowell, author interview, 2015.
12 Patti Bellantoni, 32.
13 Stuart Craig, author interview, 2000.
14 Stuart Craig, author interview, 2014.

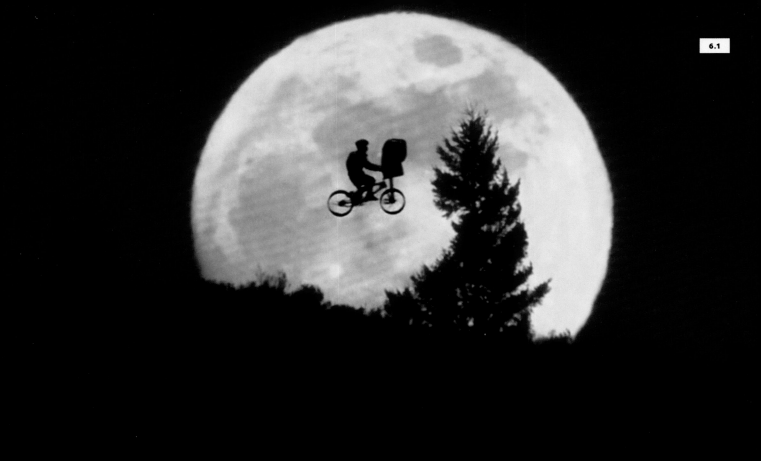

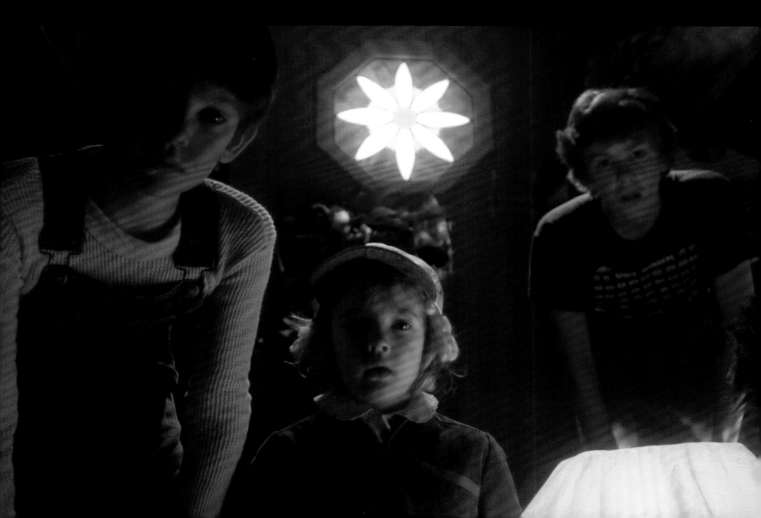

CHAPTER 6
COLOUR

The psychological effects of colour can be crafted to evoke atmosphere, time, place, character and even plot development. Choices around promoting certain colours and erasing others will be considered in this chapter. The impact of colour temperature on emotional states and the different ways palettes and key colours are selected and combined will be examined. Even when colour is not used in bold ways, it is always carefully considered to tie in and enhance the concept.

The selection and combination of colours evokes mood and emotion that helps delineate personality and place on screen effectively. Patti Bellantoni believes that colour influences our choices, opinions and feelings – powerful information for visual storytelling. Some productions use a colour's transformation or its flow to support the evolution of the characters and story. Others have one brilliant scene that captures a colour's role in defining a character or expanding a story. Our often visceral response to colour is, she says, due to the resonance of light/colour physically – in other words we don't just react emotionally to colour: the response begins physically.[2] Technical choices around film stock, lighting and so forth impact on the way colour is perceived on screen. Hence, discussions take place as early as possible between the designer, the DoP and the director to ensure agreement across the project.

"With the proper colours you hardly need words. I like to use them as a musician uses a melody. Every mood and emotion has its shade. (Powell and Heckroth in discussion, 1950). [1] *"*

6.1
PD Jim Bissell says the visual concept for *E.T. the Extra-Terrestrial* was the transition from magical thought to rational thinking, reflecting Elliott's development in the narrative. The children's magical world is contrast with the adult space visualised through colour palettes that define and differentiate.

COLOUR AND EARLY CINEMA

PAINTING AND PERCEPTION

During early cinema, the absence of colour had been established as a distinguishing feature of moving image as an art form, encouraging audiences to suspend disbelief without being distracted by issues of realism around the reproduction of colour.[3] The addition of colour to cinema created new opportunities and also concerns around authenticity and art. For example prejudice was voiced revealing overt contempt for its use:

Colour is made out to be the property of some foreign body, usually feminine, the oriental, the primitive, the infantile, the vulgar, the queer and the pathological… colour is relegated to the real of the superficial, the supplementary, the inessential or the cosmetic.[4]

Colour is linked to theoretical debates about realism and the image where it can both conceal and reveal the presence of the filmmaker through different aesthetic approaches to its decorative possibilities. If we consider black-and-white filmmaking and the control over the set that it requires (see Jim Bissell's discussion of *Good Night, and Good Luck* at the end of this chapter), we can see the degree to which it too is a manipulated construction, with no closer affinity to reality than colour in many respects.

In 1935, *Becky Sharp* (Rouben Mamoulian) was the first Hollywood feature to use the Technicolor three-strip camera. Other colour processes and systems were developed in an attempt to achieve realistic colour and flexible filming. Sets had always been coloured to create different gradations in the grey scale but as Mark Shiel points out the addition of colour stock impacted on budget, increasing the average costs by 30 per cent – due to it requiring more studio lighting for correct exposure than black-and-white stock.[5]

Colour is now embraced as part of the action – employed as an emotive tool in the service of the narrative. Today, colour grading is a major part of most productions, manipulated during post-production with an emphasis towards a particular colour or intensity, making a cooler or warmer overall palette. The discussion of colour in film has often been considered in terms of the technological process that enables it, rather than the subsequent psychological effects. The way we interpret colour today is acknowledged as a combination of the physical properties of light and the psychological properties of perception.

Much critical thinking around colour in moving image has been inherited from painting, inhabiting similar territory in terms of its emotional impact on the viewer.

The production and availability of pigments increased over time; when considering palettes from other periods we can see limitations due to pigment production and also the influence of trends. The Baroque, Victorian, Edwardian and art deco eras all favour different colour combinations. For example, Rembrandt's palette (1606–1669) is defined by yellow ochre, umber, lead-tin yellow, azurite, smalt, carmine lake, malachite, bone black, lead white, vermilion, ultramarine, Naples yellow, while Caravaggio's (1571–1610) chiaroscuro technique which emphasized light and shadow was achieved with a limited palette of ochre (red, yellow, umber), a few mineral pigments (vermilion, lead-tin yellow, lead white), organic carbon black and copper resinate. The 'blue period' (1901–1904) of Pablo Picasso (1881–1973) took advantage of a new range of blues that had become available. These restricted colour palettes have created distinctive combinations often called on by filmmakers to conjure an atmosphere or recreate a particular historical period.

Early abstract art explored synaesthesia,[6] seen for example in the paintings and writings of Wassily Kandinsky. Kandinsky studied the history of colour theory and sought to explain how we experience it.

COLOUR PALETTE AND PSYCHOLOGY

The Bauhaus School during the 1920s and 1930s developed colour theories in relation to mood and emotion. The school was first opened in 1919 by architect Walter Gropius, and over the years based in three different German cities: Weimar (1919–1925), Dessau (1925–1932) and Berlin (1932–1933). Josef Albers was a student at the Bauhaus where he began an exploration of colour theory. In 1963, Albers' study *Interaction of Colour* sought to encourage a new way of studying and understanding colour – which included experiments on the relationships between colours and how colour continually deceives us. The relativity and instability of colour is explored through visual perception tools to discover the magical properties of colour, rather than through dogmatic rules.

The ambiguity of colour was further demonstrated by Hiler where the same colour red was identified by a long list of different names depending on a range of individual, national and cultural distinctions highlighting issues of interpretation and subjectivity.[7]

The Pantone Colour Matching System developed in 1963 is intended in design to colour-match with precision – the colour charts have a number allocated to each colour. This system helps avoid the confusion over the subtleties between the colour perceptions of individuals.

Thus colour is highly emotive and subjective – experiments suggest that we see colour differently and that colour perception is not fixed but a flexible entity. The context influences the reading and subsequent interpretation of the chosen palette. Therefore, the colour scheme used in moving image can be articulated to create a range of feelings and responses in the audience.[8]

Working on the Technicolor three-strip subtractive process, Natalie Kalmus, the chief technical advisor, devised a system in relation to colour symbolism.

> The psychology of colour is important and we shall now illustrate the manner in which certain colours upon the screen give rise to certain emotions within the audience.

Colours connect with our instincts and can alert us to danger on the most primal level. Artists have used colour in a coded way: for example, in churches the stained glass often features blue (associated with faith) and green (associated with hope). Some of these colour connections emanate from nature, while others have been built up through cultural significance, and others actually have a physical affect on our body and mind, raising blood pressure as discussed in the Bellantoni experiments.[9]

Colour choices help to differentiate between the interior and exterior, and can add to a visual concept by heightening harmony or contrast. Designers select and combine colours to create serenity or tension in a scene, and undulate these reactions across

Colour associations

Colours may be considered in two broad categories:

Aggressive – warm. The yellows, oranges and reds. These come towards the eye more (spatially) and are generally 'louder' than passive colours.

Red is often associated with danger, energy, heat.

Orange with stability, warmth.

Passive – cool. The greens, blues and violets. These recede from the eye more (spatially) and are generally 'quieter' than the aggressive colours.

Green with nature, calm.
Blue with calm, serenity, stability.
Purple with magic, royalty, evil, death.
Purple used to be difficult to produce; its rarity resulted in it being associated with elites, for example emperors and popes. Purple is often used in film to foreshadow death, either real or metaphysical

a production. The complementary colour scheme is very popular in film and television because it creates a contrast between a warm and cold colour that is visually appealing, and has become suggestive of conflict when used in drama.

Colour harmony is where the combination of colours is attractive to the eye, in order and balance, a dynamic equilibrium. There are different ways of creating harmony; for example, using analogous colours – any three colours side by side on a 12-part colour wheel. Or using complementary colours – any two colours that are directly opposite each other; for example, red and green, or yellow and violet. This creates bold and striking combinations for example, *Amélie* (2001, Jeune-Pierre Jeunet, PD Aline Bonetto) uses a green, red and yellow colour scheme. In *Vertigo* (1958, Alfred Hitchock), Madeleine is dressed in green in contrast with the red restaurant interior; this heightens her dramatic entrance and separates her visually and metaphorically from the location.

Colour plays an important part in the integration of characters in an environment, where costume and setting coordinate to suggest notions of peace and belonging, for

example. Alternatively these colours can be combined to accentuate difference, making a character appear out of place and stand out.

Chinatown (1974, Roman Polanski, PD Richard Sylbert), employs an analogous colour scheme: colours that sit next to each other on the colour wheel, creating a harmonious palette. It doesn't have the contrasting colours of the complementary scheme. Richard Sylbert uses earthy neutrals, dusty creams and dark browns to convey the absence of water in the story. Similarly, *Diva* (1981, Jean-Jacques Beineix, PD Hilton McConnico) uses a range of blues that sit next to each other and therefore create a soothing palette that is visually pleasing, and in contrast to the drama and conflict taking place in the narrative. Criticised for its 'style over substance' approach, the distinct colour palette predominates the screen. The colours connect with a unique visual style that conveys an impression of a dangerous and exciting world populated with edgy subcultural characters.

Other colour combinations can be harmonious without adhering to these formulas, as this is subjective and based on

lots of inidvidual and cultural factors (e.g. age, gender, nationality, shifting fashions). The fact that colour is so personal lends itself to the representation of different perspectives and ways of looking and seeing the world. That is, distinctive other-worlds that don't quite cohere with everyday depictions (this is also seen in painting, that is, the ability to portray a scene subjectively from the point of view of the maker/practitioner). This potential to heighten and explore different subjectivities departs from the drive for realist representation – from what is seen to what is felt. Thus colour can alert us to the artifice of filmmaking by drawing attention to the nature of screen images. (e.g. *A Matter of Life and Death* (1946, Powell and Pressburger PD Alfred Junge) begins in colour, then turns to black and white for the other-worldly scenes.

Cultural specificity is explored in Krzysztof Kieślowski's Three Colours trilogy – *Three Colours Blue* (1993), *Three Colours White* (1994) and *Three Colours Red* (1994). The three colours refer to the colours of the French flag specifically to generate meaning and context and the ideals of the French Republic – liberty (blue), equality (white) and fraternity (red). The inventive use of the colours in their respective films tease out emotions, define the settings, and create a transcendent visual experience. The colours are intended to convey these ideas, but as we have seen colour connotations are not fixed and fluctuate depending on variables.

6.2

6.2
The colour concept for this paper based student project uses a distinctive palette for the scenes set on the stage. Golden yellows, rich browns and lush greens suggest an attractive theatrical setting and helps draw the audience in to the story space.

THE EMOTIONAL COLOUR OF A SCENE

Stuart Craig: 'Colour does have a colour temperature and an emotional temperature that we respond to.'[10] Cool colours such as blue, green and grey are linked to detachment and logical reasoning over emotion. Warmer colours have gained associations with beauty, nature and feelings

Although a very useful way of communicating the visual concept, colour can often cause contention, with many filmmakers shying away from anything too bold as illustrated by Stuart Craig:

> The safest thing is to eliminate the colour, the more limited the palette the more effective. It allows the lighting to work. The colours that are used should be motivated by the psychology of the scene.[12]

What Craig describes here is the use of a limited and often neutral palette. This is sometimes preferred by filmmakers tó create a unified image connoting the internal logic and philosophy of a world, without clashing colour combinations fighting for visual attention and potentially distracting from the intentions of the work.

Having said this some PDs do relish stronger colours, such as Hein Heckroth who used them as key ingredients.

> For Heckroth this is an exercise in pure colour where the action takes place in yellow… The dominant colour is mauve; the decoration more exotic…colour and line, Heckroth says are the mainsprings of emotion and should be integral to

the narrative. Referring to *The Tales of Hoffmann* (1951, Powell and Pressburger).[11]

When designers do wish to use bolder colours, it is a negotiation with the director and the DoP. For example, in *E.T. the Extra-Terrestrial* (1982, Steven Spielberg, PD Jim Bissell), a young boy helps a stranded alien return home to his family. Jim Bissell created a colour contrast to convey concept: 'The guiding principle for *E.T.* was Elliott's transition from magical thought to adult rational thinking, so it was him coming to terms with growing up.'[13] This idea is partly conveyed via the colour choices, through which Jim created a contrast between the children and the adult world.

> We went for colour contrast between Elliot living in a magical colourful world and the adult world being much more monochrome. The living room uses subdued colours compared to the children's rooms.[14]

A stained glass window in the closet between the children's bedrooms was a symbol of their magical inner life expressed through bright jewel colours.

Alex McDowell collaborated with the DoP Janusz Kamiński on *Minority Report* (2002, Steven Spielberg) to ensure that the colours would be effective with the type of lighting Kamiński planned to use. Colour choices were made based on the fact that a cold filter was going to be employed:

We put a lot of energy into the meaning of the colour and about light – the relative reflectivity of the surfaces that we used – so areas of opacity versus areas of transparency, and reflection versus matte. We worked with Janusz Kamiński who'd worked with Steven for a long time, which meant we were able to do lighting tests really early on. So we built a lot of set pieces for each of the sets and shot them relative to what kind of light would be in the space, the properties and materials. We spent a lot of time looking at materials that would change colour in light so the floor of pre-crime as they move around it changes from red to green because we painted with a paint that had filters in it, so that the whole floor would change colour according to where the camera was pointing. After doing the lighting tests, Janusz decided to put a really cold filter on everything, so we understood that he was going to cool down the whole look and make it pretty blue, and we negotiated around that. Then we made a lot of colour choices based on how they would look when they were really cooled down.

CHARACTER AND STORY

PD Martin Childs says that there are practical considerations like having conversations with costume designers, because they have more time with actors than the production designer:

> [Costume designers get to spend] more time defining a character with an actor than I do. Therefore, you find out that a character is going to be largely in a certain colour, and I would then choose a colour to complement it. A colour that would work with a person of the same taste but that doesn't make the costume disappear. And doesn't clash with the costume unless you deliberately want it to clash with the costume, in an Almodóvar kind of way. So the colour emerges from talking to the costume designer, director, actor and from your own taste. My own taste always means no colour. I'm inclined towards drabs and shades of grey, and shades of sludge, and shades of beige, and shades of brown. I'm inclined towards that and I then start to introduce colour on top of that.[15]

Colour is used consistently to amplify character and elaborate story. Designer Moira Tait says she wouldn't use colour in arbitrary ways but is driven by the character. 'It would all depend on the character – what do I think they would have?'[16] In *A Visit from Miss Prothero* (1978, Stephen Frears, PD Moira Tait), recently retired Arthur Dodsworth lives alone and is visited one day by his former secretary Peggy Prothero. 'The colour palette was in the beige range – but quite a lot of pattern. Neutral apart from the budgie which was colourful – standing out amid a symphony of beige to reflect the lonely character who lived there.'[17]

Certain colours predominate in different eras that are subsequently used as shorthand. When Mimi Gramatky worked on *Miami Vice* (1984) she says colour was everything. The bible set out that no red, brown or orange should ever appear in the show. Two undercover detectives crack down on crime. The context of 1980s fashion, music and culture was an integral element of the show's appeal. Place and period were articulated through these colour choices.

In *Tinker Tailor Soldier Spy* (2011, Tomas Alfredson, PD Maria Djurkovic), the colour palette was controlled in such a way as to convey period, story, character and atmosphere. Set in 1970s during the Cold War, George Smiley comes out of retirement to try and track down a Soviet double agent within the British intelligence agency. A distinct look is created through the repetition of box shapes and rectangles creating labyrinth-like grids that trap or contain the characters. The concept of compartmentalization is conveyed through this continued boxing in of characters. Long lenses used by the DoP created a flattening effect to the frame – compressing space. Maria Djurkovic finds colour to be the key in creating mood:

> It's all about mood and atmosphere, and colour is probably my most useful tool in achieving that. I 'see' what a film looks like during my first reading of the script. I do a huge amount of research but I don't feel compelled to adhere to it. I like to make fully informed decisions though. Sketching and location scouting are the first steps in finding the visual language for the film. Colours always come from the research – I tend to play with a quite restricted colour palette and make sure that it leads us into the aesthetic world of that film.[18]

The colours chosen for *Tinker* help evoke the 1970s but without the usual browns and oranges often relied on for that period. The palette is not only monochrome as it may seem on first impression – it features desaturated reds, teal and mustard. The aesthetic world of the film is articulated through the restricted palette employed by Maria Djurkovic and Tatiana Macdonald.

Gemma Jackson used the colour palette in *Iris* (2001, Richard Eyre) to help tell story and indicate shifts in time. Throughout the 1950s section she used oranges and reds:

> Almost like light bulb colours, you know when you string them up, that kind of thing. She wore a wonderful orangey-red party dress and it looked lovely. I was really pleased with the way that worked. And then when you went into their present day house, we took out any red covers or any intense colours. It didn't make it grim particularly, it just made it softer, which was effective. I had to get the costume designer on board to ensure the colour story was coherent. We are trying to tell a story. Cinema is storytelling.[19]

The film was shot on a tight budget, with little money available for props and dressing – colour was one of the simplest and most effective routes to a coherent design.

The whole team had to agree and work to the colour palette, otherwise the look would have fragmented and the visual style diluted. As Jackson points out, it can often be a case of taking colours out that contradict the concept, or using a colour sparingly to ensure it stands out and acts as punctuation.

Colour was crucial in conveying an attractive sense of adventure in the syndicated series that Mimi Gramatky worked on where Pamela Anderson heads a team of beautiful bodyguards at the VIP agency.

'When I was doing VIP with J. F. Lawton, he had written one of the best bibles I had ever seen. We added colour to it – hot dry colour-embracing reds, oranges and browns as well as hot pinks, yellows, purples, swimming-pool turquoise and palm greens.'[20].

Tom Turner's background images for *Banaroo* (2015) (Figures 6.3a, 6.3b and 6.3c) use red and green to indicate the greed of the character and the presence of danger. Red and green combinations are often used to illustrate conflict and discord.

For the animation, the background of the hall, I only used red and green. The hall is in a castle on Christmas Island, and is the home to a greedy king. I wanted the red to look a bit sinister and the lighting to make it seem like the king was hoarding his treasure in a massive lonely room. The door is where a character enters, so it would be good if the eye is drawn towards it to see the character enter, as it is such a big space.[21]

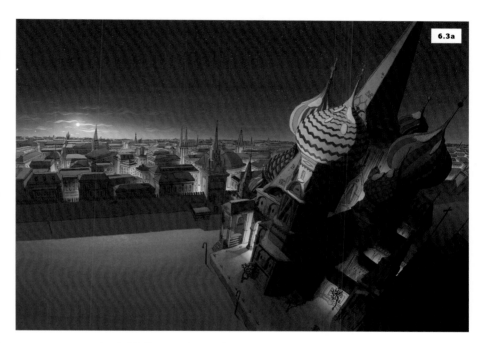

6.3a

6.3b

6.3a
Tom Turner's animation backgrounds for *Banaroo*. The exterior cool colours contrast with the interior palette.

6.3b
Red was used to suggest danger. Tom Turner highlights his deliberate use of colour to help convey character and tell story in this animation.

6.3c
The exterior for *Banaroo*.

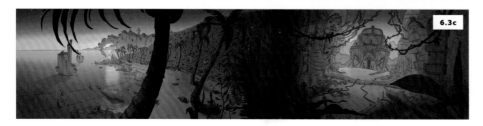

6.3c

The Green Mile (1999, Frank Darabont, PD Terence Marsh) tells the story of Paul and his life as a corrections officer on death row during the Great Depression and the supernatural powers he witnessed in John Coffey (a prisoner on death row). Production designer Terence Marsh researched and visited death row prisons but he did not find them pictorially interesting, the intentions for the set being to give a sense of space, of history and mystery. This led to the decision to use elongated church-like windows to tie in with the mystical element in the film. The 'Green Mile' describes the section of green flooring that takes convicts from their jail cells to the electric chair. As well as being a part of the environment, it plays the protagonist in several scenes. The colour green is often used to represent life and since the film looks at the prisoners' last moments, it helps to psychologically convey issues around life and the spirit. The colour is a part of the backdrop in death row, helping to emphasize the contrast of life and death, good and evil, themes which are frequently explored in the film. The contrast would be less effective if the green floor was black for example, impacting on the mood of the film.

The Matrix (1999, the Wachowskis, PD Owen Paterson) uses the colours green and blue to represent the two realities. The film is set in a dystopian future where perceived reality is actually an illusion created to control and pacify the human population with machines. Thomas Anderson, a computer programmer, becomes unplugged from the Matrix and is traumatized to see the world as it is for the first time. The different colour schemes help represent the false consciousness model underpinning the narrative as explored in Plato's *Allegory of the Cave* and Jean Baudrillard's *Simulcra and Simlation*. Green is the Matrix and blue is the 'real world'. This colour-coding of the two realities helps tell story and ensures that the audience can navigate between them. This includes the setting, wardrobe and lighting – all building a picture of place.

The colour-coding of character and story adds a layer visually that connects with our physical and thus emotional sense of the story. Martin Childs was working on a brief for a film in development that had 400 scenes, spanning 150 to 200 sets. The design solution to this huge number of sets looks to be around colour-coding to achieve coherence:

I had a big meeting with the director and because it's about a person with multiple memories we need to convey things through a visual shorthand. We came to the conclusion that, much to my relief, we will have to be very, very bold with colour. So in a sense, without the audience noticing it, we're going to have to almost colour-code the sets. There are several lives running in parallel. So we're going to have to say: 'This is his blue life. This is his red life. This is his yellow life.' We're going to run with an idea as simple as that but execute it as subtly as possible so the audience doesn't necessarily spend its time identifying with the colour, but so it sinks into the brain.[22]

For each of the lives a different key colour enabled a multi-strand narrative; an audience could immediately see whose version of events were being represented. Childs doesn't want his colours to stand out, he prefers to use colour for dramatic effect and for key props.

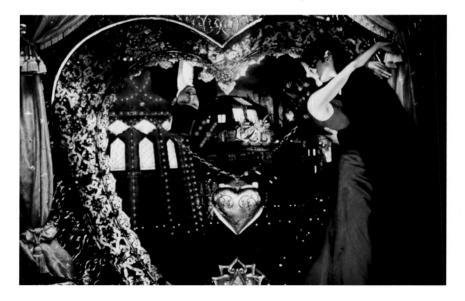

6.4
Moulin Rouge, 2001, Baz Luhrmann, PD Catherine Martin. Satine and Christian situated in the red environment of the Moulin Rouge theatre.

THE COLOUR RED

Red is a popular choice for designers working on powerful subject matter that requires bold attention-grabbing key colours. Red is often prominent on screen, perhaps linked to its primacy in nature, the colour of life blood concealed within the body, and thus red manifests a rich history of cultural connotations, with symbolic and emotional significance to be drawn on.[23]

Red recalls to mind a feeling of danger, a warning. It also suggests blood, life and love, stimulating, wine, passion, power, excitement, anger, turmoil, tragedy, war, sin and shame…The introduction of another colour with red can suggest the motive for a crime, whether it be jealousy, fanaticism, revenge, patriotism or religious sacrifice.[24]

Hitchcock's first colour film *Rope* (1948) makes use of a restricted subdued palette with the exception of the colour red at pivotal points. *Rope* is a single set, a Manhattan apartment featuring a panoramic window. The colour was to play a dramatic role in the film and as such, red is present in two interior scenes where characters are injured. After sunset, colours from the exterior intrude into the apartment with a neon sign flashing red and green at the point of revelation. In *Marnie* (1964, Alfred Hitchcock), the colour red is used as an enigmatic concept drawing us through the narrative. As John Belton says, the colour red enjoys an independent existence, with her red-tinted reactions making the colour primary and the object secondary. The use of red is a reflection of Marnie's psychological state: she has repressed memories which eventually surface along with the reconnection of the colour with its object – and the mystery is solved.[25]

In the examples that follow costume and design integrate to illustrate the fundamental nature of costume in relation to the overall visual concept. The way a costume designer and production designer collaborate varies to the same extent as other key collaborators mentioned earlier.

In *Don't Look Now* (1973, Nicolas Roeg, AD Giovanni Soccol), we are introduced to red in the form of the little girl's shiny mackintosh in the opening scene of her playing out in the garden, which is immediately cut with the red of a stained glass window on a slide that her parents Laura and John Baxter (Donald Sutherland and Julie Christie) are looking at. The happy primary childhood red is linked in this way to religion, suffering and death, represented by the red of the church window. As wine is spilt on the slide and the colour red spreads across the frame, her father is suddenly compelled to go outside to look for his daughter. Distraught he finds her drowned in the garden pond.

The couple travel to Venice where John is working on a church renovation. The use of red in the film is a carefully choreographed strand that features very sparingly, with the deliberate intention of signalling and drawing us through the Venetian labyrinth of otherwise monochromatic streets. Red continues to feature dramatically throughout the film, foreshadowing death until ultimately the father physically and metaphorically follows red to his death.

Moulin Rouge (2001, Baz Luhrmann, PD Catherine Martin) is the story of a young writer who falls in love with a beautiful courtesan. In this example, the production designer Catherine Martin also worked as costume designer with Angus Strathie. On occasion, the production designer may also be responsible for costume in this way. The flamboyant and theatrical costume works here on the level that the story is set in a performance space – a cabaret nightclub. Simultaneously, the costume is designed to enhance the genre credentials as spectacular musical extravagance. The theatrical setting of the nightclub also gives the opportunity for dramatic design elements that are free from conventional representation. In this fantasy world, interiors feature huge, glittering heart-shaped doorways, opulent boudoirs and malleable multi-faceted performance space. The exteriors include stylized models of classic Parisian landmarks such as the Eiffel Tower and the windmill of the Moulin Rouge.

The design takes pleasure in referencing other musicals in a pastiche of the genre itself. Satine's (Nicole Kidman) world is red which is used to represent passion, lust and fantasy, but also disease and death. Christian is represented by the colour blue: he is a poet in search of truth, love and freedom. This colour contrast sets up the two distinct worlds – inside and outside the nightclub and reflects the conflict in the story effectively. Satine's life is consumed by the theatre, performance and facade. When she develops feelings for Christian, the possibility of another world opens up to her, the duality of love and the performance of passion on stage every night. The colours of the theatre promote its fantasy dreamlike qualities, making it appear exciting and attractive, whilst also containing the darkness of nightmares. Trapped in the nocturnal space without daylight, the colours are distorted and false. Nothing is as it appears, it's all a show.

The red that made Satine appear exciting and sexually alluring also becomes dangerous in its consumption of her character. Red eventually appears out of place in the form of disease, and the foreshadowing of her death from tuberculosis. The interior emotional world of the nightclub characters is expressed through the colours, with Satine's transformation taking place in natural light, suggesting possible future happiness if she can break free from the consuming environment of the Moulin Rouge. Following on from this abundant use of red to signify

sexuality *Black Narcissus* (1947, Powell and Pressburger, PD Alfred Junge) employs red as a significant departure from the other colours that dominate the palette. In the context of this design, red is a subversive element that stands out and constitutes a dramatic challenge to the status quo.

A group of British nuns struggle to establish a convent in the Himalayas, in the face of isolation and the extremes of altitude, climate and vast cultural differences. The nuns unravel psychologically as they each face their own personal demons and inner conflict: religion, society and domesticity are at loggerheads with desire and nature. Two in particular struggle with the memories of past relationships that led them to seek solace in religion: Sister Ruth (Kathleen Byron) who is overcome with desire for Mr Dean (David Farrar) and Sister Superior Clodagh (Deborah Kerr) who resists temptation.

The contrast between the British and the Indian environment stirs up buried emotions in the characters. The intimidating opulence and scale of the Mopu Palace positioned on the edge of a mountain cut off and surrounded by a snow-capped mountain range. Their inner turmoil is mirrored in the environment and symbolized in the tension that visually plays out on the screen between a vivid interior world and reality. The colours follow the nuns' psychological journey, from cool subdued colours in the British convent to the other-worldly saturated luscious colours of nature and desire. The nuns' white habits act as blank canvases, reflecting the environment which was safe back in England. In their new setting, they absorb the vibrant and vivid colours which become overwhelming as desire builds. Red is used to symbolize danger and foreshadow death.

Sister Ruth becomes increasingly deranged, and decides to abandon the Order in pursuit of Mr Dean. When Sister Clodagh confronts

Ruth, she finds her in a crimson red dress applying red lipstick in a prolonged gesture of defiance. Sister Clodagh turns to the Bible for support – such is the power represented by the colour red – in this instance blood, sexuality, desire and death are described by its use. The potentially threatening nature of female sexuality is associated with the use of red here, used as a contrast and transgression of her sisterly vows. The story punishes Sister Ruth by death as she falls from the bell tower, having tried to push Sister Clodagh from it. The Mission accept that 'this is no place to put a nunnery' and leave the Mopu Palace.[26]

In Bram Stoker's *Dracula* (1992, Francis Ford Coppola, PD Thomas Sanders), the use of red is overtly connected to the insatiable quest for blood featured in the story – the screen is awash with the colour in the setting, the costume and the bloodshed itself. The obsession and consumption of blood is visualized through the presence of red on the screen. Blood from the bodily interior is externalized and envelops characters in danger. Although a warning, it is also used in some of the film interiors as comforting, nurturing and womb-like – seductively

drawing the characters into the trap. The train carriage windows connect the interior with the exterior landscape which is overpowered by a blood-red sky. The contrast is created with the home of Mina in England, seen sitting at a desk positioned in front of a large window, bathed in daylight and surrounded by green plants, separate from the seduction of red which seems to overwhelm the other characters in blood, sex and death.

Connotations of blood can also be identified in *Paris Texas* (1984, Wim Wenders, PD Kate Altman), the colour red has the effect of connecting the film's estranged family. Red can be considered as the family blood line flowing between the mother, father and son. When we first see Travis (Harry Dean Stanton) walking through the desert his red baseball cap provides a bright pop of colour – a striking primary colour in the neutral landscape. Later, when he is reunited with his son Hunter, they both begin to wear red clothing that connects them to each other and separates them from the other two characters (Travis' brother and wife who have been acting as his parents in the absence of his real parents). The two go in search of Jane, respectively their estranged wife and

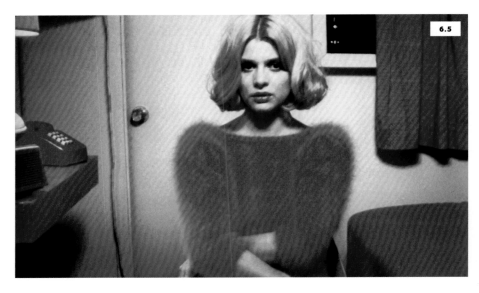

6.5

mother (Nastassja Kinski) who is driving a red car that they follow and with whom they eventually make contact. As mentioned earlier in this chapter, the costume designer works closely with the production designer collaborating on colours, shapes, textures and so on, to create coherence in the visual concept. This is a simple and elegant example of the coordination between these departments to strengthen the image. The colour scheme is emotive throughout the film, creating atmosphere and underscoring the concept of the characters' emotional and familial connection – in spite of the physical distance between them they are inextricably linked.

Conversely red is employed to illustrate family division in the next example where the colour separates the home according to gender. A space is physically demarcated through the colour choices that signify a physical and emotional division between a husband and wife in the film *Home from the Hill* (1960, Vincente Minelli). Tensions are expressed through the spatial design of the home and the colour palette, which uses red to punctuate and illustrate the destruction of domestic happiness:

> The film revolves around a conflict between a man and his wife. The husband's den in the film is painted deep blood-red all over and is furnished in a 'masculine' way, with leather armchairs, rifles and hunting trophies. The rest of the house is the woman's domain...the house is divided dramatically between the male and female parts.[27]

The following films also use red in dynamic ways that enrich the story world and our understanding of character:

Schindler's List (1993, Steven Spielberg) – the red of the little girl's coat is used to symbolize the bloodshed of the Holocaust and as a wake-up call for Schindler, puncturing his ambivalence and stirring him into action.

The Village (2004, M. Night Shyamalan) – red is seen as a sign of the outside dangers of the world, and uses yellow to identify the village and its inhabitants as secure and safe.

Her (2013, Spike Jonze) – in contrast to the monochrome of many futuristic worlds, this film features a strong primary colour. The environment is bathed in a warm, hazy neutral glow which is punctuated by the liberal use of red.

The films of Pedro Almodóvar use bold colour that is integrated with the characters and story. *Volver* (2006) employs a great deal of red in costume and dressing, including the food.

Paddington (2014, Paul King, PD Gary Williamson) uses red as a representation of character development and story structure. The red of Paddington's hat connect him to Mrs. Brown, who wears colourful clothes that feature red. As the story develops, red is seen to slowly take hold as a positive force in the Brown household that was a bit lacking in warmth before Paddington came into their world. The colour signals the wider transformation of family relations in the house.

In Last Tango in Paris (1972) Ferdinando Scarfiotti visualized the underpinning idea of an animal existence through the use of flesh tones in the interiors, including colours that were intentionally uterine.

In *The Cook, The Thief, His Wife and Her Lover* (1989, Peter Greenaway, PD Ben van Os, Jan Roelfs), red features in the restaurant , green in the kitchen, white in the toilets, yellow for the antique book and blue for exteriors. The costumes are also colour coded resulting in colours changing when a character steps from one room into another breaking the illusion of continuous time and space.

The Sixth Sense (1999, M. Night Shyamalan) uses red for any elements in the real world that have been touched by the other world: Cole wears a red jumper, he has a red blanket, and the cellar door handle is red. The colour connects with the afterlife and furnishes the audience with clues that lead to the narrative conclusion.

In *Malcolm X* (1992, Spike Lee) his journey is characterized through colour, with his early years predominantly red, his middle years blue, and his epiphany and conversion, gold. PD Wynn Thomas used colour in this way to define the three acts of the film.

6.5

Paris Texas (1984, Wim Wenders, PD Kate Altman). Red costume and props dominate the small room that Jane (Nastassja Kinski) works in. The colour red links the family, symbolically representing love and blood ties.

INTERVIEW WITH JIM BISSELL

Jim Bissell began his career as a production designer on Steven Spielberg's classic *E.T. the Extra-Terrestrial* (1982, Steven Spielberg), and was nominated for a BAFTA Award for Best Production Design. Reunited with director Spielberg on the films *Always* (1989) and *Twilight Zone* (1983) and producer Spielberg on *Harry and the Hendersons* (1987, William Dear) and *Arachnophobia* (1990, Frank Marshall).

Over his 35-year, career he has also collaborated with directors such as John Schlesinger (*The Falcon and the Snowman*), Ridley Scott (*Someone to Watch Over Me*), Joe Johnston (*The Rocketeer* and *Jumanji*) and Ron Shelton (*Hollywood Homicide* and *Tin Cup*). More recently, he was honoured with nominations from the Art Directors' Guild for his work on Zack Snyder's *300* (2006) and *The Spiderwick Chronicles* (2008, Mark Waters).

Bissell is also known for his collaboration with director George Clooney, *Confessions of a Dangerous Mind* (2002). *Good Night, and Good Luck* and *Leatherheads*. *Good Night, and Good Luck* gained Art Direction nominations from both the Art Directors' Guild and the Academy of Motion Picture Arts and Sciences, as well as a Satellite Award for Best Production Design.

Can you talk about your process a little bit please?
Constructing a vision depends on the material and your relationship with the material itself, so any project we pick is not going to be representative of my overall approach except in very broad strokes. The most important thing at first is to wrestle with and grab the big idea as quickly as possible, and by the big idea I mean what the guiding philosophy is for the picture. As an example, on *The Falcon and the Snowman* (1985, John Schlesinger), the guiding idea was for the beginning with the two adolescent boys to be a youthful adventure. The Tim Hutton character was full of a rebelliousness towards his father, so when his father out of frustration got him a job in a high security position in a rival firm, he looked at what was going on in the US government and used it as a way of getting back at his father. But the whole thing was a youthful adventure, and eventually they were in way over their heads and wound up in prison. So the overarching idea was to fill the beginning with colour and chaos and adventure. Then there was a pivotal scene when he met the KGB agent who said 'we now own you and you are a spy', and from that point on we started draining the colour out of the film. The final scene when they are marching down the long corridor was a very monochromatic setting, juxtaposed and intercut with grainy colour movies of their youth together; there was a strong sense of them reminiscing about their youth. It had a flow and a feel to it, the final scene was very powerful.

Can you describe how that decision came about? In that instance where did that idea come from?
I originated the idea, and John was very enthusiastic and thought it was a very good guiding principle and the DP, Allen Daviau thought so too. I'd worked with Allen before on two films, *E.T.* and one of the episodes of *Twilight Zone* which Steven Spielberg had directed. The guiding principle for *E.T.* was in a way similar because it was Elliott's transition from magical thought to adult rational thinking, so it was him coming to terms with growing up. Elliott lived in a very colourful, magical, youthful world, but whenever you saw the adult world it was much more monochromatic – you looked into the living room and it was much more subdued, as opposed to the children's areas.

Can you talk a bit further about Elliott's room in particular?
Steven is a very visual director, adept at how you involve a familiar geography to a set. For instance, the stained glass window in the closet that separates the two children's rooms, these are situations that never exist in reality – how often do you see a closet like that that connects two kids' rooms? That was Steven's idea because when E.T. was in the closet which was his little nest he could relate to both the kids and he wanted to have a little bit of tension with E.T. having a little bit of a crush on Mum. When Mum's reading to Gertie he looks through the slats. So this gave E.T. access to both rooms from a shielded position, and we had to make it feel as natural as possible and no one really questioned that situation.

To what extent do you think about the character's movement in the setting?
I don't come from painting, I come from model-making. Even when I was very young, I built models and I would love to imagine what would happen in the models – cars, aeroplanes, balsa-wood models of old plantation houses. I always thought in terms of design and movement, and then when I studied dramatic design I would think in terms of images that forward a story, but I would also think in terms of the movement within those spaces and how you discover those spaces. So in a way I learned how to evolve a space within which narratives would take place.

I'm starting on a new project with George [Clooney] and I'm starting to build models already. The whole time I'm building it, then I take stills of them, and I do Photoshop paintings on top of them.

How did you address the issue of black and white in *Good Night, and Good Luck* (2005, George Clooney, PD Jim Bissell)?
On *Good Night, and Good Luck*, we used colour film stock because there was nowhere that processes black and white. It was a colour stock that was taken down to black and white, so it was relatively easy for me to take props out of the rental houses and evaluate their tonality by shooting them with a digital camera, and make it black and white and see how it would react. So that was how we came to terms with the tonality. And I'd made George promise from the beginning that no one on the set would take colour pictures because it would look hideous – even for publicity we would shoot in black and white which was the way the set was intended to be shown.

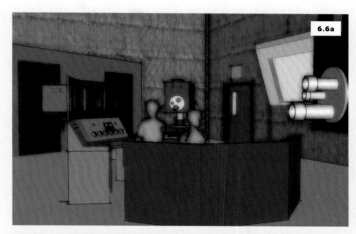

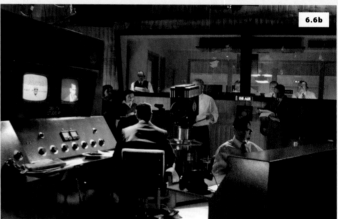

6.6a
Good Night, and Good Luck (2005, George Clooney, PD Jim Bissell). Drawing of the control room.

6.6b
Good Night, and Good Luck (2005, George Clooney, PD Jim Bissell). Set build control room. The compact black and white image echoes the real show and mirrors the wider struggle of the McCarthy witchhunts it dramatises.

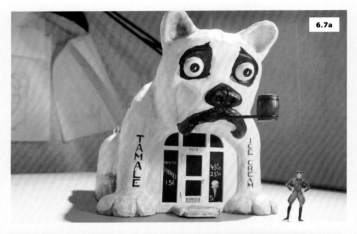

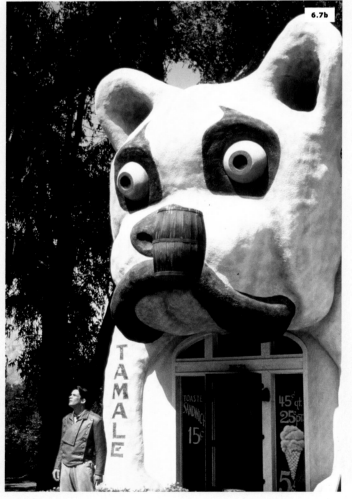

Can you identify a time when you've chosen the palette directly as a result of the psychology of the scene?

Rocketeer (1991, Joe Johnston) was trying to evoke the feeling of an era and a place that never existed, as if Los Angeles never existed. But it was like looking at a history book of nothing but nice postcards. The psychology of the scenes was to give that homespun feeling to the places where the character hung out, at the airport and the hangar and the Bulldog Café, and then a sophistication to the places where Neville Sinclair hung out in the club. So we used separate palettes for a contrasting look.

The Spiderwick Chronicles (2008, Mark Waters) was colour and texture and it was nothing but organic colours and trying to create a highly textured detailed environment where if you looked closely at any given object or space you would detect another world. It was so filled with complexity, and all of the motifs that were represented in the other world were represented in the house.

6.7a
Rocketeer (1991, Joe Johnston, PD Jim Bissell). Scale model of Bulldog Café exterior.

6.7b
Rocketeer (1991, Joe Johnston, PD Jim Bissell). Exterior set build of Bulldog Café.

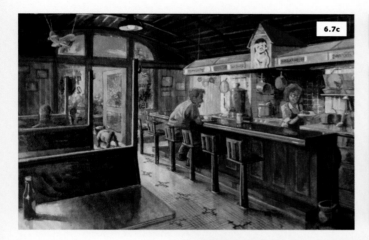

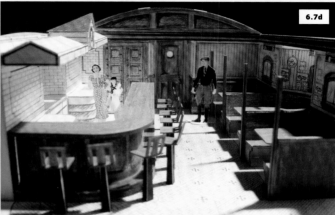

6.7c
Rocketeer (1991, Joe Johnston, PD Jim Bissell). Illustration of the interior of the Bulldog Café.

6.7d
Rocketeer (1991, Joe Johnston, PD Jim Bissell). Scale model of the interior of the Bulldog Café.

6.7e
Rocketeer (1991, Joe Johnston, PD Jim Bissell). Interior set build of the Bulldog Café.

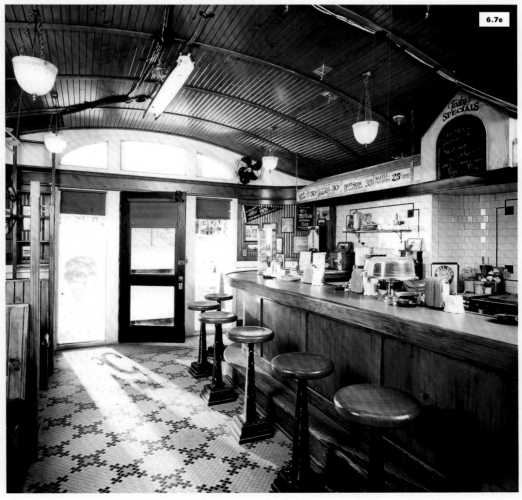

6.8a

6.8b

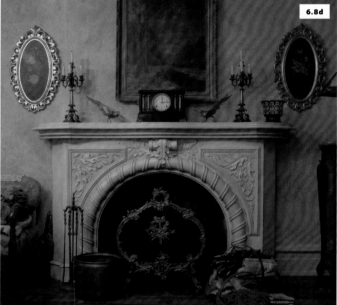

6.8d

6.8c

6.8a
Spiderwick Chronicles (2008, Mark Waters, PD Jim Bissell). Spiderwick Mansion.

6.8b
Spiderwick Chronicles (2008, Mark Waters, PD Jim Bissell). Mansion illustration.

6.8c
Spiderwick Chronicles (2008, Mark Waters, PD Jim Bissell). Mansion photo of set.

6.8d
Spiderwick Chronicles (2008, Mark Waters, PD Jim Bissell). Interior fireplace featuring oak motif. The wallpaper echoes the sculpting on the mantelpiece. Organic colours and textures hint at the fairytale world.

6.8e
Spiderwick Chronicles (2008, Mark Waters, PD Jim Bissell). Interior detail featuring oak motif.

6.8e

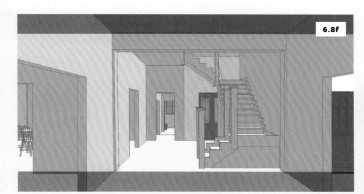

6.8f

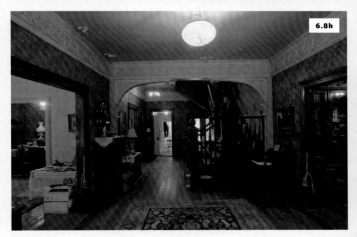

6.8g

6.8h

6.8i
Spiderwick Chronicles (2008, Mark Waters, PD Jim Bissell). Drawing of interior attic room.

6.8j
Spiderwick Chronicles (2008, Mark Waters, PD Jim Bissell). Drawing of attic room including dressing and props.

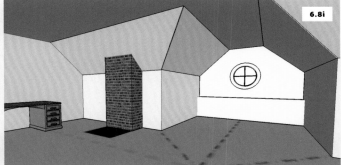

6.8i

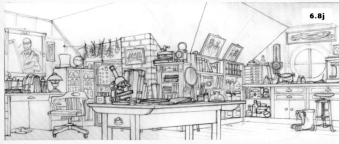

6.8j

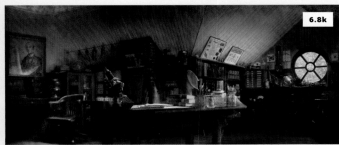

6.8k

6.8l

6.7f
Spiderwick Chronicles (2008, Mark Waters, PD Jim Bissell). Drawing of interior hall and staircase.

6.8g
Spiderwick Chronicles (2008, Mark Waters, PD Jim Bissell). Interior hall and staircase.

6.8h
Spiderwick Chronicles (2008, Mark Waters, PD Jim Bissell). Interior set build of hall and staircase.

6.8k
Spiderwick Chronicles (2008, Mark Waters, PD Jim Bissell). Attic room.

6.8l
Spiderwick Chronicles (2008, Mark Waters, PD Jim Bissell). Attic room set build.

Where do you look for inspiration?

Each one is so different. In *Good Night, and Good Luck* it started with the iconic photographs of Edward R. Murrow and his station when he did *See It Now* (CBS, 1951–1958) and all the different programmes that he did. Those images of him from the 1950s with his burning cigarette behind his little console helped me build that into the imagery of the overall set, so you could almost quote the famous photographs, and people were feeling they were a participant in history.

On *Spiderwick* it was trying to take a lot of the European myths and Americanize them so I went to the oldest of the American areas, the New England area, and looked for iconographic architecture, and stumbled on the inspiration for the Goblin Forest. It was a forest we had to build because it was so filled with special effects, and it had kids in it and it wasn't something we could do in a real forest. The central coast of California has pygmy oaks and I went into a pygmy forest late in the afternoon and shot a bunch of photographs, and that served as the inspiration for the forest.

6.8m
Spiderwick Chronicles (2008, Mark Waters, PD Jim Bissell). Jim Bissell's photograph of pygmy oaks – the inspiration for the Goblin Forest.

6.8n
Spiderwick Chronicles (2008, Mark Waters, PD Jim Bissell). Illustration of Goblin camp.

Which films do you admire?

I guess we all aspire to good storytelling to some form of transcendence and that's ultimately what all of this is about. I often think about the image in *Ran* (1985, Akira Kurosawa), when the old King Lear character is stunned at his defeat and walks past the burning castle, past these soldiers, and they freeze and part ways for him, with this five-storey castle roaring away with fire – and it's actually on fire. There's something almost historic, you're participating in an historic event.

If you look at *How Green Was my Valley* (1941, John Ford), *Citizen Kane* (1941, Orson Welles) or *Gone with the Wind* (1939, Victor Fleming, George Cukor), the same principles apply – you design and you compose the shots and your deep background is one-dimensional and in those days it was painted and now it's handled by green screen. In the mid-ground you'd put in something that's up for grabs, so you look at the compositional elements that are going to give you a transitional element from the front to the background, and how you're going to wind up there when you need it. But you're still giving yourself the dynamic foreground the actors can work in. You're looking at the elements that make it real – what the elements are in the foreground that really tell the story, not only of the actors but the story of the space they're in. Those principles sometimes get abandoned with visual effects, but the overall feel when you walk onto a set and you see what it's meant to accommodate in terms of action, and you see what it's going to look like later on when the backgrounds are added – I do that on all the films. So I have a handoff with the visual effects supervisor and say 'here's what it needs to look like', and inevitably as long as it's designed well, it works.

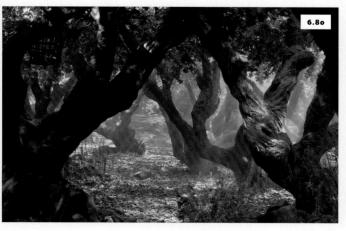

6.8o
Spiderwick Chronicles (2008, Mark Waters, PD Jim Bissell). Goblin camp set. Bissell takes the familiar and builds on it as the foundation of an imaginary land.

6.8p
Spiderwick Chronicles (2008, Mark Waters, PD Jim Bissell). Goblin camp set.

Exercises

1. Consider the films discussed in this chapter and their use of key colours – try changing them for a contrasting colour – what happens?

2. Devise a colour palette/scheme for the *Clay* script provided in the Appendix.

 – Add colour swatches to your mood board – using fabric, wallpaper and any other samples that convey colour, pattern or texture.

 – Choose the colours to tie in with your overall concept.

 – Using the visual concept you devised for the sample script, think about how colour could be utilized to communicate your ideas visually. Is there a specific set of colours that would illustrate the concept throughout the film? Or would the palette change echoing the characters' journey, for example?

 – Research the specific colours you are thinking of using and collect reference material for each one.

Further Reading

Albers, Josef. *Interaction of Colour*. New Haven: Yale University Press, 1963.

Arnheim, Rudolf. *Visual Thinking*. Berkeley: University of California Press, 1969.

Batchelor, David. *Chromophobia*. London: Reaktion Books , 2001.

Bellantoni, Patti. *If It's Purple Someone's Gonna Die: The Power of Color in Visual Storytelling*. Burlington: Focal Press, 2005.

Birren, Faber. *The Symbolism of Color*. Secaucus: Citadel Press, 2001.

Brown, Simon, Street, Sarah and Watkins, Liz. *Colour and the Moving Image. History, Theory, Aesthetics, Archive*. London: Routledge, 2013.

Chevreul, Michel Eugène. *De la loi du contraste simultané des couleurs et de l'assortiment des objets colorés*. Translated by Charles Martel as *The Principles of Harmony and Contrast of Colours: And their Applications to the Arts* (1855). Whitefish: Kessinger Publishing, 2009.

Coates, Paul. *Cinema and Colour: The Saturated Image*. London: British Film Institute, 2010.

Dyer, Richard. 'Minelli's Web of Dreams'. In *Movies of the Fifties*, edited by Ann Lloyd and David Robinson, 86–89. London: Stackpole Books, 1982.

Eisenstein, Sergei. 'On Color'. In *Towards A Theory of Montage: Eisenstein Selected Works Vol II*, edited by Richard Taylor and Michael Glenny, London: British Film Institute, 2010.

Galt, Rosalind. *Pretty: Film and the Decorative Image*. New York: Columbia University Press, 2011.

Goethe, Johann Wolfgang von. *Theory of Colours*. London: John Murray, 1810.

Kalmus, Natalie. *Colour Consciousness*. In an Address to the Branch of Academy of Motion Picture Arts and Sciences, 1935.

Kalmus, Natalie. 'Colour Consciousness'. *Journal of the Society of Motion Picture Engineers* 25, no. 2 (1935): 139–147.

McIver, Gillian. *Art History for Filmmakers. The Art of Visual Storytelling*. London: Bloomsbury, 2016.

Moor, Andrew. 'Hein Heckroth at the Archers: Art, Commerce, Sickliness'. *Journal of British Cinema and Television* 2, no. 1 (2005): 67–81.

Newton, Isaac. 'A Letter of Mr. Isaac Newton, Mathematicks Professor in the University of Cambridge; Containing his New Theory about Light and Colors.' *Philosophical Transactions of the Royal Society* 80 (1671/2): 3075–3087.

Shiel, Mark. 'Classical Hollywood, 1928–1946'. In *Art Direction and Production Design*, edited by Lucy Scher, 69. New Brunswick: Rutgers University Press, 2015.

Ed. Michael Glenny & Richard Taylor, *Cinema & Color. The Saturated Image*. (BFI, 1991)

http://wesandersonpalettes.tumblr.com

http://www.storarovittorio.com

Vittoria Storaro official website

http://moviesincolor.com. *Movies in Color* is a project by LA-based designer Roxy Radulescu. She derives light, medium and dark colour palettes from movie stills and merges them into a 21-colour spectrum.

Notes

1 Andrew Moor, Gothic Riots: The Work of Hein Heckroth, https://www.criterion.com/current/posts/404-gothic-riots-the-work-of-hein-heckroth, 2009.

2 Patti Bellantoni, xxiii.

3 Rudolf Arnheim, cited in Rosalind Galt, 44.

4 David Batchelor, 23.

5 Mark Shiel, 69.

6 A joining together of sensations that are normally experienced separately.

7 Rudolf Arnheim, 348.

8 Natalie Kalmus, 4.

9 Patti Bellantoni, xxi.

10 Stuart Craig, author interview, 2000.

11 Andrew Moor, 75.

12 Stuart Craig, author interview, 2008.

13 Jim Bissell, author interview, 2015.

14 Jim Bissell, author interview, 2015.

15 Martin Childs, author interview, 2007.

16 Moira Tait, author interview, 2015.

17 Moira Tait, author interview, 2015.

18 Maria Djurkovic, author interview, 2015.

19 Gemma Jackson, author interview, 2005.

20 Mimi Gramatky, author interview, 2014.

21 Tom Turner, author interview, 2015.

22 Martin Childs, author interview, 2005.

23 Paul Coates, 69.

24 Natalie Kalmus, *Journal of the Society of Motion Pictures*,1935, 4.

25 John Belton, 189–195.

26 *Black Narcissus* is based on the novel by Rumer Godden. The film's title comes from a British perfume which the young General uses. Its scent is taken from a flower, named after a Greek myth youth of the same name, who died of his own vanity. Young women torn between duty and passion, *Black Narcissus* has common elements with the Archers' next film *The Red Shoes* (1948), while its evocation of the mystical power of landscape and geography positions it in a line of Powell's work which includes *The Edge of the World* (1937), *I Know Where I'm Going!* (1944) and *A Canterbury Tale* (1945). Oscars were awarded for Alfred Junge's art direction and Jack Cardiff's cinematography. The film was described as a work of rare pictorial beauty. A sensuous vision convincingly created a Himalayan convent on a Pinewood soundstage, lending the proceedings a tense, claustrophobic atmosphere. An oppressive jungle scene was filmed in a Kent tropical garden.

27 Richard Dyer, 1981, 1154–1155.

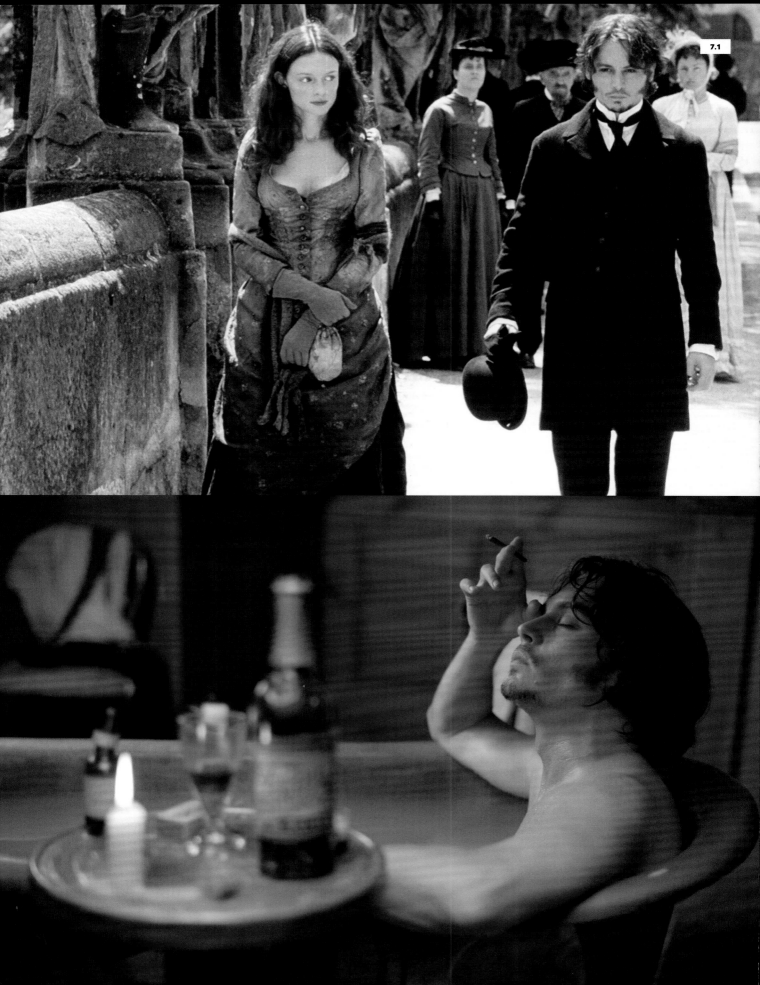

CHAPTER 7
SET DECORATION

The dressing of a setting involves choosing furniture and decoration that create an environment physically appropriate for the action to take place in and emotionally resonant with the characters inhabiting that story world. Decisions like size, shape, style and texture combine to create mood and further enhance the concept – already established by the fundamental building blocks such as light and space as discussed in earlier chapters. Which furniture, textiles, props and decoration are chosen and the ways in which they are arranged in the space is essential to establishing and developing the visual concept.

The designer and the set decorator work very closely to ensure that the concept translates into the specific choices of fabrics, colours, patterns and shapes chosen. Inspired by painting, architecture, furniture, fashion and of course the story and characters of the script, items are selected and combined. The designer will usually draw a dressing plan with the key items in position in each space. Having said this, the decorator will also have a degree of creative freedom to enhance and offer their ideas, and on some occasions the set decorator draws the dressing plan themselves.

This is the point where life is breathed into the environment through the use of decoration to define and enhance space – a magical moment when all the elements are pulled together culminating in a unique dialogue between objects in relation to the light, the colour, the actors and their spatial relation to each other.

7.1
From Hell (2001, Hughes brothers, PD Martin Childs). Design contrast achieved through the home and the street. The Inspector's home is decorated to highlight the absence of his wife.

THE SET DECORATOR

The set decorator invigorates the set with furnishings, light fittings, drapes, carpets, art and exterior dressing. Finding a way of balancing the furnishing that looks and feels right for character and action is a skill that appears effortless on screen.

The best sets are a kind of metaphor for the person and the action that takes place in them. The most important thing is to look into the soul and mind of the character and make that come to life in their environment.[1]

The production designer and set decorator are often compared to the architect and interior designer in the sense that the key focus of one is the building itself while the other is all about the detail within the subsequent build. Set decorators say that it's all about the characters – no two people will live in an identical environment. Continuing the work of the designer, set decoration is about making the characterization work in the details of everyday life – by creating somewhere that appears lived in by the personalities featured in the script. Often a set decorator will arrange the set according to plans from the designer, who will then fine-tune them and make small adjustments. However, in some instances the designer prefers to dress the set themselves – this can also be the case out of necessity on low-budget productions. It is an exciting stage in the process when ideas are energized and physically realized – culminating in a set ready to shoot on.

PD Alex McDowell says:

I don't think we have ever really done a dressing plan – the way we dress sets is pretty intuitive – you gather everything that you would want and you know where the beds are going to be and you know where the lights are going to be, but other than that we build the dressing of a set quite slowly – we spend a lot of time in the space and we're distributing objects as a sort of environmental exercise so you're sitting there and you're trying things out. Trying to build it up in 3D space in reality, not with a flat-plan approach. I think we design a space around its functions so the built in surfaces or where a fridge is going to be or where a table is going to be is part of the architectural design but once you get there and you see the real objects in space you make a lot of decisions based on how they look in reality.[2]

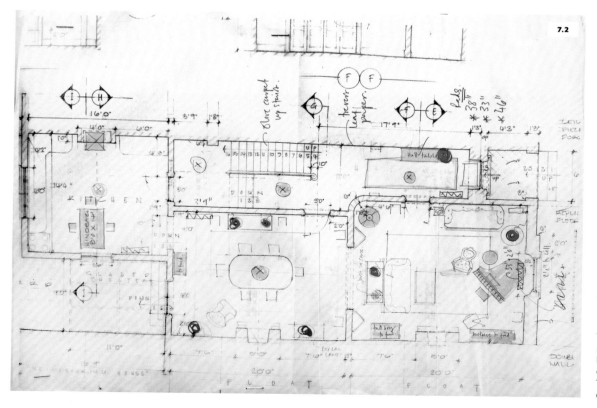

7.2

7.2
Tatiana Macdonald's dressing plan for *Tinker Tailor Soldier Spy* (2011, Tomas Alfredson, PD Maria Djurkovic). Finding balance between items can be intuitive says Tatiana Macdonald, set decorator.[3]

REFLECTING CHARACTER

Maria Djurkovic working closely with set decorator Tatiana Macdonald finds that the character and the dressing are key to the storytelling process, giving her the opportunity to establish mood and create an environment that resonates with the actors. *Tinker Tailor Soldier Spy* (2011, Tomas Alfredson, PD Maria Djurkovic) is set in 1970s during the Cold War. The character George Smiley comes out of retirement to try and track down a Soviet double agent within the British intelligence agency:

> Every space that any character inhabits obviously has to be full of clues for that character. Control's crazy messy flat gives us plenty of clues for his state of mind. Rather flatteringly, John Hurt said that he didn't realize how mad Control was until he saw where he lived. Dressing any set is hugely important to me, I am very involved in it, it is crucial to the storytelling.[4]

Maria's drawings feature furniture and dressing that create a sense of character for the set decorator to work with. (For further discussion of this film see interview with Tatiana Macdonald at the end of this chapter.)

The home is a setting in which a character's psychology can be mirrored and explored. Interior landscape and layers of backstory contribute to our understanding of narrative. The character and story are particularly closely entwined in the domestic setting, and this is often the place that undergoes transformation to signify the changes taking place in the narrative arc. The set decoration established in the beginning will follow the character arc in practical and emotional ways. So for example, a home space may begin in darkness with curtains closed to suggest that a person is depressed or hiding from something, and as the story progresses this can be adjusted – curtains may be opened, changed or torn down completely. This is a particularly simple example but this sort of shifting and redressing of the setting allows subtle changes in mood to be signified. Settings are in a state of flux in this way, providing an ongoing commentary on the character who inhabits the space.

Gemma Jackson describes the process behind the choices made for set decoration on *Bridget Jones's Diary* (2001, Sharon Maguire, PD Gemma Jackson).

> That location just worked in a number of ways, and I loved the kind of fairy-tale aspect of it. When we came to do the inside, you begin to feed the character to somebody, so you have to be very careful. If you put paintings on the wall what are they of? Why are they there, etc.? The idea was that she'd got this place, but she'd only managed to do up a certain amount of it because she hadn't got the money, so she'd pop things on the top like a Cath Kidston cushion and all her self-help books, and she tried to make it lovely and she put her Christmas tree up but then she forgot to take it down. We had her in the kitchen doing the cooking and you can see the balcony covered in fag ends and candle stumps. There was a feeling that she was trying to make it homely but her character wouldn't spend much money on the home; she spends her money on clothes and going out.[5]

How much detail is included will be tied to the genre and style of the production. Thus in realist production where invisible design is an essential element, the environment must not bring attention to itself and is there to serve the story.

A character orientated realism on the other hand, while remaining plausible overall is likelier to use elements of design that provide details about individuals that exceed narrative requirements.[6]

In other words, further emotional depth and interest can be woven into a space that contributes to atmosphere and character motivation, but that is not necessarily furthering or pushing the story on.

Invisible decor

Moira Tait says :

> I didn't ever want a signature – I want to be at the service of the script and the character and I've got a great belief in invisible design.[7]

The relative visibility of a setting is a notion that is in the foreground of production design as illustrated by the production designers interviewed in this book. Jim Bissell:

> This is something that's on my mind all of the time. When something is in the foreground you have to think carefully about what it's saying, whether it's

supporting the narrative or is it something that's going to be making its own separate statement and pulling the audience out of the narrative – in which case it shouldn't be there. So all of the visual elements in the sets I design have to go through that careful scrutiny.[8]

The realist nature of much of film and television production means that a large proportion of the designer's work goes unnoticed in effectively constructing a plausible setting for the action to take place in. Designers stress the importance of their job in support of the story – enhancing without upstaging. PD Martin Childs says:

My instinct in general is to do slightly more 'invisible' sets, than other designers do. I don't draw attention to the work – I think the more invisible the set is, the better.[9]

However, there are productions where settings are deliberately under or overdressed to highlight concept. This approach departs from the invisible decor we are more familiar with and moves into more poetic and expressionistic styles of filmmaking. In *Jubilee* (1978, Derek Jarman, PD Christopher Hobbs) for example, the primary location was a disused warehouse painted black and the very lack of other settings and props

Moira Tait – creating real-life detail from close observation

Moira is Visiting Professor in Production Design at the Norwegian Film School, Lillehammer University College. She was previously Head of Production Design at the UK National Film and Television School for many years and is currently a Senior tutor there in the Production Design Department. She studied Theatre Design at the Slade School of Art before pursuing a career in Production Design at the BBC. During this time, she worked on several films with director Stephen Frears. Her design credits range across a variety of film and TV productions. She was recently awarded a Lifetime Achievement Award (2016) by the British Film Designers' Guild.

Moira describes the way the team collaborated:

> At the BBC we set dressed with a crew. The prop buyer would do all the trips round the prop houses, auctions and junk shops. The buyer would also help set dress. So it was a team effort – myself the design assistant and the prop men set dressing.

The role of the painter and getting the finishes – that is so important – you're only as good as your reference – you had to go and photograph everything. Your assistant was like the art director really.[10]

Moira worked on the drama *Play Things* written by Peter Prince (1976, Stephen Frears, BBC2 Playhouse). A young man working at a children's adventure playground in a deprived area of London finds himself threatened and intimidated by two opposing (racial) gangs; (there was a subtext of drug trafficking). The playground was a location in Notting Hill:

> We constructed a series of slides, rope climbs and a tyre wire, all of which are burning in the opening sequence. Then bit by bit we built the structure up adding graffiti and set dressing, which included painting one building facade pillar-box red. It was very sculptural, with different levels operating, there was a wall so they could be up on a level and someone else could be lower down and there was a staircase where the gangs would be threatening. We got the

kids to do some of the drawing and graffiti and we used a palette of pinks and a bit of red, not too much but what they might have done. The interior was difficult because we didn't have much money so we had to be very resourceful. We set up two identical concrete huts, the exterior one on the playground site, and a duplicate, which was used for the interiors, was located inside a nearby church hall. We dressed it with fruit machines with lights, and glittery patterned fabric to add pattern and texture. For my research I looked at colours and real texture and places and took lots of photographs – I always take lots of photographs as part of my process. There was a distinct design contrast between the two gangs in terms of costume and in their hangouts. One gang was Jamaican and that influenced our choice of colour palette for their den. It was minimal – what you put there mustn't distract but it must enhance.[11]

Moira looked at lots of other adventure playgrounds and went to Teddy Boy gigs for ideas and inspiration. She says:

helps convey key ideas in the film. It is a punk world, where mainstream ideology is rejected. By stripping down the settings the audience becomes involved in the aesthetic of the film. There is no comfortable naturalism or normality to find – even the garden is constructed from plastic; this is undeniably intriguing visually but the comment it makes is stronger still in terms of sterility and lack of life. The weeds have gone but so have the flowers and the creatures that lived on and off them. *Dogville* (2003, Lars von Trier, PD Peter Grant) takes this aesthetic even further dispensing with built sets in favour of a floor plan chalk outline

on the studio floor to represent where the settings would be constructed. There are few dressing or props either. The actors enter and exit each space through the chalk marks on the floor that represent doorways.

Considering what possessions different characters surround themselves with, either deliberately or subconsciously, adds depth to the story and visual interest to the screen. From a kitchen littered with empty takeaway boxes (*Withnail & I* (1987)) to a houseplant that is transported to each new hotel room (*Leon* (1994)), simple and mundane items can unlock character. Henry Bumstead elaborates:

Take Scottie Ferguson in *Vertigo* (1958). An ex-cop, probably not a great reader. I made him a philatelist and dressed a corner of his living room with stamp magazines, magnifying glass and all the equipment a stamp collector uses.[16]

Gemma Jackson worked closely with her set decorator on *Iris* (2001) to create a lived in clutter that supported the character and concept. Working on a tight budget meant that they had to get lots of props from car boot sales, charity shops and similar.

I don't look at other films as I want a new view. I think it's better to look at life and detail and take photographs from life. If I'm looking for colour and light I will go for a wander and see what I can find. Focusing on what the script is looking for – texture, fabric, light, whatever.[12]

Moira had this approach working on the BBC Play for Today *Sunset across the Bay* (1975, Stephen Frears). Written by Alan Bennett and partially based on his parents, the production documents a married couple retiring and contemplating their lives:

I would have alternatives of chairs for example – Alan Bennett would come on set and I would say, 'do you think they would have had this?' On one occasion Alan came with us on a recce and took us to his mother's house and said he wanted me to see his parents' bed as part of the research process! So you meet people who are real and you are creating the artificial version that stemmed from that reality.[13]

You can suggest different settings to the ones in the script and shift it a bit. On Z Cars *(1962–1978, BBC) a crime drama TV series set in the fictional British town of Newtown, I found this wonderful watchmakers' in Clerkenwell. I took photographs of it and the wiring was quite eccentric and we replicated it for the show. People said 'What is this?' They commented and said it didn't look like* Z Cars.[14]

Moira was pleased with this response as it suggested that she had imbued the set with more depth than perhaps other episodes. This is characteristic of Moira's approach which springs from the close observation of real life with the intention of creating authentic textures on screen:

You can always adapt and change things to accommodate once you are dressing a space. I used to rough dress everything – slightly overdress and then have the possibility of pruning away and taking back a bit and I think that's really interesting. You can do that on the computer too – overload and then refine and hone it and dress to camera.[15]

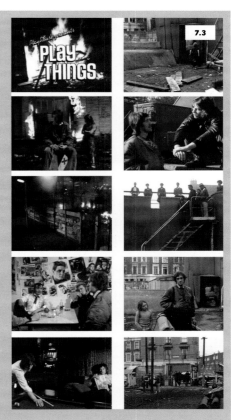

7.3
A series of stills that illustrate the look and feel of *Play Things* written by Peter Prince (1976, Stephen Frears, PD Moira Tait, BBC2 Playhouse). The adventure playground setting creates a dynamic flow teasing out the sculptural possibilities.

I had to say to my set decorator, you must be vigilant, because the minute our backs are turned and you leave everyone on the set, they move a pile of junk and there's something completely not 'Iris' in the frame. You've got to be careful that every piece of junk is ok to have on set. A lot of that meant food and drink and books. Then what we did was dress a layer and then bring the painters in, and we'd paint a bit and then we'd layer a bit more. It was just a lovely job to do.[17]

Gemma also used some of her old artwork from her days at art school to dress one of the settings in the film. She took work from her portfolio and decorated the house with it:

In the original house in John Bailey's house, he has a lot of 60s and 70s art, so I just emptied out my portfolio from my St Martin's days and they looked great because they're slightly sort of expressionistic, you know not awfully good but very passionate work.[18]

This indicates the organic nature of decorating a setting – the process differs according to the people involved and the type of job itself but invention and resourcefulness is integral to the process.

Martin Childs explains how Inspector Abberline's home in *From Hell* (2001, Hughes brothers), was informed by conversations with Johnny Depp and with the directors about the fact that the character has lost his wife:

The loss has had a great effect on his life and therefore we thought it should have a great effect on his home. I included lots of symbols of the kind of warmth that you would get from living with your wife but you've had to find substitutes. Such

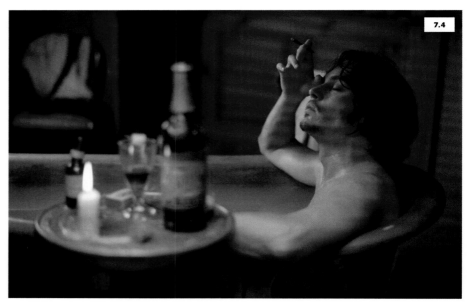

7.4

as a dog and a mad machine to keep his bathwater hot. We constructed this huge Heath Robinson machine at the end of the bath. It wasn't in the script, we invented it. It's a bit of science fiction in a sense, because no such thing ever existed. We just went through one of those catalogues of things like Victorian boilers and ironing machines and liked the imagery, the sort of Jules Verne science fiction kind of stuff and applied it and made it look as if we had done a tremendous amount of research and discovered this thing, and of course we hadn't, we'd just invented it. And it doesn't even make any sense at all because in order to make the bathwater hot, you'd have to have it underneath the bath, like a hob or something. Instead of that it was above the bath and at one end of it. How that would keep the bathwater hot, I've no idea. But nobody questioned it and everybody thought: 'That's a nice thing for the Victorians to have.'[19]

Thinking of the actors in the space influences the dressing and knowing who is cast can be helpful when considering the decoration. The context of place and character can create new meanings that aren't apparent in the unpopulated set. The costume and make-up are also essential in reflecting character and supporting the concept – what people wear is often mirrored in how they live. These elements interplay in the setting, creating a distinctive look, feel and dynamic. Seeing the actors physically in the setting can be influential – their frame, demeanour, how they move within the space and even skin tone affects the colours of the walls and furnishings. Thus, being familiar with the way an actor relates to a set is integral to set decoration.

7.4
From Hell (2001, Hughes brothers, PD Martin Childs). The Inspector's (Johnny Depp) bath was invented as a substitute for the warmth he is missing from losing his wife.

Sometimes the actors get involved in the dressing – Hugh Grant made some adjustments to the apartment in *About a Boy* (2002, Chris Weitz and Paul Weitz) to ensure that his character struck a balance with him being a single man but without any sinister undertones. Thora Hird liked to ensure that soft furnishings were dry cleaned and pristine, and she would look after the plants on set with great care. Johnny Depp and Robert Downey Jr, both get a feel for the character through the hand props and a sense of how their character lives day to day. Gemma Jackson says that she likes to ask the actors if they want anything or feel anything to let her know, particularly in relation to hand props; for example, Johnny Depp wanted to talk about his walking stick on *Finding Neverland* (2004, Marc Forster). Gemma goes on:

I kept lots of things around on the desk. For Judi Dench, [who played Iris Murdoch in *Iris*] things you never saw like an old birds' nest, and she selected the things she wanted and moved things around and on the whole she loved it. Actors rarely come along and say this is all wrong for my character.[20]

Working on television series provides an opportunity to get to know the actors in relation to the setting very well. The *Sex and the City* series (1998–2004) featured four key characters whose personalities and trajectories were at the heart of the show. The four friends had diverse sensibilities, wardrobes and apartments

to match. Production designed by Jeremy Conway and set decorated by Karin Wiesel, the apartments convey their distinct personalities. Colour is employed as shorthand – Samantha's ochres and reds are earthy and sexually voracious, Charlotte has pristine whites and neutrals, Miranda's sensitive vulnerability is seen in plums and greens and Carrie is a soulful soft teal.

For Miranda, the complexity of her character is visualized in the use of hard lines and edges and a multifaceted mirror. The bedroom is more intimately dressed with antique perfume bottles, candles and family photos that highlight her more feminine side. Charlotte's apartment

7.5a
Sex and the City 2 (2010). Mr Big's (Chris Noth) apartment.

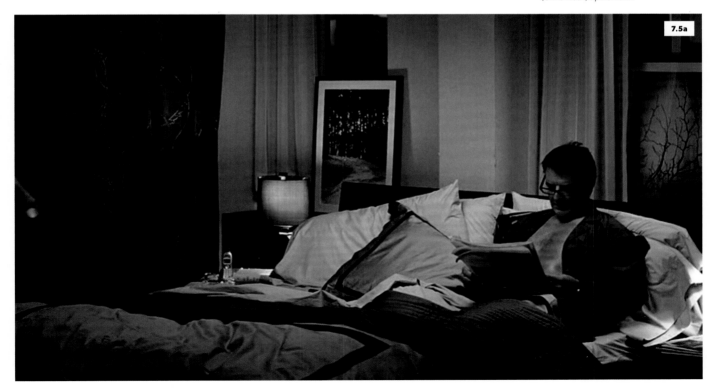

7.5a

features white with parquet floors and architectural details similar to Upper West Side pre-war buildings. When she moves in with Trey she redecorates and transforms it to reflect her personality. Carrie's closet is a key feature of her apartment and is dressed with clothes she has been seen wearing on the show. Dressing such as magazines, books and contents of drawers are regularly rotated. If Carrie is seen reading a book the team consider what she might be reading in relation to the storyline and action before and after. The actress who plays Carrie, Sarah Jessica Parker's own photos of friends and family dress the space. Samantha's apartment is styled to match the converted warehouse she lives in (in the meatpacking district) with a bed on wheels, and instead of a door a gauze hangs between the bed and the living area – tying in with Samantha's character and the overt nature of her sexuality.[21]

The *Sex and the City* films followed the television characters into different settings as a result of changing relationships. For example, *Sex and the City 2* (2010) saw Carrie and Mr Big move into the marital home. Their shared space after years of dating and living separately provided a challenge for the design team who had to combine their two previously distinct styles into one residence – the scale, fabrics, colours and accessories were all chosen to represent how those two individuals might decorate collaboratively.

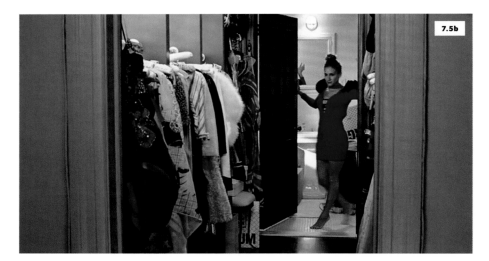

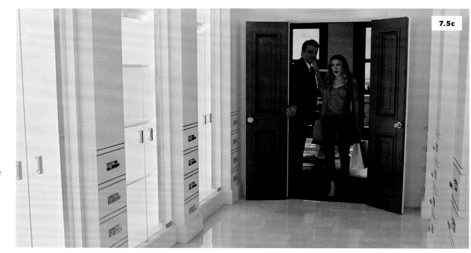

7.5b
Walk-in wardrobe, Carrie's (Sarah Jessica Parker) apartment from *Sex and the City* (1998–2004). Carrie's wardrobe is a key feature of the show, including an eclectic mix of styles, colours and fabrics.

7.5c
Sex and the City 2 (2010). Custom-made walk-in wardrobe in the new shared home.

Props

Props can be symbolic devices that reference themes that exist in the narrative. For *Caravaggio* (1986, Derek Jarman) designed by Christopher Hobbs there were very few props and each one had a specific function; for example, the Inuit knife that is at the centre of the story. The Cardinal was a great art collector, which Hobbs implied through strategic use of select props and large quantities of dust cloths wrapped around random objects to suggest a collection, which occasionally peeped out in the form of a sculpted head or foot.[22]

Alex McDowell recognizes the importance of props and collaborating with the set decorator to ensure that a coherent look is achieved:

> I've worked with Anne Kulijian who was the decorator on *Minority Report* a lot – maybe six movies – and she's a high level collaborator. I spend a lot of time on the objects and the props – we designed a huge amount of the props. Vehicles, guns, the technology – we considered that to be as important as the architecture, and I put as much attention into the manufacturing of props as I do to the manufacturing of the building. It's an enormous part of the narrative so I go to the prop houses with the decorator, I look at every photograph, I'm involved in the choice of every piece of set decoration, working closely with the decorator who is going to drive it to make sure that we're aligned.[23]

Prop houses supply a vast and diverse collection of items that might be needed for a shoot. The designer, set decorator and prop buyer will often visit them to source much of what is required.[24] However, if the budget allows, props buyers and makers will source and craft more bespoke items. An effective prop can stand for the film as a whole by distilling the period, character and narrative. According to Stuart Craig, in every film there are one or two objects that become really special:

> The book in *The English Patient* [1996, Anthony Minghella, PD Stuart Craig] – so much love was poured into the making of that thing, Ralph Fiennes' drawings went into it, it was lovingly bound in leather by a book binder in Rome and aged with real sweat from real palms…it becomes a great symbol of the film.[25]

Props are both functional and emotive, in this way enhancing notions of character and concept. Recurring props can be used to punctuate and reiterate, such as everyday action props – telephones, televisions, newspapers, books and guns.

In *The Grand Budapest Hotel* (2014, Wes Anderson, PD Adam Stockhausen) the set is like a dolls' house with infinitesimal details included such as handcrafted props—newspapers, patisserie boxes, passports, a claim ticket for a Persian cat (deceased)—taking their inspiration from the nineteenth-century grandeur of the hotel. Often the props and dressing dominate the frame with frivolous detail such as the pink Mendl's patisserie boxes that surround the couple in a pink bubble as they fall for each other.

When furniture is off the shelves of a prop house it can look generic – seeing the same chairs repeatedly used across productions can feel tired. Conversely, the reusing of certain items on occasion adds depth and emotional significance. For example, an unusual bed was sourced originally for *Phantom of the Opera* (1925, Rupert Julian) that had belonged to entertainer Gaby Deslys and subsequently reused in *Sunset Boulevard* (1950, Billy Wilder) in Norma Desmond's bedroom. The baggage and backstory of objects used in this way are reconfigured and re-contextualized in relation to each new setting, set of characters and story.

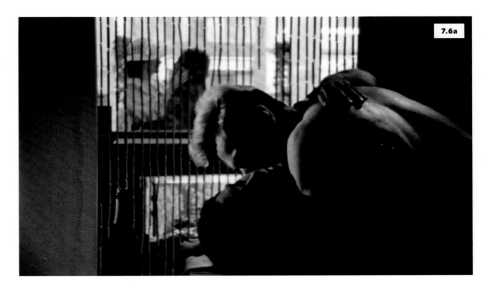

7.6a

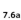

7.6a
My Beautiful Laundrette (1985, Stephen Frears, PD Hugo Luczyc-Wyhowski). Salim (Derrick Branche) and Johnny (Daniel Day Lewis) carry on their relationship in privacy and away from the judgement of others. At the same time Salim's uncle dances with his girlfriend in the launderette. In contrast, Salim's uncle's affair is out in the open and condemned.

7.6b

Mirrors are embedded in film language, bouncing light and playing tricks with perspective, reflecting beyond the foreground and adding depth and extra detail. Scratched mirrors are sometimes used to draw attention to the layers, and two-way mirrors such as in *Paris, Texas* (1984, Wim Wenders, PD Kate Altman), *My Beautiful Laundrette* (1985, Stephen Frears, PD Hugo Luczyc-Wyhowski) and *Cloud Atlas* (2012, Tom Tykwer, Lana Wachowski, Lilly Wachowski, PD Hugh Bateup, Uli Hanisch) have been effective in indicating the collision of ideologies and worlds, with one being hidden or subversive, and the other representing mainstream/false consciousness. In *Paris, Texas*, Jane (Natassja Kinski) gazes into the two-way mirror that merges her image with that of her ex-husband Travis (Harry Dean Stanton) indicating the bond that may still exist between them in spite of years of estrangement. While in *My Beautiful Laundrette* the two-way mirror allows us to see a space beyond a space, privileging those in the back room who can see into the launderette without being seen themselves. The back room conceals the clandestine relationship between Salim (Derrick Branche) and Johnny (Daniel Day Lewis) whose faces eclipse each other at one point, echoing the scene with Jane and Travis in *Paris, Texas*.

7.6b
My Beautiful Laundrette (1985, Stephen Frears, PD Hugo Luczyc–Wyhowski). Salim observes the launderette without being seen. Johnny knowingly returns the gaze.

FURNITURE AND DRESSING

From an action point of view furniture is functional and often necessary for a character to go about their daily activities – they will usually need items to sit on, sleep on or put things on or in. The designer and the set decorator are knowledgeable about the history of furniture and interior design and research the specifics of the period they are working on to help generate accurate and evocative responses.

On a basic level, furniture is indicative of a settled existence and a cultural life above subsistence, a measure of social status, and it can be used to make statements about an individual. The way pieces of furniture can be repositioned, added to or taken away is like a shifting collage. The history of furniture echoes the general development of society and begins to speak of the psychology of the individual. During the eighteenth century, the work of individualists such as Horace Walpole and William Beckford contributed to the breakdown of fixed categories in favour of stylistic choice. Ideas and emotions were attached to furniture above and beyond its appearance, and reflecting the social status and psychology of the individual as well as the wider development of society.[26]

Each piece of furniture is transformed when positioned in relation to another – the repositioning conveys ideas about the person, the nature of the company they keep and their social interaction. The way people live and arrange their lives using key items such as chairs, beds, tables, lamps, pictures, ornaments, drapes, flooring, soft furnishings and electronic equipment speaks of the individual and the context of time, place and story.

Screen choices about what is selected and combined, and in what way, are tied to concept. There must be a governing concept that guides filmmakers in deciding which details to emphasize. You can't select items randomly to dress with, they all lead back to the visual concept. PD Martin Childs believes that there are lots of details that an audience may not register consciously, but that sink in and affect our psychological sense of a character and their story:

It's to do with props and clutter and dressing. How you make clutter look as if it wasn't done yesterday, but so it looks like it has been created over decades of this person's life. Making dressing look as if it has evolved that way rather than placed on a shelf yesterday by the props department. I remember working on a TV production many years ago, we had to do an Edwardian junk shop that was also somebody's home. We had very little money and the prop people dressed it with completely random clutter. So I said: 'Wouldn't it be better if all of the barrels were together, all of the carpets were together and such and such?' And that way it made it look as if this man had made at least some effort over the years to keep on top of this clutter.[27]

Childs says that to make absence work you have to have a certain presence and to make clutter work, you have to have a bit of order to compare it to. By showing what something isn't, you help accentuate what it is – which is the key to contrast as a method.

Size

The size of furniture, props and dressing is considered in relation to the space being dressed. In the dressing plan, items are drawn in position and to scale to get a sense of the proportions of the room.

Moira Tait says:

Every time I went to look at props I took a plan – that is the heart of what I do and I would measure everything to make sure it fitted in. In terms of space, everybody says you need more space for cameras but actually it can look wrong if the spaces between things are too big, so I always plotted in the furniture, measured and drawn to scale and I would give that to the props department to dress from, with a props list.[28]

Scale expectations can be challenged such as seen in *Brazil* (1985, Terry Gilliam, PD Norman Garwood). Set in a dystopian future, the bureaucratic work space is alienating in absurd ways, culminating in Sam Lowry (Jonathan Pryce) having half an office – a wall divides the space into a ridiculously narrow room that resembles a corridor. The desk adds to the visual joke in that it is half a desk – shared with the adjacent office – and occasionally tugged between the two in a bid to get more of it.

CHAPTER SEVEN – SET DECORATION

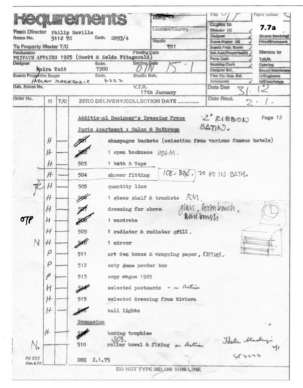

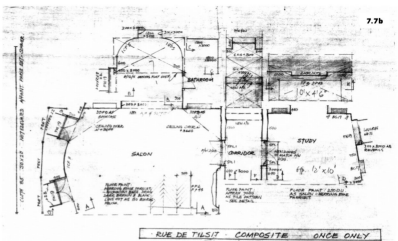

7.7b

· RUE DE TILSIT · COMPOSITE · ONCE ONLY

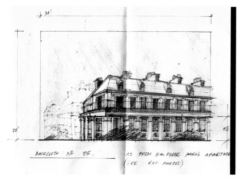

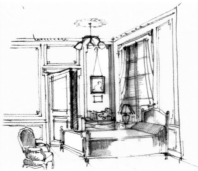

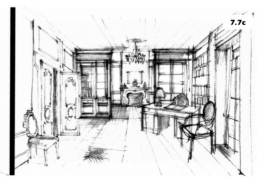

7.7c

7.7a, 7.7b, 7.7c, 7.7d
Private Affairs (A Dream of Living)
(1975, Philip Saville). BBC
production designer Moira Tait's
prop requirements, floorplan,
interior sketches, wallpaper and
fabric swatches. Ideas about
dressing are indicated here from
a range of sources, including
sketches that give a clear sense of
scale and proportion in addition to
style and period detail.

7.7d

PERIOD AND STYLE

Most productions exist in a given period – sometimes several – time like other elements on screen is often embellished for dramatic effect. The dressing is necessary to help an audience believe in the environment and to anchor the story. From a contemporary point of view we live in a mixture of periods – where architecture, furniture and props from previous periods in history sit next to each other. Set decoration can situate different pieces in conversation relative to each other, positioned in combinations that offer comment and reflection.

Historical specificity means researching the life of the period – what people did or do in their spare time, what inventions are around or on the horizon, and basic everyday details such as what size paper is in use. An understanding of period styles is essential to ensure that the visual narrative has integrity and whether aspects of furnishing or architecture are appropriate. It is also important to be mindful of the co-existence of different styles and periods – for example, although a film is set in the 1980s, it does not mean that all aspects of the design should be from the 1980s – it is actually the 1970s style that will likely be dominant because people don't all furnish their homes with contemporary pieces. A sense of what a contemporary audience perceives that period to look like, whether it actually does or does not is important – the details are all choices based on what is accurate, what the audience believes to be accurate, and what best serves the story visually.[29]

Recreations of the past can easily become parody and pastiche. Even if it was possible to define exactly how a particular place in time appeared, recreating it accurately can be problematic. The process of building, decorating and dressing all present practical issues relating to time, money and authenticity which will influence the design. For example, sourcing authentic textiles, furniture and so forth may prove too expensive, so a cheaper alternative may be necessary – practical and technical issues may impact on the process.

Screen design interprets historical information and sits somewhere on a continuum in relation to issues of realism and historical accuracy. The choice of furniture and how it is arranged with other pieces becomes incorporated into the scenes of a particular period and integrates into a visual shorthand for that period. For example, audiences have become familiar with the stylistic conventions of certain dramatic periods such as seen in the Western genre, the Victorian age, the Jane Austen genre, the seventeenth century and so on. It can be exciting and refreshing for a designer to break out of the screen conventions and explore further possibilities that create inventive images of the past in unfamiliar ways. For example, Christopher Hobbs[30] uses historical research as a springboard into the sensibility of a period to capture the spirit of the times and create a visceral sense of a place in time.

Historical studies of furniture enable a closer understanding of societies of the past and how people of different times and cultures lived. The style and shape of furniture often relates to the period so for example, the curves and flamboyant shapes of the Rococo period contrast strongly with the angular utilitarian silhouettes of the 1950s. Different design movements embody ideas percolating at the time – the arts and crafts movement, art nouveau and then modernism, for example, are all expressions of rebellion against revivalism's nostalgia for the past.

The architectural space, the furniture and objects within it are in dialogue, the context of which shifts according to the period. Colours, materials and modes of production also change according to technological developments, availability and fashions of the time.

The Ballets Russes in the 1920s had an impact on seating – big sofas and floor cushions affected attitudes toward behaviour, manners and the body: 'Now it was permissible to sprawl and loll where formerly it was necessary to sit upright.'[31] The tension between fashion and comfort is reflected in such changes, as are shifting societal values around hierarchy, luxury and utilitarianism for example. Novelist Edith Wharton is credited with inventing the concept of interior decoration in her manual of interior design *The Decoration of Houses* (1897), and Elsie de Wolfe is acknowledged as the first person to decorate as a profession. She gained her reputation decorating the Colony Club in New York in 1905, which was a club for women, a feminist enterprise. The rise of the decorator made eclecticism a principle – interiors became a collage, balancing personality with practicality.

The 1960s are a popular source of inspiration for the fashion, music and cultural shifts taking place during that era. The sixties setting and styling for the American TV series *Mad Men* (2007–2015, AMC) is a big part of its appeal. However, it created an early sixties feel which included the essence of the 1950s, in a fresher interpretation of the era. Set in a prestigious New York ad agency, Sterling Cooper Draper Price, the interiors reflect the glossy commercial world (the furniture manufacturers Herman Miller and Knoll were used as a reference) and nods at the design trends popular at the time, echoing the cultural and social shifts taking place in the States. The inclusion of more comfortable seating and sofas in the creative industries became a feature of interiors from the mid-fifties onwards.

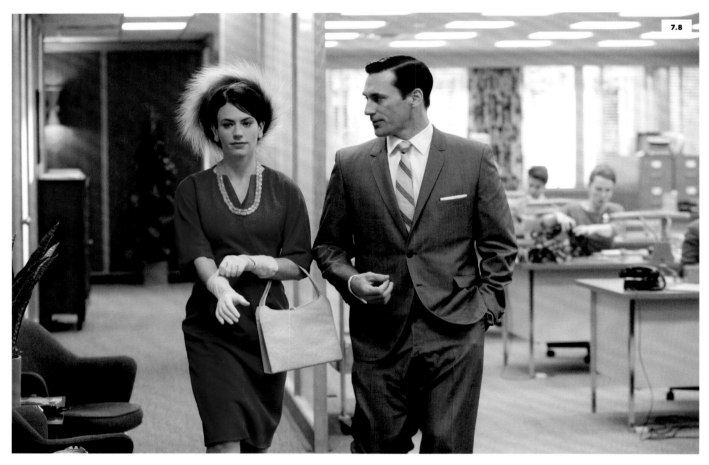

7.8

PD Dan Bishop and set decorator Claudette Didul created sixties furnishings with attention to detail, including the distinction between East Coast and West Coast mid-century modernism. The team looked at documentaries and commercials from the time to educate themselves. The clutter has been chosen for authenticity – in an attempt to make it feel real details are included that are often deliberately omitted in sets because they are visually unappealing. For example, as much attention is given to the wiring for lighting that looks messy hanging down from a desk and the paraphernalia in a character's desk drawer, as is given to larger furnishings such as tables and chairs.

The Drapers' apartment in *Mad Men* is intentionally designed, the idea being that those characters would have hired a decorator to create a magazine spread-style home. It includes impractical details such as a white carpet that would be difficult to maintain in real life – which again provides further insight into the Megan character. It is a fantasy space, aspirational in detailed texture and dressing.

7.8
The ad office in *Mad Men* (2007–2015, AMC) captures the mood of the period and includes details often omitted, such as wires that interrupt the clean lines of the composition. Modern minimalism with a predominantly cool-toned set allows bold costume colour to stand out.

For *LA Confidential* (1997, Curtis Hanson), Jeannine Opewall (PD) and Jay Hart (set decoration) put the antagonist – a high class pimp – in a contemporary setting, an early 1950s state-of-the-art house dominated by straight lines as opposed to the more usual period choice of heavy dark furnishings. As the first ones to shoot in the pioneering Richard Neutra Lovell Health House, the team had furniture custom made from original Neutra designs. Everything is in complete symmetrical balance, so although carefully designed, the rigid aesthetic produced is uncomfortable. To establish the prostitute's character (Kim Basinger) the decor was executed in rich creams, undulating fabrics and curved furnishings. It was a lush Hollywood starlet set – the intention being to make it look completely artificial, an untouchable fantasy facade. In contrast, her real apartment was upstairs

and filled with colour and warmth. This exemplifies the way dressing can produce visual contrast to promote the concept.

If the production is based on real-life events, then there is a different duty to historical accuracy than if the story is fictional; for example, for *Atonement* (2007, Joe Wright) Sarah Greenwood and Katie Spencer's research took in war museums, speaking with veterans and visiting Dunkirk in response to a sense of responsibility to be authentic in the portrayal. Original furniture, dressing and small props are sometimes preferred to reproduction because they contain their own histories and the stories of the people who owned them. However, sometimes they don't exist or are no longer available, in which case may be made especially for a production.[32] As with the Neutra designs in the last example.

Marie Antoinette (2006, Sofia Coppola, PD K. K. Barrett) presents a different interpretation of a familiar historical period set in sixteenth-century France. Costume, colours, patterns and textures integrate with earlier screen presentations of the time but other elements deliberately jar. Shot on location in Versailles, a restricted colour palette, period costume, furnishing and lighting are dressed in accordance with era from the perspective of a young woman swept up in court life and fashion in particular.

7.9
Marie Antoinette (2006, Sofia Coppola, PD K. K. Barrett). Instead of adhering to the conventions of historical drama, the film playfully attempts to conjure the spirit of the times and an energetic atmosphere. Food plays an important decorative role as an emblem of the excesses of court during this time.

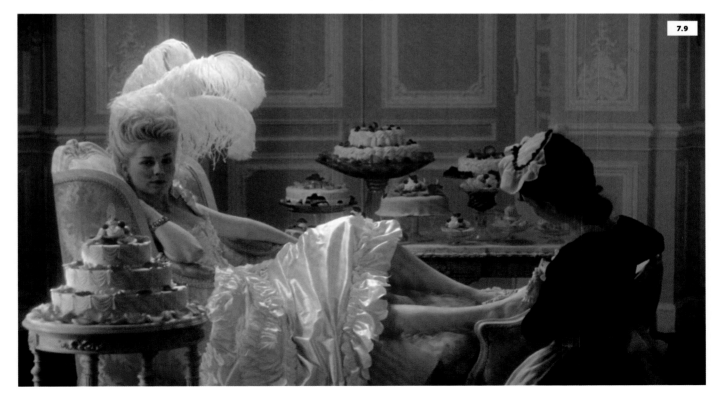

7.9

The research process can also encompass looking at other films. Martin Childs says that watching films from an early age has deepened his awareness of the moving image and its history. He finds this a useful form of communication with directors who have a similar feel for film, enabling a shorthand to develop between them. Childs refers to films and scenes in this way not for plagiarism, but as a springboard into ways of visualizing the story.

The Third Man [1949, Carol Reed, PD Vincent Korda, Joseph Bato, John Hawkesworth] has had a huge influence on me – there are bits of that film in everything I've designed. It's not about period. It's about architectural detail and about props. The way props are handled. The way things happen for a narrative purpose. There's no finer film, in terms of storytelling, than The Third Man and I constantly refer back to it. There is a certain sort of abstract quality to it, I've watched it many times. I also keep referring back to Carol Reed films like The Fallen Idol (1948).[33]

Visualizing the future presents different challenges to that of the past, as authenticity cannot be questioned in the same way as periods that have occurred and been documented. A greater freedom to invent exists, usually led by the guiding principle or philosophy of the story (see discussion of Minority Report in Chapter 3 for a particular example).

Visual shortcuts used to signify the future often fall into two main categories – utopian or dystopian – with efficient sleek, shiny surfaces or crumbling, decaying infrastructures respectively.

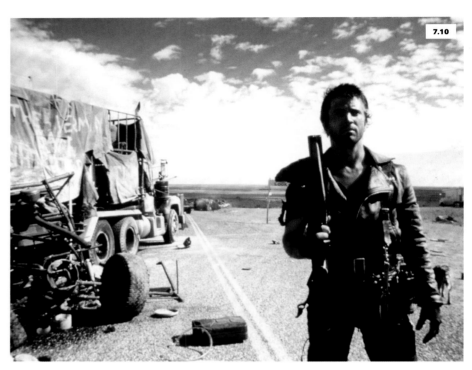

7.10

Minority Report (2002, Steven Spielberg, PD Alex McDowell) plays with this duality by creating a sense of a utopian future in the first instance only to reveal an unwholesome underbelly that exists in parallel to the shiny surface of a crime-free world. (See Chapter 3 for further discussion and images of the film.)

Mad Max (1979, George Miller, AD John Dowding) created a world where most of the resources had been used up and waste littered the landscape to illustrate the point. A road movie that is based on the shortage of fuel. Set in a post-apocalyptic wasteland the protagonist Max helps a community escape the gangs who want their precious preserves of fuel.

7.10
Mad Max (1979, George Miller, AD John Dowding). The remnants of the pre-apocalyptic world are strewn through the film as a visual anchor to the setting – authenticating the premise of the world created in the story.

Materials and texture

Cloud Atlas (2012) includes many historical periods and explores the impact of the actions of individuals across time. The past, present and future converge which creates interesting challenges for the Art Department. For example, there are two settings in the future that contrast with each other – in one, Zachry (Tom Hanks) exists in a rural landscape of woods in what appears to be a pre-industrial age, with the houses, clothing and props all suggesting that we are in the past. However, when a spaceship lands on the island, it becomes clear that this is set in the future and there are different tribes of people living in entirely different contexts according to their available resources. Meronym (Halle Berry) is clothed in a shiny white jumpsuit and has access to advanced electronic equipment. Zachry lives off the land and has limited resources, which contrasts with the technology used by Meronym, and illustrates the two different co-existing futures. It is also Meronym who has access to knowledge and history, telling Zachry the truth about past events. Set in nature, Zachry's environment indicates a backward sensibility.

Chosen materials add layers of resonance; whether shiny reflective plastic or chrome, rustic textured wood, or smooth polished marble, materials all create a different atmosphere and change the way light is reflected. Smooth surfaces can shimmer magically or bounce hard bright light. The choice of material will also be influenced by period – organic materials of wood and stone have a warmth and resonate positively, while more synthetic materials can be used to suggest themes such as alienation. Martin Childs considered materials carefully when thinking about the homes of Shakespeare and his contemporaries for *Shakespeare in Love* (1998, John Madden).

> You have to research characters of a completely different social class and how homes might have been, because you have to have a visual shorthand. Nobody's going to linger over the fact that this is the home belonging to the Simon Callow character or the Rupert Everett character in *Shakespeare in Love*, for example. You have to say 'He's going to get the wooden interior, he's going to get the plaster interior, he's going to get the colourful interior, he's going to get the drab interior.' This is because there are only a certain amount of visual shortcuts that you can use, that make a subconscious impact on the audience.[34]

Designer Peter Lamont says that he learnt a lot from Ken Adam who used all the real materials he could. When he can Lamont does the same:

> On the original *Titanic* everything was oak so we used oak. If you want a mahogany door, use the real material because if you don't you're spending the time of the master painter recreating something. Let them do something that you can't do for real – like metal or marble. Simon Wakefield [the set decorator on *Casino Royale*] got some beautiful pieces – lots of leather and brass and at one time we had black satin sheets until Martin decided that it was going over the top! And our painter Gary did some wonderful marble on the bathrooms.[35]

In this way the skills and resources of the team are being utilized effectively. It's important to spend time and budget wisely on materials that can't be reasonably sourced.

INTERVIEW WITH TATIANA MACDONALD

Tatiana Macdonald describes the journey she goes on in her role as set decorator:

> You don't know where you're going to end up but funnily enough when you finish filming and you look back at the references on the wall – there it is, that's what the film was always going to look like, it was on the walls from day one and yet it's not been prescriptive, you've done it in not such a rigid way.[36]

Tatiana Macdonald is a set decorator and art director, known for *The Imitation Game* (2014), *Tinker Tailor Soldier Spy* (2011), *Billy Elliot* (2000), *The Invisible Woman* (2013) and *Cassandra's Dream* (2007). She was nominated for BAFTAs for *Tinker Tailor Soldier Spy* in 2012 and *The Imitation Game* in 2015.

Can you give a brief overview of *Tinker Tailor Soldier Spy* (2011, Tomas Alfredson, PD Maria Djurkovic)?
What stands out about *Tinker Tailor* is Tomas. He's fantastically visually clever and inventive, so you're working with someone who has incredibly good ideas and is very receptive. He deals with Maria [Djurkovic, the production designer] directly and then Maria will start to research and come up with an amazing array of images and references, which go up on the walls. Once I've seen those I understand where we're going and I go out and try and find what we need.

And how would you describe your role on that project?
My role is very practical – to try and physically manifest the director and designer's vision. You see images of rows and rows of incredible desks and you know that you have to produce that thirty years down the line – it's not so easy they're not there anymore. I go, okay that's what we're doing, and just set off and try to pull everything in – it's like a collage, a little bit of this and a little bit of that. Chucking things into baskets effectively – you have 72 sets and you've got them all listed and you begin to look at the location photos, and you stand in the space and you understand what's happening there and you've spoken to Maria about it. And I do that on IPhoto – I have a file for every set and it gets chucked in, and by the time we're half way through prep I'll have quite a lot in my baskets and I'll look at it carefully and plot it. What do I need, what don't I have, what are we still looking for. I usually have about 8 to 10 weeks' prep then 10 to 12 weeks to shoot.

So you do your dressing plan after you've sourced the items?
Yes, I get a lot of stuff and then I'll fit it that way. I think that when you're looking for things, you can go out and find something quite quirky and look at it, and go I didn't think of that, but it might work so sling it into your basket, and measure everything and list everything, so I know I've got it, it's booked. It might move but it's there and that will lead you to another decision and another and it's much more organic.

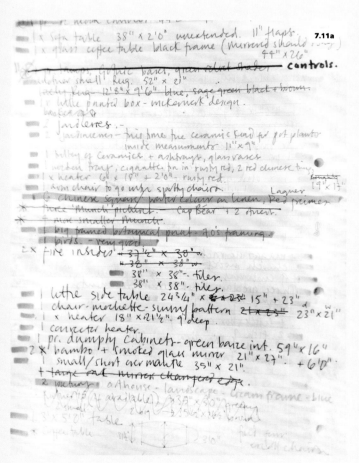

7.11a

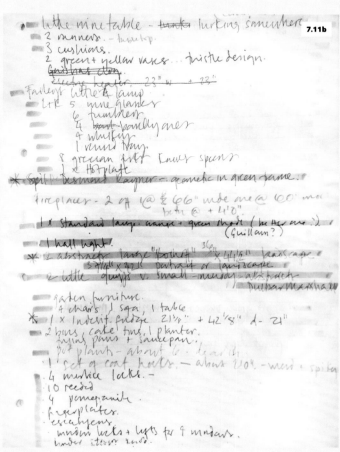

7.11b

7.11a
Tatiana's colour-coded props list for
Tinker Tailor Soldier Spy (2011, Tomas
Alfredson, PD Maria Djurkovic). Tatiana
intuitively knows when furniture and
props are right for a project, having
studied the source material and
absorbed Maria's drawings and research.

7.11b
Tinker Tailor Soldier Spy (2011, Tomas
Alfredson, PD Maria Djurkovic). Tatiana
lists everything she wants for each set
before putting it into her dressing plan.

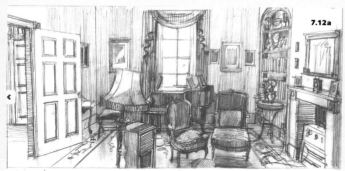

Smiley's Living Room

7.12a

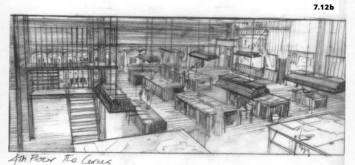

4th Floor The Circus

7.12b

5th Floor The Circus

7.12c

And have you always worked that way round since film school?

Well, I left film school as an art department runner, so I was photocopying drawings and driving round and picking things up, and then I was an assistant art director and then I was standing by with Maria and she recognized that she thought I had a similar eye aesthetically, so she asked me to decorate.

So can you say a bit more about how you and the designer work together?

She has done the research and knows what she wants and hopefully it takes me a second to grasp what she's after because we have a shared history of working together.

She will come out with me on day one, day two and together we'll book key pieces, and then after that I will carry on on that trajectory. Everything I choose is an instinctive response, I have to make the decision – otherwise you can be thrown off course.

Can you talk me through the dressing plan?

I do that, I show Maria everything and if there's anything she's not comfortable with, she will say but that rarely happens. If I'm not sure about something I will run it past her. If she's signed off on it and is happy, I can move on and not worry. Now we've got iPads and digital photography you can look at a set easily. So I'll do the dressing plan and show Maria and if it needs to change on the day that's fine, no one's obsessive about it. I do them because I need to know I've got what I need, and it feels right and it's the thing that I love doing the most, because you're virtually dressing the set.

7.12a
Maria Djurkovic's drawing of Smiley's living room in *Tinker Tailor Soldier Spy* (2011, Tomas Alfredson, PD Maria Djurkovic). Tatiana responds to Maria's drawings in her search for the decoration to realize the atmosphere and vision contained in the images.

7.12b
Tinker Tailor Soldier Spy (2011, Tomas Alfredson, PD Maria Djurkovic). Maria Djurkovic's drawing of 'The Circus', fourth floor.

7.12c
Tinker Tailor Soldier Spy (2011, Tomas Alfredson, PD Maria Djurkovic). Maria Djurkovic's drawing of 'The Circus', fifth floor.

7.12d

What were some of the key ingredients when dressing *Tinker*?

The colour springs up very quickly from Maria's research and it will present itself. And we knew we were not going to do brown and orange. We did use a lot of a dirty pink. Also I will throw in another colour if another colour works. We love a bit of pattern, and pattern on pattern – the more the better. We tend to use quite a bit.

What about your approach to character and story?

With character I think about colour, I think about the period, I immerse myself in it, the period, the script, the character. *The Invisible Woman* [2013], for example – there was a big biography and I'll download that and listen to it as I drive. The same with the Turing book (*The Imitation Game* [2014]) which is so dense. So I immerse myself like that and hopefully I'll get little bits of detail that I can then use. I inform myself and after that I act instinctively.

What was great with *Tinker* was that I went into a prop house called Newman [London] and they had these amazing white Italian glass lamps, and I said I want them, and he said no I don't rent those out, they're too valuable. Anyway I got them, had

shades made for them, and put them in the set. John le Carré's grand-daughter was working on the film and right at the end of filming she told me that he has the same lights in his house. And that's amazing, so I kind of innately knew that they were right. And then another odd one was one of the line producers was connected to one of the heads of intelligence, and he sidled over. He said, I've got a desk for you, and eventually I got a photo of it, it was the actual desk, and I'd already booked an identical desk for that character. So it's done by feel, and sometimes you hit the nail on the head.

How helpful do you find it knowing who has been cast?

I think you have to ignore it but it depends how they work. They might come and ask for stuff. We had Harvey Keitel wanting a loaded gun and things in his pocket. Certain actors are more involved with their props. Benedict [Cumberbatch] was keen to suss things out on *The Imitation Game* – very sweet and well-informed. Things like choosing his pen and other hand props like that. I would give them as much help as they wanted.

7.12d
Tinker Tailor Soldier Spy (2011, Tomas Alfredson, PD Maria Djurkovic). 'The Circus' set built and dressed.

To what extent do you consider the action/movement when dressing?

Sometimes the director will describe the actor's passage through the set at the technical recce and they might move things that are too low or in the middle of the room. I like putting in obstacles – you don't want to treat it like a stage set and put everything around the outside, you want things that you can shoot past and through, so I tend to dress the set for visual interest and practically how that set would have been dressed. So in certain periods they did put all the furniture around the outside of the room and then the Victorians had all the incidental tables, so I would be true to the period and then they can navigate it. I think if they have to navigate things it can make the scene so much more interesting as well, otherwise the actors are just rattling around in a box.

What is your approach to the visibility of the set and issues around realism?

Different directors want different things – like Tomas [Alfredson] features it as a character in itself – it's there, it's very deliberate, it's telling a story. For others it's wallpaper, just background. I put in all the detail, it'll all be there then, whether or not they shoot it is down to them. You don't know where the camera is going to be, they could be focusing in on some tatty corner that hasn't been painted. I like to fill all the drawers, and if I was on a Mike Leigh set I would have to. It has to be done so that the camera can look anywhere with enough detail to be convincing.

Who are the other key people in your crew?

If I can I'll have an assistant and a buyer who does all the budgetary stuff and I give them the tricky stuff to find. I don't go round with them because I think that wastes time doubling up. For example, on *Imitation Game*, Liz Ainley had the job of finding all of those radios and all of the technical equipment and dealing with Bletchley and she did a phenomenal job getting all of that together.

The buyer is incredibly important and so is an assistant. Then the art director does the drafting and construction and there's a lot of collaboration there – I'll get plans off them. Then the painters go in and the prop men go in and that's all in close collaboration. Graphics produce all of the printed stuff and signage. So it works well – a great team.

When would you make a decision to have something made?

So I would look and look – always find it rather than have it made. I'd rather it was real – because then it's going to have a patina and history. It's expensive making things well, and it's always a gamble that it's not going to work. We try to be incredibly thrifty, we don't go over budget and we try not to waste money. So I don't book more than I need and the dressing plan helps with that. I'll get one extra piece as a contingency but what goes on the truck gets used. I'm very meticulous – I leave nothing to chance. It's tightly scheduled – on *Tinker* we were doing something like two sets a day so you are constantly on the move and there's no time to stop and think.

In what ways does budget influence your work?

Well you wouldn't want it to be open-ended – there have to be limitations and budget is a good a limitation as any. I wouldn't want a huge amount more. I like working within constraints so you make it work with what you've got.

Do you have similar places that you return to repeatedly to source items?

I might go to a prop house one day and then plenty more times in the next 10 weeks. There's so much there and you'll have walked past it a thousand times, and suddenly you spot the best thing for the job. And it's all to do with where you are and what you're thinking and you walk round and round and then you see it.

Do you look at other films for inspiration or reference?

I watch films because I just love watching them. I'm sure I absorb them and they come out in my work but I'm not sure in what ways. Not for inspiration or reference because I think you can't trust them – they are all somebody else's interpretation. Even if you look at something that was shot in the 1970s, the set might still be a bit mannered because it's still someone's interpretation. But you can look at the streets in documentary footage and take in period from the exteriors.

7.12e

7.12f

7.12e
Tinker Tailor Soldier Spy (2011, Tomas
Alfredson, PD Maria Djurkovic).
'The Circus' set built and decorated.

7.12f
Tinker Tailor Soldier Spy (2011, Tomas
Alfredson, PD Maria Djurkovic). Control's
living room set.

7.12g
Tinker Tailor Soldier Spy (2011, Tomas
Alfredson, PD Maria Djurkovic). George
Smiley's home. Seeing the drawings
translated into the set decoration
illustrates the degree to which Djurkovic
and Macdonald collaborate.

7.12g

Exercises

1. Draw a dressing plan for two key settings from either the *Clay* script provided in the Appendix or another you are working on/interested in.

 - Do you have to add or take away from your original script breakdowns for these scenes/ settings?

 - Do any new ideas occur to you going through this process?

 - Do the two spaces both work to convey the same visual concept?

 - What elements are you using to communicate this?

 - Do the two spaces contrast with each other enhancing the concept further?

 - Visit a prop house or look at one online – which furniture and props would you choose to dress the settings?

 - Cast the script with your chosen actors, then look at props and dressing for each character, with a definite sense of the actors' physical presence. See how this might alter your dressing choices.

 - What shapes, textures and styles will you choose and why?

Further Reading

American Institute of Architects. *Architectural Graphic Standards*. Hoboken: John Wiley & Sons, 2016.

Aronson, Joseph. *The Encyclopedia of Furniture*. New York: Crown Publications, 1961.

Barnwell, Jane. *Production Design: Architects of the Screen*. London: Wallflower, 2004.

Bradbury, Dominic. *The Iconic Interior*. London: Thames & Hudson, 2012.

Burg, Karen. 'The Art & Craft of Set Decoration'. *The Scenographer* (2004). Available online: http://it.thescenographer.org/the-art-and-craft-of-set-decoration/ (accessed 8 September 2016).

Calloway, Stephen. *The Elements of Style: An Encyclopedia of Domestic Architectural Detail*. Richmond Hill: Firefly Books, 2012.

Ching, Francis D. K. *A Visual Dictionary of Architecture*. Hoboken: John Wiley & Sons, 2011.

Ettedgui, Peter, ed. *Production Design & Art Direction*. Woburn: Focal Press, 1999.

Friedman, Diana. *Sitcom Style: Inside America's Favourite TV Homes*. New York: Clarkson Potter, 2005.

Grouchnikov, Kirill. 'The Fine Craft of Set Decoration – Conversation with Katie Spencer'. *Pushing Pixels*, 18 January 2012, http://www.pushing-pixels.org/2012/01/18/the-fine-craft-of-set-decoration-conversation-with-katie-spencer.html.

Hart, Eric. *The Prop Building Guidebook. For Theatre, Film and TV*. Burlington: Focal Press, 2013.

Hemela, Deborah Ann. *Debbie's Book*. 27th edn. Altadena: Debbiesbook.inc, 2015.

Lucie-Smith, Edward. *Furniture. A Concise History*. London: Thames & Hudson, 1989.

Miller, Judith. *Chairs*. London: Conran, 2009.

Riley, Noel. *The Elements of Design: A Practical Encyclopedia of the Decorative Arts from the Renaissance to the Present*. Brookvale: James Bennett Pty, 2003.

Sohn, Amy. *Sex and the City: Kiss and Tell*. New York: Pocket Books, 2002.

Tashiro, Charles. *Pretty Pictures. Production Design and the History Film*. Austin: University of Texas Press, 1998.

The Call Sheet. 'Interview with Standby Art Director, Philippa Broadhurst'. www.thecallsheet.co.uk/news/interview-standby-art-director-philippa-broadhurst.

Notes

1 Karen Burg, *The Scenographer*.
2 Alex McDowell, author interview, 2015.
3 Tatiana Macdonald, author interview, 2015.
4 Maria Djurkovic, author interview, 2015.
5 Gemma Jackson, author interview, 2005.
6 Charles Tashiro, 104.
7 Moira Tait, author interview, 2015.
8 Jim Bissell, author interview, 2015.
9 Martin Childs, author interview, 2005.
10 Moira Tait, author interview, 2015.
11 Moira Tait, author interview, 2015.
12 Moira Tait, author interview, 2015.
13 Moira Tait, author interview, 2015.
14 Moira Tait, author interview, 2015.
15 Moira Tait, author interview, 2015.
16 In Peter Ettedgui, 20.
17 Gemma Jackson, author interview, 2005.
18 Gemma Jackson, author interview, 2005.
19 Martin Childs, author interview, 2005.
20 Gemma Jackson, author interview, 2005.
21 Amy Sohn, 60–61.
22 Jane Barnwell, 85.
23 Alex McDowell, author interview, 2015.
24 *Debbie's Book* is a compilation of all rental and purchased sources for props, wardrobe, lighting for film, television, theatre, commercial photo shoots and events.
25 Stuart Craig, author interview, 2000.
26 Edward Lucie-Smith.
27 Martin Childs, author interview, 2005.
28 Moira Tait, author interview, 2015.
29 *The Call Sheet*.
30 Christopher Hobbs, author interview, 2000.
31 Edward Lucie-Smith, 168.
32 Kirill Grouchnikov, 'The Fine Craft of Set Decoration – Conversation with Katie Spencer', *Pushing Pixels*, 18 January 2012.
33 Martin Childs, author interview, 2005.
34 Martin Childs, author interview, 2005.
35 Peter Lamont, author interview, 2007.
36 Tatiana Macdonald, author interview, 2015.

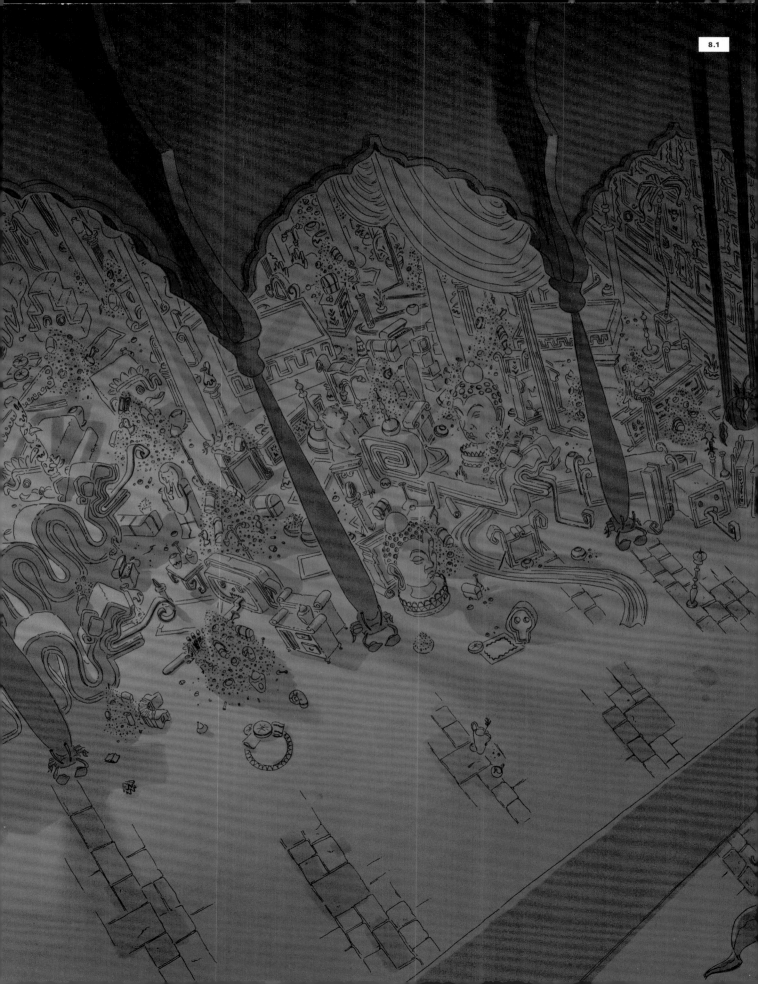

APPENDIX

8.1
Red was used to suggest danger.
Tom Turner highlights his deliberate
use of colour to help convey
character and tell story in this
animation for *Banaroo*.

CLAY

Samuel Thornhill

1

EXT. MOOR - DAWN

A thick fog shrouds the moorland. At the woodland's edge, a man (gaunt, clothes ragged, his hands and ankles shackled) is led slowly through the foliage by two men. Shaken by exposure to the elements, his progress is slow.

 MAN
 Please. It never arrived. We never got it. Please.

As he attempts to determine his whereabouts, he begins to whimper. Condensation leaves his mouth with every utterance.

 MAN
 Pl-pl-please... you know I had nothing to do with
 it. Come on. I didn't take it, I wouldn't know what
 to do with it. Please.

Silence.

He begins to sob, whimpering as he pleads with his captors. His pace slows as he tries to halt proceedings, the cold precipitation of the morning soaking into his clothing as he shivers. He hangs his head, exhausted by his travails.

 MAN
 I'll do anything. Please, just let me go.

He is hoisted to his feet again before slowly resuming progress. As they reach a secluded part of the woodland, they stop.

 MAN
 Don't do this. You don't have to do this. I'll make
 up for it, I can take more on. Please, I'll do
 anything. Just let me go.

The man continues to plead as he is lowered to his knees.

2

 MAN
 Please, I have a family. Don't do this. I'll do
 anything.

His pleas are unanswered as he regretfully falls silent. His hands restrained, he clears the tears on his shoulder before closing his eyes and lowering his head. He begins to pray under his breath.

 MAN
 (sniffling) ...with all its pains, penalties and
 sorrows, in reparation for my sins, for the souls
 in purgatory, for those conversion of sin-

His voice becomes muffled as a burlap sack is placed over his head, a thick tape securing the garment around his neck. The man's muffled whimpers can be heard as he is pushed forward, his head becoming submerged in a pool of water.

INT. MORTUARY - DAY

FRANCIS (mid twenties, pale skinned with dark hair) emerges from washing his face in a basin. We follow as he enters the postmortem suite tucking a packet of cigarettes into his jacket pocket. ALAN (mid-late fifties, greying/balding), a senior mortician and friend, is working. The room is a small but efficient workspace for both men to carry out their business alongside one another. FRANCIS takes his place behind a mortuary slab. A portly gentlemen lies before him, his body concealed by a sheet.

 ALAN
 Is it still raining?
 FRANCIS
 Pissing it down.

3

 ALAN
 Serves you right. Those things'll kill you. Where
 are you up to with this chap?

 FRANCIS
 Came in this morning. No autopsy so I can get on
 with the arterial.

 ALAN
 Okay, he's due out on Monday.

 FRANCIS
 No problem.

FRANCIS begins preparation on the man.

 ALAN
 Did you see the game last night?

 FRANCIS
 No, tele's still broken and the signal's shit
 anyway. Les Dennis has never looked better to be
 honest.

 ALAN
 You should have seen it - an absolute classic. Took
 me back to being on the terraces in the 80's...

As ALAN begins a detailed analysis of the game, FRANCIS' focus turns to a poorly sutured incision present on the torso of the deceased man. Intrigued, FRANCIS slowly attempts to reopen the wound. With considerable application of force, he individually cuts each stitch to examine the wound. As the final stitch is broken, a series of bloodied isotropic stones ooze from the wound. FRANCIS is enraptured by their diamond-like properties. ALAN's prolonged analysis is interrupted by the sound of one of the stones rattling across the slab before dropping onto the mortuary floor.

4

ALAN
Are you alright?

FRANCIS
Me? Yeah I'm fine... Sorry what were you saying?

ALAN
Anyway, Isabella came in and turned the bloody thing off just as...

ALAN resumes their conversation as FRANCIS' focus returns to the incision. Intrigued, he opens the wound further to reveal a package with a vast amount of similar sized stones occupying the abdominal cavity of the deceased man. Unable to alter his gaze, FRANCIS breaks his infatuation only to glance over to see if ALAN has noticed his muted surprise.

ALAN
Are you even listening to me?

FRANCIS
Yes, of course. Liverpool '83, Isabel ruining your evening - it's always the same.

ALAN
Oh really Francis. Insightful as always. You're about as good company as he is.

(pointing to the deceased man)

FRANCIS takes a knee and anxiously seeks out the fallen stones.

ALAN
I bet you'll miss me tomorrow.

FRANCIS
What?

5

ALAN
I'm not due in. Isabella's family are in town for the weekend - unfortunately. So you'll be on your own for the day. You'll see just what it's like when 'boring old Alan' isn't here to keep you entertained.

FRANCIS finally grasps hold of the stone before rising to his feet. Placing the loose stone into his pocket, FRANCIS closes the incision, sealing the contents back inside the deceased man.

FRANCIS
So - I've almost finished the arterial but I'm gonna need some more time to finish the set.

ALAN
Alright, let's call it a day then.

Before joining ALAN in putting his coat on, FRANCIS glances back to the source of his discovery as ALAN turns the mortuary lights off. Silhouetted in the doorway, ALAN pats FRANCIS on the shoulder.

ALAN
Don't make it a late one, I need you in early doors in the morning.

EXT/INT. MORTUARY CAR PARK - DAY

A car speeds across the mortuary car park, screeching to an abrupt halt, stopping across a number of parking spaces.

FRANCIS emerges from the vehicle before running towards the mortuary doors only to see ALAN leaving the building.

6

FRANCIS
Alan? What are you doing here?

ALAN
Finishing the work that you should have done this morning. How many times have we been through this now Francis?

FRANCIS
(clearly exasperated)
I'm sorry, Alan. I didn't think-

ALAN
I know you didn't think. It makes me wonder whether you actually do any work whilst I'm away or if you just turn up whenever you bloody well feel like it.

FRANCIS
I'm sorry, Alan. It won't happen again. This is the last time, I'll-I'll work as many weekends as you want-

FRANCIS moves towards the mortuary door.

FRANCIS
I'll finish it - it won't take me long.

ALAN
Well, you can't do much about it now. When the family rang the mortuary and no one answered, I knew I'd have to come in and get it done.

FRANCIS
Get what done?

7

ALAN
The family of the bloke you were prepping yesterday moved the burial forward, something to do with bad weather forecast next week.

FRANCIS
mortified)
They moved it forward?

ALAN
Yes, Francis, they moved it forward. Now if you'd have turned up on time then you'd have handled

(MORE)

ALAN (cont'd)
it and we wouldn't be having the same conversation we seem to be having week in, week out.

FRANCIS lets out a sigh of exasperation, throwing his head back in despair. ALAN begins to walk past him, keys in hand.

ALAN
Come on, tomorrow's another day. You've probably saved me enduring those miserable bastards harping on about the WI all day anyway. It's almost knocking off time. Let's get a swift half in.

FRANCIS remains rooted to the spot. He furrows his brow with his hand.

ALAN
(gesturing towards the car) Come on!

8

INT. BAR - DAY

FRANCIS and ALAN are sat in a booth tucked away to one end of the room. The bar is dated with dark wooden panels adorning the walls whilst a small number of patrons line the bar, dimly illuminated by the occasional overhanging, exposed light bulb.

FRANCIS absent-mindfully plays with the ice in his drink.

 ALAN
 I mean it's like talking to a brick wall with John,
 he's not interested in his old man, but at least a
 'hello' would be nice.

 FRANCIS
 (distracted)
 Well that's how teenagers are, isn't it?

 ALAN
 And Isabella - I mean, I get back and all she
 wants to do is lecture me about the person she
 wishes I was. Honestly, I get home, have a brandy
 and I can't wait to get to bed - and I'm too old
 for any of that nonsense, so...

FRANCIS continues to clink the ice cubes in his glass, the sound becoming more noticeable as ALAN pauses for a moment before realising it's fallen on deaf ears.

 ALAN
 Jesus Francis. You were late, I said it was fine
 and I've bought you a drink. The least you can do
 is pretend to be interested.

 FRANCIS
 Sorry.

 9

 ALAN
 What's the matter with you? It's like you're not
 really here at the moment.

FRANCIS takes a prolonged pause, considering the merits of what he's about to reveal. He takes a deep breath before engaging in a determined eye contact with ALAN.

 FRANCIS
 Something happened yesterday.

 ALAN
 What do you mean?

 FRANCIS
 I was working on that man. He had a suture on
 his side - at first I thought it was a pace-maker
 but... it was amateur. So I opened it and this fell
 out.

FRANCIS slides one of the small isotropic stones into the middle of the table. ALAN maintains his position, glaring at the stone placed before him. FRANCIS anxiously checks that their conversation hasn't been overheard.

 FRANCIS
 He was full of them Alan. They were spilling out
 of him.

 ALAN
 What is this Francis?

 FRANCIS
 I don't know exactly what they are but they're
 obviously in there for a reason. I think they
 might be—

 10

 ALAN
 (raising his voice angrily) They might be what
 Francis?

 FRANCIS
 (Attempting to stop Alan from raising his voice)
 Sh-sh-sh!

A couple of patrons sitting at the bar cast fleeting glances at the men before slowly returning to their glasses.

 FRANCIS
 (In a hushed voice)
 I'm sorry Alan, I wasn't trying to deceive you.
 I didn't know what to do so I slept on it. I was
 going to tell you. I was.

 ALAN
 (matching Francis' hushed whisper)
 Oh you were going to tell me were you?

 FRANCIS
 Yes I was going to tell you!

 ALAN
 You don't tell me anything! This is just another
 entry on the list of things that you've fucked up.
 What were you thinking? This is my business - my
 business! I put myself out for you and all you
 do is let me down. You break the law, you risk
 everything I've worked for and then you lie to me
 - you lied to me Francis. And on top of that, you
 waltz in here and put this thing in front of me
 and expect what? A pat on the back?

 11

 FRANCIS
 I didn't waltz in here! Don't treat me like an
 idiot, Alan. We've worked together for how long
 now?

 Not everything revolves around the fucking
 mortuary. We all end up on the slab eventually. Do
 you really want to spend any more time staring at
 the people already on it?

The pair share a moment of silence.

 FRANCIS (CONT'D)
 You're miserable Alan. You've got a wife and kids
 that you can't stand to be around so you'd rather
 spend all day with corpses than—

 ALAN
 DON'T YOU TALK ABOUT MY FA—!

The bar falls silent as its occupants stop their conversations to glare at the men.

 ALAN (CONT'D)
 You've lost it.

 FRANCIS
 Just think about it Alan, think what you could
 do with it - what we could do with it. You could
 take Isabella and the kids away - patch things
 up. Forget bodies. Forget funerals. Forget fucking
 formalde—

ALAN, having heard enough, rises abruptly and storms out of the bar bursting through the doors. The occupants of the bar glare in FRANCIS' direction.

 12

FRANCIS
(calling after ALAN)
Just think about it. If you found a winning
lottery ticket why would you bury it in the
ground?

The patrons of the bar stare at FRANCIS before eventually
returning to their drinks. FRANCIS sinks forward, his head
in his hands. He anxiously mulls over the events just passed
before he sits back, exasperated his head sinking back into
his shoulders as he closes his eyes.

After a considerable silence. ALAN abruptly re-enters the
booth.

ALAN
He's being buried on Nichol's Mount tomorrow.

INT. CAR - DAY

FRANCIS and ALAN sit in a stationary vehicle aside a road as
it bends around the hillside. Below them, a modest memorial
is taking place. A miserable drizzle engulfs those paying
their respects.

FRANCIS retrieves a small carton from the inside pocket of
his jacket before pulling out and lighting a cigarette.

ALAN
D'you mind?

FRANCIS
what?

ALAN
Smoking in my car!

FRANCIS
Oh jesus. Come on Alan.

13

Both men share an uncomfortable silence as FRANCIS opens a
small partition in the window. The silence is broken as ALAN
reaches over and takes a cigarette from the carton.

ALAN
(looking at his cigarette) It's been a while since
I had one of these. My mother used to say you
can tell a lot about a man by the small habits he
keeps.

They smoke their cigarettes in silence.

FRANCIS
Smoking a cigarette doesn't make you a bad person,
Alan.

ALAN
Robbing a dead body does.

FRANCIS
It's not as black and white as that.

They share a further silence before FRANCIS leans forward to
adjust the radio control. Music is quietly heard.

ALAN
I used to know a guy, worked down the road for
25 years - a real pillar of the community.
Between us, we used to put respectable people in
the ground but times changed. He moved on, took
up a position in a prison mortuary burying the
murderers and rapists. There's no sentiment in our
line of work. They're just bodies.

FRANCIS
You sound old, Alan.

Guests at the memorial remain by the burial plot,
disregarding the weather to pay their respects.

14

FADE TO BLACK.

ALAN awakes to find FRANCIS asleep in the passenger seat.
Night has fallen, the only sound is that of a news report
detailing a murder that's taken place on the moors quietly
emanating from the radio. ALAN wakes FRANCIS before
switching it off.

ALAN
Let's get this over with.

ALAN retrieves a spade from the boot of the car before
throwing it to FRANCIS.

FRANCIS
Where's yours?

ALAN
Have you seen the boot?

FRANCIS
Oh for god's sake.

EXT. BURIAL PLOT

FRANCIS and ALAN are illuminated by only the flooded
headlights of their car overlooking the burial plot. FRANCIS
systematically wields his spade. With a final thrust, the
spade connects with a solid thud. ALAN moves closer as
FRANCIS kneels scraping the dirt aside with his hands. They
exchange a solitary glance before Francis places his spade
in the joint of the casket and forcefully opens it as ALAN
looks on, checking they're not being watched.

FRANCIS casts the spade aside as he clambers next to the
casket.

Here.

15

ALAN
(Passing a small leather sleeve)

From the sleeve, FRANCIS retrieves a small scalpel. He pauses
before taking in a large intake of breath. He kneels beside
the body and begins to retrieve the missing contraband.
ALAN turns away. The camera remains with ALAN as the sound
of FRANCIS rooting through the cavity of the deceased is
clearly distinguishable. The camera returns to FRANCIS.

FRANCIS
Torch, give me the torch.

ALAN hands FRANCIS a torch before he illuminates the
package.

FRANCIS
This is it Alan! Look at this, I told you. I told
you. This is it.

As FRANCIS celebrates jubilantly, his arm covered in residue
aloft in the air clutching the package, ALAN is no longer in
position.

FRANCIS
Here take this. Help me out. Alan?

ALAN emerges from behind FRANCIS wielding the spade
forcefully down upon his head.

CUT TO BLACK. FADE IN FROM BLACK

The sound of shovel noises can be heard as ALAN is revealed
(sleeves rolled up, a smoking cigarette in his mouth)
replacing the soil atop the burial plot before striking the
spade in the ground aside the plot.

END TITLES.

16

GRADUATE INTERVIEWS

The two graduates interviewed, Yasmin Topliss and Ashley Phocou, are both alumni of the BA (Hons) Filmmaking degree course (specializing in Production Design), at the Northern Film School, Leeds Beckett University. The Northern Film School also runs an MA and MFA in Filmmaking, incorporating a Production Design specialism, and an MA in Documentary Filmmaking. For more information, please use this link www. northernfilmschool.co.uk.

Yasmin Topliss, graduate of Northern Film School, Leeds Beckett University

Can you give me an overview of a particular film/TV project you have worked on in the Art Department?
I worked on the first series of a children's television show over a period of three months.

What was your job title and how would you describe your role on the production?
My official job title was design assistant. As this particular production only had three members in its Art Department (including myself), roles overlapped a lot of the time. My role consisted of buying for the production, prop making, set dressing, logistics and generally assisting with the needs of the production designer and prop maker.

How closely did you work with the production designer?
We worked very closely, spending 12–14 hours a day together, five to six days a week.

Can you describe the chain of communication on the production?
At the beginning of the production, the production team and Art Department met to discuss a full breakdown of the three months of filming. The production designer would then communicate directly with directors, production managers, etc. thereafter, attending recces and meeting on a regular basis. The Art Department would be updated as to progress and changes on a regular basis, directly from the production designer. On occasion the director would come to the design workshop to check progress and give the Art Department a chance to ask questions.

Can you describe a typical day on the production?
Every day on the production was very different but typically the team would come together in the morning and discuss what we aimed to achieve throughout the day, air any questions or queries we had about prop makes/buys, run through script breakdowns ensuring we all knew what was required, or if all was clear we would just continue from where things were left the previous day.

Were you aware of a design concept? If so, what was it and how was it expressed in the design (colours, light, space, dressing, etc.)?

The show itself was based around six very different characters. The designer chose certain colour swatches for each character (usually about five main colours) and these colours were then used for the set design and props for that specific character. As the budget was fairly tight, the production sometimes had to compromise on space, which often made our job very challenging.

Have you been involved in research? What form did it take?

Yes, I took part in games testing. The show communicates with its audience through various game playing, (e.g. observation games, listening games). I visited a primary school with the production to see how the children reacted to the games we asked them to take part in. We were mainly researching difficulty levels, how fun the children found the games, and which games would work well on television.

Can you give an example of how you see the design contributing to story/character in this production?

The production had to be visually engaging in order to grasp the audience's attention (aimed at children). As it was interactive, the set design had to be striking but not distract from the action, as this was an important part of the game play. Props had to be easily identifiable by children so often things were made very simple, with strong themes, nothing too over-complicated.

In what ways has budget influenced the process?

As this particular job required us to build and dress sets as well as source and make the props for six different characters, budget had to be restricted and careful planning for each block was essential. Sometimes this limited the achievement of big over-ambitious builds.

Could you outline a rough timeline/workflow of this project or a 'typical' one to illustrate the process?

- Meet the production crew, read through scripts
- Three weeks of prep (script breakdown, prop sourcing, prop buying for first block)
- Set up Location 1 – filming begins
- Prep for next location (set and props, buying and making)
- De-dress Location 1, set up Location 2, etc.

This process continued: as one character was being filmed, the Art Department was in the workshop preparing for the character the following week. One member of the Art Department (standby art director) was always on set during filming.

Do you have any tips on portfolios – how people starting out should present themselves/their work and how to get work/ who to contact, etc.?

It's always useful to put together a website, a quick way for people to get an overview of your work. I have found social media to be a great way of finding contacts and opportunities. Facebook and Twitter are great platforms where companies and people often post useful information, links to job openings, etc. Private Facebook groups such as 'art dept crew UK and Eire' is a great one for posting your availability and search for jobs. A direct phone call is always better than a text or an email, more personal and people tend to appreciate this and remember you.

Ashley Phocou, graduate of Northern Film School, Leeds Beckett University

Can you give me an overview of a particular film/TV project you have worked on in the Art Department?
My first job in an Art Department is on a brand new children's TV series. The idea of the show is that we create dens for children to escape to in their houses or back gardens. Each one is themed on the children's favourite activity or hobby.

What is your job title and how would you describe your role on the production?
I am a design assistant. I assist the designer and production team with any design-related projects they need. This can include anything from doing research, making graphics, buying and making props and decorating the den on location. Every day there is something different to be done.

How closely did you work with the production designer?
Very closely. The Art Department on this production is small, therefore we have to work extremely closely to ensure that we get everything done that is required for each episode.

Can you describe the chain of communication on the production?
Series producer–series manager–producer–director–designer–design assistants.

Can you describe a typical day on the production?
Days vary a lot. A day in the office can consist of doing research, finding places to buy props, and dressing, making graphics and technical drawings, whereas, a day on set is 'full steam ahead'. The contractors and Art Department work all day to make the designs on paper come to life in the children's homes. This usually involves a lot of building, painting and dressing.

Were you aware of a design concept? If so, what was it and how was it expressed in the design (colours, light, space, dressing, etc.)?

Each episode of the series has a different theme and design depending on the individual child's interests. However, each one has an up-cycle feature. We usually turn old materials into new interesting furniture or dressing. The series has a strong recycle and DIY concept.

Have you been involved in research? What form did it take?

Yes, I would say that research is a big part of each design. We aim to make each design as relevant and true to the chosen theme as possible. This includes the outside look of the den as well as the interior, props and dressing features. However, a lot of our inspiration comes from the children. They tell us what they imagine their dens to look like and what the purpose of it should be. They are all very interested in their chosen theme, so communication with them is a big part of our research and key to a successful design.

Can you give an example of how you see the design contributing to story/character in this production?

This series is different to most as it is heavily design-based but it is not a fictional story. Having said that, each design is very personal to the individual child involved. In each episode, the children have a different story as to why their themed den is going to be so important to them. Whether it is a space for them to get away from their busy family or a space for them to practise their favourite hobby, each one has a story. So in fact it is the opposite, the story and passion that each child has is what fuels our designs and builds.

In what ways has budget influenced the process?

Each episode has a budget assigned to it. A portion of that is designated for the Art Department. However, dressing the space and filling it with props is not the only expense we have to think about. The designer also has to factor in the cost of building the space if it is outdoors; for example, laying concrete bases and putting up building structures, or safety-proofing the spaces that are inside to make them usable. For example, damp proofing or plastering walls, etc. It is these costs that can take a large chunk of the budget away before we have even started to design the space. So yes, sticking to the budget is really essential; if one area goes over, it can affect the design of the rest of the dens.

Do you have any tips on portfolios – how people starting out should present themselves/their work and how to get work/who to contact, etc.?

All of the social media pages and websites are great starting places. The production and Art Department Facebook pages always have a lot of posts to read, including job posts, where to buy useful things from, and lots of other advice. I recommend joining these and also the job websites. They are a great way to get started, see what is out there and what other people's skills are.

My first paid job came about through doing a couple of weeks of work experience first. When I left the Northern Film School I struggled to find paid work straight away. Instead I took an Art Department assistant role on a feature film in Yorkshire. Although I wasn't getting paid, it was a great way to break into the industry. The film had an exciting atmosphere with a large crew; therefore, I not only gained priceless experience, but I also acquired lots of industry contacts. Networking with other filmmakers led me to a contact for my current job. These work placements may feel like a step backwards after you've finished your degree, but I highly recommend putting yourself forward for just one as it can set you up for future opportunities.

DESIGNER BIOGRAPHIES

Jim Bissell

Jim Bissell began his career as a production designer on Steven Spielberg's classic *E.T. the Extra-Terrestrial* (1982, Steven Spielberg), and was nominated for a BAFTA Award for Best Production Design. Reunited with director Spielberg on the films *Always* (1989) and *Twilight Zone* (1983) and producer Spielberg on *Harry and the Hendersons* (1987, William Dear) and *Arachnophobia* (1990, Frank Marshall).

Over his 35-year, career he has also collaborated with directors such as John Schlesinger (*The Falcon and the Snowman*), Ridley Scott (*Someone to Watch Over Me*), Joe Johnston (*The Rocketeer* and *Jumanji*) and Ron Shelton (*Hollywood Homicide* and *Tin Cup*). More recently, he was honoured with nominations from the Art Directors' Guild for his work on Zack Snyder's *300* (2006) and *The Spiderwick Chronicles* (2008, Mark Waters).

Bissell is also known for his collaboration with director George Clooney, *Confessions of a Dangerous Mind* (2002). *Good Night, and Good Luck* and *Leatherheads*. *Good Night, and Good Luck* gained Art Direction nominations from both the Art Directors' Guild and the Academy of Motion Picture Arts and Sciences, as well as a Satellite Award for Best Production Design.

Martin Childs

Martin Childs is known for *W.E.* (2011, Madonna), *Lady in the Water* (2006, M. Night Shyamalan), *From Hell* (2001, Albert Hughes, Alan Hughes), and *Mrs Brown* (1997, John Madden) which presents two entirely different visualizations of a period. Martin's work for this film created a stylized vision of Victorian England – the nature of the subject allowed him to explore more expressionistic aspects of the era. Other film credits include: *Shakespeare in Love* (1998), *Calendar Girls* (2003) and *The Boy in the Striped Pyjamas* (2008). Key focal points for Martin are creating visual shortcuts, a predilection for neutral colour schemes, attention paid to architectural detail, and the importance of layered dressing. The motifs of *The Third Man* (1949) are a recurring point of reference in most of his films.

Jim Clay

Jim's filmography includes *The Singing Detective* (1986), *The Crying Game* (1992), *Onegin* (1999), *About a Boy* (2002), *Love Actually* (2003), *Match Point* (2005), *Children of Men* (2006), *You Will Meet a Tall Dark Stranger* (2010), *Great Expectations* (2012) and *Red 2* (2013). The diversity of Jim's work is indicated in the distance between frothy romantic comedies, heritage films and 'shoot 'em up' action productions.

Working with the directors Alfonso Cuaron, Martha Fiennes, Woody Allen, Mike Newell, Neil Jordan, Richard Curtis, John Madden, Jim has much to say about the relationship between director and designer, and the importance of forging strong strategies for collaborative creating. His approach failed on one particular occasion – with Stanley Kubrick – a working method became impossible and Jim left the film *Eyes Wide Shut* (1999).

From fleshing out the 'matchstick men' of Richard Curtis' characters to keeping to the integrity of Woody Allen's aesthetic – he says it all comes down to his emotional response to a script. Jim follows the rules of 'Who are we? Where are we? Why are we here?' in relation to character and designs for them with consideration of where they are placed spatially.

Stuart Craig

Stuart Craig, the three-time Academy Award-winning production designer is perhaps best known over the last decade as production designer on one of the most successful film series around the world: *Harry Potter*. The average *Harry Potter* film cost US$280 million to make, taking seven months in pre-production and another seven or eight to shoot. Based at Leavesden Studios, Craig typically employs around 40 people in his immediate Art Department and can be in charge of up to 200 employees.

Craig's first job was as a junior in the Art Department for *Casino Royale* (1967), a James Bond spoof. His work with Richard Attenborough on *A Bridge Too Far* (1976) led to designing *Gandhi* (1982) and his first Academy Award in 1983. Craig went on to work with Attenborough on *Cry Freedom* (1987), *Chaplin* (1992), *Shadowlands* (1993) and *In Love and War* (1996). He received further nominations for *Harry Potter and The Sorcerer's Stone* (2001), *Harry Potter and the Goblet of Fire* (2005), *Chaplin*, *The Mission* (1986) and *The Elephant Man* (1980). He has won Academy Awards for *Dangerous Liaisons* (1989) and *The English Patient* (1996).

Other films include *Greystoke* (1984), *The Secret Garden* (1993), *Memphis Belle* (1980), *Mary Reilly* (1996), *The Avengers* (1998), *Notting Hill* (1999) and *The Legend of Bagger Vance* (2000).

Ronald Gow

Ronald Gow's professional experience as a designer has been both in film and television, including feature films, short dramas, sitcoms, talk shows, game shows and variety shows, as well as in developing and producing non-fiction programmes and film documentaries. He has also designed and collaborated in staging a number of exhibitions, conferences and festivals, as well as producing corporate-related graphic design material and designing shops and furniture.

Mimi Gramatky

Production designer Mimi Gramatky was elected President of the Art Directors Guild (ADG, IATSE[1] Local 800) in 2013. However, her skills reach beyond production design into interior and landscape architecture, theatre design, visual FX and animation, documentary filmmaking and teaching. Having worked in the industry for more than three decades, her credits began as production designer on 'Fatso' (the short) for her mentor Ann Bancroft; *Altered States* and *Superman 1 & 2* (as VFX executive); *Miami Vice* (as art director); and now embracing the twenty-first century, as production designer of the virtual world pilot production *Xxit* (2011), and the first all-union new media science fiction series, *10,000 Days* (2014). She has been a member of the ADG Board of Directors and a past member of its Council. Mimi is a former member of the Board of Governors of the Academy of Television Arts and Sciences and is a graduate of the University of California, Berkeley and San Francisco State University, and a Bush Fellow in theatre design, interning at the Guthrie Theatre, Minneapolis. As a parallel career Mimi has developed and taught the production design curriculum for more than two decades.

1 International Alliance of Theatrical and Stage Employees.

Gemma Jackson

When I met with the award-winning, Oscar-nominated designer Gemma Jackson, I asked her about the pivotal nature of designing the home space in film. She elaborated on her process and we examined her use of basic tools such as movement, light and colour. Gemma's distinct style has evolved from her background in theatre, which was built on a strong understanding of space and movement. She has taken these principles and embedded them in her film practice across the course of her career. With a diverse range of work, Gemma's designs span films such as *Paperhouse* (1988), *The Borrowers* (1997), *Winslow Boy* (1999), *Bridget Jones's Diary* (2001), *Iris* (2001), *Finding Neverland* (2004) and *Bridget Jones: The Edge of Reason* (2004). More recently she has been working on the HBO TV series *Game of Thrones* (2011). Through a discussion of Gemma's designs, patterns in her working methods begin to emerge, including the organic approach she adopts in relation to space and texture.

Alex McDowell

Alex McDowell has worked as a production designer with David Fincher, Steven Spielberg, Terry Gilliam and Anthony Minghella. He is now working as Professor of Practice at the USC School of Cinematic Arts and says what he teaches now is a holistic approach – trying to rethink design and narrative style.

Anna Pritchard

Production designer Anna Pritchard has worked in film and television for over a decade honing her craft. More recently in her work in television drama, Anna has collaborated with some of the best directors and writers in the business, including Dominic Savage on his projects *Dive* (ITV), *Freefall* (BBC) and *The Secrets* (2014, Working Title TV for the BBC), with credits including series two of Channel 4's acclaimed *Top Boy* (2013), Sky Living's *The Psychopath Next Door* (2013), BBC's *Inside Men* (2012) and the RTS-nominated drama, *My Murder* (2012).

Moira Tait

Moira Tait is Visiting Professor in Production Design at the Norwegian Film School. She was previously Head of Production Design at the UK National Film and Television School (NFTS) and is currently a senior tutor at the NFTS. She is an external examiner at Wimbledon School of Art. In addition, she lectures at the London Film School and at Farnham (University of the Creative Arts). Moira graduated in English from King's College London and studied Theatre Design at the Slade School of Art before becoming a BBC production designer. Her design credits range widely across film and TV including *A Tale of Two Cities* (1965, BBC), and the Alan Bennett plays *Sunset Across the Bay* (1975, Stephen Frears), and *A Visit from Miss Prothero* (1978, Stephen Frears). As a teacher she has constructed and taught on BA and MA design courses in the UK and in Europe including the Royal College of Art, Kingston University and Wimbledon School of Art. She is an Honorary Fellow of the RCA, a Fellow of the RSA and a BAFTA member. She was awarded a Lifetime Achievement Award (2016) by the British Film Designers' Guild.

Hugo Luczyc-Wyhowski

The production designer Hugo Luczyc-Wyhowski's work spans the cult 1980s film *My Beautiful Laundrette* (1985), to period drama *Mrs Henderson Presents* (2005), where Soho theatre The Windmill is resuscitated to its risqué wartime glory. Chapter 4 considers his focus on the design of the home in the films *My Beautiful Laundrette* (1985), *Nil by Mouth* (1998) and *Dirty Pretty Things* (2002), and in so doing these films illustrate Luczyc-Wyhowski's development as a designer (*My Beautiful Laundrette* being the first film he designed), making it possible to trace themes from his early work to the present. Distinctive textures are created in each of these examples, which support themes in the narrative and convey ideas about the character that promote depth.

SELECTED FILMOGRAPHY

CHAPTER 1 – Practicalities: The Design Process

10,000 Days (2014, Eric Small, PD Mimi Gramatky)

Elizabeth: The Golden Age (2007, Shekar Kapur)

Inside Men (2012, BBC, James Kent)

Iris (2001, Richard Eyre, PD Gemma Jackson)

Minority Report (2002, Steven Spielberg, PD Alex McDowell)

Mrs. Brown (1997, John Madden)

Nil by Mouth (1997, Gary Oldman, PD Hugo Luczyc-Wyhowski)

CHAPTER 2 – The Visual Concept

8 ½ (1963, Fellini)

10,000 Days (2014, Eric Small, PD Mimi Gramatky)

About A Boy (2002, Chris Weitz and Paul Weitz, PD Jim Clay)

Black Narcissus (1947, Powell and Pressburger, PD Alfred Junge)

Brazil (1985, Terry Gilliam)

Bridget Jones's Diary (2001, Sharon Maguire, PD Gemma Jackson)

Captain Corelli's Mandolin (2001, John Madden)

Caravaggio (1986, Derek Jarman, PD Christopher Hobbs)

Chinatown (1974, Roman Polanski)

Django Unchained (2013, Quentin Tarantino, 2013)

Do the Right Thing (1989, Spike Lee, PD Wynn Thomas)

Edward Scissorhands (1990, Tim Burton, PD Bo Welch)

Eternal Sunshine of the Spotless Mind (2004, Michael Gondry)

From Hell (2001, Hughes brothers, PD Martin Childs)

Game of Thrones (2011, HBO)

Harry Potter (2001–2011, PD Stuart Craig)

Iris (2001, Richard Eyre, PD Gemma Jackson)

Last Tango in Paris (1972, Bernardo Bertolucci, PD Fernando Scarfiotti)

Love Actually (2003, Richard Curtis)

Match Point (2005, Woody Allen)

Minority Report (2002, Steven Spielberg, PD Alex McDowell)

My Beautiful Laundrette (1985, Stephen Frears, PD Hugo Luczyc-Wyhowski)

Notting Hill (1999, Roger Michell, PD Stuart Craig)

Onegin (1999, Martha Fiennes)

Panic Room (2002, David Fincher)

Pans Labyrinth (2006, Guillermo del Toro)

Rebecca (1940, Hitchcock, AD Lyle R. Wheeler)

Shallow Grave (1994, Danny Boyle, PD Kave Quinn)

Strictly Ballroom (1992, Baz Luhrmann)

The English Patient (1996, Anthony Minghella, PD Stuart Craig)

The Godfather trilogy (1901–1980, Francis Ford Coppola, PD Dean Tavoularis)

The Hunger Games (2012, Gary Ross 2012, PD Philip Messina)

The Legend of Tarzan (2016, David Yates)

The Long Day Closes (1992, Terrence Davies, PD Christopher Hobbs)

The Red Shoes (1948, Powell and Pressburger)

The Servant (1963, Joseph Losey, PD Richard Macdonald)

The Third Man (1949, Carol Reed, PD Vincent Korda, Joseph Bato, John Hawkesworth)

Withnail & I (1987, Bruce Robinson)

CHAPTER 3 – Space

Blade Runner (1982, Ridley Scott)

Closer (2004, Mike Nichols, PD Tim Hatley)

Delicatessen (1991, Jean-Pierre Jeunet and Marc Caro)

Dr Strangelove: Or How I Learned to Stop Worrying and Love the Bomb (1964, Stanley Kubrick, PD Ken Adam)

Edward Scissorhands (1990, Tim Burton, PD Bo Welch)

Fight Club (1999, David Fincher, PD Alex McDowell)

Good Night, and Good Luck (2005, George Clooney, PD Jim Bissell)

Inception (2010, Christopher Nolan, Guy Hendrix Dyas)

Labyrinth (1986, Jim Henson, Elliott Scott)

Man of Steel (2013, Zak Snyder, PD Alex McDowell)

Minority Report (2002, Steven Spielberg, Alex McDowell)

Nil by Mouth (1997, Gary Oldman, PD Hugo Luczyc-Wyhowski)

Notting Hill (1999, Roger Michell, PD Stuart Craig)

Paddington (2014, Paul King, PD Gary Williamson)

Shakespeare in Love (1998, John Madden, PD Martin Childs)

Shallow Grave (1994, Danny Boyle, PD Kave Quinn)

Sweeney Todd (2007, Tim Burton)

The Cabinet of Dr Caligari (1920, Robert Wiene)

The Incredible Shrinking Man (1957, Jack Arnold)

The Island (2005, Michael Bay, PD Nigel Phelps)

The Matrix (1999, Wachowski brothers, PD Owen Paterson)

The Shining (1980, Stanley Kubrick,
PD Roy Walker)
The Terminal (2004, Steven Spielberg,
PD Alex McDowell)
The Truman Show (1998, Peter Weir,
PD Dennis Gassner)
The Village (2004, M. Night Shyamalan,
PD Tom Foden)
Total Recall (1990, Paul Verhoeven,
PD William Sandell)

CHAPTER 4 – In and Out:
Boundaries and Transitions
12 Angry Men (1957, Sidney Lumet,
PD Bob Markell)
A Matter of Life and Death (1946, Powell
and Pressburger, PD Alfred Junge)
A Single Man (2009, Tom Ford,
PD Dan Bishop)
About A Boy (2002, Chris Weitz and
Paul Weitz, PD Jim Clay)
Alien (1979, Ridley Scott,
PD Michael Seymour)
Battleship Potemkin (1925, Sergei Eisenstein)
Being John Malkovich (1999, Spike Jonze,
PD K. K. Barrett)
Betty Blue (1986, Jean-Jacques Beineix,
PD Carlos Conti)
Bridget Jones's Diary (2001, Sharon Maguire,
PD Gemma Jackson)
Carnage (2013 Roman Polanski,
PD Dean Tavoularis)
Cheers (1982–1993)
Cloud Atlas (2012, Tom Tykwer, Lana
Wachowski and Lilly Wachowski, PD Hugh
Bateup and Uli Hanisch)
Dirty Pretty Things (2002, Stephen Frears,
PD Hugo Luczyc-Wyhowski)
Do the Right Thing (1989, Spike Lee,
PD Wynn Thomas)

Frasier (1993–2004)
Friends (1994–2004)
Gone with the Wind (1939, Victor Fleming,
PD William Cameron Menzies)
Harry Potter (2001–2011, PD Stuart Craig)
Iris (2001, Richard Eyre, PD Gemma Jackson)
Le Jour se Lève (1939, Max Carné,
PD Alexandre Trauner)
Mildred Pierce (1945, Michael Curtiz,
PD Anton Grot, Bertram Tuttle)
Moon (2009, Duncan Jones, PD Tony Noble)
My Beautiful Laundrette (1985, Stephen
Frears, PD Hugo Luczyc-Wyhowski)
Nil by Mouth (1997, Gary Oldman,
PD Hugo Luczyc-Wyhowski)
Notting Hill (1999, Roger Michell,
PD Stuart Craig, 1999)
Paris, Texas (1984, Wim Wenders)
Rear Window (1954, Alfred Hitchcock,
AD J. McMillan Johnson and Hal Pereira)
Rocky (1976, John G. Avildsen,
PD Bill Cassidy)
Rome, Open City (1945, Roberto Rossellini)
Seinfeld (1989–1998)
Sex and The City series (1998–2004)
Spellbound (1945, Alfred Hitchcock,
PD James Basevi)
The Cave of the Yellow Dog (2005,
Byambasuren Davaa)
The English Patient (1996, Anthony
Minghella, PD Stuart Craig)
The Godfather: Part 2 (1974, Francis Ford
Coppola, PD Dean Tavoularis)
The Grand Budapest Hotel (2014, Wes
Anderson, PD Adam Stockhausen)
The Great Beauty (2013, Paolo Sorrentino,
2013)
The Hustler (1961, Robert Rossen,
PD Harry Horner)
The Lord of the Rings trilogy (2001,
Peter Jackson, PD Grant Major)

The Matrix (1999, Wachowski brothers,
PD Owen Paterson)
The Money Pit (1986, Richard Benjamin,
PD Patricia Von Brandenstein)
The Sheltering Sky (1990, Bernardo Bertolucci)
The Shining (1980, Stanley Kubrick,
PD Roy Walker)
The Untouchables (1987, Brian de Palma)
The Wizard of Oz (1939, Victor Fleming,
George Cukor, 1939)
Vertigo (1958, Alfred Hitchcock,
PD Henry Bumstead)

CHAPTER 5 – Light
10,000 Days (2014, Eric Small,
PD Mimi Gramatky)
Barry Lyndon (1975, Stanley Kubrick,
PD Ken Adam)
Betty Blue (1986, Jean-Jacques Beineix,
PD Carlos Conti)
Blade Runner (1982, Ridley Scott,
PD, Lawrence G. Paull)
Breaking Bad (2008–2013, AMC)
Bringing Out the Dead (1999, Martin
Scorsese, PD Dante Ferretti)
Caravaggio (1986, Derek Jarman,
PD Christopher Hobbs)
Chicago (2002, Rob Marshall)
Children of Men (2006, Alfonso Cuaron,
PD Jim Clay)
Cloud Atlas (2012, Tom Tykwer,
Lana Wachowski and Lilly Wachowski,
PD Hugh Bateup and Uli Hanisch)
Dark City (1998, Alex Proyas,
PD George Liddle, Patrick Tatopoulos)
Days of Heaven (1978, Terrence Malick,
AD Jack Fisk)
Delicatessen (1991, Jean-Pierre Jeunet
and Marc Caro)
Dirty Pretty Things (2002, Stephen Frears,
PD Hugo Luczyc-Wyhowski)
Easy Rider (1969, Dennis Hopper,
PD Jeremy Kay)

Edward II (1991, Derek Jarman, PD Christopher Hobbs)

Far From Heaven (2002, Tod Haines)

From Hell (2001, Hughes brothers, PD Martin Childs)

Girl with a Pearl Earring (2003, Peter Webber, PD Ben van Os)

Gormenghast (2000, Andy Wilson, PD Christopher Hobbs)

Harry Potter (2001–2011, PD Stuart Craig)

Her (2013, Spike Jonze, PD K. K. Barrett)

Killing Time (1996, Bharat Nalluri, PD Ronald Gow)

Lust for Life (1956, Vincente Minnelli, PD Preston Ames, Cedric Gibbons, Hans Peters)

Minority Report (2002, Steven Spielberg, Alex McDowell)

Mr. Turner (2014, Mike Leigh, PD Suzie Davies)

Nightwatching (2007, Peter Greenaway, PD Maarten Piersma)

Pan's Labyrinth (2006, Guillermo del Toro, PD Eugenio Caballero)

Pennies from Heaven (1981, Herbert Ross)

Psycho (1960, Alfred Hitchcock, AD Robert Clatworthy and Joseph Hurley)

Road to Perdition (2002, Sam Mendes, PD Dennis Gassner)

Rules of the Game (1939, Jean Renoir, PD Max Douy and Eugene Lourie)

St Vincent (2014, Theodore Melfi, PD Inbal Weinberg)

Star Trek (2009, J. J. Abrams)

Subway (1985, Luc Besson, PD Alexandre Trauner)

The Addams Family (1991, Barry Sonnenfeld)

The Grand Budapest Hotel (2014, Wes Anderson, PD Adam Stockhausen)

The Hours (2002, Stephen Daldry, PD Maria Djurkovic)

The Lives of Others (2006, Florian Henckel von Donnersmark, PD Silke Buhr)

The Rewrite (2014, Mark Lawrence, PD Ola Maslik)

The Shining (1980, Stanley Kubrick, PD Roy Walker)

Traffic (2000, Steven Soderbergh, PD Philip Messina)

V for Vendetta (2005, James McTeigue)

Written on the Wind (1956, Douglas Sirk, AD Robert Clatworthy, Alexander Golitzen)

CHAPTER 6 – Colour

300 (2006, Zack Snyder, PD Jim Bissell)

A Matter of Life and Death (1946, Powell and Pressburger, PD Alfred Junge)

A Visit from Miss Prothero (1978, Stephen Frears, PD Moira Tait)

Amélie (2001, Jeune-Pierre Jeunet, PD Aline Bonetto)

Becky Sharp (1935, Rouben Mamoulian)

Black Narcissus (1947, Powell and Pressburger, PD Alfred Junge)

Chinatown (1974, Roman Polanski, PD Richard Sylbert)

Citizen Kane (1941, Orson Welles)

Diva (1981, Jean-Jacques Beineix, PD Hilton McConnico)

Don't Look Now (1973, Nicolas Roeg, AD Giovanni Soccol)

Dracula (1992, Francis Ford Coppola, PD Thomas Sanders)

E.T. the Extra-Terrestrial (1982, Steven Spielberg, PD Jim Bissell)

Gone with the Wind (1939, Victor Fleming, George Cukor)

Good Night, and Good Luck (2005, George Clooney, PD Jim Bissell)

Her (2013, Spike Jonze)

Home from the Hill (1960, Vincente Minelli)

How Green Was my Valley (1941, John Ford)

Iris (2001, Richard Eyre, PD Gemma Jackson)

Last Tango in Paris (1972, Bernardo Bertolucci)

Malcolm X (1992, Spike Lee)

Marnie (1964, Alfred Hitchcock)

Miami Vice (1984, NBC)

Minority Report (2002, Steven Spielberg, PD Alex McDowell)

Moulin Rouge (2001, Baz Luhrmann, Catherine Martin)

Paddington (2014, Paul King, PD Gary Williamson)

Paris, Texas (1984, Wim Wenders, PD Kate Altman)

Rocketeer (1991, Joe Johnston, PD Jim Bissell)

Rope (1948, Alfred Hitchcock)

Schindler's List (1993, Steven Spielberg)

Spiderwick Chronicles (2008, Mark Waters, PD Jim Bissell)

The Cook, The Thief, His Wife and Her Lover (1989, Peter Greenaway, PD Ben van Os, Jan Roelfs)

The Falcon and the Snowman (1985, John Schlesinger)

The Green Mile (1999, Frank Darabont, PD Terence Marsh)

The Matrix (1999, Wachowski brothers, PD Owen Paterson)

The Sixth Sense (1999, M. Night Shyamalan)

The Village (2004, M. Night Shyamalan, PD Tom Foden)

Three Colours Blue (1993, Krzysztof Kieślowski), *Three Colours White* (1994, Krzysztof Kieślowski) and *Three Colours Red* (1994, Krzysztof Kieślowski)

Tinker Tailor Soldier Spy (2011, Thomas Alfredson, PD Maria Djurkovic)

Vertigo (1958, Alfred Hitchcock, PD Henry Bumstead)

Volver (2006, Pedro Almodóvar)

CHAPTER 7 – Set Decoration

About A Boy (2002, Chris Weitz and
Paul Weitz, PD Jim Clay)
Atonement (2007, Joe Wright)
Brazil (1985, Terry Gilliam)
Bridget Jones's Diary (2001, Sharon Maguire,
PD Gemma Jackson)
Caravaggio (1986, Derek Jarman,
PD Christopher Hobbs)
Cloud Atlas (2012, Tom Tykwer,
Lana Wachowski, Lilly Wachowski)
Dogville (2003, Lars von Trier, PD Peter Grant)
From Hell (2001, Hughes brothers,
PD Martin Childs)
Iris (2001, Richard Eyre, PD Gemma Jackson)
Jubilee (1978, Derek Jarman,
PD Christopher Hobbs)
LA Confidential (1997, Curtis Hanson,
PD Jeannine Oppewall)
Leon (1994, Luc Besson)
Mad Max (1979, George Miller,
AD John Dowding)
Mad Men (2007–2015, AMC)
Marie Antoinette (2006, Sofia Coppola,
PD K. K. Barrett)
Minority Report (2002, Steven Spielberg)
My Beautiful Laundrette (1985,
Stephen Frears, PD Hugo Luczyc-Wyhowski)
Paris, Texas (1984, Wim Wenders,
PD Kate Altman)
Phantom of the Opera (1925, Rupert Julian)
Play Things (1976, Stephen Frears,
BBC2 Playhouse)
Private Affairs (A Dream of Living)
(1975, Philip Saville, BBC)
Sex and The City series (1998–2004)
Shakespeare in Love (1998, John Madden,
PD Martin Childs)
Sunset across the Bay (1975, Stephen Frears)
Sunset Boulevard (1950, Billy Wilder)

The English Patient (1996, Anthony
Minghella, PD Stuart Craig)
The Fallen Idol (1948, Carol Reed)
The Grand Budapest Hotel (2014,
Wes Anderson, PD Adam Stockhausen)
The Third Man (1949, Carol Reed, PD Vincent
Korda, Joseph Bato, John Hawkesworth)
Tinker, Tailor, Soldier, Spy (2011,
Tomas Alfredson, PD Maria Djurkovic)
Vertigo (1958, Alfred Hitchcock)
Withnail & I (1987, Bruce Robinson)
Z Cars (1962–1978, BBC)

FURTHER RESOURCES

Art Directors Guild, http://www.adg.org.

BECTU (https://www.bectu.org.uk/home) who have an 'early bird' production listing for members only.

BFI Screen Online: articles, stills and resources relating to British cinema,

British Film Designers Guild, http://www.filmdesigners.co.uk.

Chic Fun Gory Silly, https://lisamariehall. wordpress.com/chic-fun-gory-silly/.

Cinema Style, http://wwwcinemastyle. blogspot.co.uk/.

David Jetre blog, https://jetrefilm.wordpress. com/.Edward Hopper, http://www.edwardhopper.net.

Eldest & Only, https://eldestandonly.com/.

Kays Production Guide (https://www.kays.co.uk/) and *The Knowledge* (http://www.theknowledgeonline.com/) are publications that print names, titles and contact details. These books can be found in larger public libraries.

Magnum P.I. set decorator, http://magnumdecorator.blogspot.co.uk/.

Scala Archives, http://scalaarchives.com.

Screen International (http://www.screendaily. com/) prints productions that are currently shooting.

http://www.screenoline.org.uk.

Set Decorators Society, http://www.setdecorators.org/.

Set Design Magazine, http://setdesignmag.blogspot.co.uk/.

The Designer's Assistant, https://thedesignersassistant.com/.

Upstaged by Design, https://upstagedbydesign.com/.

Production design courses
The following institutions run courses in production design:

UK and Ireland
London Film School, UK
National Film and Television School, Beaconsfield, UK
National Film School, IADT, Dun Laoghaire, Ireland
Northern Film School, Leeds Beckett University, UK
Nottingham Trent University, UK
University for Creative Arts, Surrey, UK
University of South Wales, Cardiff, UK
Wimbledon College of Arts, University of the Arts, London, UK

Europe
Academy of Dramatic Arts, Zagreb
COFAC – Universidade Lusofona, Lisbon, Portugal
FAMU, Prague
Filmakademie Baden-Wurttemberg, Germany
Filmuniversitat Babelsberg Konrad Wolf, Potsdam, Germany
IFS Internationale Filmschule Koln, Germany
National Film School of Denmark
National Film School of Norway
Netherlands Film Academy
RITS School of Arts, Brussels

USA and Australia
Chapman University, CA, USA
Design Institute of Australia
NYU Tisch, USA
USC University of Cinematic Arts, USA

ACKNOWLEDGEMENTS

The compendium of film sets, „setscene",
www.setscene.org

The iOS app „setscene" analyses movie sets throughout cinema history and is available for iPhone/iPad. It helps the reader become acquainted with films in a new, innovative manner: where are scenes of comedies or horror films set? Do some directors prefer specific sets, locations, settings? Which movies have been set in trains, or in a skyscraper, a wine cellar, etc.? The sets are structured by searchable semantic categories. The interior or the set of the particular movie will be shown as a still. People in the media business and media theorists use „setscene" for studying scenography, lighting design and the practice of decor in set design.

The „setscene" research project is led by Prof. Heizo Schulze, department of Media Production, University of Applied Sciences Ostwestfalen-Lippe, Lemgo, Germany. The „setscene" app explicitly examines spatial relations; the story of the film is not considered at present.

Magazines and journals

American Cinematographer
Architectural Digest
Azure
Dwell
Elle Decor
Interior Design
Perspective: The Journal of the Art Directors Guild
Set Decor
The Costume Designer
The Scenographer
The World of Interiors
Wallpaper

Thank you to the following: the production designers, set decorators and art directors who gave me their time and generously shared their insights, including: Moira Tait, Stuart Craig, Hugo Luczyc-Wyhowski, Anna Pritchard, Mimi Gramatky, Alex McDowell, Tatiana Macdonald, Jim Bissell, Malcolm Thornton, Gemma Jackson, Jim Clay, Martin Childs, Ronald Gow, Christopher Hobbs, Kave Quinn; Vicky Ralph (Stuart Craig's assistant) and Emily Wanserki (Alex McDowell's assistant); Samantha Babrovskie, senior lecturer at the Northern Film School, Leeds Beckett University and her graduates from the BA (Hons) Filmmaking (specializing in production design); Anna Solic, course leader of TV and Film Set Design and her students at the University of South Wales, Cardiff; the graduate and student contributors: James Wilkinson, Samuel Thornhill, Liya Ye, Siqi Zhang, Elisa Scubla, Kit Dafoe, Amy Smith, Tom Turner, Ashley Phocou and Yasmin Topliss; Maria Harman and Paolo Felici at *The Scenographer*, the *International Journal of Production and Costume Design*; and Leonard Morpugo at Weissman Markotitz Communications. Thank you also to all at the GEECT Symposium, Ireland, 2015 for reminding me that there is an audience for production design (organized by Donald Taylor Black and Sarah Gunn) and all at the Lancaster University Perspectives on Production Design Symposium, 2013 (organized by Bruce Bennett and Catherine Spooner).

This book is dedicated to my students from the past and present – who have been a never-ending source of learning, laughter and frustration; to Rob and Ruby for intermittent encouragement and constant distraction; to Robert Murphy for introducing me to the wonderful world of Powell and Pressburger during film school and all of his support and encouragement since; to Lynsey Brough and James Piper at Bloomsbury for patience and attention to detail; and of course to members of the Barnwell and Napoletani family for the usual 'Haven't you finished it yet…why is it taking so long?' Due to the international nature of this publication it is my understanding that zs are going to replace ss in my text. I would like to make clear that this is not my personal preference for spelling and in particular wish to reassure my mother that I do not use a z where an s should be.

GLOSSARY

Art Department – the team who work under the supervision of the production designer.

Art Director (AD) – previously the head of the Art Department, now the person working directly for the production designer.

Aspect ratio – the numerical relationship of the height and width of the image frame used in film and television. There are several standard aspect ratios used internationally.

Back and front projection – a photographic technique where live action is filmed in front of a transparent screen, onto which the background action is projected. Often used to create the effect of a vehicle in motion for an interior scene. Green screen provides a more sophisticated solution to this; however, back projection is sometimes used for deliberate stylistic effect.

Backlot – the outdoor studio area where exterior sets are built.

Blocking a scene – how a director positions actors on set in relation to dialogue, movement and camera specificity.

Camera angle projection – a system of perspective, drawing where the dimensions on a plan and elevation can be processed according to the camera angles of a particular lens and aspect ratio.

Chiaroscuro – the use of strongly contrasting light and shade to create depth, and used for pictorial and dramatic effect in terms of character and story.

Colour temperature – Different light radiates different intensities – the subsequent colour temperature is measured in degrees kelvin. The warmer the colour, the lower the kelvin rating, while colder colours have a higher colour temperature. For example, North light with a blue sky is 10, 000 degrees kelvin while noon daylight in direct sun is 5,000 degrees kelvin.

Composite – combining more than one image into a single image, usually involving additional background or foreground shots to embellish a set or existing location.

Computer aided design (CAD) – software that produces architectural drawings, technical plans for the building of sets.

Director of Photography (DoP or DP) – the head of the camera department.

Establishing shot – introducing a setting where a scene will play out, establishing the environment usually in a wide shot.

Expressionism – depiction of a subject though emotional and psychological means to appear distorted in comparison to realist representations.

Green screen or blue screen – the monochrome background that has been shot against is digitally replaced in post-production by chroma keying other footage in from the background. A studio environment where settings can be digitally stitched together with live action.

Master shot – a shot that covers the whole scene, including all of the elements within it (as opposed to breaking down into close-ups, reverse and point-of-view shots that favour separate elements of a scene).

Matte shots – a photographic technique where a painting is combined with live action to create a setting.

Mise en scène – a French term referring to the composition of visual elements in the frame.

Motivated light source – the artificial light source positioned to indicate a realistic lighting design for the intended setting.

North light – light coming from the sky in the Northern hemisphere (often preferred by artists).

Poetic realism – 1930s French film movement.

Production bible – a file or book full of visual research and reference material gathered for each production.

Production designer (PD) – formerly the supervisor of the Art Department, now the person responsible for the look of the film.

Realism – exists across the arts and literature as an attempt to portray real life with an emphasis on the everyday. In cinema, the lives of ordinary people became the focus, with the dominant themes being Italian neorealism in the 1940s, French nouvelle vague in the 1950s, British social realism in the 1960s and new Hollywood in the late 1960s and 1970s.

Recce – short for reconnaissance – a field trip to all possible shooting locations to access suitability in terms of technical, practical and aesthetic considerations.

Scale models – a small-scale version of a set to enable an understanding of the design in three dimensions prior to building.

Script breakdown – a systematic way of putting script elements into a table divided up according to location and scene with all Art Department requirements listed e.g. props, dressing, vehicles, graphics.

Standing backlots – a backlot of stock settings usually featuring several standard sets; for example, streets with houses, shops, a bank, that can be used for a number of productions.

Trompe l'oeil – meaning 'deceives the eye', this is an art technique used to create the optical illusion of three-dimensional space.

Visual concept – the key idea creating visual coherence in production design.

Visual metaphor – a visual that represents something else, often in support of the overarching visual concept of a screen production.

Visual motif – a recognizable distinctive image often recurring to create patterns.

World building – a term used to describe the creation of an environment by the production designer.

PICTURE CREDITS

All reasonable attempts have been made to trace, clear, and credit the copyright holders of the images reproduced in this book. However, if any credits have been inadvertently omitted, the publisher will endeavor to incorporate amendments in future editions.

p3: Courtesy of Alec Fitzpatrick

INTRODUCTION
0.1: Méliès / Star / The Kobal Collection
0.2: Pathé Frères / The Kobal Collection
0.3: Itala Film Torino / The Kobal Collection
0.4: Wark Producing Company / The Kobal Collection
0.5: Decla-Bioscop / The Kobal Collection
0.6: United Artists / The Kobal Collection
0.7: United Artists / The Kobal Collection
0.8: Selznick / MGM / The Kobal Collection
0.9: MGM / The Kobal Collection
0.10: MGM / The Kobal Collection
0.11: Universal / The Kobal Collection
0.12: Warner Bros. / The Kobal Collection
0.13: Industria Cinematografica Italiana / The Kobal Collection
0.14: Columbia / The Kobal Collection
0.15: Black Narcissus (1947, Dir. Powell & Pressburger, PD. Alfred Junge)
0.16: Danjaq / EON / UA / The Kobal Collection

CHAPTER 1
1.1: © Jane Barnwell
1.2: © Jane Barnwell
1.3: © Jane Barnwell
1.4: Courtesy of Elisa Scubla
1.5a-b: Courtesy of Anna Pritchard
1.6: Courtesy of Elisa Scubla
1.7a-b: Courtesy of Anna Pritchard
1.8a-b: Courtesy of Siqi & Liya
1.9a-b: Courtesy of Elisa Scubla
1.10a-b: Courtesy of Anna Pritchard
1.11a-b: Courtesy of Tom Turner
1.12: Courtesy of Anna Pritchard
1.13: 'Clay' produced by James Wilkinson, directed by Samuel Thornhill
1.14: Courtesy of Mimi Gramatky
1.15a-b: Courtesy of Siqi & Liya
1.16a-g: Courtesy of Mimi Gramatky
1.17a-b: 'Clay' produced by James Wilkinson, directed by Samuel Thornhill
1.18: 'Clay' produced by James Wilkinson, directed by Samuel Thornhill
1.19: Courtesy of Tatiana MacDonald
1.20a-b: Courtesy of Elisa Scubla
1.21: Courtesy of Siqi & Liya
1.22a-b: 'Clay' produced by James Wilkinson, directed by Samuel Thornhill
1.23: Courtesy of Siqi & Liya
1.24: Courtesy of Siqi & Liya
1.25a-d: Kit Patrick Dafoe
1.26a-b: Courtesy of Anna Pritchard

CHAPTER 2
2.1 (top): Black Narcissus (1947, Dir. Powell & Pressburger, PD: Alfred Junge / General Film Distributors)
2.1 (bottom): The Archers / The Kobal Collection
2.2: Universal / The Kobal Collection
2.3a-b: Courtesy of Alec Fitzpatrick
2.4: Lionsgate / The Kobal Collection
2.5: Lionsgate / The Kobal Collection
2.6: The Archers / The Kobal Collection
2.7: Black Narcissus (1947, Dir. Powell & Pressburger, PD: Alfred Junge / General Film Distributors)
2.8: Courtesy of Elisa Scubla
2.9a-b: Rebecca (1940, Dir. Alfred Hitchcock, Art Direction: Lyle R. Wheeler / Selznick International Pictures, United Artists)
2.10: PEA / The Kobal Collection
2.11: Channel 4 Films / Glasgow Film Fund / The Kobal Collection
2.12: Channel 4 Films / Glasgow Film Fund / The Kobal Collection
2.13: Universal / Embassy / The Kobal Collection
2.14a-d: The Legend of Tarzan (2016, Dir. David Yates, PD: Stuart Craig / Village Roadshow Pictures, Warner Bros. Pictures)

CHAPTER 3
3.1a-b: Courtesy of Tom Turner
3.2: Courtesy of Alex McDowell
3.3: Warner Bros. / The Kobal Collection
3.4: Jim Henson Productions / The Kobal Collection
3.5: Universal / The Kobal Collection
3.6: Columbia / The Kobal Collection
3.7: Courtesy of James Bissell
3.8: Courtesy of Dan Fishburn
3.9a-d: Courtesy of Tom Turner
3.10a-d: Minority Report (2002, Dir. Steven Spielberg, PD: Alex McDowell / Amblin Entertainment, DreamWorks Pictures, 20th Century Fox)

CHAPTER 4

4.1: Mildred Pierce (1945, Dir. Michael Curtiz, PD: Anton Grot, Bertram Tuttle / Warner Bros.)

4.2a-d: Courtesy of Amy Smith

4.3a-e: Spellbound (1945, Dir. Alfred Hitchcock, PD: James Basevi / Selznick International Pictures/ Vanguard Films, United Artists)

4.4: Warner Bros. / The Kobal Collection

4.5a-b: Courtesy of Tom Turner

4.6: Universal / The Kobal Collection

4.7: Universal / The Kobal Collection

4.8: Weinstein Company / Fade to Black / The Kobal Collection / Grau, Eduard

4.9: Paramount / The Kobal Collection

4.10: Courtesy of Tom Turner

4.11: MGM / The Kobal Collection

4.12: 20th Century Fox / The Kobal Collection

4.13: Warner Bros. / The Kobal Collection

4.14: Mildred Pierce (1945, Dir. Michael Curtiz, PD: Anton Grot, Bertram Tuttle / Warner Bros.)

4.15: Universal / The Kobal Collection / Moseley, Melissa

4.16: Paramount / The Kobal Collection

4.17: Mildred Pierce (1945, Dir. Michael Curtiz, PD: Anton Grot, Bertram Tuttle / Warner Bros.)

4.18: Liberty Films UK / The Kobal Collection

4.19: Excelsa / Mayer-Burstyn / The Kobal Collection

4.20: Sex and the City (1998-2004, Darren Star / HBO, Warner Bros)

4.21a-d: My Beautiful Laundrette (1985, Dir. Stephen Frears, PD: Hugo Luczyc-Wyhowski / Working Title Films / Channel Four Films, Orion Classics)

CHAPTER 5

5.1: 20th Century Fox / The Kobal Collection

5.2a-b: Courtesy of Tom Turner

5.3: Courtesy of Elisa Scubla

5.4: Betty Blue (1986, Dir. Jean Jacques Beineix, PD: Carlos Conti / Gaumont)

5.5: Working Title / BBC / Br Screen / The Kobal Collection

5.6: Warner Bros. / The Kobal Collection

5.7: Courtesy of Mimi Gramatky

5.8: 20th Century Fox / The Kobal Collection / Vollmer, Jurgen

5.9: 20th Century Fox / The Kobal Collection / Vollmer, Jurgen

5.10: Wiedemann & Berg / The Kobal Collection / Keller, Hagen

5.11: 20th Century Fox / The Kobal Collection

5.12: 20th Century Fox / The Kobal Collection

5.13: Photo by Francis G. Mayer / Corbis / VCG via Getty Images

5.14: Paramount / The Kobal Collection

5.15: The Art Archive / DeA Picture Library

5.16a-c: Courtesy of Ronald Gow

CHAPTER 6

6.1: E.T. the Extra-Terrestrial (1982, Dir. Steven Spielberg, PD: Jim Bissell / Amblin Entertainment, Universal Pictures)

6.2: Courtesy of Elisa Scubla

6.3a-c: Courtesy of Tom Turner

6.4: 20th Century Fox/The Kobal Collection/ Adler, Sue

6.5: Road / Argos / Channel 4 / The Kobal Collection

6.6a-b: Courtesy of James Bissell

6.7a-e: Courtesy of James Bissell

6.8a-p: Courtesy of James Bissell

CHAPTER 7

7.1: 20th Century Fox / The Kobal Collection / Vollmer, Jurgen

7.2: Courtesy of Tatiana MacDonald

7.3: Production design by Moira Tait

7.4: 20th Century Fox / The Kobal Collection / Vollmer, Jurgen

7.5a-c: Sex and the City 2 (2010, Dir. Michael Patrick King / New Line / HBO, Warner Bros.)

7.6a-b: My Beautiful Laundrette (1985, Dir. Stephen Frears, PD: Hugo Luczyc-Wyhowski / Working Title Films / Channel 4 Films, Orion Classics)

7.7a-d: Production design by Moira Tait

7.8: AMC / The Kobal Collection

7.9: Marie Antoinette (2006, Dir. Sofia Coppola, PD: K K Barrett / Pricel / Tohokushinsha / American Zoetrope, Columbia Pictures)

7.10: Warner Bros. / The Kobal Collection

7.11a-b: Courtesy of Tatiana MacDonald

7.12a-g: Courtesy of Maria Djurkovic

APPENDIX

8.1: Courtesy of Tom Turner

INDEX

8 ½ (1963) 70
10,000 Days (2014) 40, *41*, 67, 135, *135*
12 Angry Men (1957) 118

About A Boy (2002) 65, 105, 108, 179
Adam, Ken *18*, 141, 189
Against Nature (Huysmans) 111, *111*, *130*, 131
Albers, Josef 153
Alien (1979) 115, *115*
Allen, Woody 58
Amélie (2001) 154
Anderson, Wes 84
animals 47, *47*
architecture 31–2, *32*, 83–4, 87, 99–100, 185
Atonement (2007) 187
auteur theory 7, 17

Bacon, Francis 72
Ballets Russes 185
Banaroo (2015) 157–8, *157*, *158*
Barry Lyndon (1975) 142
Barsacq, Leon 19, 58
Batman (1989–2012) 132
Battleship Potemkin (1925) 117
Bauhaus School 153
Becky Sharp (1935) 152
Being John Malkovich (1999) 117, *117*
Bellantoni, Patti 151
Belton, John 159
Bennett, Alan 177
Berkeley, Busby 16, *16*
Bertolucci, Bernardo 26
Betty Blue (1986) 108, *132*
Birth of a Nation (1915) 11
Bishop, Dan 186
Bissell, Jim 92, 93, 155, 162–9, *163*, *164*, *165*,
 166, *167*, *168*, *169*, 208
black-and-white filmmaking 152
Black Narcissus (1947) 18, *18*, 63, *63*, 160
Blade Runner (1982) 95, 132, 141
Bond films *18*, 19
boundaries 105–17
Brazil (1985) 74, *75*, 183
Breaking Bad (2008–2013) 132
Bridget Jones's Diary (2001) 69, 92, 105, 106,
 175
Bringing Out the Dead (1999) 132

budgets 38–9
Bumstead, Henry 26, 58, 177

Cabinet of Dr Caligari, The (1919) 12, *12*, 86
Cabiria (1914) 11, *11*
Calling of St Mathew, The (Caravaggio) 142,
 143
Captain Corelli's Mandolin (2001) 72
Caravaggio (1986) 60, 143, 181
Caravaggio, Michelangelo Merisi da 142, 143,
 143, 152
Carnage (2011) 118
Carrick, Edward 17
Cave of The Yellow Dog, The (2005) 121
characters 34, *34*, 68–9, 134–9, 156–8, 175–82
Chicago (2002) 140
Children of Men (2006) 140
Childs, Martin 44, 59, 74, 84, 90, 94, 156, 158,
 176, 178, *178*, 183, 188, 189, 208
Chinatown (1974) 68, 154
Christina's World (Wyeth) 142
chroma key 47
cities 120–1, *120*, *121*
Clay (2014) 38, *39*, *42*, *43*, 46, *46*, 200–3
Clay, Jim 58, 63, 65, 68, 72, 73, 134, 208
Clooney, George 162, 163
Closer (2004) 91, *91*
Cloud Atlas (2012) 110, *110*, 115, *115*, 117,
 134, 135, 182, 188–9
collaborations 26, 58
colour 59, 140, 151–69
computer-generated imagery (CGI) 19, 25, 47
contrast 62–4, *62*, *63*, *64*
Cook, The Thief, His Wife and Her Lover, The
 (1989) 161
Copycat (1995) 72
corridors 114–15, *114*, *115*, 131
costume design 47, 156, 159–60, 161, 178
Craig, Stuart 31, 57, 63, 76–8, *77*, *79*, 85, 131,
 140, 141, 155, 181, 209
Curtis, Richard 58, 68

Dark City (1998) 132
Days of Heaven (1978) 142, *142*
Delicatessen (1991) 94, 133
Descendent of Mary Magdalene, The (2014)
 48, *49*

deserts 121
de Wolfe, Elsie 185
Didul, Claudette 186
Dirty Pretty Things (2002) 124–5, 131
Diva (1981) 154
Djurkovic, Maria 156, 175, 190, *191*, 192–3, *192*
Dogville (2003) 177
Don't Look Now (1973) 159
doorways 108–10, *109*, *110*, 131, 133
Do the Right Thing (1989) 60, *60*, 112, *112*
Dracula (1992) 160
Dream of Living, A (1975) *184*
dreams 69–70
Drier, Hans 15
Dr Strangelove (1964) 92
Dyas, Guy Hendrix 31

Eastwood, Clint 26, 58
Easy Rider (1969) 131
Edward II (1991) 133, *133*
Elizabeth: The Golden Age (2007) 31
emotions and colour 153–5
End Of Violence, The (1997) 141
English Patient, The (1996) 60, 121, 181
Escher, M. C. 87
E.T. the Extra- Terrestrial (1982) 155, 162–3
expressionism 12, *12*, 16, 18, 19, 57, 86, 132
exteriors 105–6, 120–1, *120*, *121*

Falcon and the Snowman, The (1985) 162
Far From Heaven (2002) 140
Ferretti, Dante 70, 90
Fight Club (1999) 92
filming schedule 39
film noir 16, 74, 86, 132
films, as inspiration 74, 188
Finding Neverland (2004) 179
Fishburn, Dan 95–6, *95*
Fitzpatrick, Alec 61, *61*
framing 108
French New Wave 17
Freud, Sigmund 69
Friends (1994–2004) 121
From Hell (2001) 59, 136–7, *136*, 178, *178*
furniture 183, *184*
Fuseli, Henry 69
future 188–9, *188*

Game of Thrones (2011) 62
German Expressionism 12, *12*, 86
Gibbons, Cedric 15
Gilliam, Terry 83
Girl With a Pearl Earring (2003) 143
Godfather (1901–1980) 60, 108
Gone with the Wind (1939) 14, *14*, 117
Good Night, and Good Luck (2005) 93, *93*, 162, 163, *163*, 168
Gormenghast (2000) 133
Gow, Ronald 144–6, *144*, *145*, *147*, 209
Gramatky, Mimi 40, *41*, 58, 67, 74, 135, *135*, 156–7, 209
Grand Budapest Hotel, The (2014) 117, *138*, 139, *139*, 181
Great Beauty, The (2013) 120
Greenaway, Peter 84
Green Mile, The (1999) 158
Grot, Anton 15

hair design 47
Harry Potter (2001–2011) 19, 117, 140
Hart, Jay 187
Heckroth, Hein 26, 155
height 94
Her (2013) 140, 161
historical period 31–2, *32*, 185–8, *186*, *187*
Hobbs, Christopher 70, 133, 181, 185
Hogarth, William 142
Hollander, Anne 67
Hollywood studio system 14, 15–19
Home from the Hill (1960) 161
Hopper, Edward 72, 141–2, *141*
hotels 88, 89
Hours, The (2002) 140
House by the Railroad (Hopper) 142, *142*
Hunger Games, The (2012) *62*, 63

idea development 29–30, *29*, *30*
Imitation Game, The (2014) 193, 194
Inception (2010) 87
Incredible Shrinking Man, The (1957) *90*
Inside Men (2012) *29*, 32, *32*, 35, *35*, *37*, 50–2, *51*, *53*
interiors 10, *10*, 11, 105–6, 118–19, *119*
Intolerance (1916) 11, *11*
invisible decor 176–7

Invisible Woman, The (2013) 193
Iris (2001) 42, 65, 156, 177–8
Island, The (2005) 88
Italian neorealism 17

Jack and the Beanstalk 96, *96*, *97*
Jackson, Gemma 37, 42, 62, 65, 69, 91, 92, 106, 108, 156, 175, 177–8, 179, 210
Jubilee (1978) 176–7

Kalmus, Natalie 153
Kamiński, Janusz 155
Kandinsky, Wassily 152
Killing Time (1996) 144–6, *144*, *145*, *147*
Kubrick, Stanley 142

Labyrinth (1986) 87, *87*
Lacan, Jacques 69
LA Confidential (1997) 187
Lamont, Peter *18*, 189
landscapes 121
Last Tango in Paris (1972) 70, *71*, 161
Lee, Spike 26
Legend of Tarzan, The (2016) 76–8, *77*, *79*
Le Jour se Lève (1939) 116
lens flares 131
lifts 116–17, *117*
light 59, 129–47
Lives of Others, The (2006) 137, *137*
location shooting 17, 19, 33, 42, *42*, *43*, 119; *see also* exteriors
Long Day Closes, The (1992) 70
Lord of The Rings (2001–2003) 108, 121
Losey, Joseph 26
Lourie, Eugene 26
Love Actually (2003) 58, 68
Luhrmann, Baz 19, 26
Lust for Life (1956) 143

McCann, Ben 116
MacDonald, Richard 26
Macdonald, Tatiana *44*, 156, *174*, 175, 190–4, *191*, *193*, *195*
McDowell, Alex 25, 68, 85, *85*, 98–101, *99*, *100*, *101*, 138, 155, 174, 181, 210
Mad Max (1979) 188, *188*
Mad Men (2007–2015) 185–6, *186*

make-up design 47, 178
Malcolm X (1992) 161
Man of Steel (2013) 86, *86*
Mapplethorpe, Robert 73
Marie Antoinette (2006) 187, *187*
Marnie (1964) 159
Marsh, Terence 158
Martin, Catherine 19, 26
Match Point (2005) 58
materials and texture 189
Matrix, The (1999) 88, 108, 158
Matter of Life and Death, A (1946) 18, 117, 154
Mean Streets (1973) 142
Méliès, Georges 10
memories 69–70
Menzies, William Cameron 14
Metropolis (1927) 13
Miami Vice (1984) 156
Mildred Pierce (1945) 116, *116*, 118, *118*
Minority Report (2002) 19, 25, 67, 95, 98–101, *99*, *100*, *101*, 138, 140, 155, 181, 188
mirrors 182, *182*
models 13, 37, *37*
Money Pit, The (1986) 117
mood boards 29, *29*
Moon (2009) 118, *119*
Moor, Andrew 26
Moulin Rouge (2001) 19, 159
Mrs. Brown (1997) 44
Mr. Turner (2014) 143
museums 88, 89
music, as inspiration 72
My Beautiful Laundrette (1985) 73, 122, *123*, 125, *181*, 182, *182*

nature 121
Neverwhere (Gaiman) 95–6, *95*
Newton, Helmut 73
New York 121, *121*
New York Movie (Hopper) 141, 142
Nicholls, Mike 26
Nighthawks (Hopper) 141, *141*
Nightmare, The (Fuseli) 69
Nightwatching (2007) 143
Nil by Mouth (1977) 34, 94, 105, 124, 125
Notting Hill (1999) 94, 105, 106

INDEX

Onegin (1999) 68
On The Waterfront (1954) 17, *17*
Opewall, Jeannine 187
Our Dancing Daughters (1928) 13, *15*

Paddington (2014) 94, 161
paintings 69, 72–3, 87, 108, 141–3, *141*, *142*, *143*, 152–3
Panic Room (2002) 72
Pan's Labyrinth (2006) 140
Paris, Texas (1984) 121, 160–1, *160*, 182
Pastrone, Giovanni 11
Pennies from Heaven (1981) 141
Perrier, Jean 13
Phantom of the Opera (1925) 181
Phocou, Ashley 206–7
photographs, as inspiration 73
Picasso, Pablo 152
Play Things (1976) 176–7, *177*
poetic realism 12, 57
Polglase, Van Nest 15
Porter, Edwin S. 10
postmodernism 19
Powell, Michael 18, 26
Pressburger, Emeric 18, 26
Pritchard, Anna *29*, 32, *32*, 35, *35*, *37*, 50–2, *51*, *53*, 210
props 25, 27, 34, *34*, 42, 44, *44*, *45*, 181–2, 183, *184*
Psycho (1960) 138–9, 142
psychology and colour 153–5

real and imagined worlds 85–8
realism 11, 12, 19, 57, 120, 152, 175, 176, 194
Rear Window (1954) 113, *113*
Rebecca (1940) 65, *66*
red (colour) 159–61
Rembrandt Harmenszoon van Rijn 143, 152
Renoir, Jean 26
Rewrite, The (2014) 137
Road to Perdition (2002) 142
Robin Hood (1922) 13, *13*
Rocketeer (1991) 164, *164*, *165*
Rocky (1976) 117
Rome 120, *120*

Rope (1948) 159
Rules of the Game (1939) 145

Sabriel (Nix) 106–7, *106*, *107*
St Vincent (2014) 137
scale 90, 183, *184*
Scarfiotti, Fernando 26, 70, *71*
Schindler's List (1993) 161
Scorsese, Martin 142
script breakdown 27, *27*, *28*
Scubla, Elisa *28*, *30*, 34, 64, *64*, *131*
Seinfeld (1989–1998) 121
Servant, The (1963) 65
set decoration and dressing 34, *34*, 42, *43*, 44, *44*, *45*, 59, 173–95, *184*
Sex and the City 2 (2010) *179*, 180, *180*
Sex and the City (1998–2004) *121*, 179–80, *180*
Shakespeare In Love (1998) 84, 94, 189
Shallow Grave (1994) 72, *72*, *73*, 94
shapes 84
Sheltering Sky, The (1990) 121
Shiel, Mark 152
Shining, The (1980) 87, 114, 136
shooting script 39
Single Man, A (2009) 112–13, *113*
Sixth Sense, The (1999) 161
size 90, 183, *184*
sketches 35, *35*
Smith, Amy 106–7, *106*, *107*
space 59, 83–101
special effects 10, 47, *48*, *49*
Spellbound (1945) 108–10, *109*
Spiderwick Chronicles, The (2008) 164, *166*, *167*, 168, *168*, *169*
staircases 116–17, *116*, *117*
Star Trek (2009) 131
Stevens, Robert Mallet 13
Stewart, Eve 108
stock settings 15, 88–9
story 68, 134–9, 156–8
storyboards 30, *30*
studio shooting 33, 40, *40*, *41*, 119
Subway (1985) 135
subways 88, 89
Sunset across the Bay (1975) 177

Sunset Boulevard (1950) 19, 181
surrealism 70
Sylbert, Richard 26, 58, 68

Tait, Moira 141, 156, 176–7, *177*, 183, *184*, 211
Tarantino, Quentin 74
Tashiro, Charles 69
technical drawings 36, *36*
Terminal, The (2004) 93
Thief of Baghdad, The (1924) 13
Third Man, The (1949) 74, 188
Thomas, Wynn 26
Three Colours (1993–4) 154
Thrice (2014) 33, 40, 45, 47
Tinker Tailor Soldier Spy (2011) 44, 156, *174*, 175, 190–3, *191*, *192*, *193*, 194, *195*
Topliss, Yasmin 204–5
Total Recall (1990) 88
Traffic (2000) 140
transformation 65, *66*
transitions 105–17
Trauner, Alexander 116
Truman Show, The (1998) 88
Turner, J. M. W. 143
Turner, Tom 96, *96*, *97*, 111, *111*, 114, *114*, *130*, 131, 157–8, *157*, *158*

Van Gogh, Vincent 143
vehicles 46, *46*, *47*
Vermeer, Johannes 143
Vertigo (1958) 117, *117*, 154
V for Vendetta (2005) 140
Village, The (2004) 88, 161
Visit from Miss Prothero, A (1978) 156
Volver (2006) 161

Way Down East (1920) 12, *12*
Wharton, Edith 185
windows 108, 111–13, *111*, *112*, *113*, 131, 133
Withnail and I (1987) 69
Wizard of Oz, The (1939) 14, *14*, 114, *114*
Written on the Wind (1956) 145, 146
Wyhowski, Hugo 34, 73, 83, 94, 122–5, *123*, 131, 211